D0939157

Marcel Duchamp
Artist of the Century

edited by
Rudolf Kuenzli and
Francis M. Naumann

The MIT Press
Cambridge, Massachusetts
London, England

Fourth printing, 1996

First MIT Press paperback edition, 1990

Originally published as the journal *Dada/Surrealism,*
no. 16, by the Association for the Study of Dada and
Surrealism, The University of Iowa.
© 1987 Association for the Study of Dada and
Surrealism

Printed and bound in the United States of America.

Library of Congress Cataloging-in-Publication Data

Marcel Duchamp : artist of the century.

 Bibliography: p.
 1. Duchamp, Marcel, 1887–1968 – Criticism and
interpretation. 1. Dadaism – France. 3. Surrealism –
France. I. Kuenzli, Rudolf E. II. Naumann, Francis M.
N6853.D8M354 1989 709'.2'4 88-13035
ISBN 0-262-11136-5 (hb) 0-262-61072-8 (pb)

Contents

1 Introduction
Rudolf E. Kuenzli

I. ESSAYS

12 Marcel
Beatrice Wood

18 Marcel Duchamp: The Man, Even
Arturo Schwarz

20 Marcel Duchamp: A Reconciliation of Opposites
Francis M. Naumann

41 Resonances of Duchamp's Visit to Munich
Thierry de Duve

64 Marcel Duchamp's *Fountain:* Its History and Aesthetics in
the Context of 1917
William A. Camfield

95 The *Tzanck Check* and Related Works by
Marcel Duchamp
Peter Read

106 Duchamp's Silent Noise/Music for the Deaf
Carol P. James

127 Duchamp's Ubiquitous Puns
George H. Bauer

149 Duchamp's Eroticism: A Mathematical Analysis
Craig Adcock

168 Duchamp's Etchings of the *Large Glass* and *The Lovers*
Hellmut Wohl

184 Rendezvous with Marcel Duchamp: *Given*
Dalia Judovitz

II. DOCUMENTS

203 Marcel Duchamp's Letters to Walter and
Louise Arensberg, 1917–1921

228 Marcel Duchamp's *Des Délices de Kermoune*

III. BIBLIOGRAPHY

231 Marcel Duchamp: A Selective Bibliography
Timothy Shipe

Introduction
Rudolf E. Kuenzli

The check. The string he dropped. The Mona Lisa. The musical notes taken out of a hat. The glass. The toy shotgun painting. The things he found. Therefore, everything seen – every object, that is, plus the process of looking at it – is a Duchamp.

John Cage[1]

He declared that he wanted to kill art ("for myself") but his persistent attempts to destroy frames of reference altered our thinking, established new units of thought, "a new thought for that object."

Jasper Johns[2]

Has it already been a hundred years since Duchamp was born? He seems to belong to a younger generation – that of the post-1945 artists of Pop Art, Happenings, Op Art, Minimal Art, Fluxus, Conceptual Art, Postmodernism. They all felt that Duchamp belonged to them, that he was their "prototype." Rarely do we celebrate the hundredth birthday of an artist whose works seem so contemporary, exciting, and still provocative. In 1966, two years before his death, Duchamp felt that until very recently he had "had anything but a public life. What little public life I did have was in Breton's group, and with others who were interested in my work a bit."[3] Only in 1963, when Duchamp was seventy-six years old, did he have his first retrospective exhibition. Duchamp's "public life" has grown enormously since then through the intense interest of a new generation of artists, major exhibitions and an avalanche of interpretations. Robert Lebel, who published the first monograph on Duchamp in 1959, describes the sudden change of Duchamp's reputation and importance in his recent new edition:

[In 1959] I described Marcel Duchamp the way he could be defined then: complex personality, uncommon, distant, esoteric, retired for a long time from art after the unforeseeable sensation at the Armory Show in 1913. Only a few initiated were attracted to him. . . .

Then, suddenly, infatuation set in. The reasons for this elevation are contradictory, but they can be found primarily in the sudden emergence of "anti-art," or better, "anti-

esthetic" sentiments. This movement began in the United States, where the Pop artists attacked their too "arty" predecessors, the Abstract Expressionists, and Duchamp became the chosen precursor for this new wave.[4]

These artists were the first to recognize Duchamp's importance. Although Lebel is correct in situating the emergence of the artists' interest in Duchamp in the late fifties and sixties, the period of the major shift from a painterly tradition to a more conceptual artistic activity, he neglects Duchamp's impact on a much earlier generation of American artists and writers. From the moment he arrived in New York in 1915, Duchamp was a major catalyst. Charles Demuth's poem "For Richard Mutt," written in celebration of Duchamp's ready-made urinal – Duchamp signed it "R. Mutt 1917" – suggests his significance for that group of young American artists:

For some there is no stopping.
Most stop or never get a style.
When they stop they make a convention.
That is their end.
For the going everything has an idea.
The going run right along.
The going just keep going.[5]

Duchamp inspired the young artists in Walter Conrad Arensberg's circle to "go on" exploring new subject matter, new media, and to throw off the burden of conventional art. For Stuart Davis, Duchamp's *Fountain* was a "time bomb." He recalls that "Duchamp's suggestion worked slowly. Unesthetic material, non-arty material – ten years later I could take a worthless eggbeater, and the change to a new association would inspire me."[6] Duchamp's *Fountain* also assisted in the making of another plumbing device, Elsa von Freytag-Loringhoven and Morton Schamberg's *God* (1918). Man Ray's ironic, mechanical *Self-Portrait* (1916), an assembly of ready-made objects, or his photograph of an eggbeater which he entitled *L'Homme* (1918) can easily be related to Duchamp's notion of the readymade. Duchamp's *Large Glass* incited Joseph Stella to experiment with glass himself in his *Man in Elevated (Train)* (1918); his *Chocolate Grinder* (1914) encouraged Demuth and Schamberg to work with mechanistic forms. John Covert's precisionist art, with its visual puns and use of non-art material, invokes works by Duchamp, who considered Covert "an outstanding figure from the beginning."[7] But with the exception of works by Man Ray and Covert, the young Americans' experimenting lacked the irony, playfulness, eroticism and strategic nonsense of Duchamp's works. Nevertheless, these artists' interpretation of Duchamp's anti-art and a-art as a rejection of the European modernism that was exhibited at the Armory Show encouraged them to explore their own ways of bringing art and American life more closely together. Duchamp insisted on the Americans' rejection of European modernism very early, when he stated in an interview in 1915: "If only America would realize that the art of Europe is finished – dead – and that America is the country of the art of the future, instead of trying to base everything she does on European traditions!"[8]

Duchamp's works and ideas played a similarly liberating role for a more recent generation of artists after the Second World War. The intermediary between Duchamp and these young Americans was undoubtedly John Cage, who began his dialogue with Duchamp and his works in 1942.[9] Robert Rauschenberg and Jasper Johns were friends of Cage. Allan Kaprow, the theoretician of Happenings, George Brecht, Dick Higgins and other members of Fluxus studied with Cage, who saw in Duchamp a Zen master, a great liberator from any traditional conception of art, who creatively opened the way to new possibilities. Duchamp became the reference point for these young artists who opposed Abstract Expressionism – painting as personal expression appealing primarily to the eye. They found Duchamp's use of chance and his readymades most useful for their purposes. Everyday objects in chance positions and locations became works of art for the Nouveaux Réalistes, Fluxus, and Pop artists. Although they appropriated only a few of Duchamp's ideas, Duchamp applauded their break with tradition, their constant experimenting with and rethinking of art, their moving away from easel painting as far as possible. He only hoped that they would move on and not repeat themselves.[10] For post-1945 artists, Duchamp has been the most influential catalyst.

The artists' early interest in Duchamp's works was, however, not shared by museums. The first acquisition of a work by a French public collection occurred only in 1954, when Duchamp was sixty-seven years old. He was seventy-six at the time of his first retrospective exhibition at the Pasadena Art Museum, which was followed by the "almost complete" retrospective at the Tate Gallery in London in 1966. Other important exhibitions were organized only after his death: Philadelphia Museum of Art, 1973; Centre Georges Pompidou in Paris, 1977; Tokyo, 1981; Barcelona, 1984.

Duchamp must have realized after his work had not been accepted at the Salon des Indépendants in 1912, suppressed at the Independents exhibition in 1917, and ridiculed at the Armory Show, that his work was not understood by his contemporaries, that he had to wait for a future generation. "It's the posthumous spectator" who, according to Duchamp, is important, "because the contemporary spectator is worthless. . . . He is a minimum value compared to that of posterity."[11] While he was patiently waiting for a better understanding, his friends could see his works in the Arensbergs' salon, which was the gathering place of European and American artists, musicians, and writers, in Katherine Dreier's house, and in his own studio. Although he considered public exhibitions of his works as futile, he was actively engaged in exhibiting the works of his fellow artists. Together with Man Ray and Katherine Dreier he founded the Société Anonyme, the first museum of modern art in America. His installations of Surrealist exhibitions and his "Notes" for the Yale University catalogue of the Société Anonyme suggest that he did not reject the notion of the museum nor of exhibitions. He himself seems quite early to have had a plan for a future public display of his works gathered in one place. In giving his works to the Arensbergs and Dreier, he hoped that they would donate them to the same museum at a future date. In 1950 he wrote on the back of a preparatory drawing for the *Large Glass:* "I would be immensely grateful to the owner of this drawing, if

he consented to donate it to the Institution which eventually will own the *Large Glass* (of which this drawing is the first sketch). At this time, the *Large Glass* is owned by Miss Katherine S. Dreier, and she intends to bequeathe it to a museum."[12] Duchamp helped the Arensbergs and Dreier to acquire additional works of his, which he had given to other collectors. He assisted the Arensbergs in finding the Philadelphia Museum of Art for their collection, and helped to install his works there in 1954. As executor of Katherine Dreier's will, he made sure that the *Large Glass* also went to Philadelphia. And shortly before his death, he specified the precise location of his parting gift, *Etant donnés* (the title can also be read as *Et tant donné*) in his collection at Philadelphia.

But even prior to his establishing his own "museum" for a future generation, he repeatedly made new works by assembling his previous ones. *Boîte-en-valise* (1938–41), his portable museum with sixty-eight miniature reproductions of his works in an edition of three hundred, is only the most obvious example. The *Box of 1914* and *The Green Box* (1934) are carefully executed facsimile collections of his notes. Even some of his major works assemble, combine, resituate and recontextualize previous works: the *Large Glass*, which contains *Network of Stoppages*, the *Glider*, and the *Chocolate Grinder;* and *Tu m'*, which reproduces the shadows of several readymades.[13]

Throughout his life, Duchamp felt the need to assemble and collect his works. Although he never wanted to repeat himself, these assemblages of previous works and his collection at Philadelphia suggest that he wanted to preserve his works for a future public: "It is only a way of putting myself in the right position for that ideal public. The danger is in pleasing an immediate public; the immediate public that comes around you and takes you in and accepts you and gives you success and everything. Instead of that, you should wait for fifty years or a hundred years for your true public. That is the only public that interests me."[14]

Duchamp's reception by critics and art historians, like that by museums, occurred rather late. In France Guillaume Apollinaire and André Breton tried without much success to point out the significance of his work. The first monograph on Duchamp, by Robert Lebel, appeared in French and English in 1959, when Duchamp was seventy-two years old. Unlike the post-1945 artists who have selected and appropriated from Duchamp whatever they found productive for their own work, his commentators have attempted to establish thematic and iconographic continuities in his works and gestures. The systems of alchemy and psychoanalysis have been used to find the key to the meaning of Duchamp's work. Numerous inventive narratives have been proposed that tell the story from the *Large Glass* via related works to *Etant donnés*. These logical, coherent interpretations seem less and less convincing in light of the contradictory, polyvalent works of Duchamp. Paul Matisse, who attempted for years to "put together into a single whole" Duchamp's art, suggests that any imposition of a coherent structure or system forecloses the irreconcilable contradictions, which call for a different understanding: "Instead of altering our own structure of understanding so that this work and words could make sense to us just as they are, we have tried again and again to translate his expression into a

form that will fit into our own structure of understanding just as it has always been. What could be more natural?"[15] According to Jindřich Chalupecký, Duchamp's art "is alien to anything which could be called system: system of art, of theory, of society."[16] And François Lyotard refuses any attempt that recuperates meaning in Duchamp's work.[17]

The endlessly multiple and contradictory meanings in Duchamp's work challenge any interpretative discourse as perhaps no other work has done. It seems to defy any commentary. Confronted with this utter incomprehensibility, tempting radical "solutions" have been proposed. In 1924, Pierre de Massot published his "Wonderful Book," *Reflections on Rrose Sélavy.* It consists of a title page followed by blank pages.[18] Massot thus emphasizes the impossibility of any adequate statement about Rrose. Lyotard proposes that commenting about Duchamp would require a "counter-ruse: in talking about Duchamp, one would not try to understand and show that one understood, but rather the opposite: to try not to understand and to show that one did not understand."[19] According to these critics Duchamp's work, despite the hundreds of interpretations, remains an enigma that "insolently rejects any solution, any key which might be applied."[20]

The frustration, exasperation and puzzlement of Duchamp interpreters seems to be due largely to their persistent but hopeless attempt to find something which does not exist: a consistent meaning in a work by Duchamp. In order to avoid this futile search, we might shift our focus from a fixation on meaning to an analysis of Duchamp's strategies, through which he precisely explodes the notion of a single meaning, of identity. From his *Nu descendant un escalier* on, Duchamp's works seem to present processes that question the principle of identity, on which our whole understanding is based. *Nu* presents indeed an explosion, not so much of a shingle factory, but of identity, which is *mis à nu* through motion, process, and thus transforms the *nu* into a *nue* without fixity. The wordplay in the title consists in the inversion of *un* and *nu: un mis à nu*, identity stripped.[21] In his interview with Pierre Cabanne, Duchamp states: "I don't believe in the word 'being.' The idea of being is a human invention. . . . It's an essential concept, which doesn't exist at all in reality, and which I don't believe in."[22] His works and texts can be seen as machines that de-essentialize essentialist concepts of art, sexual identity, the self, meaning in language and iconography. His chief strategy consists in multiplying identities in order to undo any kind of fixity.[23] He therefore takes on the alter egos of Rrose Sélavy, R. Mutt, Marsélavy, marchand du sel. In the poster *Wanted* (1923) he parodies the wanted, desired ability to identify a person by taking on a multiplicity of identities: "George W. Welch, alias Bull, alias Pickens etcetery, etcetery. Operated Bucket Shop in New York under name HOOKE, LYON and CINQUER. . . . Known also under name RROSE SÉLAVY." He significantly used this work again in 1963 as exhibition poster for his first retrospective – an oeuvre of and by a multiplicity of contradictory identities.

Duchamp's most frequent strategy to dissolve essentialism, or, as he put it, "to break up forms – to 'decompose' them,"[24] is his use of puns and spoonerisms. In his interview with Katharine Kuh he states:

I like words in a poetic sense. Puns for me are like rhymes. . . . For me, words are not merely a means of communication. You know, puns have always been considered a low form of wit, but I find them a source of stimulation both because of their actual sound and because of unexpected meanings attached to the interrelationship of disparate words. For me, this is an infinite field of joy – and it's always right at hand. Sometimes four or five different levels of meaning come through.[25]

Duchamp's play with words, including his frequent switching from French to English pronunciation for the same word, dissolves any fixed, culturally assigned meaning and makes any attempt at establishing a definite understanding impossible. He collected some of his wordplays in *Rrose Sélavy & Co.* (1939), which includes the expression "La bagarre d'Austerlitz," a play on Napoleon's battle and the railway station (*gare*) in Paris. But it also is a homophone of "la bague, garde d'austère lits" (the ring, keeper of austere beds).[26] These three levels of contradictory meanings cannot be reduced, reconciled into one meaning. Duchamp therefore admired Alfred Jarry, Raymond Roussel, Jean-Pierre Brisset, and his co-conspirator Francis Picabia for their delirium of words. Some of his own nonsensical concatenations of similar-sounding words he put on rotating disks, such as "ESQUIVONS LES ECCHYMOSES DES ESQUIMAUX AUX MOTS EXQUIS," and used them in his *Anémic Cinéma* (1926). The rotating movement emphasizes the constant transformation from one meaning to another. Unlike Stéphane Mallarmé, who suggested in his poetry and in his *Mots anglais* underlying semantic connections between similarly sounding words, Duchamp uses homonyms in order to generate a multiplicity of meanings in every word, and thus to dissolve, explode any semantic identity. In radically disturbing the socially affixed meanings of words, Duchamp creates non-meaning, non-sense. Writing a text without any sense was his aim in "Meeting of Sunday," one of his first texts in English, which he sent to Arensberg in 1916. Arensberg shortly thereafter wrote a similar non-sensical text, significantly entitled "Vacuum Tires: A Formula for the Digestion of Figments," which was published in *TNT* in 1919.[27]

Duchamp's "infinite field of joy" in playing with words is, however, not restricted to his writing; it also informs most of his visual works. The pun, according to Robert Pincus-Witten, is "the central organizing principle of Duchamp's art."[28] André Gervais, in his *La raie alitée d'effets: Apropos of Marcel Duchamp* convincingly demonstrates that Duchamp's works, from his early cartoons to the readymades, to *The Bride Stripped Bare, Fresh Widow, Torture-Morte, sculpture-morte,* and *Morceaux choisis* are based on wordplays.[29] Duchamp himself stated that he was "interested in ideas – not merely in visual products. I wanted to put painting once again at the service of the mind. And my painting was, of course, at once regarded as 'intellectual,' 'literary painting.'"[30] He suggested to Pierre Cabanne that "art is taking more the form of a sign, if you wish; it's no longer reduced to a decorative role. This is the feeling that has directed me all my life."[31]

In addition to puns Duchamp uses chance, pseudo-science, and eroticism as productive strategies to confuse the identity principle. His *Three Standard Stoppages* (1913–14) exposes the arbitrariness of the conventional measuring unit and proposes, through the aid of chance, an unlimited number of differ-

ent units. Although the one-meter-long strings, which he drops from a height of one meter, are still one meter long on the floor, the linear measurement is always different because of the chance configuration of the strings. Chance functions like the puns; it "stops" identity, standardization, and replaces them with multiplicity. Duchamp commented that *Three Standard Stoppages* "tapped the mainspring of my future" and "opened the way to escape from those traditional methods of expression."[32] He again used chance in his *Erratum Musical* (1913) in order to replace the laws and strictures of musical composition with a new freedom in music. Chance occurrences, such as the dust on the *Large Glass* or the cracks which occurred in transporting it in 1926, were welcomed by Duchamp as additional levels of meaning.

His interest in non-Euclidean geometry and the fourth dimension can be seen as yet another strategy to dislocate cultural truths and systems. Like the Berlin Dadaists' use of Albert Einstein's principle of relativity in their critique of social formations, Duchamp's strategic use of the fourth dimension allows him to question everything that is two- or three-dimensional. His experiments in non-Euclidean geometry are a similar means to call into question the social constructions of reality based on the laws of Euclidean geometry.

Duchamp's eroticism, the only -ism he was tempted to subscribe to, is yet another of his strategic devices to question the social interpretation of reality. He saw his use of eroticism as "a way to try to bring out in the daylight things that are constantly hidden – and that aren't necessarily erotic – because of the Catholic religion, because of social rules. . . . [Eroticism] kept me from being obligated to return to already existing theories, aesthetic or otherwise."[33] Erotic works, such as *Female Fig Leaf* (1950), *Objet-Dard* (1951), *Wedge of Chastity* (1954), and *Etant donnés* (1946–66), which reveals so much (*Et tant donné*), function in part as a means to question the arbitrary moral laws and conventions.

Duchamp used alter egos, puns, chance, the fourth dimension, alchemy, non-Euclidean geometry and eroticism as strategies, and not as ends in themselves. He did not present a new set of geometric or alchemical truths, but used them as devices to question and dissolve the standardization of cultural formations, and to suggest an unlimited number of new possibilities. Duchamp's humor and irony should prevent anybody from taking his strategic use of the fourth dimension as a new law, a new order, a new truth. His de-essentializing does not lead to a new essentialism, but rather to an ironic "amusing physics" or "pataphysics." His critique of the cultural principle of identity is always done "with his tongue in his cheeck." He recognized that his strategic use of irony made his critique different from the Dadaists' oppositional discourse, which he felt was always caught in the essentialism it opposed: "Literary Dada was oppositional, and in opposing became the tail of that which it opposed."[34] Duchamp therefore distinguishes between negative and affirmative ironism: "Ironism of affirmation: differences from negative ironism dependent solely on Laughter."[35]

Closely connected with Duchamp's all-pervasive laughter, which de-essentializes oppositional critique, is his notion of the principle of contradiction, "defined only by these 3 words: i.e. Counderstanding of Opposites." He

suggests by this statement the simultaneous process of opposing and de-essentializing:

the statement A., against B no longer A's opposite, but different (the no. of B's is infin-ite, analogous to the plans of a game which would no longer have rules.)
After having multiplied B. to infinity the result eventually no longer validates the statement of A. (A, theorem, is no longer formulated, nor formulatable.) It liberates the word from definition, from the ideal meaning.[36]

Through his multiplication of meanings via his strategies of alter egos, puns, and pseudo-science Duchamp creates a new "infinite field of joy," where the original, conventional meaning is obliterated, where the word, "reduced to literal nominalism, is independent of the interpretation."[37] Duchamp calls himself therefore a clown who strategically, ironically, amusingly mixes up everything, turns everything inside out, upside down, in order to dissolve the principle of identity and to open up the field of indifferent free play, where "there is no solution, because there is no problem."[38]

While there are no problems for Duchamp, there have been many for his viewers/readers. The literally hundreds of questions posed to him in inter-views are an indication of their difficulties. The reason for most of these problems lies in the viewers' horizon of expectation; they look passively at Duchamp's works, as they look at works by nineteenth-century painters, and expect to have a sensual experience. But Duchamp rejected "retinal" painting precisely in order to deny this conventional, passive viewing ex-perience. Through the indeterminacy of his works, Duchamp hoped to acti-vate the viewers, whose involvement he considered as important as his own: "It is the REGARDEURS who make the pictures."[39] And he mentioned to Ca-banne: "It's a product of two poles – there's the pole of the one who makes the work, and the pole of the one who looks at it. I give the latter as much impor-tance as the one who makes it."[40] Works that conform to the viewers' expec-tations do not activate them. Only works that run counter to their conven-tions can prompt this activity. Duchamp therefore insists that "a painting that doesn't shock isn't worth painting."[41] Significant works call the familiar norms into question; they disturb the viewers' expectations. Duchamp's multiple and contradictory levels of meanings, permeated with irony, are his strategies that frustrate the viewers' attempts to create a definite inter-pretation. His incongruent titles and inscriptions suggest other levels for the viewer to explore: "That sentence instead of describing the object like a title was meant to carry the mind of the spectator towards other regions more verbal."[42] The frustration in attempting to build consistency between the titles and the contradictory levels of the work may lead the viewers to ques-tion their own habitual frame of reference, to discover the limitations of their own familiar norms and codes, and to alter their own structure of understanding. Duchamp's works are only a set of strategies to explode the viewers' socially formed conventions and values; they are transforming machines which activate his spectators to creatively enter the field of play.

The essays in this collection, written for the occasion of Duchamp's hun-dredth anniversary, attempt to respond to Duchamp's hope for posterity's

better understanding of his works. The contributions of Beatrice Wood and Arturo Schwarz pay tribute to Marcel Duchamp the person, whose modesty, generosity, tolerance, understanding, friendship and serenity were often felt to be in sharp contrast to his disturbing works. Francis Naumann's essay, "Duchamp: A Reconciliation of Opposites," traces the important theme of co-understanding polarities in Duchamp. In his essay, "Resonances of Duchamp's Visit to Munich," Thierry de Duve focuses on reasons for the radical change in Duchamp's art in 1912–13. His careful analysis convincingly suggests that the different structure of the institution of art in Munich, with its acceptance of utilitarian objects, was an influential climate for Duchamp's conception of the readymade. William Camfield's exploration of the history of Duchamp's readymade *Fountain* presents a wealth of new information, which leads him to question recent interpretations of Duchamp's readymades as objects only of anti-art. Peter Read's essay, "The *Tzanck Check* and Related Works," traces the intricate recurrence of Duchamp's complex web of symbols even in Duchamp's minor gestures. "Duchamp's Silent Noise/Music for the Deaf" by Carol James ingeniously examines a very much neglected aspect of Duchamp's work: his constant preoccupation with sound and its visual presence in most of his works. George Bauer's essay, "Duchamp's Ubiquitous Puns," reenacts Duchamp at play with his outrageous visual and verbal puns, his humorous references to well-known works of art, and his constant transformation and multiplication of meanings. Craig Adcock convincingly demonstrates in his essay, "Duchamp's Eroticism: A Mathematical Analysis," that Duchamp's eroticism is intricately linked to his speculations on the fourth dimension through his geometrical transformations, rotations and inversions. In "Duchamp's Etchings of the *Large Glass* and *The Lovers,*" Hellmut Wohl analyzes these late, neglected works as suggestive references and allusions to the passage between *The Bride Stripped Bare by Her Bachelors, Even* and *Etant donnés.* "Rendezvous with Marcel Duchamp: *Given*" by Dalia Judovitz presents a powerful reading of Duchamp's last work, *Etant donnés,* on which he secretly worked from 1946 to 1966. Duchamp made sure that this work would join the collection of his works at the Philadelphia Museum of Art, and that it would be made known only after his death. This work has perturbed Duchamp's interpreters more than any other of his gestures. Judovitz's analysis interprets this work as Duchamp's reflection on the life of the dead artist in the cemetery of the museum.

The "Documents" section includes Duchamp's letters to Walter and Louise Arensberg (1917–1921), which are published here for the first time, and a reproduction of Duchamp's *Des Délices de Kermoune,* a work that has only been known to a few people. Our thanks to Mme Duchamp and the Board of Trustees of the Francis Bacon Library for the permission to publish the letters, and to Claude and Bertrande Blancpain for allowing us to reproduce Duchamp's *Des Délices.*

I would like to thank Francis Naumann for his expert collaboration in conceiving this collection and in selecting the contributions, Gail Zlatnik for her generous and superb editorial assistance, Judith Pendleton for her artistic sense, and June Fischer for her excellent typing.

Notes

1. John Cage, "26 Statements re Duchamp," *Art and Literature* (Paris) 3 (1964); reprinted in Anne d'Harnoncourt and Kynaston McShine, eds., *Marcel Duchamp* (New York: The Museum of Modern Art, 1973), 188.

2. Jasper Johns, "Marcel Duchamp (1887–1968): An Appreciation," *Artforum* 7.3 (November 1968), 6: reprinted in d'Harnoncourt and McShine, eds., *Marcel Duchamp*, 204.

3. Pierre Cabanne, *Dialogues with Marcel Duchamp* (New York: Viking Press, 1971), 17.

4. Robert Lebel, *Marcel Duchamp* (Paris: Belfond, 1985), 12–13.

5. *The Blind Man* 2 (May 1917), 6.

6. See Rudi Blesh, *Stuart Davis* (New York: Grove Press, 1960), 16.

7. *Collection of the Société Anonyme, Museum of Modern Art, 1920* (New Haven: Yale University Art Gallery, 1950), 192.

8. "The Iconoclastic Opinions of M. Marcel Duchamp Concerning Art in America," *Current Opinion* 59 (November 1915), 346.

9. For informative overviews of Duchamp's relationship to post-1945 artists, see John Tancock, "The Influence of Marcel Duchamp," in d'Harnoncourt and McShine, eds., *Marcel Duchamp*, 159–78, and Germano Celant, "Marcel Duchamp and the Babel of Languages," in *Duchamp*, ed. Gloria Moure (Barcelona: Fundación Caja de pensiones, 1984), 68–80.

10. Cabanne, *Dialogues with Marcel Duchamp*, 99, 103.

11. Ibid., 76.

12. Quoted in Robert Lebel, *Marcel Duchamp*, 190.

13. In his interviews with Duchamp, Pierre Cabanne observed: "Every time you made a new experiment, you integrated it into the *Large Glass*. The *Large Glass* represented the successive sum of your experiments for eight years." And Duchamp answered: "That's exactly right" (Cabanne, *Dialogues with Marcel Duchamp*, 64).

14. James Johnson Sweeney, "A Conversation with Marcel Duchamp," in *Salt Seller: The Writings of Marcel Duchamp*, ed. Michel Sanouillet and Elmer Peterson (New York: Oxford University Press, 1973), 133.

15. Paul Matisse, "Some More Nonsense About Duchamp," *Art in America* 68.4 (April 1980), 78.

16. Jindřich Chalupecký, "Art et transcendance," in *Duchamp. Colloque de Cérésy*, ed. Jean Clair (Paris: Union Générale d'Editions, 1979), 34–35.

17. François Lyotard, *Les Transformateurs Duchamp* (Paris: Editions Galilée, 1977), 17.

18. Pierre de Massot, *Reflections on Rrose Sélavy* (Paris: Imprimerie Ravilly, 1924).

19. Lyotard, *Les Transformateurs Duchamp*, 20. Lyotard's statement recalls Alain Jouffroy's proposal: "When one submits in principle, as Duchamp did, that an artist does not have to have any system, one can finally only contradict the system that one tends to create" ("Etant donné Marcel Duchamp," *Opus International* 49 [March 1974], 22).

20. This is Robert Lebel's conclusion in 1985. See his *Marcel Duchamp*, 18.

21. I am indebted to Tom Conley, whose comments prompted me to look more closely at *Nu descendant un escalier*. *Nu* is of course also the thirteenth letter of the Greek alphabet, and it thus points to the wordplay which consists in the movement of the letter "n": *nu – un*.

22. Cabanne, *Dialogues with Marcel Duchamp*, 89–90.

23. In order to avoid any kind of identity that might be created through repetition, he constantly changed: "I have forced myself to contradict myself in order to avoid conforming to my own taste" (Quoted by Harriet and Sidney Janis, "Marcel Duchamp, Anti-Artist," in Joseph Masheck, ed., *Marcel Duchamp in Perspective* [Englewood Cliffs, N.J.: Prentice-Hall, 1975], 31).

24. *Salt Seller*, 124.

25. Katharine Kuh, "Marcel Duchamp," in her *The Artist's Voice: Talks with Seventeen Artists* (New York: Harper & Row, 1962), 88–89.

26. *Salt Seller*, 110.

27. Duchamp's "Meeting of Sunday, February 6, 1916 at 1:45 P.M." is reprinted in *Salt Seller*, 174. Arensberg's text is reprinted in *New York Dada*, ed. Rudolf E. Kuenzli (New York: Willis, Locker & Owens, 1986), 153. For an exploration of Duchamp and nonsense, see Lawrence D. Steefel, Jr., "Marcel Duchamp and the Machine," in *Marcel Duchamp*, eds. d'Harnoncourt and McShine, 69–80.

28. "Man Ray: The Homonymic Pun and American Vernacular," *Artforum* 13.8 (April 1975), 56.

29. *La raie alitée d'effets. Apropos of Marcel Duchamp* (Ville LaSalle, Quebec: Editions Hurtubise, 1984). For this collection, Gervais sent an exhilarating essay which, unfortunately, pushed several translators to despair, since Duchamp's wordplays between French and English could not be translated without losing their effect.

30. James Johnson Sweeney, "Interview with Marcel Duchamp," in "Eleven Europeans in America," *The Museum of Modern Art Bulletin* 13.4–5 (1946); reprinted in *Salt Seller*, 125.

31. Cabanne, *Dialogues with Marcel Duchamp*, 93.

32. Kuh, *The Artist's Voice*, 81.

33. Cabanne, *Dialogues with Marcel Duchamp*, 88.

34. Michel Sanouillet, ed., *Duchamp du signe* (Paris: Flammarion, 1975), 248.

35. *Salt Seller*, 30.

36. Paul Matisse, ed., *Marcel Duchamp: Notes* (Boston: G. K. Hall, 1983), note 185.

37. Ibid., note 186.

38. See Rudi Blesh, *Modern Art U.S.A.* (New York: A. Knopf, 1956), 37.

39. Sanouillet, ed., *Duchamp du signe*, 247.

40. Cabanne, *Dialogues with Marcel Duchamp*, 70. See also Duchamp's "The Creative Act," in *Salt Seller*, 138–40.

41. See Cabanne, *Dialogues with Marcel Duchamp*, 69.

42. *Salt Seller*, 141.

Marcel
Beatrice Wood

I entered the hospital room to find Varèse, the young French musician, still on his bed. His broken leg was in a cast, and his other leg, naked and hairy, stuck out of the sheets, taking possession of its immediate surroundings and embarrassing me with its manliness. He had recently arrived in America and spoke hardly any English. Because Varèse was lonely, a friend asked me to visit him.

This was the second time I had gone to see him. I hardly knew how to talk to a man of such rebellious vitality, for his arms and spirit animated the entire room. "Les Américains sont des pompiers!" he kept saying. "They do not understand art. My music they do not listen to, it is the bells of the streetcars. . . ."

A cough made me turn to face a man sitting at the far side of the bed. With a slight shock, I became aware of a truly extraordinary face. He did not exhibit the hardiness of a lifeguard flexing his muscles, but his personality was luminous. He had blue, penetrating eyes and finely chiseled features.

Marcel Duchamp smiled. I smiled. Varèse faded away.

"You are acting in the French Theatre," he began. Suddenly, all of my interest in the theatre vanished. "It is good you came here," he said. After a few more words, he began immediately to speak with me on a more informal basis, using the *tu* and *toi* the French use for family and friends. At that moment we were lovers. The conversation went on about art. I said anybody could do such scrawls. Marcel asked: "Why don't you try to make some?"

I went home and made a drawing. When I showed it to him, he asked why I did not draw instead of act. "No room in my mother's house," I answered, thinking of the rooms filled with priceless antiques that had smothered me since childhood.

"Come to my studio and paint. When I'm not in, I'll leave the keys for you. I am taking your drawing to a friend, Allen Norton, and I'll have him publish it in his little magazine, *Rogue.*"

Time stopped. My heart lost a beat. Scientists say there is no such thing as time. Maybe they're right.

His room was located in a large apartment house on West Sixty-seventh Street. There lived also the Walter Arensbergs, among the earliest collectors of modern art. Duchamp's studio was a typical bachelor's niche, with a wall bed, usually unmade, projecting out into the middle of the room, with a chair and table nearby. There were always chocolate bars on the window sill. To my astonishment, ordinary objects were scattered about: a coffee grinder, a bicycle wheel mounted on a box, an advertisement for Sapolin Enamel on the wall.

When I asked why he was keeping such things around, he smiled. They had their purpose, he said, but I should not give them a thought. Once I remember pointing to a square box that had sugar in it. "What is that?" I asked, wanting to be sympathetic to his ideas. "Cela n'a pas d'importance," he would say. And I knew nothing was as important as just being there.

I did not particularly care about drawing, but kept at it, as an excuse to be near him. At the end of a visit, he would spread the drawings I had done on the floor, carefully looking at each one of them and commenting, "Good. Bad. Bad. Bad. Good. Bad. Good. . . ." He especially like the scrawls that I did when I had nothing else on my mind (when I ignored my desire to draw like Maxfield Parrish).

Though we acted like lovers from the moment we met, the act itself did not occur for quite some time. It was not necessary. Besides, I was a virgin. And Frenchmen customarily respect "jeunes filles."

One evening, Marcel wanted me to meet the Arensbergs. Louise and Walter lived below him. He presented me with pride, holding onto my elbow. They stood at the door, smiling. I was surprised at their warmth, but I realized that it was on account of Marcel. They loved him too, as did everyone who met him. Arm in arm, Marcel and I walked through the doorway. His nearness put me at ease. The room was huge, with an enormously high ceiling, the walls covered with ghastly paintings: Picasso, Rousseau, Picabia. In the place of honor hung Marcel's *Nude Descending a Staircase*, the sensation of the Armory Show.

Much as I liked these new friends, I thought they must be crazy to hang such hideous paintings all over their walls. I liked them so much, though, that I decided if I were to enter into their world, I would have to understand and learn this kind of art. It was not easy. Many evenings passed before my prejudices surrendered, and the inconceivable attained meaning. My conversion occurred when I gazed at a Matisse; out of its stillness emerged a new dimension of space and composition.

It was not long before another form of education would change me, particularly where my virginity was concerned. Marcel introduced me to Henri-Pierre Roché, a friend he had known earlier in Paris, where they used to go around buying Picassos and Brancusis.

Roché, however, approached the "jeune fille" situation differently from Marcel. A man of obvious experience, he soon engulfed me in a love affair that was to end in emotional disaster. But the fact that Roché became my Knight on a White Charger was no cause to stop me from being in love with Marcel. I dreamt about him every night. As I lay in Roché's arms, I told him tenderly of my betrayal. He only laughed, for he too loved Marcel.

From then on our relationship "à trois" began. The three of us were constantly together. Both men took charge of my education, wanting to draw me away from romantic concepts. Part of what they taught me was to pronounce vulgar French words, without letting me know their meanings. And when I used these words at the Arensbergs' parties, Marcel and Roché took on the innocence of cats sipping cream. To share the joke, their eyes would meet when I came out with the word "merde." At one party, a Russian even got down on his knees and begged me never to say the word "merde" again,

since it was a word no young woman should utter.

The weeks passed in total enchantment. I would often run from my work at the French Theatre to Marcel's studio. We went frequently to a bistro and sat in privileged silence, while the El trains roared overhead. It was a magical existence. We often went to the Arensbergs'. One evening, Francis Picabia, Albert Gleizes, Walter Pach, Joseph Stella, Charles Sheeler, and John Covert were there, discussing the evils of the jury system. I did not share in the intellectualizing, but sat on the sofa near Walter's wife, Lou, thinking only of love and the two men who filled my life. At midnight, Lou would go to the kitchen and bring back trays laden with drinks and chocolate éclairs.

The result of these many discussions at the Arensbergs' was the formation of the Independents, who in 1917 staged one of the most highly publicized exhibitions since the time of the Armory Show. But here, there were to be no judges. Anyone who sent in six dollars could have two of his paintings shown. The artists, then, decided what was art. Not outsiders. I sent in a painting of a nude woman taking a bath, with only her torso showing and a piece of real soap covering a certain part of her anatomy, like a fig leaf. The soap was Marcel's idea: "Be sure to choose the right shape and color," he advised. Then he helped me glue it to the canvas. I thought it might have been one of the earliest works of abstract art by an American artist. In the exhibition, crowds gathered before my picture. Men left their calling cards attached to the frame. Marcel's charming mischief was everywhere.

A day before the opening, I walked into a storage room of the exhibition hall, only to find Walter Arensberg and the painter George Bellows in heated conversation. "But we cannot show it," bellowed Bellows. "It is indecent." "Only in the eyes of the beholder," shouted Walter. I giggled. Both men paid no attention to me. Bellows took a step towards Arensberg and demanded: "You mean to say that if an artist put horse manure on a canvas and sent it to the exhibition, we would have to accept it?" With a sweet smile, like an undertaker, Walter answered: "I fear we would. The purpose of our bylaws is to accept anything an artist *chooses.*"

Fearing an outbreak of violence, I fled.

The object in question was a white porcelain form, not unlike a Brancusi, with curved lines of genuine sensitivity. It was a man's urinal. Its original function, however, was obscured. It was placed upside down, on a pedestal, and signed "R. Mutt."

Never for a moment did I doubt that Marcel was the scoundrel, wanting to test the allegedly liberal minds of the middle class. *Fountain,* as it was called, was never shown. It became, nevertheless, the cause célèbre of the exhibition. Reviews of the exhibition were hilarious. Unfortunately, with all of the commotion, I think the real artists were neglected.

As far as Marcel was concerned, this was not the end. He took me with him to Stieglitz's gallery, and, after a long conversation and a good deal of laughter, both men agreed that Stieglitz should make a photograph of *Fountain.* But the image should be seen by many. Perhaps, they thought, it would be a good idea if the photograph were reproduced on the cover of an art magazine. But what magazine would put this kind of a thing on its cover?

The idea of freedom in art was so compelling to Marcel and Roché, they

thought there should exist a magazine dedicated to the cause. So they decided to publish one. How these two Frenchmen were going to deal with manuscripts without editorial policy, I never knew. They enlisted my help. I wrote some articles and worked with them at the printers. Shortly before the magazine was scheduled to appear, Marcel and Roché met in hushed conversation. Occasionally they laughed and threw me a glance. Finally, Marcel approached and explained: "You see, little one, we are here as guests of the American government. Henri is officially affiliated with French foreign affairs, so we have decided that it would be best not to put our names on this venture. Would you mind being listed as the editor?"

It didn't seem like such a bad idea, and at first all went well. The day before the magazine was to be distributed on the newsstands, however, the entire run was delivered to my parents' home. The packages filled the entire front hall, from floor to ceiling. When I returned home late in the afternoon, my father was waiting for me. He looked sick.

"I have never interfered with your life," he began. "But, in this case, I can see that you do not know what you are doing. It really makes me wonder what kind of people you are mixed up with." His voice was ponderous. Taken aback, I really did not know what to say. He indicated that I should sit down. "At first," he said, "I did not know what these packages were doing in our hallway. I opened one, and found your name listed as publisher. In one of the articles, I then discovered three offensive words that no young girl should ever know. I beg, I plead with you, do not place this filthy sheet on the newsstands, or send it through the mails. If you do, you will likely be sent to prison."

Alarmed at his reaction, I immediately raced down to Frank Crowninshield, editor of the magazine *Vanity Fair,* for he had read the proofs with me and I wanted to know his advice. "My father is a typically honest, uncomplicated businessman," I told him, "who knows nothing about art. If he feels this way, I fear others like him may feel the same. And Mrs. Harry Payne Whitney, who contributed $500 for the printing, would not want her name associated with pornography – nor would Walter Arensberg, for that matter, or the numerous galleries that placed ads in the magazine."

The results were that *The Blindman* was never put on the newsstands, and it was never sent through the mails. It's now a rather rare collector's item.

In celebration of the magazine, a Blindman's Ball was organized, and Marcel suggested I make a poster advertising the event. Of the many I tried, he chose a stick figure thumbing its nose at the universe, and fifty years passed before I realized he liked it on account of the freedom it expressed. The ball was a riotous affair. Marcel climbed a chandelier and I performed a Russian dance. At three in the morning, a few of us returned to the Arensbergs' for a snack. Because it was so late, we decided it was no use returning home, and we decided to spend the night in Marcel's studio. We all slept on his bed: Mina Loy, the beautiful poet, dressed in white with a style all her own, Arline Dresser, and Charles Demuth, the painter, threw themselves on Marcel's bed. The women made themselves at home, sprawling about, while Charles dangled on one end of the bed, one of his legs hanging out from the covers exposing a garter on his bare leg. Marcel squeezed into a small space

15

against the wall, and I, with no room left, cuddled up against him. The women closed their eyes and fell into a dream state. I, too, dreamt – but awake, content in hearing Marcel's heart beat during the quiet of the night.

Soon after, another incident served to liberate me from my conservative past. Anybody foolish enough to fall in love with an intelligent and fascinating Frenchman should take out insurance against the worst. It wasn't long before Roché started practicing what he preached. I was crushed. Soon he left for a visit to Paris, and, like tides moving towards the moon, Marcel and I became closer. A physical relationship was inevitable. But he still continued to utter the same words, a phrase that he would repeat time and time again: "Cela n'a pas d'importance."

There is a wonderful Indian saying that the eyes cannot see until they are incapable of tears. Marcel's saying that "nothing had importance" somehow reflects the same idea. It was as if he had gone through all trials of the flesh and left that behind. With his grave perception, did he realize that in the long space of time, nothing really mattered? He had the objectivity of a guru. His mind touched stillness, beholding the unity of life. Yet with this understanding went a certain deadness. Many have observed it. The upper part of his face was alive, the lower part lifeless. It was as if he suffered an unspeakable trauma in his youth.

The romantic side of our friendship dissolved when I went to Canada to act with the National French Theatre in Montreal. Our intimacy faded, for I stayed away for a year, making a mess of my life by having married (in name only) an unfortunate example of the human race. When I returned, I was completely shattered by that disaster. Without money, I did not want friends to know about the despair that had enveloped me. Weeks passed, and eventually Marcel found out where I was living. He stopped over one evening to take me to dinner. "Eat, eat," he kept repeating, to my amusement. He asked no questions, I gave no answers. There was not a word about my failed marriage, my condition, just a wonderful beam between the two of us. When accompanying me back to my little room, he pressed an envelope into my hand, asking me not to open it until I was alone. "But I am alone," I laughed. "Do not open it until you are completely alone," he repeated. He tossed his head, saying, again, "Cela n'a pas d'importance," and with a peck on my cheek, he walked off.

My heart beat as I rushed up the four flights of stairs to my room. Breathlessly, I wondered if the envelope contained a proposal of marriage. Such an idea was strange, for ages ago we had settled that question by simply letting it drop by the wayside. I tore open the envelope to find five ten-dollar bills.

Hearing I was without money, Marcel, of all my friends, acted. As always, he understood the most basic thing.

Soon after, I moved to California. During the years that passed, Marcel came occasionally to visit the Arensbergs, who had moved to Hollywood, and we met in comfortable formality. On another occasion, in 1944, I returned to New York for an exhibition of my pottery. I wrote to Marcel to say I would be there, without telling him the reason for my visit, for pottery was not one of his preoccupations. I was speaking to people from a balcony when he appeared. I rushed down to embrace him. As soon as we could get away,

we went out for luncheon. He encouraged me to continue what I was doing. Later, he took me to a gallery, telling the owners that they should consider giving me an exhibition. "Her work is different from that of the others," he kindly explained.

Marcel was then living in a small studio on Fourteenth Street. I went to see him there, and found the same unmade bed, chocolates on the window sill, and more readymades. Again I told him that I could not understand the readymades, but I do not think he really listened. To him, it made no difference whether people responded to his work or not. Chess was his mistress, perhaps his escape from fame, from worldly stupidity.

He showed me a miniature chess set he had designed. "You should put that on the market," I said. "You could make a great deal of money." He took his pipe out of his mouth, relaxed back on his chair, and drawled: "What would I do with money? I have enough for my needs. I don't want any more. If I had a lot, I would have to care for it, worry about it."

He took me to luncheon with his great friend Mary Reynolds, and though I felt the same secret pull between us, there was no jealousy within me. I rejoiced in knowing that he cared for such an attractive woman.

Over the years, when I came up for air, I resumed contact with Roché, and the three of us kept in constant communication. Not that we wrote often, but that we always knew what the others were doing. With the passing of Roché and the Arensbergs, Marcel shared his grief with me. And when he married Teeny Matisse, he assured me of his happiness. I was pleased to learn that, in his last years, he was in the company of such an endearing and wonderful woman.

The last time I saw him was in 1963, when he came to California for his retrospective exhibition at the Pasadena Museum. A dinner and ball were given in his honor, and he arranged for me and my escort to be seated at his table. Teeny glowed in a green dress, but I had little chance to talk with her. Champagne flowed like water, and I danced all evening with young men. At one point, I saw Marcel sitting on the sideline watching me. Though his arms were not around me at the time, it was with him that I danced, as the music played on.

He and Teeny came to visit me in Ojai, the quaint little town north of Los Angeles where I lived. During luncheon, I went on and on about India, from which I had recently returned. It was a pleasant afternoon. After his death, Teeny told me of her relief that he had gone quietly, in his sleep, not knowing that he had cancer, and that the last night had been a happy one, spent with friends he loved.

Many think Duchamp was the greatest painter of the period, the most inventive. I must confess that, with the exception of *Nude Descending a Staircase*, I really did not understand his work. He meant so much to me personally, as he did to so many others. I was in no way the great love of his life, but one who for a short time was close to him. That I am now sentimental about him is something that Marcel probably would not have liked. But that the man meant more to me than his art is something that he would have understood, always smiling and murmuring, "Cela n'a pas d'importance."

17

Marcel Duchamp: The Man, Even
Arturo Schwarz

In the early fifties I had an astonishing dream concerning somebody I had never met before but who had haunted my thoughts for the previous ten years. I shared my vision with that person and Duchamp promptly answered back, although at the time I was a total stranger to him.

Thus started a relationship that led me, in 1956, to start working on a project that ended ten years later with an essay published in 1967 in a limited edition illustrated by an extraordinary series of etchings. When Harry Abrams issued the trade edition in 1969, Marcel had left us the year before.

Duchamp's works and words have persisted in my eyes and inhabited my mind ever since 1942 – I was eighteen and was just beginning to look at works of art with the stare of Alice in Wonderland. Breton's *Le Phare de la mariée* (which I read several years after its first publication in the Winter 1935 issue of *Minotaure*) was my first initiation to Marcel's mysteries.

I have mentioned elsewhere how Bachelard's remark about alchemy being a science for bachelors, for initiates, prompted me to verify whether in a world as pragmatist, prosaic and fragmented as ours, an irrational, poetic and holistic adventure could still be lived. I had come to the conclusion that nobody but Duchamp could be its hero; no work but the *Large Glass* could attain the complex transparence of the Philosopher's Stone.

Throughout the years I worked close to Marcel, I experienced some of the most enriching emotions a friendship can offer. He was, in all respects, a *maître à penser;* to me he was even more, I dare say he was a *guru,* in the Indian sense of the word. He would not, of course, have favored being so called, and he certainly did not consider himself to be either one or the other.

His simplicity was a way of being, modesty was never a pose with him, he was as natural as his breath. He was generous and understanding – if you revealed a problem to him, he really cared, participated, and was immediately perceptive. His advice could not be wiser and his concern would never be merely skin-deep. Yet his manners were as discreet as his feelings were secret.

The warmth of his friendship defied time, distance, and ideological differences. Duchamp outlived Picabia and Breton, who with Man Ray had been his earliest friends. In both instances he found the most touching words to remember their departure. In a copy of a book he inscribed to Man Ray he wrote: *"A Man, en éternelle amitié,"* and, for once, the word *éternelle* did not sound affected.

A lifelong attitude of tolerance, of non-commitment, of happily accepted inconsistency – Keats would have better defined it as "negative capabil-

ity"—was the outcome of his demanding and imperious yearning for freedom. Duchamp was well aware that the world of values is not a world of polaristic logic; placed between the dictates of false antinomies he would refuse to make a choice, once and for all, between mutually exclusive values. Thus he preserved his spiritual independence. Life continually places us between alternative situations, between two doors, both of which are marked Entry, but neither Exit. Duchamp invented the door that is neither open nor closed.

Inconsistency is practiced more than proclaimed. He once remarked to me, "You see, I don't want to be pinned down to any position. My position is the lack of a position, but, of course, you can't even talk about it; the minute you talk you spoil the whole game." Going on to discuss art, he added: "Painting is a language of its own. You cannot interpret one form of expression with another form of expression."

Lest what has now been said give the impression that, in his artistic or poetic activity, Duchamp had a free-wheeling attitude, I want to emphasize that when his creative imagination was at work, nothing was left to chance or improvisation. Even the choice of a readymade was regulated by strict rules and subject to a complicated ritual, not to mention the hundreds of notes and preliminary studies that preceded and accompanied the elaboration of the *Large Glass*.

For Duchamp, being a poet was at least as important as being an artist. He has embodied more consistently than anybody I know the concept of the *homo faber* in its fullest connotation of poet, artist, and maker, three words which, by the way, were perfect synonyms in ancient Greece (*poietes* designated both the maker and the poet, just as the *demiurgòs* was equally the artist and the poet) and in Sanskrit India (*karaka* stands for both the artist and the maker). Duchamp has succeeded in transcending both the poet and the artist and has become the demiurge who, by his sole decision, can rescue the common ready-made object from banality and raise it to the level of a work of art.

Duchamp's favorite weapon for undermining absolutes and certainties was humor; being humorous was another way to reaffirm his freedom, to defend individualism. A "serious" person is a consistent person, and consistency leads to fanaticism, while inconsistency is the source of tolerance. Through humor, Duchamp also abolished the difference between that which possesses an aesthetic quality and that which doesn't. His "ironism of affirmation" naturally led to the "beauty of indifference."

He retained a sharp sense of humor in all circumstances—even to his death. A last recollection: The evening of October 1st, 1968, had been an especially pleasant one—he had dined at home in Neuilly with Man Ray and Robert Lebel. It happened suddenly and peacefully, a little while after his guests had left. He was about to retire and his heart simply stopped beating at five past one A.M. That morning I found him resting on his bed. Beautiful, noble, serene. Only slightly paler than usual. A thin smile on his lips. He looked happy to have played his last trick on life by taking French leave.

Marcel Duchamp: A Reconciliation of Opposites

Francis M. Naumann

Any attempt to establish a formula, a key, or some other type of guiding principle by which to assess or in other ways interpret the artistic production of Marcel Duchamp would be – in the humble opinion of the present author – an entirely futile endeavor. Of course, this is due largely to the fact that by the time he had reached his twenty-fifth birthday, after a few years of experimenting in a variety of prevailing artistic styles – from Intimism and Fauvism, to Futurism and Cubism – Duchamp adopted a highly individualistic approach to the art-making process, one wherein each creative effort was conceived with the intention of consciously defying convenient categorization. "It was always the idea of changing," he later explained, of "not repeating myself." "Repeat the same thing long enough," he told an interviewer, "and it becomes taste," a qualitative judgment he had repeatedly identified as "the enemy of art," that is, as he put it, art with a capital "A."[1]

Although Duchamp generally accepted whatever anyone had to say about his work – in accordance with his belief that the artist played only a "mediumistic" role between the art object and the public – we cannot help but suspect that he would not have willingly lent his approval to the more arcane and convoluted interpretations of his work. When once asked for his opinion about the various analyses that had been suggested for the *Large Glass*, for example, he responded that each writer "gives his particular note to his interpretation, which is interesting," he added, "but only interesting when you consider the man who wrote the interpretation."[2]

If Duchamp felt this way about the interpretation of a single work, we can only assume that he would not have lent his enthusiastic support to any artist, critic, or art historian who wished to establish a systematic approach to an understanding of his complete *oeuvre*. Indeed, a few years before his death, he told Pierre Cabanne that his approach differed from that of his contemporaries because he steadfastly refused to accept any form of systematization. "I've never been able to contain myself enough," he said, "to accept established formulas, to copy, or to be influenced."[3] Yet for those who feel as if they still need some kind of formula to unlock the mysterious message underlying the enigmatic productions of this highly provocative and influential artist, Duchamp provided a few comforting words of advice: "There is no solution," he has often been quoted as saying, "because there is no problem."[4]

As often as I have personally sought solace behind those very words, I cannot help but regard Duchamp's systematic avoidance of repetition as a sys-

tem in and of itself, an ideological commitment to the art-making process that inevitably results in certain philosophical contradictions – or another way of putting it, a system that by its very nature creates problems with no apparent need for solutions. It may have been Duchamp's instinctive quest for an alternative method of expression that led him to develop a body of work that can be seen to parallel a series of essentially opposing themes – themes that when carefully analyzed reveal a consistent duality of compatible opposition. Whether conscious or unconscious, by the early 1920s, he had already established the major tenets of this working method, exploring and reexploring themes of opposition that would prevail in his work for the rest of his life. Before investigating the possible philosophical origins of this approach, let us examine a few selected examples from Duchamp's work, and determine, if possible, exactly when and why this method became so thoroughly entrenched at the very root of his artistic sensibilities.

The most outstanding example from Duchamp's work would have to be the creation of Rose Sélavy, a compatible fusion, or, to employ the term used in the title of this essay, a reconciliation of opposing sexual identities. Rose – or Rrose (with the double "r"), as Duchamp would soon begin calling her – was born fully mature in New York in 1920. She was not created by Duchamp's hands, in the fashion that an academic sculptor might carve an Olympian goddess. Rather, like Athena, who sprang forth fully formed from the head of Zeus, Rrose came from Duchamp's forehead, or, to be more accurate, she emerged directly from his cerebral facilities. Unlike the Greek deity, however, Duchamp's creation was not designed to exhibit her beauty (although perhaps it is no coincidence that Athena served as the ancient patroness of learning and the arts). But this, of course, was not the reason why Duchamp invented a female alter ego. "I wanted to change my identity," he told an interviewer. Initially, as he later explained, he simply wanted to change his religious background, and searched for a Jewish name, but found none that tempted him sufficiently. Then, he claims, the idea suddenly came to him: "Why not change sex? It was much simpler."[5] So, he took on the name "Rose," which, he explained, was a particularly awful name in 1920, to which he added the punning surname "Sélavy," and had himself – or, rather, herself – photographed by Man Ray on several occasions, posed in a rather affected manner, sporting samples of the fashionable, though perhaps somewhat conservative clothing of the day (Fig. 1).

Although it has not been previously noted in the vast literature on Duchamp, Rrose's appearance may have been styled after that of a character played by his favorite film personality in these years, Charlie Chaplin. I am here specifically referring to Chaplin's *A Woman*, a film Duchamp may very well have seen shortly after his coming to America in the summer of 1915.[6] In the most famous scene of the film (Fig. 2), Chaplin impersonates a woman in order to gain entrance to the boarding house where his girlfriend lives, and most of the comic routines that follow are based on the predicaments that arise as a result of his male-female identity. Of course the idea of men dressing up as women in order to set up comic situations had been explored in the theatre on many occasions, from Shakespearean times to the Comédie Française. While these sources may help to explain Rrose's affected manner

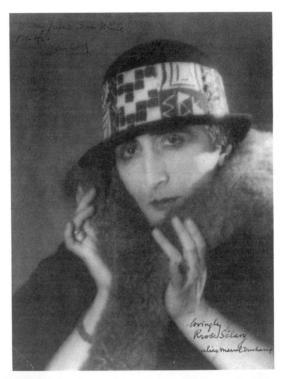

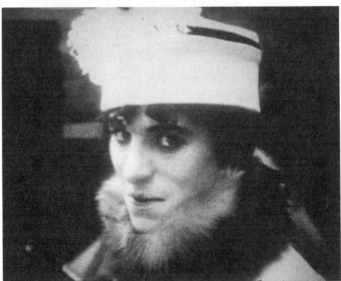

Fig. 1 Man Ray, *Rrose Sélavy*, c. 1920–21. The Philadelphia Museum of Art; gift of Samuel White.

Fig. 2 Charles Chaplin in *A Woman*, 1915. The Museum of Modern Art, New York.

and poorly disguised identity, they do not really help to reveal why Duchamp chose to adopt a female personage in the first place. If we should wish to explore the possible psychological motivations behind this role-playing identity – as many already have for Duchamp – we could readily base our studies on a number of complicated Freudian and Jungian theories, from an unconscious expression of bisexuality, to man's primordial desire to combine and unify the sexes. Rather than investigate the possible significance of such universal principles, however, let us for the moment look briefly to Duchamp's earlier work, where, to a certain extent, themes of sexual identity and opposition had already been explored.

Long before the concept of opposition can be understood as a factor that may have contributed to the theoretical foundation of Duchamp's unique *modus operandi*, it can be seen to have emerged from its more literal employment in his early work. Themes of sexual opposition, for example, are sharply juxtaposed in a number of drawings he prepared in his early twenties to serve as humorous illustrations for popular French journals. In several of these drawings, men and women are cast in stereotypical roles, guises that are meant to emphasize their opposing sexual and sociological identities. The man appearing in a drawing entitled *Conversation* (Fig. 3), for example, is shown leaning longingly over a partition, in quest of the woman seated at the table, while she (even though we cannot see her face) maintains an erect posture, indicating perhaps that her pretense to dignity prevents her from warmly accepting the man's advances. In another drawing from this period (Fig. 4), a dejected husband pushes a baby carriage in the company of his melancholic, bored, and somewhat disheveled wife, who is quite obviously pregnant for at least a second time. The inscription – *Dimanches* [*Sundays*] – was likely derived from a series of poems by Jules Laforgue bearing the same title, wherein Sunday is a day of the week characterized by its monotony and boredom.[7]

Fig. 3 *Conversation,* 1909, pen and ink and ink wash on paper, 12 × 9⅞ in. The Museum of Modern Art, New York; promised gift of Mary Sisler.

Fig. 4 *Sundays* [*Dimanches*], 1909, conté pencil, brush, and "splatter" on paper, 24 × 19⅛ in. The Museum of Modern Art, New York; promised gift of Mary Sisler.

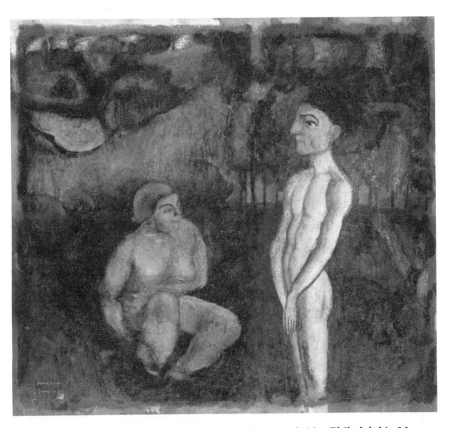

Fig. 5 *Paradise,* 1910–11, oil on canvas, 45 1/16 × 50 9/16 in. Philadelphia Museum of Art; Louise and Walter Arensberg Collection.

These stereotypical models of male and female behavior are provided with even more specific symbolic identities in a painting of 1910 entitled *Paradise* (Fig. 5), where, judging from the title, the nude figures of a man and a woman were meant to represent Adam and Eve, *the* archetypical models of male and female identity. In the following year, this nude couple reappears, forming the prominent figurative motif in a painting entitled *Young Man and Girl in Spring* (Fig. 6), a highly provocative image that has been the subject of numerous speculative interpretations. The work was painted in the spring of 1911, at a time when Duchamp's favorite sister, Suzanne, was preparing to marry a Rouen pharmacist, Charles Desmares. When the couple married in 1911, Duchamp presented this small canvas as a wedding gift. Since the painting was given to the couple, but dedicated only to Suzanne, Arturo Schwarz sees the painting as an affirmation of Duchamp's "unconscious incestuous love," an interpretation which he then extends to the hidden symbolism of the *Large Glass.*[8]

Schwarz's interpretation relies on the assumption that Suzanne's marriage was an unconscious betrayal of her brother's incestuous affection. Du-

24

champ, on the other hand, may very well have regarded the marriage of his sister as a welcome event. In this light, the two outstretched nude figures could have been intended to represent Suzanne and her future husband, seen in nothing less than the guise of the world's first lovers, Adam and Eve, who in the painting appear to be frolicking in the Garden of Eden, leaping upward toward the lower branches of a tree located in the center of the composition, which, in this context, would represent the newlyweds reaching for the Forbidden Fruit. Once this interpretation has been accepted, a far less esoteric symbolism can be seen to emerge from the abstract forms in the painting's complex landscape; the form of a child encased in a circular orb in the center of the composition, for example, may have been intended as a reference to successful procreation, while the pink tonality given to the various circular forms in the background may refer to the cherry blossoms of spring – the traditional season of lovers – a subject suggested by the painting's title and explored by Duchamp in an earlier landscape. Moreover, this tonality may have been designed in order to invoke an association with the most conventional and age-old symbol of love: a large, geometrically simplified human heart, its upper lobes defined by the outspread branches of the centrally placed tree, and its lower portion formed by the two semicircular arching black lines that converge at the base of the picture.[9]

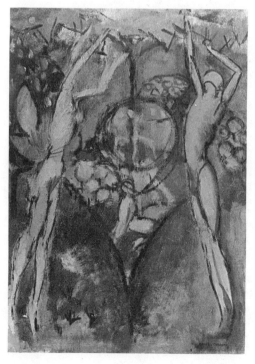

Fig. 6 *Young Man and Girl in Spring,* 1911, oil on canvas, 25⅞ × 19¾ in. Collection of Arturo Schwarz, Milan.

During the fall and winter of 1911–12, Duchamp appears to have absorbed fully the stylistic dictates of Cubism, the emergent artistic movement he later claims to have accepted more "as a form of experiment, than conviction."[10] With some variation, however, the complex fragmentation and indeterminate spatial structure common to Analytical Cubism dominate the general appearance of the majority of paintings from this period, a stylistic progression that culminates in the production of his most famous painting, *Nude Descending a Staircase* (Fig. 7). As important as this particular work may have been in helping to establish Duchamp's reputation on both sides of the Atlantic, it was not the painting itself, but, rather, its subsequent history that can now be seen to have had the most significant impact on the future development of his work, a development that would not only represent a radical departure from his own earlier work, but one that would also represent a definitive break from the previously established and accepted conventions of the art-making process.

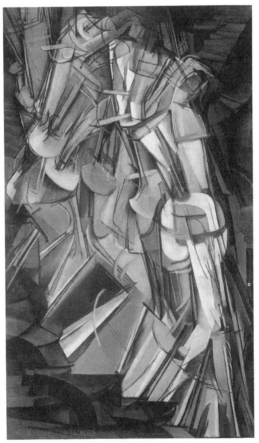

Fig. 7 *Nude Descending a Staircase* (No. 2), 1912, oil on canvas, 57½ × 35 1/16 in. Philadelphia Museum of Art; Louise and Walter Arensberg Collection.

It should be noted, of course, that I am not the first to notice that a major transition took place in Duchamp's work during this period. For example, Walter Arensberg, the poet and wealthy collector who befriended Duchamp during his first trip to America and went on to assemble the single largest collection of his work, was often puzzled by this abrupt departure and at least on one occasion addressed the question directly to his old friend: "I have been meaning for a long time," he queried in a letter to Duchamp written from his California home in 1937, "to write you about those early paintings. To me," he wrote, "in view of your later work, they remain your greatest mystery. In the whole history of painting I know of no such complete and abrupt transition as these paintings show in relation to the work with which you immediately follow them. Can you remember at all," he asked, "anything that happened that would account for the change? Some autobiographical record of that period would be invaluable to the understanding of your work."[11]

Unfortunately, Duchamp's response to Arensberg—if there ever was one—does not survive. But on several subsequent occasions he responded to essentially the same inquiry, asked, as it frequently was, by a host of inquisitive well-wishers, who, in the late 1950s and 1960s, flocked to Duchamp's side during the last decade of his life, in a period of renewed interest in his work. When Cabanne asked Duchamp why he quit painting—which the critic considered the "key event" in the artist's life—Duchamp explained that it was due primarily to the rejection of his *Nude Descending a Staircase* from the Independents' exhibition of 1912.[12] The very people Duchamp had regarded as his friends and fellow painters, including his very own brothers, found the painting objectionable, out of line with their established notions of what Cubism should be. Duchamp immediately thought their attitude abhorrent; later he called it "naively foolish." The event "gave him a turn," as he put it, and from that time onward, he would consider such conservative and overtly dogmatic behavior an aberration, particularly for artists who purport to be more open-minded than the general public. Rather than allow himself to be subjected to any compromising situations in the future, Duchamp's "solution" to this "problem"—to turn his own words around—came in the form of employment he accepted at the Bibliothèque Sainte-Geneviève in Paris. "I wanted to be free of any material obligation," he explained, "so I began a career as a librarian, which was sort of an excuse for not being obliged to show up socially [as an artist]."[13] Moreover, with the modest income provided by this job, Duchamp would no longer be under pressure to produce paintings and other works of art for the sole purpose of exhibition and sale. This situation liberated him from having to conform to the accepted styles of the day, allowing him to pursue his individual interests, in whatever direction they might take him.

It was April of 1912, the very month when Duchamp withdrew his *Nude* from the Independents' exhibition, that he completed two drawings featuring a king and queen surrounded by animated nudes, a theme drawn from the principle components of a chess game, as well as the movement of its pieces. The drawings culminated in the production of a major work painted during the course of the next month, *The King and Queen Surrounded by Swift*

Fig. 8 *La Mariée mise à nu par ses célibataires, même (Le Grand Verre)* [*The Bride Stripped Bare by Her Bachelors, Even*] [The *Large Glass*], 1915-23, oil, varnish, lead foil, lead wire, and dust on two glass panels, 109¼ × 69¼ in. Philadelphia Museum of Art; Katherine S. Dreier Bequest, 1953.

Nudes (Cat. no. 189). In July, Duchamp travelled to Munich, where he developed the theme of *The Bride Stripped Bare by the Bachelors* (Cat. no. 190), a subject that would be retained as the central iconographic motif of the *Large Glass* (Fig. 8), a work whose motif—as the complete title acknowledges—is devoted to the mechanical movements of the bachelors in quest of their disrobing bride. It was during the summer of 1912, then, in Munich, that Duchamp had replaced the identity of a chess "King" and "Queen" with their

more familiar and domestic counterparts: an alluring "Bride" and her sexually aroused "Bachelors." But whether Adam and Eve, King and Queen, or Bride and Bachelor, these exclusively male and female identities represent established polarities of opposition, like the black and white pieces in a chess game, a theme Duchamp had already investigated in an earlier series of drawings and paintings. More than simply this activity of concentrating on subjects of thematic opposition, however, the works produced in Munich mark the beginning of Duchamp's first systematic efforts to develop an iconographic content unique to his own work, one that harbored meaning only within the narrowly established confines of an extremely personal, highly individualistic and self-reflexive narrative context.

Whereas it may be relatively easy to rationalize why the artist developed a completely new attitude towards his work immediately after the rejection of his *Nude,* it has been more difficult to explain exactly why this important transition took place three months later in Munich. It may have been that the physical separation from his brothers and Parisian colleagues provided the necessary detachment required in order to provide Duchamp with the freedom of mind to develop his own ideas. It may also have been, as some have suggested, that the paintings and aesthetic theories of Kandinsky and the Blaue Reiter group, centered as they were then in Munich, influenced Duchamp's thoughts about the potential of abstraction as both a thematic and stylistic component in his work. Whatever his sources, the Bavarian capital seems to have provided the ideal atmosphere in which Duchamp succeeded in severing all artistic ties, not only with concurrent stylistic trends, but also with his own earlier work. "My stay in Munich," he later reported, "was the scene of my complete liberation."[14]

This statement, combined with the fact that he had immersed himself in the center of a German-speaking environment, may be enough evidence to suggest that it was during the time of his stay in Munich that Duchamp first discovered the writings of Max Stirner (1806–1856), an obscure nineteenth-century German philosopher whose anarchistic theories may have provided the most extensive theoretical basis for Duchamp's newfound artistic freedom.[15] When he was asked later in life to identify a specific philosopher or philosophical theory that was of special significance to his work, he cited Stirner's only major book – *Der Einzige und sein Eigentum* – which was originally published in 1845 but which appeared in a French edition in 1900 under the title *L'Unique et la propriété* and later in English as *The Individual and His Own.*[16] In this highly provocative book, Stirner outlined a controversial treatise in defense of philosophic egoism wherein, based on his observation that all people are beings who possess unique qualities unto themselves, he championed the right of the individual to assume a superior position in society. To this end, he rejected all systematic philosophies and launched a bitter attack on all levels of social and political authority. Stirner regarded the state as the supreme enemy of the individual, and he supported its destruction by rebellion rather than revolution, a position that has linked his philosophical beliefs to existentialism and nihilism.

The one work Duchamp produced that he said was specifically influenced by Stirner's philosophy was his *Three Standard Stoppages* of 1913–14 (Fig. 9),

Fig. 9 *Three Standard Stoppages* [*Trois Stoppages-Étalon*], 1913–14, assemblage, 11⅛ × 50⅞ × 9 in. (overall). The Museum of Modern Art, New York; Katherine S. Dreier Bequest.

a box containing three separate measuring devices that were individually formed by identical systems of chance operation: held horizontally from the height of one meter, a meter-long length of string was allowed to fall freely onto a canvas surface. The resultant impressions were then more permanently affixed to glass plates, from which were prepared three wood templates, duplicating the subtle twists and curves of their chance configuration. Duchamp later explained that this work was made as "a joke about the meter,"[17] making it clear that his central aim was to throw into question the accepted authority of the meter, the standard unit of measurement adopted by Europeans and officially established to be precisely the distance between two scratches on a platinum-iridium bar housed in a temperature-controlled chamber in the Academy of Science located just outside Paris (Fig. 10). Thus, just as Stirner rejected all systems of authority and championed the supreme rights of the individual, Duchamp conceived of the *Three Standard Stoppages* as a unique system of measurement that was determined by the chance of a given individual, and which was to be utilized exclusively within the framework of his own personal requirements.

In this context, it is important to emphasize that Duchamp chose to repeat this operation three separate times. "For me the number three is important," he later explained. "One is unity, two is double, duality, and three is the rest." Or, as he put it on another occasion: "1 a unit / 2 opposition / 3 a series."[18] In other words, creating a single new "meter" would only result in producing an entirely new system of measurement, with no more (or less) claim to authority than the old. Creating two new meters would only com-

pound the problem by setting up polarities of opposition (one "meter" vs. the other), while three results in a self-sustaining system, one which does not present a simple alternative, nor a choice between two variants, but a complete system that must be comprehended and utilized in its entirety. Three, then, introduces a factor of reconciliation, serving to unite the two elements of opposition, while simultaneously producing a compatible and comprehensive fusion of all three.

Fig. 10 Standard Meter, Pavillon de Breteuil, Sèvres, France. Photograph courtesy French Embassy, New York.

Although Duchamp may not have been aware of it at the time, this system of reconciliation very closely duplicates a philosophical system that is nearly as old as philosophy itself. Heraclitus, for example, the fifth-century B.C. Greek philosopher, believed that unity in the world was only formed through the combination of these opposing extremes. With some variation, this same idea is used to help explain theories of immortality by a number of other Greek philosophers, including Socrates and Plato. But as far as I have been able to determine, it would not be until the writings of Bishop Nicholas Cusanos, the fifteenth-century German scientist, statesman, and philosopher, that these theories of opposition would begin to approach an organized system of logical discourse. Cusanos criticized previous philosophical systems where contradictories were not allowed, and maintained that a "coincidence of opposites," or what he called the *coincidenta oppositorum,* clearly existed in God, the infinite being wherein all extremes of opposition are reconciled in perfect unity.[19] Of course, the best-known application of this system formed the basis of Hegel's famous dialectical method, wherein the truth of a given proposition could be clarified and established on the basis of triadic divisions: a *thesis* (the thing), an *antithesis* (its opposite), and *synthesis* (the process of their unification). Hegel's dialectical method profoundly influenced the development of German philosophical thought in the nineteenth century. Max Stirner, for example, came under Hegel's influence while studying philosophy at the University of Berlin, and later he became associated with a group of young Hegelians known as *Die Freien* [The Free Ones], which included such notable figures as Karl Marx and Friedrich

31

Engels, whose socialist inclinations Stirner would come to reject strongly, as he would, for that matter, philosophical systems of any kind.[20]

It should of course be noted that theories of opposition and reconciliation are not restricted exclusively to the realm of philosophy, but can be found in varying forms in a number of diverse areas of intellectual and scientific thought. Today, for example, such theories can be detected as prevalent factors in disciplines as diverse as structuralist theory and molecular biology. In literature, the concept was already well established in the Renaissance, particularly as it pertained to theories of the "conceit" or metaphor, ideas that were elaborated upon and refined by literary critics and rhetoricians of the seventeenth century, to such a degree that some historians believed it formed the theoretical basis for the style of metaphysical poetry in the period.[21] More relevant as a possible source for Duchamp, however, would have been the efforts made by French poets and literary critics from the Romantic to Symbolist periods, to reconcile concepts of the real and the imaginary, and, in the late nineteenth and early twentieth centuries, of the conscious and unconscious. As the inheritor of this tradition, Apollinaire, for example, sought a completely new method by which to free himself from the restrictions of metaphor, approaching a poetical form that could be appreciated directly for what it was, rather than whatever it might represent.[22]

While Duchamp was of course familiar with the writings of Apollinaire, as well as those of the French Symbolist poets, there is yet one other source that utilized at the very basis of its operations a reconciliation of opposing entities, and that is the art of alchemy. In ancient and medieval times, alchemy was traditionally understood to be a craft devoted exclusively to finding a universal elixir of life, and to the transmutation of base metals into silver or gold (in this respect, it is generally considered the historical forerunner of the science of chemistry). More recently, the practice of alchemy has been studied for its symbolic significance or, as Carl Jung utilized it, as a metaphor for various psychological processes that form the basis of life's inherent contradictions. Jung's thorough study of this subject resulted in a massive compilation of material brought together in a book entitled *Mysterium Coniunctionis: An Inquiry Into the Separation and Synthesis of Psychic Opposites in Alchemy*.[23] Here, as the title suggests, Jung traces the duality of opposites and their reconciliation (the *coniunctio oppositorum*), identifying Mercurius as the unifying agent in alchemical texts, while the process of what he calls "individuation" accomplishes this reunion in the realm of psychotherapy. As compelling as the comparisons might be with specific works by Duchamp, or with his working method – as I have outlined it here – it is doubtful that alchemy had anything to do with the formation of his approach to art. "If I have ever practiced alchemy," Duchamp told the French critic Robert Lebel, "it was the only way it can be done now, that is to say, without knowing it."[24]

It is my feeling that Duchamp's disclaimer should not be treated lightly. No matter what his sources may have been – if any – his exploration of opposites and their reconciliation seems to have been motivated more by his unwillingness to repeat himself, than by any possible willingness to conform to the dictates of a previously established system – philosophical, literary, alchemical, or otherwise. His working method involved a constant search for

alternatives—alternatives not only to accepted artistic practice, but also to his own earlier work. It was perhaps with this in mind that in 1913 he asked himself the provocative question: "Can one make works which are not works of 'art'?"—a question he answered within a year by his invention of the readymade, "a work of art," as he later described it, "without an artist to make it."[25] In strictly Hegelian terms, a work of art could be seen to represent the *thesis;* an object that is not a work of art, its opposite, or *antithesis;* while the readymade succinctly combines these ideas in a single artifact, bringing about their reconciliation, or *synthesis.*

The most literal and abstract manifestation of this approach in Duchamp's work can be found in his lifelong devotion to chess, a game which in itself has often been compared to Hegel's dialectical triad. In 1932, Duchamp published a book on pawn and king endings entitled *Opposition and Sister Squares Are Reconciled,* which he wrote in collaboration with the German chess master, Vital Halberstadt (Figs. 11 and 12).[26] Accompanying a series of parallel texts in French, German, and English, the authors included an abundance of carefully designed diagrams, many of which were printed on both sides of translucent paper in order to explicate fully the various nuances of their complex treatise. "But the end games in which it works," Duchamp later explained, "would interest no chess player. Even the chess champions don't read the book, since the problems it poses really only come up once in a lifetime."[27] In agreement with its author, most of the individuals who have

Fig. 11 *L'Opposition et les cases conjugées sont réconciliées* [*Opposition and Sister Squares Are Reconciled*], cover. Philadelphia Museum of Art; Louise and Walter Arensberg Collection.

Fig. 12 *L'Opposition et les cases conjugées sont réconciliées* [*Opposition and Sister Squares Are Reconciled*], interior pages. Philadelphia Museum of Art; Louise and Walter Arensberg Collection.

bothered to assess this book have repeated these very aspects of its impracticality, but none (so far as I know) have noted the significance of its central treatise, clearly announced by its title: to reconcile the alleged differences that had developed over the years between positions of opposition and the concept of sister squares. The opening sentences of this study make its purpose abundantly clear:

Curiosity has impelled us to elucidate a question which, for twenty years, has periodically given rise to bitter articles in chess literature.

Opposition *or* "sister squares."

Let us simplify: Opposition *and* "sister squares." (Emphasis added)

In other words, Duchamp and his coauthor have set about to prove that theories of opposition and theories of "sister squares" (usually referred to as "related squares" in modern chess terminology) are actually one and the same, and that they represent only variant methods by which to solve essentially the same endgame situation.[28]

Perhaps the purest example from Duchamp's artistic production to illustrate the reconciliation of contradictory or opposing entities is a work simply known as *Door: 11 rue Larrey,* a construction that was nothing more than a door he had designed for the main room of a small apartment he moved into in 1927 on the rue Larrey in Paris (Fig. 13). This door was located in a corner of the main living area, positioned in such a way as to close the entrance either to the bedroom or to the bathroom, but not to both at the same time. In opposition to the axiom implicit in the common French adage—"Il faut

34

qu'une porte soit ouverte ou fermée" ["A door must be either open or closed"][29] – Duchamp has ingeniously managed to defy the assumption of mutual exclusivity, uniting these contradictory themes into a compatible totality, or as he might have preferred to describe it, "a reconciliation of opposites."

* * *

Fig. 13 *Door, 11 rue Larrey*, 1927, wood door (made by a carpenter following Duchamp's instructions), 86⅝ × 24 11/16 in. *In situ* photograph by Arturo Schwarz. Door subsequently detached; currently Collection Fabio Sargentini, Rome.

35

In conclusion, it should be acknowledged that my remarks about Duchamp's work and working method are *not* made with the intention of establishing yet another method by which to view or in other ways interpret his artistic production. Rather, my comments are submitted with the intention of simply pointing out a recurrent theme, a casual observation about the artist and his work, about which he himself may very well have been unaware. Indeed, it has been convincingly demonstrated that various concepts of polarity and their ultimate unity – light/darkness; life/death; good/evil – form the basis of virtually all myths and folkloric traditions, from the Taoist, Buddhist and Hindu religions in the East, to the dualism of Heaven and Hell in the Christianized West.[30] If we should wish to believe that Jung was correct – and we have all somehow managed to inherit a storehouse of archaic images and ideas from the past (as part of what he called our "collective unconscious") – then we can just as easily assume that in his exploration of opposing identities, Duchamp was simply echoing a basic human concern: to unify or in other ways reconcile the conflicting dualities of life.

Yet, we might ask ourselves, just exactly how aware – or unaware – was Duchamp of the operation of this psychic phenomenon in his work? Was he not aware of the fact that the construction of puns and other word games – literary activities that delighted him, and at which he excelled – involved the formation of intentionally alternate readings, their precise meaning or humorous content understood (reconciled in the mind) only when both their literal and suggested meanings were fully comprehended? Moreover, when he conceived of the realistic, nearly trompe l'oeil figure in *Etant donnés,* was he not immediately aware of the fact that, in stylistic terms, this figure represented the virtual antithesis of the abstract elements in the *Large Glass?* And by implication, with the important role he realized for the spectator, was he not also aware of the fact that any viewer who tried to comprehend the totality of his work would be placed in the position of having to reconcile these differences? It would seem implausible that such a profound thinker as Duchamp did not – at least momentarily – reflect upon the possible sources and operational motivations for his work.

So far as I have been able to determine, Duchamp specifically addressed a theory of opposition on only one occasion – in a note which he wrote in 1914 entitled "Principle of contradiction," wherein he hints that any such formulation would, by its very process, invalidate itself. But through a series of wonderfully illogical though remarkably convincing suppositions, he goes on to develop a theory of "literal nominalism," wherein the conceptual content of words is to be discarded, replaced only by an understanding of their plastic and abstract qualities.[31] Even though in this very note Duchamp reminds himself that this theory should be developed, he never really carries it beyond this point. Outside of chess – which he took quite seriously – the only ideological construct he might have considered a possible metaphor for his work was his own concept of "infrathin," a detailed investigation he began in the late 1930s that concerned itself with the nearly imperceptible nuances that exist between things: from the warmth left by a recently occupied seat, to the sound made by velvet trouser legs rubbing together.[32] Even though this theory involves a study of many of the same concerns Duchamp

investigated in his earlier work – the differences between objects and their shadows, mirrors and their reflection, originals and copies, etc. – the reasons for his preoccupation with such tenuous, nearly immeasurable factors can, I suspect, be more accurately traced to his quiet, unaggressive, and comforting personality.

It may have been these very aspects of Duchamp's persona that once led the composer John Cage to compare his old friend to a Zen master. And the sculptor Arman, who saw quite a bit of Duchamp in the 1960s, characterized the artist as a "King Arthur presiding over the Round Table." "Above all the fights," he recalled, "nobody ever had the smallest chance to have a fight with Marcel." In fact, among the people who knew him well, no one seems to be able to recall having quarreled with Duchamp. Beatrice Wood, a lifelong friend and admirer who knew the artist for over fifty years, recalls that his very presence was a calming force. "We had wonderful moments of silence," she remembers. "There are times when we would spend the entire evening together, exchanging only a few words. I just assumed we were on the same wavelength. Marcel was not the kind of person you would argue with. Whenever an issue came up, he would simply say 'Cela ne pas d'importance.'" And Paul Matisse, the artist's stepson, explained that Duchamp rarely disagreed with whatever you had to say: "For him [Duchamp]," he recalled, "agreement was the way he kept his freedom. He felt arguing was just falling into a trap, and for him to argue against another's idea was to get caught up in it just as surely as if he had promoted it himself."[33] In short, it would appear that throughout his life, Duchamp successfully avoided situations that might have resulted in the possibility of a confrontation – reconciling, one could say, polarities of opposition even before they were given the opportunity to establish themselves.

Notes

This article is based on a lecture of the same title presented at an international conference, "Avant-Garde Art and Literature: Toward a Reappraisal of Modernism," organized by Barbara Lekatsas and Pellegrino D'Acierno at Hofstra University, Hempstead, Long Island, in November 1985. I am indebted to Professor D'Acierno for having drawn my attention to a number of the literary sources identified in the accompanying notes. An expanded version of this paper was presented at the centenary conference on Duchamp organized by Thierry de Duve at the Nova Scotia College of Art and Design, Halifax, Canada, in October 1987. I am grateful to the various participants in this colloquium, many of whom provided helpful comments and suggestions that have been incorporated into the present text. I am particularly indebted to Teeny Duchamp, who kindly read this paper in manuscript form, and graciously offered her encouragement for its publication.

1. James Johnson Sweeney, "A Conversation with Marcel Duchamp," television interview, NBC, January 1956; published in James Nelson, ed., *Wisdom: Conversations with the Elder Wise Men of Our Day* (New York: W. W. Norton & Company, 1958), 92, 94–95; quoted here in the variant transcription published by Michel Sanouillet and Elmer Peterson, eds., *Salt Seller: The Writings of Marcel Duchamp (Marchand du Sel)*

(New York: Oxford University Press, 1973), 130, 133–34; see also the interview with Francis Roberts, "I Propose to Strain the Laws of Physics," *Art News* 68, no. 8 (December 1968), 62; and Duchamp's interview with Otto Hahn, *Art and Artists* 1, no. 4 (July 1966), 10.

2. Interview with Pierre Cabanne, *Dialogues with Marcel Duchamp,* trans. by Ron Padgett (New York: Viking Press, 1971), 42.

3. Cabanne, 26.

4. As quoted, for example, in Arturo Schwarz, *The Complete Works of Marcel Duchamp* (New York: Harry N. Abrams, 1969; second rev. ed., 1970), 201. Catalogue numbers (Cat. no.) in this essay refer to this catalogue.

5. Cabanne, 64.

6. This film was produced by Essanay Company and released on 12 July 1915 (see *Circulating Film Library Catalogue* [New York: Museum of Modern Art, 1984], 47); Duchamp arrived in America about a month earlier, on 15 June 1915.

7. Both of these drawings were discussed at greater length in Francis M. Naumann, *The Mary and William Sisler Collection* (New York: Museum of Modern Art, 1984), 126–27; 130–31.

8. See Schwarz, "The Alchemist Stripped Bare in the Bachelor, Even," in *Marcel Duchamp,* Anne d'Harnoncourt and Kynaston McShine, eds. (New York: Museum of Modern Art; Philadelphia: Philadelphia Museum of Art, 1973), 81–98.

9. This is essentially the same interpretation as that provided in Naumann, *Sisler Collection,* 138–39.

10. Cabanne, 27.

11. Walter Arensberg to Marcel Duchamp, 26 August 1937 (Francis Bacon Library, Claremont, California).

12. Cabanne, 17.

13. Cabanne, 41.

14. Notes for a lecture, "Apropos of Myself," delivered at the City Art Museum of St. Louis, St. Louis, Missouri, 24 November 1964; published in d'Harnoncourt and McShine, *Marcel Duchamp,* 263.

15. Stirner was the pen name of Kaspar Schmidt. On Stirner and his philosophy, see James Hunecker, "Max Stirner," *Egoists: A Book of Supermen* (New York: Scribner's Sons, 1910), 350–72; Sir Herbert Edward Read, "Max Stirner," *The Tenth Muse* (New York: Books for Libraries Press, 1958), 74–82; James J. Martin, introduction to Stirner, *The Ego and His Own: The Case of the Individual Against Authority* (New York: Libertarian Book Club, 1963), xi–xxii; and S. A. Grave, "Max Stirner," *The Encyclopedia of Philosophy,* vol. 8 (New York: Macmillan, 1967), 17–18.

16. Duchamp recalled the title of Stirner's book as "Le Moi et la propriété" (in a questionnaire about the *Three Standard Stoppages,* Artist's Files, Museum of Modern Art, New York; undated, but probably written shortly after the work was acquired by the museum in 1953). Later, when Duchamp was asked by the Swiss artist and critic, Serge Stauffer, if there was a particular philosopher or philosophical theory that had captured his attention, he again identified Stirner and his book (see Stauffer, "Hundert Fragen an M. Duchamp," in *Marcel Duchamp: Die Schriften,* vol. I (Zürich: Regenbogen-Verlag, 1981), 290.

17. From the Museum of Modern Art questionnaire (see previous note).

18. Cabanne, 47; and the Museum of Modern Art questionnaire (see n. 16); the foregoing analysis closely follows my earlier reading of this work (see Naumann, *Sisler Collection*, 168–71).

19. See Armand A. Maurer, "Nicholas of Cusa," in *The Encyclopedia of Philosophy*, vol. 5 (New York: Macmillan Company, 1967), 496–98, as well as other works cited in Maurer's extensive bibliography.

20. Marx and Engels denounced Stirner's philosophy in their book, *Die deutsche Ideologie* [*The German Ideology*], written in 1845–46, but not published in its entirety until 1965 (London: Lawrence & Wishart; Moscow: Progress Publishers). Nearly the entire second part of this book is devoted to a line-by-line attack on Stirner and his book (for a concise summary of these comments, see C. J. Arthur, "Introduction: The Critique of Stirner," in *The German Ideology: Part I* [New York: International Publishers, 1970], 24–32).

21. See, for example, R. L. Colie, "Some Paradoxes in the Language of Things," in J. A. Mazzeo, ed., *Reason and the Imagination: Studies in the History of Ideas: 1600–1800* (New York: Columbia University Press, 1962), 93–128; and Joseph Anthony Mazzeo, "A Seventeenth-Century Theory of Metaphysical Poetry," Chapter 2 in *Renaissance and Seventeenth-Century Thought* (New York: Columbia University Press, 1964), 29–59.

22. See Marcel Raymond, *From Baudelaire to Surrealism* (New York: Wittenborn, Schultz, 1950), 221–25; and Jean Pierrot, *The Decadent Imagination: 1880–1900* (Chicago: University of Chicago Press, 1981).

23. Originally published in German in two volumes by Rascher Verlag (Zurich) in 1955 and 1956; trans. by R. F. C. Hull, vol. 14 of *The Complete Works of C. G. Jung* (Princeton: Princeton University Press, 1963).

24. Duchamp's words recalled by Robert Lebel in *L'Art magique*, ed. André Breton and Gérard Legrand (Paris: Club Français de l'Art, 1957), 98; quoted in Lebel, *Marcel Duchamp* (New York: Grove Press, 1959), 73; and in Arturo Schwarz, "The Alchemist Stripped Bare," 81. Unfortunately, Duchamp's denial has not deterred a host of insistent scholars who continue to investigate his possible alchemical sources. See, e.g., Maurizio Calvesi, *Duchamp invisibile: la costruzione del simbolo* (Rome: Ufficiana, 1975), and the writings of John Moffitt, who is preparing a book-length study on the subject of Duchamp and alchemy (see his "Marcel Duchamp: Alchemist of the Avant-Garde," in *The Spiritual in Art: Abstract Painting 1890–1985* [New York: Abbeville Press, 1986], 257–71).

25. Roberts, "I Propose to Strain the Laws of Physics," 47; Duchamp's question to himself was preserved in a note dated 1913 on its verso, published in facsimile in the collection *A l'infinitif* (New York: Cordier & Ekstrom Gallery, 1966).

26. This book was released in both paperback and deluxe hardbound editions (Brussels: L'Echiquier, Edmond Lancel, 1932). The original notes for this book are preserved in the so-called *Box of 1932* (currently in the collection of the Philadelphia Museum of Art; on extended loan from Richard Feigen, Inc., New York).

27. Cabanne, 77–78.

28. Until recently, few Duchamp scholars have taken this chess treatise seriously, most choosing to echo the relatively simplistic description of this book provided by Duchamp's lifelong friend, Henri-Pierre Roché ("Vie de Marcel Duchamp," *La Pari-*

sienne [January 1955], 3–4; trans. by Geórge Heard Hamilton in Robert Lebel, "Souvenirs," *Marcel Duchamp* [New York: Grove Press, 1959], 83–84). A notable exception is the analysis of Hubert Damisch, "The Duchamp Defense," *October* 10 (Fall 1979), 22–24.

29. This saying originates from the play *Le Grondeur* (scene 1, act 4), a comedy written in 1691 by Jean Palaprat (1650–1721) and David Augustin de Brueys (1640–1723); see Maurice Maloux, *Dictionnaire des Proverbes, Sentences et Maximes* (Paris: Librarie Larousse, 1986), 16. This citation was kindly drawn to my attention by Billy Kluver. On *Door, 11 rue Larrey,* see Naumann, *Sisler Collection,* 210–12.

30. See the excellent and comprehensive study on this subject by Alan W. Watts, *The Two Hands of God: The Myths of Polarity* (New York: George Braziller, 1963); see also Mircea Eliade, *The Two and the One,* trans. J. M. Cohen (New York: Harper & Row, 1965).

31. See *Marcel Duchamp, Notes,* arrangement and trans. by Paul Matisse (Paris: Centre National d'Art et de Culture Georges Pompidou, 1980), notes 185 and 186. It is interesting to note that coincidentally – though quite independently – Paul Matisse cited this very note as the principle document that led him to a greater understanding of the meaning and value of Duchamp's "illogical logic" (see "Some More Nonsense about Duchamp," *Art in America* 68, no. 4 [April 1980], 81–82).

32. See *Marcel Duchamp, Notes,* notes 1–46.

33. See "John Cage on Marcel Duchamp," an interview with Moira and William Roth, *Art in America* 61, no. 6 (November–December 1973), 74; Arman is quoted from a taped interview with Moira Roth, 26 February 1973; quoted in Alice Goldfarb Marquis, *Marcel Duchamp: Eros, c'est la vie: A Biography* (Troy, New York: Whitston Publishing Company, 1981), 308; Beatrice Wood is quoted from a telephone interview with the author, 10 November 1987 (see also Wood's recollections prepared for the present volume); and Paul Matisse, "Some More Nonsense About Duchamp," 77.

Resonances of Duchamp's Visit to Munich

Thierry de Duve

In leaving Paris for Munich, Duchamp fled the Cubist group and changed his context, since he plunged himself into a milieu that seemed dominated by Expressionism.

This change of context has largely been ignored by art historians and Duchamp's biographers. There are several good reasons for this, and others that are not so good. Biographical clues concerning Duchamp's stay in Munich are extremely meager: not only do we know nothing about the reasons for his departure, but we know just as little about the reasons that led him to choose Munich rather than Vienna, Prague, or Berlin, which he visited on his return trip. We know little more about what he did to keep busy in Munich. From a photo and correspondence with Apollinaire we know that he went to a photographer named Hoffmann, at 35 Schellingstrasse, to have his photograph taken, and from a postcard to Jacques Bon we know that he occasionally went to Munich beer halls. That is pretty much all we know. Beyond the two paintings and the four drawings that we have, Duchamp's activities in Munich are a matter of pure conjecture. In any case, given the absence of witnesses, it seems that he was very solitary during the whole of his stay in the Bavarian capital and that he had no significant contact with the artistic milieu of Munich.

This is the first reason for the prudent silence of the historians and the biographers on the significance of the Munich episode. There is another reason, one that is no less important: nothing in Duchamp's work or behavior allows us to link him with the German Expressionism that was flourishing in Munich precisely in 1912, when the Blaue Reiter group took up the work of the Brücke group in Dresden. It is obvious that there was not the least affinity between Duchamp and Expressionism; that he not only did not have the temperament of the Expressionists but also, unlike them, was not an artist "of temperament"; that he had no religious feeling, no social revolt, no nature symbolism, no identification with a Great Force, no feeling of participation in the expression of a communal *Zeitgeist,* whether Germanic or not. In short, Duchamp cannot be suspected of having been influenced by German Expressionism, and this is the entirely justifiable reason for art historians' lack of interest in a close examination of his stay in Munich.

However, the concept of influence by no means explains everything that "works" on an artist, and the traditional methods of art history give influence an exaggerated importance when they imagine, as if it were a general law,

that the evolution of an artist is best described as a dialectic made up exclusively of influences and ruptures. There are other means than influence for the artist to be permeated by a context and to draw from it some consequences that will show up in the artwork itself. We have seen that the stay in Munich was the occasion for a decisive turn in Duchamp's life and work, a turn whose sense, although still obscure to him, was revealed to him during the physical and intellectual experience he lived through in painting *The Passage from the Virgin to the Bride*. We could hypothesize that this experience was born out of a great need for solitude and owed nothing to the Munich context. But we could also well believe that the opposite is the case. A young man of twenty-five does not leave on a trip in order to enclose himself in an ivory tower but in order to discover the world. Whatever the secret reasons for his departure and for his choice of Munich, it was undoubtedly with an aroused and lively curiosity that Duchamp entered that city. It is probable that there was no personal encounter with the artistic milieu of Munich. No doubt he was still too uncertain of himself to risk meetings that might have threatened his search for his own way of thinking. But we can imagine that, like the artist-*flaneur* in Baudelaire, he visited the town from top to bottom, that he savored the half-bourgeois, half-bohemian atmosphere of Schwabing, and that he did not miss a single one of those expositions that demonstrated the complicated vitality of this capital of the arts so different from Paris, so curiously divided between its *mittel-Europa* traditions and the advanced avant-gardes inspired by work in Russia and, especially, in France. This is a hypothesis that is at least as plausible as the need for solitude; it is also compatible with what we know of Duchamp. It thus demands attention, even with some necessary precautions.

First of all, I am not trying to establish the most minor of biographical facts. That would demand an on-site archival investigation, which, even if necessary, does not form part of my project. But on the other hand, I am not setting out to build an interpretation of the work that would be based on conjectures about what Duchamp could have done or seen in Munich. Such an argument would be too vulnerable to eventual disproofs arising out of subsequent investigations. But I shall try to describe succinctly that state of the questions and artistic practices that Duchamp would have found on his arrival in Munich. I shall do this without assuming any particular sort of influence but, rather, by considering these "questions and artistic practices" as a field of resonances that welcomes or rejects the new artist, that could intensify or minimize the intuitions that ran through him in Munich, and that obviously could find their own resonance in the work only after Munich.

In Munich the experience of painting, and especially of painting *The Passage from the Virgin to the Bride,* led Duchamp to the threshold of a revelation that, borrowing from Lacan, I refer to as a "revelation of the Symbolic": Painting is named, always already named, even before the artist, impelled by his desire to become a painter, puts his brush to the canvas; his historical task, in a culture circumscribed in time and space by the phenomenon of the avant-garde, is to break the pact that gives painting its name and to anticipate a new pact that will be renewed later in a new situation; the destiny of the artist to whom this is revealed will be linked to the death of painting in-

sofar as this death, always already announced, is the paradoxical historical condition for the survival of painting, the reprieve that comes from its name being unpronounceable for a while.

A few months after the Munich trip it was the "invention" of the ready-made that would confirm this revelation. Duchamp abandoned painting for the first time, or, to be more precise, he abandoned painting as a doing and seeing, as an artisanal pleasure, an "olfactive masturbation." But he did not abandon the paradoxical contract that tied him to the history of painting; rather, he reduced the act of painting to nothing more than the enunciation of this contract itself: to name the death of painting and its survival in a single moment, to name the broken pact and the new pact that, since Manet at least, was part of the rhythm of the destiny of an avant-garde painter, and, by a supplementary turn of the screw, to name the name. To pass from "ol-factive masturbation" to "a sort of pictorial nominalism" would be the second passage that built on the passage from the *Virgin* to the *Bride* and that *Bicycle Wheel* would take account of in 1913, although Duchamp would not yet be aware of this since he would not use the word "readymade" until two years later.

Here we cannot treat "the state of the questions and artistic practices" in Munich in 1912 in all its complexity, its origins, its nuances. To consider it as a field of resonances, we will have to have an idea of what is resonating there. The readymade provides us with this idea in two ways: that of the fully constructed utilitarian or commercial object, which is the challenging, non-art side of the readymade; and that of color, of the enunciation of color, which is its artistic side and its particular link to painting and its history. The first aspect is easily understood and can itself be divided into two parts: utili-tarian as opposed to contemplative, and ready-made, as opposed to artisanal. The second aspect, which will be developed later, needs some justification. We can find this justification in several interviews with Duchamp in which, in relation to the readymades but also in relation to some of the Cubist paint-ings like *Nude Descending a Staircase,* he explains how in his view the words, the name, and the title of his works must work to "add color to the object."

The Munich in which Duchamp entrenched himself in July and August of 1912 is not the whole of the Munich art world but a field of possible res-onances that would be specified after the fact, that is, after having found a particular resonance in Duchamp's later practice. It was both more and less than the choir of Expressionist voices that could be heard in the entourage of the Blaue Reiter. It was everything that, in the summer of 1912, was percep-tible in one way or another in the quests to introduce into pictorial painting utility, work, and color.

A complementary hypothesis is encouraged by our investigatory project: the artistic milieu of Munich was in itself sufficiently different from that of Paris for the "state of questions and practices" to manifest itself differently in the two cities. In particular, the reception of Post-Impressionism and of Cubism was not the same; the institutional history of the avant-gardes did not look the same; the problematic of color as treated by the Blaue Reiter be-longed to an intersection of traditions that had no parallel in Paris; the very identity of the various arts was not organized according to the French model

of the Beaux-Arts and instead followed a very different organizing principle that, for example, would give an entirely different status to the decorative arts and to the Kunstgewerbe. Our hypothesis is that this constellation of differences between Paris and Munich was in itself capable both of displacing the questions that Duchamp posed to himself about his practice and of leading to new questions even if he was not yet aware of them. It is this constellation of differences that we must now briefly describe.

Munich in 1912

The painter Hans van Marées, representing with Böcklin, Feuerbach, and Klinger a current of Italianizing and "Romantic idealist" painting that had its roots in Friedrich, Runge, and the Nazarenes, was not really "discovered" in Munich until 1908, almost thirty years after his death, when his works were exhibited at the Sezession at the same time as those of Hodler and Munch. There is an interesting lag here that is a first demonstration of the fact that the relations between the avant-garde and academicism were not ruled in Germany, and in Munich in particular, by the same sharp opposition as were those in Paris between official art and independent art. Marées, like Böcklin, but also like Bouguereau in France, was part of Cézanne's generation.[1] But if Bouguereau and Cézanne could stand at the end of the nineteenth century as symbols around which academicism and avant-garde respectively rallied, this sort of institutional opposition was much more blurred in Germany and gave form to various amalgams that retrospectively can seem quite strange. Thus, for example, Paul Fechter, the first critic to have come up with a full theory of Expressionism, was still associating the spirit of Marées with the premises of the new art of the Brücke as late as 1914. The conjoining of Marées and Munch in the Sezession in 1908 had its justification; in any case, it does not seem to have had anything to do with that "implosive coexistence" of the advanced and backward artistic institutions that made up the French artistic milieu.

In 1912 Marées had been dead a long time, but Franz von Stuck, a disciple of Böcklin and a former professor of Kandinsky and Klee, still ruled as master over the Munich milieu. He was still exhibiting at the Sezession those allegorical or mythological paintings that had made his reputation at the beginning of the century, and even though he was beginning to be violently challenged by the avant-garde, his conservatism still weighed heavily on Munich's art life, and his influence was great in the Sezession and in "moderate" art journals like Die Kunst.

Moreover, the word "secession" itself is a good symptomatic indication of the un-Parisian way in which the institutional conflicts inherent in the history of modern art were settled in Austria and in Germany. Paris functioned by means of rejection, whereas Munich, Berlin, and Vienna worked by means of scission. From the time of the Salon des Refusés, which still had a paradigmatic value, the conflict between the Parisian avant-garde and Parisian academicism was settled from on high in a way that could not help being political and that had its starting point in a gesture of exclusion coming

from the established authorities, the Academy or the Society of French Artists. It was in this way that again and again the avant-garde was led to situate itself in relation to the rejections that it came up against and to begin from a position (however momentary) of exteriority. In Vienna, Munich, and Berlin, in contrast, the initiative seemed to come no less frequently from the artists themselves, who, feeling more advanced than, but out of power in, the artistic institutions, moved ahead by seceding. Thus, it was from the interior of the art institution that the avant-garde was defined and, as such, through a movement of retreat.[2]

Depending on whether the dynamic of the avant-garde follows the paradigm of rejection or that of secession, art will not be the object of identical strategies, and the connection to tradition will be completely different. In rejection, the institution of authority will take over the right to decide the legitimate contours of art and will accuse the avant-garde of seeking to break them. The consequence is the creation of a counter-institution that forms a new pact around the new painting and pushes the official institution to question the traditional notion of art and to expand the concept of art. The idea of the avant-garde is thus based on the evident rupture of tradition, not because the artists wanted rupture but because rupture was attributed to them, giving them no other possible strategy than to claim it as a proof of modernity and as the basis of a tradition to come. In secession, in contrast, the avant-garde makes some conflict (which can be a rejection, although this is not obligatory) serve as a pretext in order to quit the official institution and declare that the pact drawn around the concept of art has become too rigid. It is thus the avant-garde that makes the first move and gives itself the goal of renovating the notion of art by arguing the emptiness of the adversary's conception. Academicism, far from representing the law and order against which the avant-garde poses itself as a transgressive force, is that which remains of previous avant-gardes when they have run out of their scissional energy. In this situation the avant-garde has no need to call for a rupturing of tradition, since no one really accuses the avant-garde of doing so. Rather, the avant-garde accuses academicism of being only a dead tradition, while it conserves the power of presenting itself as the authentic and energetic inheritor of this very tradition.

It has often been noted that the art of central Europe at the beginning of this century seemed to evolve along lines that were infinitely more supple than in Paris, infinitely more tangled and intersecting, much less under the irreversible pressure of a privileged historical movement. Not that conflicts or attacks against modern art or "revolutionary manifestos," all of which can harden positions, were lacking. But one of the reasons for the fluidity of positions is no doubt related to the phenomenon that I am describing here: a historical force that followed the paradigm of secession more than that of rejection. This created a climate that could not be the same for Munich as for Paris, a climate that was no less made up of ideological struggles between artistic factions but that brought about amalgams that the much more "geometrical" French attitude would have resisted. The Viennese and Munich avant-gardes were not forced to define themselves, block against block, in relation to a monolithic academicism or on the basis of radical break. The

avant-gardes certainly defined themselves as the irreversible movement of history, but they always did so in relation to what had gone before and, to a large degree, according to traditions that they sought to declare as part of their heritage.

The paradigm of secession was omnipresent in German artistic life at the beginning of the century, and not only in the art movements that took that name. First of all, in 1892, there was the Sezession in Munich around Fritz von Uhde and, in the same year, that in Berlin around Liebermann. But the two movements that bore the same name were not at all ideologically homogeneous: Uhde was a religious painter poised between Symbolism and Leibl's naturalism; together with Corinth and Slevogt, Liebermann was one of the rare German Impressionists. In 1897 Klimt founded and directed the Viennese Sezession, and in this case it was Art Nouveau that served as the ideological basis for the movement. In 1910 the Berlin Sezession split to give birth to the Neue Sezession, which included Nolde, Pechstein, Kirchner, and Schmidt-Rottluff – in other words, most of the artists of the Brücke, to whom the name Expressionist had not yet been applied. In 1912 there was a Sezession in Cologne, but the word had lost its forceful reference to a scission and now designated only a group of conventional artists who wanted to give themselves the allure of modernity. During this period the Munich Sezession had rapidly become academicized.[3]

Here, we should note a second lag that shows that the Munich avant-gardes did not in any way undergo the pressures of a history oriented, as in Paris, by the trajectory of realism-Impressionism-Cézannism-Cubism. Quite the contrary, they greeted these movements – in those cases, indeed, where they did in fact greet them – in a curious chronological disorder, with emphases that were quite different from Paris, and amalgamating them in quite distinct ways.[4] At the end of the century the Sezession, which had been more or less based on naturalism at the beginning, gave an increasing place to Art Nouveau, which had been promoted since 1896 by the journal *Jugend*. The naturalism of Menzel and Leibl, the only extended connection of German art with French realism, had degenerated into the rural mysticism of the group Die Scholle. And Impressionism had more and more difficulties in getting itself accepted: Corinth and Slevogt left Munich for Berlin in 1900 and 1901. With Liebermann, they engaged in Impressionism thirty years after their Parisian counterparts. This lag may explain the strange reception of Impressionism in Munich as an art that was too modern for the Academy, the Kunstverein, and even the Sezession and that was considered already outdated by Kandinsky, who in *Über das Geistige in der Kunst* saw nothing more in it than naturalism and positivism. However, *Über das Geistige* appeared only in 1912. Before this, Kandinsky had already created in 1901 and dissolved in 1904 the Phalanx group, which proposed to unite young artists and give them a chance to exhibit. If we can judge by the French painters whom this group with such a militant name showed as examples to the young Munich artists, we will see that the Phalanx did not escape from the contradictions coming out of a short-circuited reception of Impressionism. The seventh exposition (1903) had presented Monet and Pissarro, and the tenth (1904) had shown Neo-Impressionist work, notably that of Signac, Laprade, and Van

Rysselberghe; but, in a move that is incomprehensible to us, it had also given a place to Flandrin! Undoubtedly, this was a way for Kandinsky to compensate by means of an "inspired" and symbolic painting for what he must have judged as excessively materialistic in Neo-Impressionism.

If Impressionism was so poorly welcomed, both by academicism and by the avant-garde, we cannot equally say that the importance of Cézanne was completely ignored. But with a remarkable constancy, the name of Cézanne came to be associated by the Germans with those of Gauguin and Van Gogh and the whole then was amalgamated with Munch. The Sezession of 1904 and the Kunstverein of Munich exhibited the first three together; the Brücke specifically claimed Gauguin, Van Gogh, and Munch as its own; and the whole of the institution of criticism spoke of this quadruple association as if it were the most natural of groupings. We can see a proof of this in the fact that the Sonderbund in 1912 – an important exhibition of the avant-garde that took place during the summer in Cologne and that Duchamp probably visited on his return trip – identified itself completely within a lineage of Van Gogh, Cézanne, Gauguin, and Munch, these "masters from which the new movement has emerged."[5]

It is obvious that Germany's understanding of the work of Cézanne – as a step toward Expressionism, not toward Cubism – was completely different from that of France. If we make an exception of Feininger, who came later and who, moreover, remained an American, there were no German Cubists. As for the French Cubists, they were misunderstood or ignored or assimilated into the Expressionists. The Berlin Sezession in 1911 had exhibited eleven French artists in a separate room with the title *"Expressionisten."* Among them were the Fauves (but not Matisse), as well as Braque, Picasso, and Herbin (with protocubist works, it is true). At the fifth exposition of the Sturm in August 1912, Walden had presented six French artists, including Braque, Herbin, and Marie Laurencin, under the title *"Französische Expressionisten."* In any case, before the publication in 1914 of Fechter's book *Der Expressionismus*, which limited the use of the term to the Brücke and the Blaue Reiter, the word "expressionism" was used by virtually everyone to refer ambiguously to a whole international current that "was opposed to Impressionism."[6] For Klee himself, Cubism in this period was "a specific branch of Expressionism."[7]

In Munich, Kandinsky was the first to give a place to the Cubists. Faithful to the dynamics of secession, Kandinsky and Jawlensky left the Kunstverein in 1909 to found the Neue Künstlervereinigung, which would experience a similar secession two years later when Kandinsky quit with all of those who would soon after create with him the Blaue Reiter. Yet the Vereinigung, which exhibited Cubist canvases of Braque and Picasso in 1910, included two French members, Le Fauconnier and Pierre Girieud.[8] This was virtually the only Cubist presence in Munich around 1910; once again, it was assimilated to the current that would become the Blaue Reiter and not at all presented as the autonomous avant-garde that it was in France.

What other marks of a French presence could Duchamp have been able to notice in wandering through the art milieu of Munich in 1912? Since the start of the year the Neue Pinakothek had housed the Tschudi donation, a

prestigious collection of modern French art assembled by the dynamic Hugo von Tschudi, recently deceased, who had been director of the National Museum of Berlin and then of Munich. From Courbet to Matisse, the Tschudi collection presented the whole history of Impressionism and, in regard to the recent movements, emphasized the Neo-Impressionism of Luce and Signac, unto which it assimilated Matisse.[9] We can consider this as the only antidote to the bad welcome given to Impressionism in Munich, but it also involved a short-circuiting of its own: although it had not yet been assimilated by the academic milieus and had already been rejected by the Blaue Reiter, the Impressionism of the Tschudi collection already presented itself as museum art. Moreover, if it promised, like every sort of museum art, a certain reading of history, this was not oriented toward Cubism but toward Divisionism and Fauvism—in other words, toward that art and those theories of color in which Franz Marc and Kandinsky, who came from a different tradition, saw a strong encouragement for their own particular practice.

Here in broad outline is "the state of the questions and the artistic practices" that presided over the birth of the Blaue Reiter and that Duchamp encountered soon after settling in Munich. Of course, it did not present itself to Duchamp with that synthetic clarity that we can achieve only through historical distance. But it did present itself as a sort of climate that was undoubtedly ambiguous and untheorizable but also stimulating for artistic intuition. It seems to me that a young artist who had for the first time left the milieu in which he originally began to fashion his craft must have been extremely sensitive to such a climate or at least to those forces in the climate that differentiated it from his original climate. It is thus not pushing things to imagine that Duchamp took something from this new climate, by osmosis we might say, and that what he took from it would have been a series of authorizations:

1. Cézanne was not really unknown, but he was "misinterpreted" by German art. Cézanne himself vehemently rejected the association of his name with those of Gauguin and Van Gogh, as is shown by his declarations to Emile Bernard, who was interested in all three.[10] As for the Cubists, who saw themselves as the true inheritors of Cézanne, they were not accepted in the Munich art world any more than Cézanne. As much as the history of the French avant-gardes passes through Cézanne and Cézannism, that of the German avant-gardes follows other paths that have nothing to do with the Cézanne-obstacle. Caught by this obstacle, a veritable name-of-the-father, Duchamp may have felt that his time in Munich, which he later called "the occasion of my complete liberation," was a formidable relief: another history of painting was possible, one that did not have to struggle ceaselessly with Cézanne. The need to repress and sublimate his oedipal conflict with the master from Aix could perhaps be partially assuaged. The censorship that had guided the displacements of his desire to become a painter along the associative chain woman-painter could now relax its vigilance, and the repressed signifier, Suzanne/Cézanne, could return, leading to the revelation that we have already mentioned. We will never know if it really happened this way. All we can say is that the much less forceful reception of Cézanne by the Munich milieu could have created the favorable conditions for such a

biographical occurrence. Having at our disposal a pictorial fact – *The Passage from the Virgin to the Bride* – we can connect it to this aspect of the Munich scene and argue that there was a resonance.

2. The Munich reception of Impressionism and Cubism reinforces this argument. One of the few things that Duchamp shared with Kandinsky was the reaction to Impressionism, which both of them condemned, the former as "retinal," the other as "naturalist." But whereas in Paris such a judgment, which was that of Gleizes and Metzinger, would have led the Cubists to defend a conceptual realism and not a visual one, in Munich it led Kandinsky to give up absolutely any idea of realism. Similarly, the Parisian Cubist reaction to Impressionism would have had as a corollary the abandonment of color, which was judged too decorative or not conceptual enough. In Munich the reverse was the case: Kandinsky and Marc freed color precisely because its autonomy vis-à-vis the represented object seemed to them to be the best guarantee of a new conception of painting, liberated from the retinal. It is true that they referred back to a whole theoretical tradition that was not that of Impressionism and that would lead them to the idea of a language of the emotions and of an expressive code of colors that were both absent from French painting. This was also a set of favorable conditions for Duchamp. During the year that preceded his stay in Munich, he dissociated himself from Cubism at the same time as he initiated himself into it. Cubism thus remained his point of reference, despite his desire to pass beyond it "at high speed." Neither Delaunay nor Kupka, both of whom were nonetheless working under his very eyes to escape from Cubism by means of color, seemed to have gained his attention and even less to have influenced him. It was in Munich that he encountered color, in a climate that was not feeling the authority of Cubism and did not engage in Cubism's repression of color. Here again, we should not see anything more than an authorization, and certainly not an influence. Duchamp would not become a colorist. Nonetheless, a very specific examination and experimentation with color would lead to the idea of "pictorial nominalism" as the intersection of two theoretical traditions that were resonating, each in the other.

3. The dynamics of secession meant that the Munich avant-gardes did not experience the same cases of mutual confrontation with academicism as occurred on the Parisian scene. Munich thus did not experience those misunderstandings that led to a notion of the avant-garde as tabula rasa. In Paris the artist-innovator saw himself first of all as someone who had been refused, accused of non-art. From this came conflicts of personalities, of styles, and of ideologies always cast together in institutional conflicts, since it was always the institutionalized concept of art that confronted its contrary. Later, when the avant-garde's provocation was accepted and it was reintegrated into the category of art, it still carried within it the connotations of "non-art" that resulted from its rejection. Thus was created the misleading image of a history of art that "advanced" only by integrating a rapidly changing succession of negations of itself, as if changing a tradition meant the same as effacing memory, as if the only guarantee of the future was to make a tabula rasa of the past. The dynamics of secession would not lead to this illusion of the tabula rasa. It gave an essential place to provocation, as we have

defined it above as a call for recognition, but insofar as the artists had the initiative for secession and the institutions lacked the initiative for rejection, provocation appeared much less as means for assassinating tradition than for splitting off from a tradition that was already dead. For the painters, the other name of a dead tradition was "museum art." As such, it merited all their respect, did not arouse any anger, and remained open to new pictorial interpretations. For these avant-gardes of secession, the technical and aesthetic rupture with tradition was not and did not appear as the motor-force of modernity.

I noted above that Duchamp did not entertain the fantasy of a tabula rasa. Nor did Manet or Cézanne, for that matter: the former never stopped linking his art to tradition, and the latter kept working at "re-doing Poussin." Artists started assuming the ideology of the tabula rasa attributed to them only from the moment of Futurism and Dadaism on. We well know Duchamp's disdain for Futurism and his reluctance to see himself assimilated into Dada. He never wanted to burn down the museums as did Marinetti or to break completely with art as did the Cabaret Voltaire. His "Dadaism" was never made up of social condemnations of art, but only of personal secessions.[11] He never wanted to engage in a tabula rasa of tradition, nor did he believe that it was possible to do so; he never wanted to break with art in order to efface the memory of it. In Munich, in any case, he got down to work and did not feel the need to produce a pictorial novelty that would gain its heroic modernity from its rejection of the past or from the past's rejection of it. Lebel has noted that the execution of his Munich paintings "seems to have [been] taken right from the old masters."[12] Maybe we have to understand that the Munich climate, less avant-gardist and less dogmatic than that of Paris, had something to do with this execution. More at ease in the milieu of these avant-gardes that did not deny their past but separated themselves from it in order to better claim it for themselves when they felt that it had lost its vitality, Duchamp was able without shame to give himself over to a pictorial practice that was connected through the notion of craft to a tradition that he chose for himself. Whether or not this is the "explanation" for his sudden return to the techniques of the old masters, it was one of the conditions that authorized him and gave him his particular field of resonance.

4. In fact, it seems as if immediately after Munich Duchamp passed from a Parisian strategy to a Munich one. He had just finished his masterpiece (in the older sense that this word had), his analysis of the passage to a pictorial craft. And what did he do now? He stopped painting; he withdrew from the scene; he engaged in a secession. It is obvious that the "abandonment of painting" was a strategy. If Duchamp had really abandoned the craft of the painter for something completely different, like the job of librarian, we would say nothing more about him, and nothing would force us today still to ask the question of the meaning of this "abandonment." If we still have to ask it, this is because its meaning is most immediately that of a strategy, one that is inherent in painting. It is not different in principle from the one that led Manet to abandon chiaroscuro, or Cézanne to abandon linear perspective. It was not different in principle from the abandonment of figuration, which around 1912 was the strategy of painters as diverse as Kupka, Mondrian, De-

50

launay, Picabia, Kandinsky, and Malevich. But it was not a strategy that responded to rejection with rejection. It was not a provocation that assumed a negative pictorial novelty that the artist demanded be accepted as meaningful. The provocation lay elsewhere, in splitting and secession. In abandoning painting, Duchamp was referring everything that this name designated to a dead tradition. He relegated the totality of the pictorial tradition to the museum, including the contemporary avant-gardes and even his own recently completed work, *The Passage,* which had been the means for his becoming-painter, and *The Bride (Mariée),* which was already conjugating this becoming in the past tense.

There is still a great deal to say about Duchamp's "abandonment" of painting. For the moment we will note only that in Munich he found the favorable conditions and maybe even the model for an artistic strategy that functioned along the lines of secession and that would take on its full provocative sense once it had been imported into Paris, an artistic milieu that functioned along the lines of rejection. Reciprocally, we will note that the complex totality of conditions behind the artistic practice of Munich resonated under the blow of this "abandonment" and gave off a particular sound to which the rest of this analysis will now be attuned.

Marcel Duchamp, Art Worker

To the rejection of *Nude Descending a Staircase* by the Indépendents in 1912, Duchamp answered with the secession that followed Munich, in which he gave himself the motto "Marcel, no more painting; find some work." Thus, the abandonment seemed to conclude a series of defeats whose first example in 1905 had been the failure of the entrance exam to the Ecole des Beaux-Arts. But the amusing logic of the "subsidized symmetry" that seems to have organized all of Duchamp's life means that this abandonment also concluded a series of successes that had also begun in 1905 with a secession, a separation.[13]

Shortly after his rejection by the Ecole des Beaux-Arts, Duchamp, who was trying to get out of the obligatory two-year military service recently instituted, learned that a year's dispensation would be granted to anyone who enlisted, provided that he was a lawyer, doctor, or art worker. Having neither the time nor the desire to embark on paths that his brothers had abandoned, he got a job as an apprentice engraver in a print shop in Rouen. He conscientiously applied himself to learning the trade by printing the engravings of his grandfather, Emile Nicolle, and after great success was given his certificate as an *ouvrier d'art.*

This was the only diploma he would ever receive and the only institutional success in his early years. With distance, it came to seem as worthless as the failure in the competition of the Ecole des Beaux-Arts. But the two events, with only one or two months between them, were "symmetrically subsidized," as if the fundamental anxiety of becoming a painter had been compensated for early on by the assurance that he would be a good technician. But in Munich, it was through a particularly minute investment in the pictorial technique that he would accomplish his becoming-painter, and it was

51

through a perfectly mastered craft and two superbly realized paintings that the uselessness of continuing to paint would be revealed to him.

We can well imagine the "irony of affirmation" with which Duchamp at the end of his life declined this identification as an art worker. But, in the period when his greatest desire was to be recognized as a painter, we can be sure that he got no glory from it. In the Paris of the years around 1910, nothing could be more contrary to the title of artist than that of the art worker. Art had to be a form of thought, not a manner of execution. Thus, we should not imagine that Duchamp was the only person to despise the "stupidity" of painters, that he was the only one to disapprove of "retinal painting." All the avant-garde painters shared this desire to be recognized for their pictorial thought rather than for their manual craft. While the avant-garde abandoned the skills of the hand to the *pompiers* and other academic painters, the prestige demanded from painting quite naturally displaced onto an activity more emotional and conceptual than manual. And a good part of the ideological ambitions of the new painters was to free themselves of the status of artisans and, in particular, to avoid any confusion of their work with that of the decorative arts. The more they moved toward "pure" painting and toward abstraction, the greater was the danger of this confusion, and so the greater was the insistence on getting rid of the utilitarian and artisanal values associated with the decorative arts.

Only at the end of the war was there a reversal of these tendencies in France; only then entered into the work of certain painters like Delaunay or Léger the desire – a frequently contradictory one, moreover – to see the rise of a "pure" art that would simultaneously be a "useful" art integrated into everyday life. It would take until Le Corbusier, *l'Esprit nouveau,* and the Salon des Arts Décoratifs of 1925 for such a desire to gain a certain prestige in France and for a functionalist aesthetics to make an inroad, although a tentative one.

At this time, the functionalist movement had already had a long history in Germany, one that would no doubt not be without implication for the "invention" of the readymade.

Two interwoven traditions must be taken into account. The first, which was in fact the newer of the two, was that of a functionalism *stricto sensu*. It is not my goal here to lay out the whole of its history, but I can note some of the signposts that marked the path that would be followed by the new idea of an industrial aesthetics. From the Viennese Sezession to the Bauhaus, this path passed through the Wiener Werkstätte, Olbrich, Hoffmann, Adolf Loos, the Deutsche Werkstätte founded in 1906 by Bruno Paul, the Werkbund founded in 1907 under the encouragement of Muthesius, the first efforts in industrial design undertaken by Peter Behrens for AEG in 1907–1908, and so on. For the most part, it was mixed up with the history of architecture in the period, but it went well beyond that history since it transferred the "pure," "disinterested" artistic responsibility of the autonomous artists to a new figure invested with all the ambitions of the *Gesamtkunstwerk,* the *Gestalter,* the "conceiver of forms." Without going into detail, let us note two things: not only was the functionalist aesthetic a "mechanical" avatar of the applied arts, it was the carrier of an ambition of cultural creation that was at

least as strong as that of the pictorial avant-gardes and that was, moreover, tightly linked to them. We can see a remarkable index of this in the fact that Gropius, who declared in the first phrase of the Bauhaus manifesto that "architecture is the goal of all creative activity," surrounded himself almost exclusively with painters at the moment when he founded the school.[14] On the other hand, the nodal and most controversial point of the functionalist ideology was the abandonment of artisanal values in favor of industrial values, the substitution of an aesthetics of standardization for an aesthetics of the "handcrafted." This did not happen in a day. In the Bauhaus manifesto Gropius still wanted architects, sculptors, and painters to go back to craftsmanship.[15] From 1914 on, however, Muthesius announced his opposition to Van de Velde within the Werkbund, responding to the call for a "universal meaning" contained within standardization against the attachment of Van de Velde to a "great reservoir of creativity" represented for him by an artisanal approach to art.[16]

It is not difficult, in retrospect, to see the extent to which the "invention" of the readymade was tied up, by "subsidized symmetry," once again, to a functionalist aesthetic. This aesthetic tried to dissolve the autonomy and the specificity of art into a general practice of the environment that it, paradoxically, invested with all the values of purity and disinterestedness that had been attached to the name of art. Reciprocally, the readymade attached the name of art to a banal object of the environment that had not been understood according to a functionalist point of view and, pulling it out of its usual usage, brusquely conferred on it the uselessness and the disinterestedness of "pure" art. Functionalism fostered respect for materials, emphasized clarity in production processes, and exalted utility, all seen as aesthetic values that were immanent in usage and that did not need to make use of the institutional value attached to the name of art. The readymade equally emphasized material, production processes, and utility, but as a means to isolate the institutional value of the name of art to the detriment of all aesthetic value and all use values, both now losing their point and purpose. Finally, functionalism transferred to the mode of industrial production all the investments of taste and savoir-faire that had been carried up until then by stylistic tradition and the manual craft of the artisan. The readymade offered itself as an industrial object without connection to artisanal tradition, it cut short any appreciation by means of aesthetic savoir-faire or recognition by means of artistic taste, whether good or bad.

This game of symmetries and reciprocities well inscribes the gesture represented by the readymade in the heart of a problematic of the period that was of considerable importance for modern art and architecture. But obviously the readymade did not directly intervene in this problematic. It found a paradoxical resonance there but did not take part in it. It designated this problematic in its totality and with all its ideological variations as its own conditioning field, but it was not itself reinscribed within this field. The readymade engaged in a secession. Duchamp was not the artist-artisan of the industrial culture that Gropius had dreamed of forming; nor was he the inspired designer of a mechanical production that was to become the true art of the century since it had kept everything of art—its talent, its work, its am-

bition, its culture – everything except its name. Of the very requisites of functionalism, Duchamp kept nothing of art but its name. His readymade was a "reciprocal functionalism." Through "subsidized symmetry," the functionalist object revealed itself to be a "reciprocal readymade," a work of art to which one denied this name in order to use it as a utensil.[17] Read in terms of the social, let alone, socialist, ambitions of functionalism and in terms of its failures in the rest of the history of modern architecture, this reciprocity gives its tone of enigmatic truth to the famous prediction of Apollinaire that we must cite in its entirety:

> This technique can produce works of a strength so far undreamed of. It may even play a social role.
>
> Just as Cimabue's pictures were paraded through the streets, our century has seen the airplane of Blériot, laden with the efforts humanity made for the past thousand years, escorted in glory to the [Academy of] Arts and Sciences. Perhaps it will be the task of an artist as detached from aesthetic preoccupations, and as intent on the energetic as Marcel Duchamp, to reconcile art and the people.[18]

This phrase was written in the fall of 1912. Duchamp, who was just back from Munich, had not yet "invented" the readymade and did not know that soon a urinal named *Fountain,* like the Cimabue or Blériot's airplane, would be triumphantly displayed by Arensberg "as though it were a marble Aphrodite."[19] But between 26 October and 10 November he went to the Salon de la Locomotion aérienne and, to Léger and Brancusi, who were accompanying him, he offered this verdict: "Painting is over and done with. Who could do anything better than this propeller? Look, could you do that?"[20] He was thus sensitive, like Sullivan, like Muthesius, like all the pioneers of functionalism, and like Le Corbusier later, to the immanent and involuntary beauty of the modern machine adapted to its function. In contrast to them, he did not reinvest this sensitivity in a voluntarist aesthetics based on the machine. He was content to make a declaration – "Painting is over and done with" – which designated the readymade, Blériot's airplane and propeller, and soon the bridges and plumbing fixtures of the New World, as the only things worthy of supplanting painting under the title of art. In Munich he had done a drawing entitled *Airplane,* a drawing that was completely heterogeneous to the problematic of the *Virgin* and the *Bride.* Could it be that it was inspired by what was already being said, in the climate of the Werkbund, about functionalism? Reciprocally, could it have "subsidized" in advance the verdict that he delivered at the moment of abandonment in front of the propeller? There is not and never will be a definite answer to such questions. At the most, they offer their own conditional answer: Munich in 1912 offered an excellent field of resonance for a revelation of the Symbolic that isolated the name of art to the degree that the social function of the artist in an industrial society found itself tied to the question of the survival of artisanal practice within art.

To understand this we have to deal with the second tradition – chronologically the first – which was interwoven with the history of functionalism and which functionalism in the literal sense came out of in part. I am referring to the Kunstgewerbe. The word and the practice have no equivalents in

France. "Art craftsmanship," "applied arts," and "decorative arts" are the approximate and partial translations. Less inaccurate would be "arts and crafts" (*arts et métiers*), but, for complicated reasons, some of which are institutional, the expression does not really work in French. It works in English, since the German practice of the Kunstgewerbe and its promotion by ad hoc institutions, the Kunstgewerbeschulen, came directly out of the Arts and Crafts Movement.[21] Why didn't France experience a movement comparable to the English Arts and Crafts Movement? Why didn't it know how to give birth to a talent like William Morris? Why didn't a Viollet-le-Duc, who was certainly more modern in his reading of the "Gothic Golden Age" than was the English Gothic Revival itself, lead to as many progressive interpretations of his doctrine as did Ruskin, for example, or, after him, Morris or Ashbee? Why in France didn't artisanal art develop in competition with the pictorial avant-gardes and with as much ambition as they? Why was a Clémont-Janin or a Paul Boncour able to proclaim in 1912, "Decorative art no longer exists in France"?[22]

Of all the explanations that overdetermine the answer to these questions, there is one that seems to me to be particularly pertinent for the case of Duchamp, because it deals with the manner in which the institutions divided up the name of art in the social realm. The French expression *arts et métiers* does not at all have the same sense as its literal translation in English: "arts and crafts." This is because the phrase was already being used for something else, and this had been true since the time of the *Encyclopédie*. Diderot and d'Alembert's great project of classification had divided up human practices into sciences, arts, and crafts. When the Convention wanted to turn its *dictionnaire raisonné* into law, it was virtually with a single gesture that the division underwent a triple institutionalization: 1793 witnessed the creation of the Museum of Natural History, the opening of the Grande Galérie du Louvre, and the establishment of the Conservatoire des Arts et Métiers. A triple classification, a triple pedagogy: on one side was the domain of empirical and experimental knowledge, which thought of itself as a science of nature and taught by observation; on another side, the public representation of Representation itself at its best, which taught by example. On a third side, finally, was the concrete exposition of the active power of the human being as technician, artisan, and manufacturer, which taught by demonstration. It seems to me that this tripartition, which resulted from a virtually unique decision, had a paradigmatic value and that it oriented the "museo-polemic" history of French art toward paths that were much more sharply drawn than elsewhere, paths that for a long time handicapped any hybridization of domains. The binary form that aesthetic judgment adopted and that we have seen crystallize around the Salon des Refusés could well have been an indirect consequence of this. In any case, the Louvre and the Conservatoire des Arts et Métiers split up the name of art around a division that is not surprising in the West – the division that distinguishes ends and means, final cause and efficient cause: on the one hand, art as thought, model, example; on the other hand, art as technique, process, sleight of hand. Technicity, artisanal savoir-faire, and everything in the artist that alluded to the worker, even to a worker of art, found itself inscribed in the French social system, in its insti-

tutions and in its ideologies, in a site other than that designated for art "properly speaking." It was for this latter art that was reserved the appellation "Beaux-Arts" [Fine Arts] and the support of its institutions: museums of fine arts, the Academy of Fine Arts, the schools of fine arts. In France before 1914 these three forms, which were part of a single "ideological state apparatus," were in an open crisis but they continued nonetheless to impose on practitioners of all stripes their exclusional dictates and to reject categorically the artists of the avant-gardes. As a symptomatic example, we can note the "subsidized symmetry" of defeat and success: having failed the entrance competition for the Ecole des Beaux-Arts, Duchamp brilliantly succeeded in his exam as an art worker.

During this time, the Kunstgewerbeschulen in Germany were in full bloom. They were simultaneously open to two completely contradictory currents of ideas, but ones that were correlates of each other, two currents that in the 1920s would still dramatize the whole history of the Bauhaus and would set the tone of its internal struggles. On the one hand, they were open to the trend of functionalist ideas.[23] The values of personal expression in which art workers could still, at their modest level, invest their savoir-faire, were losing ground against the collective semantics that functionalism found in the immanent aesthetics of the machine. Artisans became intellectualized, and this was for them a social elevation: they became conceivers more than makers, equals of engineers more than of workers. But this elevation took place to the detriment of the "human" and individualist values that had been part of their production before division of labor had set in. In moving closer to the engineer, the artisan moved away from the artist. On the other hand, this tendency engendered a reverse tendency with which it maintained an inherent conflict. In moving away from the artist at the level of making, from the personal mark of the artist, the artisan moved closer to the artist at the level of creation, as an author. The evolution of the Kunstgewerbeschulen shows that the arts were equally open to this tendency. Destined at the start to train workers of art who were skilled but had little originality, they gave an increasingly large place to research on new forms and demanded more and more personal initiative from their students. This was true to such a degree that in 1912 a critic, observing this evolution and calling on Friesz, Derain, Matisse, Braque, Picasso, and, from the German side, Melzer, Pechstein, Kirchner, Heckel, and Schmidt-Rottluff, was able to declare that the Kunstgewerbeschulen were perhaps as good a preparation for contemporary art as the academies.[24]

The rest of history would reproduce this clash of tendencies with a remarkable consistency. Throughout the length of their common modernist history, architects, even painters, and especially designers, vehemently denied that they were artists at the same time that they demanded for themselves the highest prerogatives of art: to create something new, to found a new language, to build a new culture, to anchor the social contract in a judgment of taste generalized to the whole of the constructed environment. From coffee spoons to urbanism and landscaping, the *Gestaltung* would diffuse through the whole of society artistic attitudes and requirements even as the specific trade and identity of the artist would have to disappear. This was the

contradictory ideological program that was found with slight variations in each twist of the functionalist project. The many "abandonments" of painting other than Duchamp's – Rodchenko's, for example – carry the marks of this. From congress to congress, the CIAM repeated this process until it exploded under the force of its internal contradictions. From the 1920s on the conflicts of Gropius and Hannes Meyer in the Bauhaus or of the Suprematists and the Productivists in the *Vhutemas* had aggravated all the incompatibilities of the functionalist program.

This is to say that in 1912 whoever came as a stranger to the milieu of the Kunstgewerbe would have quickly perceived the nodal points of a contradiction that, seen from within, must have seemed mired in the confusion of a day-to-day polemic. It is as if Duchamp, who was this stranger, had put his finger on a naked fact, which was not dialectizable no matter how much effort was exerted in trying to resolve the contradiction. On the one hand, the artisan and also the artisan-painter were condemned to economic decline by the pressing needs of an industrial culture. On the other hand, industry could not claim a cultural dimension without some kind of consciousness registering its raw creativity in continuity with a tradition. The functionalist "resolution," from Morris to Gropius and beyond, was the history of an acceptance – slow and reticent at the start, and then triumphant afterwards – of the death of the artisan and, with it, of painting. But nourished by the illusion of the tabula rasa, it was also the fantasy of a transfer of power from the former artist-artisan to the new conceiver-projector, the fantasy of an integral and virtually instantaneous transfer of all the acquisitions of a now defunct older tradition to a new culture that did not yet have its own traditions. To dissolve the former specificity of the trades into the ideological generality of a *Gesamtkunstwerk* that did not dare to speak its name of *Kunst* demanded a consciousness that knew that there was a transfer of power where the layman saw only death and murder; it demanded a memory that, in the void of everything that the new art refused to take from the past, knew how to read in the most dignified way a respect for a tradition that had now been abolished. The pioneers of functionalism wanted to be this consciousness and this memory; they also dreamed of communicating their ideas to the masses without delay. They all were thus essentially pedagogues – pedagogues rushing most urgently toward a sort of artistic alphabetization of the people. But they aspired to act on the social, and thus on the Real, and never stopped denying the level of the Symbolic wherein their work was situated. In promoting the idea that "form follows function" and that function is utilitarian, ergonomic, "real," they denied their own intervention, suggesting that form is an automatic consequence of function. Here was their error, their ideology, the mark of their Imaginary. Yet their entire practice shows something else than what they imagined: that a form that was adjusted to its function was nothing other than the very symbol of this adjustment. In denying this on the theoretical level, they had eschewed the possibility of an alphabetization, a real acculturation. Because, if the social goal of functionalism was the creation of a culture, it would have been necessary for it to recognize, in order to give itself some chance of success, that its inscription in the Real was nothing other than the Symbolic: consciousness, memory, the

spatiality of the social body and the temporality of history. In not under-standing that creation can create a culture only through the movements of time, "with all sorts of delays," and by the retroactive movement of a Symbolic recognition, they failed.

The inverse of that failure is the success of the readymade. It is as if Duchamp, who certainly never attempted to solve the contradiction of the Kunstgewerbe or of functionalism, had put his finger on their blind spot. The readymade reveals precisely what functionalism denies: the function of the name. Duchamp chooses an industrial product, displaces it, puts it to another purpose, whereby it loses all its utilitarian dimension as well as all ergonomic adjustment of its form but, by the same act, gains a function of pure symbol. And this symbol alone is the link which bears within it, from a tradition which it acknowledges as dead, the anticipated value of a culture which strives to become. The readymade does not belong to the artisanal tradition; it does not aim at any reconciliation of the artisan and the artist, of the one who makes and the one who creates. And since it does not belong to that tradition, it states this fact; it is the symbol of this not-belonging, the recorded sign of the death of the artisan. On the other hand, the readymade belongs to industry, but it does not aim either at the reconciliation of the artist-artisan and the designer-engineer. No artist made the object with his hands, and no designer conceived it. A worker must indeed have made it, and an engineer must have conceived it; but there is nothing which can claim anything but technical culture. However, since the readymade belongs to industry, it states it; it is the symbol of this belonging, the recording sign of industrial culture.

Duchamp, I repeat, does not have the phantasm of the tabula rasa. There is no reason to assume that he imagines to embody the consciousness and memory of a vanished tradition, or to think that the readymade indicates the passing of power from the former painter to the future designer. Duchamp readily discharges consciousness and memory on the spectators "who make the paintings." It was up to posterity to say if the urinal belonged to culture; he himself could not care less. But he reserved for himself the naked symbolic function, the speech art that would name art. The name mattered to him, the pact that would bring the spectators to come to an agreement around some object, an object that added nothing to the constructed environment, and did not improve on it but, quite the contrary, pulled away from it, bearing no other function than that of a pure signifier, the pact itself.

Duchamp had no awareness of any of this during his stay in Munich. Not only would the readymade come much later, but it would be recognized and named as a readymade later still. However, why must we imagine that the readymade resulted from an act of consciousness when everything demonstrates that it "resulted" from a symbolic force and that it incarnated as such the emergence of the signifier? Yet the signifier is "dumb" like the painter. Even though it is the name as name; it does not even have a name. Intelligence comes only after the fact from what the name reveals when we interpret its resonance. According to the chosen resonator, we are either in the clinical field, that of "the man who suffers," or in the aesthetic and historical field of the "mind that creates." It is this latter option that I have chosen to

render intelligible as much as possible, since it is here that the signifier-Duchamp reveals itself to be "intelligent." Here, the signifier takes a name, and this name is art, painting. But there also remains the name of the name, the name in its autonymy: an art of art, painting of painting. What Duchamp brought to culture was of this order, intelligible only to those onlookers who, later on, would make the paintings. That we cannot see anything of this in his work in Munich, that we *can* be sure that the idea of a critique of the impasse of the Kunstgewerbe never occurred to him, does not prove a thing. It is still a question, since we know nothing of Duchamp's activities in Munich, of reconstituting a milieu, a climate, that we can recognize a posteriori as a good resonator.

Again, not to get lost in things, we have to rely on history as a field of possibilities. The evolution of the Kunstgewerbeschulen is a historical fact. In 1912 they pushed their students toward both "pure" art and a practice of *Gestaltung* that was disconnected from the name of art, toward both the identity – Romantic at the core – of the free, disinterested and individualistic artist, and the "technocratic" identity of a designer well integrated into economic necessities. I see Duchamp at the intersection of these two contradictory forces, like someone who, coming from elsewhere, would have perceived the interweaving of the strands. It remains to be shown that Munich offered him the possibility of this "perception." We cannot in all certainty imagine that Duchamp visited one of the Kunstgewerbeschulen; the probability of this is really too low. But there is a very strong chance that he became aware of the Kunstgewerbe in some other fashion. From May to October 1912 Munich was the site of a gigantic "industrial exposition." Or should we say an exhibition of "industrial art," "artisanal production," or "manufacturing"? In any case, it was called the *Gewerbeschau* – a name that subtracts from the name of the Kunstgewerbe the name of art – and distributed through numerous pavilions an unbelievable quantity of manufactured objects, some of which – furniture, clothing, appliances – were industrial in origin. The structure of the exposition was that of a commercial fair: large halls divided into stands in rows, festoons and garlands decorating the platforms, objects arranged on displays of all sorts. The exposition was in fact a commercial fair, in the tradition of the *Jahrmarkt,* but a *Jahrmarkt* exclusively devoted to Bavarian industries. One could even order things there and make purchases.

What is interesting is that this *Bayrische Gerwerbeschau* had a great effect on the history of the Kunstgewerbe. It was the first time, to such a degree at least, that the artisans of diverse trades and the entrepreneurs of all the art trades could appear together before the public with a dual purpose: to show off the quality, artistic as well as technical, of their products and to secure the commercial promotion of these products. We find here a desire completely like the Werkbund's to spread standards of quality widely by integrating artisans into new avenues of distribution to the greater benefit of the culture but also to the industry of the country.[25] This great desire was congruent with the evolution of the Kunstgewerbeschulen and it was marked by the same ambiguities, which were even exhibited in public places. The press, and in particular the art press, was not mistaken in giving a large play

to the exhibition and the controversies that it aroused. Overall, the press was very favorable to the *Gewerbeschau,* and the virtually unanimous argument on which it based its judgment merits some attention. The argument has three steps. First step: astonishment, worry, fear in realizing that artisans of art, who until then had benefited from an aura of artistic preciousness, could now present themselves in the vulgar and mercantile form of a commercial fair. Second step: hesitation and indecision; one recognizes that this is the price that one will have to pay if one wants these artisans to survive economically, and one connects the "vulgarity" of the event to the popular tradition of the *Jahrmarkt,* which, after all, is a form of culture in its own right.[26] Third step: relief at finding a standard for the judgment of artistic quality without which no pretension to the status of art could be upheld; an equivalent relief at seeing that a "disastrous decline in taste" could be avoided; it is noted that, even if the exposition is a market, it is nonetheless not an open market ruled solely by the interplay of supply and demand, but a juried, a selective market.[27] Here then is the artistic institution faced with economic and cultural conditions that it had not anticipated or that it had protected itself against until now; here it is forced to accept the eventuality of an art for the masses. Once the moment of confusion has passed, the artistic institution accepts this new mass art, but with one curious condition: that a principle of selection rules over its diffusion. It should be noted that none of the articles that discuss the *Gewerbeschau* mentions the names of the members of the selection jury, none examines its competence or judges its taste or questions the basis on which it makes its decisions. Everyone declares satisfaction with the simple fact of selection, as if good taste will be guaranteed and the danger of *kitsch* avoided by the simple condition that mass art be filtered through an act of judgment, no matter how arbitrary that judgment is. It seems then that we can derive from the *Gewerbeschau* and its commentaries the outlines of a paradoxical law that none of the actors of the period would have admitted as such but that nonetheless works as its latent justification: the artistic component in artisanal or industrial culture is designated by a principle of choice. One can believe that it results from the savoir-faire of the artisans, from their formal creativity, or from their capacity to think about form in connection to function; consequently, one can believe that the choice is motivated. But it is not the motivation of choice that assigns this character, isolates it, and gives it existence – in short, that names it.

This law is the same one that presides over the readymade and that the readymade reveals with an interplay of "subsidized symmetries," once again. Duchamp never tried to build a mass art; quite the contrary. He showed what the conditions were for the survival of "pure" art in a mass society, and, out of this demonstration, he built his oeuvre. Where the Munich art institution declared itself ready to admit as art the mass display of utilitarian objects, provided that this mass be screened in advance, Duchamp declared as artistic any utilitarian objects, provided that an arbitrary choice had already pulled it out of the initial display where it had been presented as mass object. Thus, the Bazar de l'Hôtel-de-Ville, where, two years later, Duchamp would choose his bottle rack, reveals itself as the "reciprocal" corollary of the *Gewerbeschau,* which he visited, or did not visit, but whose reverberations

he could not have helped noticing during his stay in Munich in 1912.

Once again, we can note that "the state of the questions and artistic practices" offered itself to Duchamp as a sort of climate at the moment when the *ouvrier d'art* took his revenge on the student excluded from the Ecole des Beaux-Arts. This "state of questions" resonated under the force of a later event that was named the *readymade* and that presents itself to us as a strategic secession having all the appearances of an abandonment of his craft, that was not an abandonment of craft in general but only that of painting in particular.

Notes

This essay by Thierry de Duve is the fifth chapter of his *Nominalisme pictural: Marcel Duchamp, la peinture et la modernité* (Paris: Les Editions de Minuit, 1984), which is forthcoming in English translation from the University of Minnesota Press.

1. Marées was born in 1837 and Cézanne in 1839. Böcklin (1827–1901) and Bouguereau (1825–1905) were their elders, but they lived long enough for us to be able to consider their careers as parallel to that of Cézanne, who died in 1906.

2. To be historically correct, we must admit that the diverse secessions sometimes found their origin in an act of rejection. But, on the one hand, these rejections did not have the categorical quality of the Salon des Refusés, and, on the other hand, they were not represented by the excluded artists as a position of exteriority that they could use to affirm themselves as an authentic, because excluded, avant-garde. Thus, for example, the Berlin Sezession was born when the Union of Berlin Painters, directed by Werner, invited Munch to exhibit and then changed its mind and closed the exposition after two days. More than Munch's exclusion, it was the indecision of the union that was the pretext for a new grouping of artists that, indicatively, was not formed around Munch, the rejected artist, but around Max Liebermann. See Jean-Michel Palmier, *L'Expressionisme et les arts,* vol. 2 (Paris: Payot, 1980), 140. Similarly, in Berlin again, the Neue Sezession came into existence when "the old guard" displayed like a call-to-arms *The Execution of the Emperor Maximilian* by Manet (painted in 1867!) while rejecting the work of twenty-seven young artists. Here again, it was not so much the rejection of these artists that provoked the scission but the symbol of a so-outdated avant-garde flaunted by the Sezession. See Bernard S. Myers, *Les Expressionistes allemands, une génération en révolte* (Paris: Les Productions de Paris, 1967), 37. In the attitude of the protagonists, the international secessionist movement bears comparison with the French phenomenon of the Refusés as a different, though parallel, strategy. Hevesi, the chosen chronicler of the Viennese Sezession, compared the movement to an "anti-salon that would naturally have all the qualities of a Salon des Refusés." Quoted in Hans-Ulrich Simon, *Sezessionismus* (Stuttgart, Germany: Metzler, 1976), 47. Finally, according to Germain Bazin, it was in France that the word "secession" was used for the first time to designate the scission of an artistic movement: in 1890 a series of artists grouped around Meissonnier and Puvis de Chavannes left the Society of French Artists to found the National Society of the Beaux-Arts. But in 1890 neither Puvis not Meissonnier could be considered part of an avant-garde. It thus seems that in France the paradigm of secession did not have the same force as rejection did. See Myers, *Les Expressionistes allemands,* 45.

3. For a detailed description of the dynamics of secession in Munich, Vienna, and Berlin, see Simon, *Sezessionismus,* 45–46.

4. The critic Julius Meier Graefe recognized these lags: "I knew Bonnard before Manet, Manet before Delacroix. This state of confusion explains many of the errors that my generation committed later on." Quoted in J. P. Bouillon's introduction to the French translation of Kandinsky's *Reminiscences* (Paris: Hermann, 1974), 22.

5. So says the (anonymous) chronicler of the "Kleine Kunst-Nachrichten," *Deutsche Kunst und Dekoration* (August 1912), 347–48.

6. See Donald E. Gordon, "On the Origin of the Word *Expressionism,*" *Journal of the Warburg and Courtauld Institutes* 29 (1966), 368–85.

7. Paul Klee, "Die Austellung des modernen Bundes im Kunsthaus Zürich," *Die Alpen* 6 (1912), quoted by Palmier, *L'Expressionisme et les arts,* 168.

8. It was the same Girieud, so much in view in the Salon d'Automne in 1912 and so forgotten since, whom Duchamp remembered so well in his interviews with Pierre Cabanne. See Pierre Cabanne, *Entretiens avec Marcel Duchamp* (Paris: Belfond, 1967), 23.

9. See H. Uhde-Bernays, "Die Tschudispende," *Kunst und Künstler* (May 1912), 379–88; and W. Bayersdorfer, "Die Tschudispende," *Kunstchronik* (27 June 1912), column 481– 85. See also the homage to Tschudi by Franz Marc in the almanac of the Blaue Reiter, *Der Blaue Reiter, Dokumentarische Neuausgabe von Klaus Lankheit* (Munich: Piper, 1979), 21–24.

10. "Know what has to be done, and you will find yourself quickly turning your back on Gauguins and Gogs [sic]." Letter to Emile Bernard, 15 April 1904, in *Conversations avec Cézanne* (Paris: Collection Macula, 1978), 27.

11. "So you want to destroy art for the whole of mankind?" "No," replied Marcel calmly but firmly, "only for myself." Simon Watson Taylor, "Readymade," *Art and Artists* 1, no. 4 (1966), 46.

12. Robert Lebel, *Marcel Duchamp* (New York: Grove Press, 1959), 15.

13. "Against compulsory military service: a *'deferment'* of each limb, of the heart and other anatomical parts; each soldier being already unable to put his uniform on again, his heart feeding *telephonically,* a deferred arm, etc. Then, no more feeding; each 'deferee' isolating himself. Finally, a Regulation of regrets." *Salt Seller. The Writings of Marcel Duchamp* (New York: Oxford University Press, 1973), 23.

14. Hans Wingler, *The Bauhaus* (Cambridge, MA: MIT Press, 1976), 31. Gropius's first collaborators in 1919 were the painters Feininger and Itten and the sculptor Gerhard Marcks. Then in 1920 came Klee, Muche, and Schlemmer, who were all painters; in 1921 Lothar Schreyer, who was a man of the theater; and in 1922 Kandinsky and 1923 Moholy-Nagy, also painters. It was only in 1927 with the arrival of Hannes Meyer that the first real architect appeared on the professional team.

15. "Artists, sculptors, painters – we must all return to handicrafts." Ibid., 31.

16. Ibid., 19.

17. "Reciprocal readymade: use a Rembrandt as an ironing board." *Salt Seller,* 32.

18. Guillaume Apollinaire, *The Cubist Painters* (New York: Wittenborn, Schultz, 1949), 37.

19. Arturo Schwarz, *The Complete Works of Marcel Duchamp* (New York: Abrams, 1970), 466.

20. Michel Sanouillet, ed., *Duchamp du signe* (Paris: Flammarion, 1975), 242.

21. See Nikolaus Pevsner, *Pioneers of Modern Design* (New York: Museum of Modern Art, 1949), 12; 136, note 33.

22. See Clément-Janin, *Le Déclin et la renaissance des industries d'art et de l'art décoratif en France,* brochure published by the author in Paris in 1912; and Wilhelm Michel, "Die Krise im Französischen Kunstgewerbe," *Deutsche Kunst und Dekoration* 30 (July 1912), 295–308.

23. See Pevsner, *Pioneers of Modern Design,* 18.

24. W. Niemeyer, "Von Vergangenheit und Zukunft der Kunstgewebeschule," *Deutsche Kunst und Dekoration* 30 (June 1912), 173–88. See especially page 178.

25. The word *Qualität* was the key word of the Werkbund propaganda for the cultural, and even artistic, renovation of German industry. By *Qualität,* the Werkbund meant "not only excellent and durable work and the utilization of authentic and flawless materials but also the achievement of an organic whole, rendered *sachlich* and noble and, if you want to put it this way, ultimately artistic." Quoted in Pevsner, *Pioneers of Modern Design,* 17.

26. "Exhibitions are today what fairs were in earlier times. The Bavarian trade show highlighted and displayed this fairlike quality as much as possible, while adapting to modern needs." G. Von Pechman, "Wege, Ziele, Hindernisse," *Die Kunst (Dekorative Kunst)* 15 (11 August 1912), 489; this was a special issue devoted to the *Gewerbeschau.*

27. "Thus, in a certain sense, it was a juried market." Kuno Mittenzweg, "Die Bayrische Gewerbeschau in München," *Deutsche Kunst und Dekoration* 30 (August 1912), 326.

Translated by Dana Polan

Marcel Duchamp's *Fountain:*
Its History and Aesthetics in the
Context of 1917
William A. Camfield

Duchamp's *Fountain* has become one of the most famous/infamous objects in the history of modern art (Fig. 1). The literature on it – counting references imbedded in broader considerations of Duchamp's work – is staggering in quantity, and one might suppose that little more of consequence could be discovered. But an examination of this literature reveals that our knowledge of this readymade sculpture and its history is riddled with gaps and extraordinary conflicts of memory, interpretation, and criticism. We are not even able to consult the object itself, since it disappeared early on, and we have no idea what happened to it. Duchamp said Walter Arensberg purchased *Fountain* and later lost it. Clark Marlor, author of recent publications on the Society of Independent Artists, claims it was broken by William Glackens. Others reported it as hidden or stolen.[1] We do not even know with absolute certainty that Duchamp was the artist – he himself once attributed it to a female friend – and some of his comments raise fundamental questions regarding his intentions in this readymade. But most critics have not been troubled by these conflicting comments from Duchamp or by the lacunae in our knowledge. Some deny that *Fountain* is art but believe it is significant for the history of art and aesthetics. Others accept it grudgingly as art but deny that it is significant. To complete the circle, some insist *Fountain* is neither art nor an object of historical consequence, while a few assert that it is both art and significant – though for utterly incompatible reasons.

In light of these diverse viewpoints I shall attempt to reconstruct what we know about *Fountain* based on documents at the time of its appearance in 1917 and consideration of relevant historical circumstances.[2]

Given the remarkable interrelationships in Duchamp's work from beginning to end, an obvious risk is involved in any study that focuses on a single object. However, *Fountain* will not be entirely isolated from the rest of his *oeuvre,* and the results of this more narrowly focused study will contribute to the whole.

I am indebted to many individuals and earlier studies. Some of the information and ideas to be presented here are not new, but I have expanded that information, ordered, focused, and flavored it with a personal bias. Indeed, this study is the long-suppressed gratification of a desire which arose in the late 1960s when, as a young teacher, I found myself fascinated with the for-

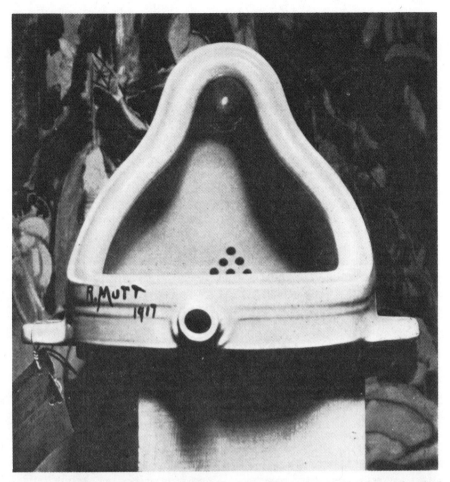

Fig. 1 *Fountain,* 1917, photograph by Alfred Stieglitz, copy negative from *The Blind Man,* no. 2, May 1917. Philadelphia Museum of Art, The Louise and Walter Arensberg Archives.

mal properties of *Fountain* and convinced that Duchamp had achieved a fusion of visual and intellectual properties which made it a masterpiece in his *oeuvre,* rather than the amusing or offensive anti-art object it was often portrayed as at that time.[3]

Fountain entered the history of art in April 1917 on the occasion of the first exhibition of the American Society of Independent Artists. Conditions regarding the organization of that Society are germane to the story.[4] To a considerable extent the Society was a direct descendant of such organizations as the Eight, the 1910 Independents Group and the Armory Show—all were formed to provide exhibitions of American art outside the structure of the National Academy of Design and the offerings of conventional art galleries. From the outset, however, the Society of Independent Artists was distin-

guished by a contingent of French artists and the intent to be an ongoing organization modeled after the French Société des Artistes Indépendants. Duchamp was chief among those French artists, but Francis Picabia, Albert Gleizes and Jean Crotti played lesser roles. They had all arrived in New York in 1915, each in his way a refugee from the devastating war in Europe, each discovering that New York was a stimulating city where he could work again.[5]

Duchamp and Picabia lost no time in enlivening the New York art scene – Picabia with his radically new mechanomorphic portraits and Duchamp with his even more unusual work on the *Large Glass* and readymade sculptures that inhabited his apartment but were also exhibited for the first time.[6] Picabia, who had established a close friendship with Alfred Stieglitz and his associates during the Armory Show, gravitated toward that sphere of influence and participated actively in the Modern Gallery and the magazine *291*, activities supported by Stieglitz but directed by Marius de Zayas. Duchamp became more attached to Walter and Louise Arensberg, recent settlers in New York who made a lasting mark through their patronage of avant-garde literature, their stimulating late-night soirées, their outstanding collection of modern art, and their commitment to Duchamp.[7] The attorney John Quinn helped Duchamp too, although he was more important for other artists and authors whose careers had been disrupted by the war.[8] These collectors, patrons, galleries, and avant-garde magazines are an indication of the lively art scene in New York from 1914 to 1918, a stark contrast to Europe, where salons had been suspended, magazines disbanded, and many galleries closed. There was cause to think that while the Europeans were absorbed by the war, the time had come for America to assume leadership in art. Some modernists even hoped that the democratic traditions of America might make this nation more hospitable toward contemporary art.

Serious discussions were initiated in the fall of 1916, and the Society of Independent Artists was incorporated in December 1916.[9] The proclaimed democratic spirit of the Society was reflected in the officers and directors. William Glackens, an original member of the Eight, was president, and three other directors were either members or associates of the Eight – George Bellows, Rockwell Kent and Maurice Prendergast. Only John Marin came from the circle around Alfred Stieglitz, but there were also three women (Katherine S. Dreier, Regina A. Farrelly, and Mary C. Rogers), Walter Pach, who bridged several groups, and six men who frequented the Arensberg salon – Duchamp, Man Ray, John Covert, Joseph Stella, Morton S. Schamberg and Arensberg himself.[10] The initial notice of the Society released in January 1917 underscored the

great need . . . for an exhibition, to be held a given period each year, where artists of all schools can exhibit together – certain that whatever they send will be hung. . . . For the public, this exhibition will make it possible to form an idea of the state of contemporary art. . . .

The program of the Society of Independent Artists, which is practically self-explanatory, has been taken over from the Société des Artists Indépendants of Paris. The latter Society . . . has done more for the advance of French art than any other in-

66

stitution of its period. . . . The reason for this success is to be found in the principle adopted at its founding in 1884 and never changed: "No jury, no prizes."
. . . .

There are no requirements for admission to the [American] Society save the acceptance of its principles and the payment of the initiation fee of one dollar and the annual dues of five dollars. All exhibitors are thus members and all have a vote for the directors and on the decisions made by the Society at its annual meetings. . . .[11]

Encouraged by a surge in membership, the Society set an opening date for April 10, and committees were formed for such activities as publication, education, and installation. The educational aims of the exhibition were to be extended by public lectures and by a tearoom managed by Katherine S. Dreier with artists present to meet the public. Duchamp, who had become a major organizer for the Society, agreed to decorate the tearoom for Dreier, an artist and an activist in art and social issues, whom he had met at the Arensbergs'. He was also collaborating with his friends Henri Pierre Roché and Beatrice Wood to publish a magazine entitled *Blindman*, conceived as a forum for opinions and commentary on the Independents' exhibition.[12]

Arensberg served as managing director for the exhibition, and his apartment was the site of some important meetings.[13] Duchamp was head of the hanging committee—a task for which he proposed a democratic solution of installation by alphabetical order rather than by groupings according to size, medium or style. Walter Pach, who sponsored Duchamp's coming to America, was treasurer, and Arensberg's cousin, John Covert, was secretary. In that capacity, Covert was responsible for instructions to the artists, which are helpful in reconstructing the sequence of events for *Fountain*. Works were to be received on April 3–5, and installation was scheduled for April 6–9. In order to be listed in the exhibition catalogue, a white card—properly filled in—had to be received by March 28, and the same deadline was set for photographs from any artist who wished to exercise his right to one illustration in the catalogue.[14]

The special opening was set for Monday evening, April 9, followed by the public opening on April 10. As those dates approached, the public was peppered with press releases stressing the democracy, the vast size, and the importance of the exhibition—2500 works stretching over almost two miles of panels.[15] Although America's declaration of war on Germany usurped the headlines in early April, by all accounts the opening of the Independents' exhibition was a rousing success—save for one episode that generated a heated dispute among the directors and the resignation of Marcel Duchamp. In conflict with its stated principle of "no jury," the directors of the Independents rejected a sculpture, and, as reported in one press account,

Marcel Duchamp . . . the painter of "Nude Descending a Staircase" fame has declared his independence of the Independent Society of Artists, and there is dissension in the ranks of the organization that is holding at the Grand Central Palace the greatest exhibition of painting and sculpture in the history of the country.
It all grew out of the philosophy of J. C. Mutt, of Philadelphia, hitherto little known in artistic circles. When Mr. Mutt heard that payment of five dollars would permit him to send to the exhibition a work of art of any description or degree of excellence he might see fit he complied by shipping from the Quaker City a familiar article of

bathroom furniture manufactured by a well known firm of that town. By the same mail went a five dollar bill.

To-day Mr. Mutt has his exhibit and his $5; Mr. Duchamp has a headache, and the Society of Independent Artists has the resignation of one of its directors and a bad disposition.

After a long battle that lasted up to the opening hour of the exhibition, Mr. Mutt's defenders were voted down by a small margin. "The Fountain," as his entry was known, will never become an attraction – or detraction – of the improvised galleries of the Grand Central Palace, even if Mr. Duchamp goes to the length of withdrawing his own entry, "Tulip Hysteria Co-ordinating," in retaliation. "The Fountain," said the majority, "may be a very useful object in its place, but its place is not an art exhibition, and it is, by no definition, a work of art."[16]

The brouhaha over *Fountain* continued to spread for several weeks, and a few corrections and additions appeared in an account in Boston on April 25:

A Philadelphian, Richard Mutt, member of the society, and not related to our friend of the "Mutt and Jeff" cartoons, submitted a bathroom fixture as a "work of art." The official record of the episode of its removal says:

"Richard Mutt threatens to sue the directors because they removed the bathroom fixture, mounted on a pedestal, which he submitted as a 'work of art.' Some of the directors wanted it to remain, in view of the society's ruling of 'no jury' to decide on the merits of the 2500 paintings and sculptures submitted. Other directors maintained that it was indecent at a meeting and the majority voted it down. As a result of this Marcel Duchamp retired from the Board. Mr. Mutt now wants more than his dues returned. He wants damages."[17]

Despite the lively interest of the press, however, the public knew surprisingly little about *Fountain*. As revealed in these articles, Richard Mutt's true identity was unknown, and no one could have been aware that the sculpture was a urinal because it was not exhibited, did not figure in the catalogue, and was neither reproduced nor described other than by the general, innocuous term "bathroom fixture." *Fountain* was not reproduced until the second issue of *The Blind Man* in May 1917 – one month after the conflict began – and it is not yet clear when it became more generally known that Duchamp himself was the artist. With so little available in the public record until publication of the all-important second issue of *The Blind Man*, the history of *Fountain* must be sought in contemporary letters and diaries and in subsequent recollections. Unfortunately, the files of the Society of Independent Artists are of no help. They contain no minutes of the relevant meetings, no formal statement regarding *Fountain* and no letters of resignation. All records except some heavy ledgers were apparently destroyed around 1930 by a fire in the studio of a member of the Independents, A. S. Baylinson.[18]

In a recollection shared with Arturo Schwarz almost fifty years later, Duchamp said the idea of *Fountain* arose in a conversation with Arensberg and Joseph Stella, and "they immediately went to buy the item."[19] The object selected was a porcelain urinal, presumably manufactured by the J. L. Mott Iron Works. Duchamp stated many years later that the pseudonym "Mutt" came from the Mott Works but was modified because

Mott was too close so I altered it to Mutt, after the daily strip cartoon "Mutt and Jeff" which appeared at the time, and with which everyone was familiar. Thus, from the

start there was an interplay of Mutt: a fat little funny man, and Jeff: a tall thin man. . . . And I added Richard [French slang for money-bags]. That's not a bad name for a "pissotière."

Get it? The opposite of poverty. But not even that much, just R. MUTT.[20]

There seems to be no reason to question Duchamp's memory of this episode. "Mutt and Jeff" was a popular comic strip, and Mott was a major manufacturer of plumbing fixtures with a large showroom in New York that could have displayed urinals closely resembling *Fountain*—insofar as may be judged from roughly contemporary illustrated catalogues (Fig. 2).[21]

Again in conversation with Arturo Schwarz, Duchamp recalled that the urinal was selected shortly before the opening of the Independents—a claim that is supported by the fact that *Fountain* did not figure in the catalogue (it missed the March 28 publication deadline), and because no witness to date has recalled seeing it in Duchamp's apartment. It (or another urinal) was in Duchamp's studio at least briefly, however, because there exists a photograph with a urinal suspended from the ceiling along with the *Hat Rack* and *In Advance of the Broken Arm* (Fig. 3).[22]

Fountain next appeared in the context of installing the Independents' exhibition, and for this stage in the history, Beatrice Wood's diary and memories are crucial. During the week prior to the opening of the Independents, Wood was constantly in Duchamp's company, working with him and Henri Pierre Roché on the magazine *Blindman* and helping Duchamp with the installation of the Independents, a labor that occupied most of April 6–8. Her laconic diary entries record those activities and the first known mention of Richard Mutt and his exhibit:

Friday [April 6] Work at Independents. Lunch Marcel Duchamp at Pollys. Home.
Sat. [April 7] Independent. Dine Roche at Chinese Restaurant. Discussion about "Richard Mutt's" exhibition. Read Roche my articles [for *Blindman*]. We work at Marcels.
Sun. [April 8] All day at Independent. Lunch. Pach, Friedman, Duchamp, Arensberg . . .
Mon. [April 9] Meet Roche at printers to see about Blind Man Magazine at 9–with him all day. Batik. Opening of exhibit. Later jolly crowd at Beaux Arts.[23]

Wood's later recollections provide a more vivid account of one of those days:

Two days before the Exhibition opened, there was a glistening white object in the storeroom getting readied to be put on the floor. I can remember Walter Arensberg and George Bellows standing in front of it, arguing. Bellows was facing Walter, his body on a menacing slant, his fists doubled, striking at the air in anger. Out of curiosity, I approached.

"We cannot exhibit it," Bellows said hotly, taking out a handkerchief and wiping his forehead.

"We cannot refuse it, the entrance fee has been paid," gently answered Walter.

"It is indecent!" roared Bellows.

"That depends upon the point of view," added Walter, suppressing a grin.

"Someone must have sent it as a joke. It is signed R. Mutt; sounds fishy to me,"

grumbled Bellows with disgust. Walter approached the object in question and touched its glossy surface. Then with the dignity of a don addressing men at Harvard, he expounded: "A lovely form has been revealed, freed from its functional purpose, therefore a man clearly has made an aesthetic contribution."

The entry they were discussing was perched high on a wooden pedestal: a beautiful, white enamel oval form gleaming triumphantly on a black stand.

It was a man's urinal, turned on its back.

Bellows stepped away, then returned in rage as if he were going to pull it down. "We can't show it, that is all there is to it."

Walter lightly touched his arm, "This is what the whole exhibit is about; an opportunity to allow an artist to send in anything he chooses, for *the artist* to decide what is art, not someone else."

Bellows shook his arm away, protesting. "You mean to say, if a man sent in horse manure glued to a canvas that we would have to accept it!"

"I'm afraid we would," said Walter, with a touch of undertaker's sadness. "If this is an artist's expression of beauty, we can do nothing but accept his choice." With diplomatic effort he pointed out, "If you can look at this entry objectively, you will see that it has striking, sweeping lines. This Mr. Mutt has taken an ordinary object, placed it so that its useful significance disappears, and thus has created a new approach to the subject."

"It is gross, offensive! There is such a thing as decency."

"Only in the eye of the beholder, you forget our bylaws."[24]

Plate 6585-A

Fig. 2 Porcelain lipped urinal, Panama model, from the J. L. Mott Iron Works, *Mott's Plumbing Fixtures Catalogue "A,"* New York, 1908. Courtesy, Henry Francis du Pont Winterthur Museum Library: Collection of Printed Books.

70

Fig. 3 Duchamp's studio at 33 West 67th Street, New York, 1917.

There was not time enough to assemble the entire board of directors, but a group of about ten was gathered to decide the issue and, according to a *New York Herald* reporter, a battle raged up to the opening hour of the exhibition on April 9, at which time "Mr. Mutt's defenders were voted down by a small margin."[25] On the face of it, that decision denied both the principle of "no jury" and the specific rules for exhibition mailed to all members, but there were grounds for suspending all of that in the view of the majority of the directors assembled. Statements quoted in the press and Beatrice Wood's memory coincide on this point: *Fountain* was not art and it was indecent. Unuttered but surely present in the decision was a concern for the reputation of the Independents in its debut before the American public.

Hostilities may have been suspended for what Beatrice Wood recorded as a spectacular opening and a "jolly crowd" later that night at the Beaux-Arts, but there should be no mistaking Duchamp's contempt for the action of the Society's directors. He resigned immediately and quietly took other actions that produced some of the few documents we possess. Those actions included initiation of the all-important second number of *The Blind Man* (May 1917) and two letters – one to his sister Suzanne in Paris and the other to Katherine S. Dreier.

Duchamp's letter to his sister on April 11 is most puzzling:

Raconte ce détail à la famille: Les Indépendants sont ouverts ici avec gros succès.
 Une de mes amies sous un pseudonyme masculin, Richard Mutt, avait envoyé une

71

pissotière en porcelaine comme sculpture; ce n'était pas du tout indécent aucune raison pour la refuser. Le comité a décidé de refuser d'exposer cette chose. J'ai donné ma démission et c'est un potin qui aura sa valeur dans New York.[26]

I see no reason to doubt the sincerity of Duchamp's earliest known statement on *Fountain*, which he described simply as "a sculpture" that "was not at all indecent." But what is not yet clear is why he claimed that the urinal had been submitted by one of his "female friends under a masculine pseudonym, Richard Mutt." Beatrice Wood – who should know – has always insisted that Duchamp was the artist. How then should we take this statement? As others have observed, it is likely that Duchamp concealed his identity in order to pose a test for the Independents that would not be compromised by knowledge that *Fountain* had been submitted by a director of the organization. But why did he mislead his sister in Paris? Was the account given to Suzanne merely a "white lie" to conceal his authorship, or might we have here an early appearance of Duchamp's female alter ego, Rrose Sélavy, or might he have been telling the truth?[27] Was *Fountain* actually submitted by a female friend? And if, indeed, a female friend sent *Fountain* to the Independents, must that mean that she and not Duchamp was the artist who conceived, selected and altered the urinal – or might she have acted merely as the shipping agent whose participation kept Duchamp out of sight? The last possibility seems most plausible, but this point remains a mystery. Even if Duchamp simply had a female "shipping agent," who was she? Did she live in Philadelphia, since newspaper reports consistently identified Mutt as a Philadelphian? To date, no Philadelphia contact has been identified, but a New York friend was implicated in a letter from Charles Demuth to Henry McBride, the art critic of *The Sun*, during the first week after the opening of the Independents:

A piece of scultor [sic], called: "a Fountain," was entered by one of our friends for the Independent Exhibition now open at the Grand Central Palace.

It was not exhibited. "The Independents," we are now told have a committee, – or jury, who can decide, "for the good of the exhibition. . . ."

If you think you could do anything with this material for your Sunday article we would appreciate it very much. . . .

P.S. If you wish any more information please phone, Marcel Duchamp, 4225 Columbus, or, Richard Mutte [sic], 9255 Schuyler.[28]

The telephone number given for "Richard Mutte" was the number for Duchamp's friend Louise Norton, the estranged wife of Allen Norton, the publisher of *Rogue*. Unfortunately, Louise Norton has not provided additional information about her role in the Richard Mutt affair, but Demuth's letter indicates that she was in the innermost circle and possessed special information which she probably used in her crucial article, "Buddha of the Bathroom," for *The Blind Man*, no. 2.[29]

Duchamp's other letter on April 11 was a simple statement of regret to Katherine S. Dreier that he would not be able to fulfill his promise to help decorate her tearoom at the Independents because he had "resigned from the board of directors."[30] This letter, however, provoked a reply on April 13, which contributes much to our knowledge of the events:

Rumors of your resignation had reached me prior to your letter of April eleventh. As a director of the Society of Independent Artists, I must use my influence to see whether you cannot reconsider your resignation. . . .

As I was saying to Arensberg, I felt it was of much more vital importance to have you connected with our Society than to have the piece of plumbing which was surreptitiously stolen, remain. When I voted "No," I voted on the question of originality – I did not see anything pertaining to originality in it; that does not mean that if my attention had been drawn to what was original by those who could see it, that I could not also have seen it. To me, no other question came up: it was simply a question of whether a person has a right to buy a readymade object and show it with their name attached at an exhibition? Arensberg tells me that that was in accord with you [sic] "Readymades," and I told him that was a new thought to me as the only "readymades" I saw were groups which were extremely original in their handling. I did not know that you had conceived of single objects.

I felt that it was most unfortunate that a meeting was not called and the matter discussed and passed upon by the Board of Directors; but I do feel that you have sufficient supporters with you to make it a very decided question whether it is right for you to withdraw. I hope, therefore, that you will seriously reconsider it, so that at our next directors' meeting I may have the right to bring forth the refusal of the acceptance of your resignation.[31]

Several points merit underscoring in this letter. First, Dreier claims that *Fountain* was "surreptitiously stolen." Second, she articulates what may be called the "plagiarism" or "originality" objection to *Fountain,* namely, that there is no "originality" to it, that a person has no right to exhibit a piece of plumbing that was merely bought as a readymade object and signed. The readymades in Duchamp's apartment had not distressed her this way. To the contrary she described them as "extremely original in their handling," but she saw those readymades as a group – a group which would have included the *Hat Rack* and snow shovel (*In Advance of the Broken Arm*) suspended from the ceiling, the coat rack (*Trébuchet*) nailed to the floor, and the *Bicycle Wheel.* In contrast to the grouping of those readymades in a private apartment, *Fountain* was a solitary item placed on a pedestal for the Independents. Finally she confirms that a vote on *Fountain* was taken among a group of the directors who, excepting perhaps only Arensberg and Duchamp himself, did not know the true identity of Mutt.

Duchamp, of course, was not persuaded to change his mind and the Richard Mutt affair was a tense topic at the next directors' meeting later in the month. To disarm the explosive situation, Glackens proposed a solution heartily embraced by Dreier as revealed in her letter to Glackens on April 26:

I want to express to you my profound admiration in the way you handled so important a matter as you did at the last meeting when it was at your suggestion that I made the motion, seconded by Mr. Covert, that we invite Marcel Duchamp to lecture one afternoon in our free lecture hall on his "Readymades" and have Richard Mutt bring the discarded object and explain the theory of art and why it had a legitimate place in an Art Exhibit. I was especially pleased because I said right along that I felt that if you had realized that the object was sent in good faith that the whole matter would have been handled differently. It is because of the confusion of ideas that the situation took on such an important aspect. I am very curious to see what the response will be, for with one stroke you cleared the atmosphere and will force Richard Mutt to show

whether he was sincere or did it out of bravado. I told Covert and Arensberg that in my judgment Richard Mutt caused the greater part of the confusion by signing a name which is known in the newspaper world as a popular joker. "Mutt and Jeff" are too famous not to make people suspect if their name is used the matter is a joke.[32]

Several statements in this letter also bear underscoring. Dreier provides the first recorded example of the "sincerity-of-the-artist defense" in this controversy. There was a "confusion of ideas," she says, largely due to Richard Mutt, because his name provoked association with Mutt and Jeff, popular jokers in a contemporary cartoon strip. If Glackens had only realized that "the object was sent in good faith," she is confident "the whole matter would have been handled differently."

The "sincerity defense" was linked to "respect for the artist." It is clear from the letter that Dreier still did not know that Duchamp was Mutt, but he had taken a stand for Mutt and that was significant. She concludes her letter to Glackens with these words:

I feel so conscious of Duchamp's brilliancy and originality, as well as my own limitation which cannot immediately follow him, but his absolute sincerity, in my judgment, would always make me want to listen to what he has to say. The very fact that he does not try to force his ideas on others but tries to let them develop truly along their own lines is in essence the guarantee of his real bigness.

Not precisely stated but implied in Dreier's letter was the fact that *Fountain* had been found, for Mutt was to be asked to bring it along with him. Circumstances regarding the finding of *Fountain* have not been documented, but clearly false are the claims that Glackens smashed it or that it disappeared soon after its rejection and was never seen again.[33] Other reports probably approach what actually occurred, that is to say, that several days after the opening of the exhibition, Duchamp (perhaps with Man Ray) searched for the missing *Fountain,* found it concealed behind a partition and removed it from the hall – with or without the flourish of Rudi Blesh's account, which has Arensberg demanding that *Fountain* be produced and signing a check for its purchase while Duchamp and Man Ray carry his purchase in triumph through the crowded galleries.[34]

The recovery of *Fountain* could have occurred as early as April 12 or 13, inasmuch as Beatrice Wood recorded in her diary for April 13: "See Stieglitz about 'Fountain.'"[35] According to Wood, it was Duchamp's idea to approach Stieglitz, and when *Fountain* was carried to his gallery sometime before April 19, the two men had a long discussion:

At Marcel's request, he [Stieglitz] agreed to photograph the *Fountain* for the frontispiece of the magazine [*The Blind Man*]. He was greatly amused, but also felt it was important to fight bigotry in America. He took great pains with the lighting, and did it with such skill that a shadow fell across the urinal suggesting a veil. The piece was renamed: "Madonna of the Bathroom."[36]

Stieglitz confirmed the commission in a letter to the art critic Henry McBride on April 19:

I wonder whether you could manage to drop in at 291 Friday sometime. I have, at the request of Roché, Covert, Miss Wood, Duchamp & Co., photographed the rejected

"Fountain." You may find the photograph of some use. – It will amuse you to see it. – The "Fountain" is here too.[37]

While McBride does not seem to have gone to 291 to see *Fountain,* Carl Van Vechten apparently did, and this author, music critic, and member of the Arensberg circle wrote to Gertrude Stein about the "object labelled *Fountain"* which had generated a scandal at the Independents:

This porcelain tribute was bought cold in some plumber shop (where it awaited the call to join some bath room trinity) and sent in. . . . When it was rejected Marcel Duchamp at once resigned from the board. [Alfred] Stieglitz is exhibiting the object at "291" and he has made some wonderful photographs of it. The photographs make it look like anything from a Madonna to a Buddha.[38]

References to Madonna and Buddha forms by Van Vechten and Beatrice Wood imply an anthropomorphic perception of *Fountain,* i.e., a simple, frontal form, the curvilinear profile of which suggests the head and shoulders of such images as those reproduced here (Figs. 4 and 5). Stieglitz himself corroborated the reference to a Buddha figure in a contemporary letter in which he remarked that *Fountain* had fine lines, that he had photographed it in front of a Marsden Hartley painting, and that his photograph suggested a

Fig. 4 Seated Amitabha Buddha, 8th century A.D. Nara, Japan.

Fig. 5 Madonna of the Seven Sorrows, 1518. Westfälisches Landesmuseum für Kunst und Kulturgeschichte, Münster, West Germany.

75

Buddha form.[39] We can, after all these years, identify the darkened, cropped and almost illegible painting in the background of Stieglitz's photograph, and it provides unexpected support for the aesthetic perception of *Fountain*. Stieglitz's choice for the background – Hartley's 1913 painting *The Warriors* (Fig. 6) – is dominated by a simple, symmetrical form similar to the shape of *Fountain*, the same shape employed as a frame for a seated Buddha in Hartley's 1913 painting *Portrait of Berlin* (Collection of American Literature, Yale University). Furthermore, it seems possible that even the subject of warriors going off to battle harbored references in Stieglitz's thought to Duchamp's conflict with the Independents.[40]

Stieglitz's letters and his photograph of *Fountain* are crucial documents – confirming the existence of *Fountain*, affirming the aesthetic argument first attributed by Beatrice Wood to Arensberg in the debate among the directors, and recording in memorable form a sculpture that did indeed vanish not long afterwards.

Stieglitz's photograph appeared in *The Blind Man*, no. 2 (May 1917), not as the frontispiece but clearly captioned "Fountain by R. Mutt," "The Exhibit Refused by the Independents" (Fig. 1). Facing the photograph were the most significant contemporary statements – an unsigned editorial entitled "The Richard Mutt Case" and Louise Norton's "Buddha of the Bathroom."[41] For the first time since the conflict had flared on April 9, a larger audience had the opportunity to see *Fountain* and to read something by way of explanation and defense of it. Even then a cautious decision was made to distribute *The Blind Man* by hand rather than risk any charge of pornography by sending it through the mail.[42]

The unsigned editorial, "The Richard Mutt Case," has been assigned to and/or claimed by different individuals. Evidently it was written by Beatrice Wood, although she, Duchamp, and Roché worked closely together, and there can be no doubt that it accurately represented Duchamp's thoughts and was approved by him, if not in part written by him.[43] It bears reprinting in full:

The Richard Mutt Case

They say any artist paying six dollars may exhibit.

Mr. Richard Mutt sent in a fountain. Without discussion this article disappeared and never was exhibited.

What were the grounds for refusing Mr. Mutt's fountain: –

1. Some contended it was immoral, vulgar.

2. Others, it was plagiarism, a plain piece of plumbing.

Now Mr. Mutt's fountain is not immoral, that is absurd, no more than a bath tub is immoral. It is a fixture that you see every day in plumbers' show windows.

Whether Mr. Mutt with his own hands made the fountain or not has no importance. He CHOSE it. He took an ordinary article of life, placed it so that its useful significance disappeared under the new title and point of view – created a new thought for that object.

As for plumbing, that is absurd. The only works of art America has given are her plumbing and her bridges.

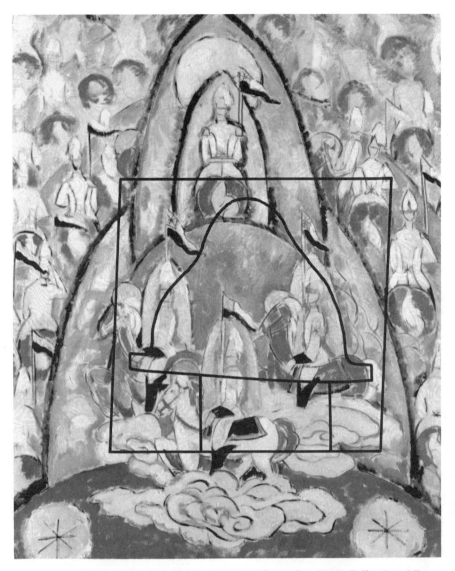

Fig. 6 Marsden Hartley, *The Warriors,* 1913, with overlay. Regis Collection, Minneapolis.

This succinct statement is a brilliant rejoinder to the critics of Mutt and *Fountain.* The object itself is not vulgar or immoral. By implication neither is the act of presenting it in public, since bathroom fixtures – including men's urinals – were displayed to the public in plumbing shops whose owners were not charged with immoral practices.

Neither is *Fountain* a plagiarism, that is, an object lacking any original con-

tribution by the artist. The editors underscore the creative act of selection. The artist CHOSE it – and it is important to stress that our visual knowledge of *Fountain* depends upon photography, an art form created by artists who do not *make* their subjects but *select* them. Several authors have commented on Duchamp's keen interest in that very feature of photography, that is, the primary role of the artist's selection.[44] And no element of chance was involved in Duchamp's choice of the photographer who had done more than anyone else to establish photography as an art in America. Stieglitz's memorable photograph of *Fountain* is integral to every issue surrounding the Mutt/*Fountain* case – and raises knotty questions of authorship. Is the photograph we see essentially the work of Stieglitz, or of Duchamp, or their collaboration?

As indicated in the *Blind Man* editorial, the originality of Mutt/*Fountain* involves more than the important act of selection. Duchamp also *transformed* the object by an action that incorporated elements of place, name/title, and point of view (both visual and conceptual). He removed "an ordinary article of life" from the context in which one normally encounters it – men's room or plumbing shop – and sought to place it in a different context (an art exhibition) with a new title (*"Fountain"*) and a new point of view (turned 90° on its back and isolated on a black pedestal) "so that its [former] useful significance disappeared" and he "created a new thought for that object." In brief, the urinal was substantially modified, although the final sentence of the editorial went further to imply that such transformation of the ordinary object is not always necessary, that some objects possess in themselves what is required to qualify as art: "The only works of art America has given are her plumbing and her bridges."

The "Richard Mutt Case" editorial was followed on the same page by Louise Norton's article entitled "Buddha of the Bathroom." Louise Norton was one of only a handful of Duchamp's friends with insider knowledge about the Richard Mutt case, and I submit that her article not only reflects the conversation within that group of friends but the concepts generated and accepted by Duchamp himself. I select four points in her article for special attention. She, too, addresses the criticism of originality:

To those who say that Mr. Mutt's exhibit may be Art, but is it the art of Mr. Mutt since a plumber made it? I reply simply that the *Fountain* was not made by a plumber but by the force of an imagination; and of imagination it has been said, "All men are shocked by it and some overthrown by it."[45]

She also deals with the question of sincerity raised in the press and in Katherine Dreier's letter. There are those, she observes, "who anxiously ask, 'Is he serious or is he joking?' Perhaps he is both! Is it not possible? In this connection I think it would be well to remember that the sense of the ridiculous *as well as* 'the sense of the tragic increases and declines with sensuousness.' It puts it rather up to you." Most important in this commentary on *Fountain* is the stress upon willed openness and ambiguity in Duchamp's work. It may be serious or humorous or both, and the effort of assessment is placed squarely on the viewer. In the final analysis, it is each individual – the artist and each spectator – who decides about art, and not a jury.

Also interesting in this section on sincerity is the reference to "sensuousness," which seems linked to the other two points I wish to stress in Louise Norton's article. Early in the article she dealt with the "vulgarity" argument, noting those jurors who "fairly rushed to remove the bit of sculpture called the *Fountain* . . . because the object was irrevocably associated in their atavistic minds with a certain natural function of a secretive sort. . . . Yet," she added

to any "innocent" eye how pleasant is its chaste simplicity of line and color! Someone said, "Like a lovely Buddha"; someone said, "Like the legs of the ladies by Cezanne"; but have they not, those ladies, in their long, round nudity always recalled to your mind the calm curves of decadent plumbers' porcelains?

Louise Norton's comments represent the first *published* witness to the "pleasant" formal properties of the object itself – not a vulgar object but a form of "chaste simplicity . . . like a lovely Buddha!" For over fifty years such perceptions of *Fountain* have almost disappeared from the literature on Duchamp, but among Duchamp's close friends in 1917 that aesthetic response was the rule, not the exception.[46] We have already encountered the irrefutable evidence of Stieglitz and Van Vechten in addition to Beatrice Wood's consistent memory of Arensberg's remarks to George Bellows about a "lovely form . . . [which] has been revealed." Other witnesses include Roché, who wrote that when Marcel "submitted a porcelain urinal to the New York Independents, he was saying: 'Beauty is around you wherever you choose to discover it.'"[47] The same sentiment had been expressed a year before the Independents by Duchamp's friend Jean Crotti when he assured an astonished reporter looking at Duchamp's snow-shovel readymade, *In Advance of the Broken Arm*, "As an artist I consider that shovel the most beautiful object I have ever seen."[48] When news of the Richard Mutt case reached Guillaume Apollinaire in Paris, he, too, associated *Fountain* with a seated Buddha and chastised the Independents for failing to recognize that art can ennoble and transform an object.[49] The Buddha-like form of *Fountain* is even more explicit in a cropped photograph recently discovered in the Arensberg papers at the Philadelphia Museum of Art (Fig. 7). It is not known when, why, or by whom this photo was cropped, but the cropping clearly enhances the reference to a seated Buddha form.[50]

The pressing question at this point is whether these perceptions of a beautiful form, of Madonnas and seated Buddhas, were products of Duchamp's mind and eye or the response of his associates. In my opinion, they were Duchamp's own, but his perceptions were shared by others, and the complex questions of form, intent, and content have hardly been exhausted. Consideration of *Fountain* in the context of other work by Duchamp and several contemporaries will contribute substantially to answering those questions.

It seems advisable to begin with the acknowledgment that most commentators on Duchamp discount the visual qualities of *Fountain*, claiming instead that it is either deliberately anti-art or aesthetically neutral – and their arguments are based on Duchamp's own word. In the frequently quoted "Apropos of 'Readymades'" (1961) Duchamp stressed aesthetic indifference:

A point which I want very much to establish is that the choice of these "readymades" was never dictated by esthetic delectation.

This choice was based on a reaction of visual indifference with at the same time a total absence of good or bad taste . . . in fact a complete anesthesia.[51]

More emphatic still was Duchamp's 1962 letter to Hans Richter, quoted in the latter's *Dada Art and Anti-Art:*

When I discovered ready-mades I thought to discourage aesthetics. In Neo-Dada they have taken my ready-mades and found aesthetic beauty in them. I threw the bottle-rack and the urinal into their faces as a challenge and now they admire them for their aesthetic beauty.[52]

Such statements by Duchamp must be taken seriously. On the face of it, who would argue that a challenge to conventional aesthetics was not a part of Duchamp's intent when he submitted a urinal to the Independents – no matter the degree to which he transformed it? At the same time, I am convinced that such statements by Duchamp contain only a partial "truth" – even a misleading "truth" – which cannot be adequately assessed without taking his comments seriously enough to consider them critically and in context.

The two statements quoted above stress significantly different considerations, namely, aesthetic indifference and aesthetic challenge, and other comments by Duchamp enlarge our possible responses to the readymades still further. It is also significant that such statements about aesthetic indifference and aesthetic challenge emerge in Duchamp's interviews only in the late 1950s/early 1960s and respond to different conditions, which are explored in a perceptive article by Robert Lebel.[53]

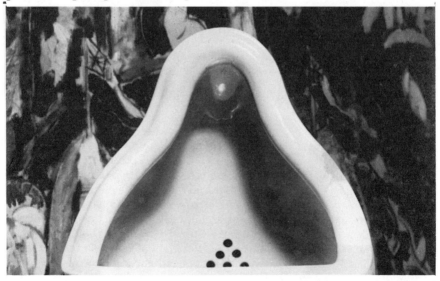

Fig. 7 *Fountain* (cropped), 1917, photograph by Alfred Stieglitz. Philadelphia Museum of Art, The Louise and Walter Arensberg Collection.

Turning from those late interviews back to the work of Duchamp that preceded *Fountain,* we find not aesthetic indifference but an *oeuvre* of extraordinary visual and intellectual rigor. And *Fountain* fits in that *oeuvre.* Far from being the product of an impulsive decision to challenge the principles of the Independents, *Fountain* seems to be expressive of its creator, related to other work by Duchamp and reflective of other art and the culture around him.

One event which must have contributed to Duchamp's concept of readymades was his visit to the 1912 Salon de la Locomotion Aérienne in the company of Léger and Brancusi. Léger later recalled that Duchamp "walked among the motors, the propellers without saying a word. Then suddenly he spoke to Brancusi: 'Painting is finished. Who can do better than that propeller? Tell me, can you do that?' He was very inclined toward precise things."[54]

Within a year Duchamp did, in fact, almost cease to paint, turning instead to studies for the *Large Glass* and to his first readymades. The early readymades selected in Paris, for example, the *Bicycle Wheel* and the *Bottlerack,* did not possess the sleek lines of airplane propellers, but neither of these two examples appears to have been motivated by visual indifference or anti-art.

In Duchamp's earliest known reference to these two objects, he refers to them simply as "sculpture already made."[55] Duchamp's later comments on the *Bicycle Wheel* vary from interview to interview, but none sustain an anti-art argument. To the contrary, he told Arturo Schwarz:

It had more to do with the idea of chance. In a way, it was simply letting things go by themselves . . . to help your ideas come out of your head. To see that wheel turning was very soothing, very comforting, a sort of opening of avenues on other things than material life of every day. . . . I enjoyed looking at it, just as I enjoy looking at the flames dancing in a fireplace.[56]

Schwarz also elicited from Duchamp the acknowledgment that "the wheel must have had a great influence on my mind, because I used it almost all the time from then on, not only there, but also in the *Chocolate Grinder,* and later in the *Rotoreliefs.* " Still more links to Duchamp's *oeuvre* have been suggested by other authors,[57] and to all those views I wish to add that the *Bicycle Wheel*—consciously or not—is effective from a visual or aesthetic perspective. Though composed of two distinct parts (the bicycle wheel and the stool), it exists as a well-proportioned whole, human in its scale and uprightness and Brancusi-like in the dialogue between "base" and "object," which share such features as light, taut, open constructions based on circles and spokes. Could it have been merely by chance, convenience, or practicality that Duchamp selected such a stool for the "base" of the *Bicycle Wheel?* Can any more appropriate "base" be conceived for it—whether designed by the artist or selected from the world of tables, chairs, benches and whatnot?[58]

Duchamp's claims for visual indifference notwithstanding, some authors have persisted in perceiving the *Bottlerack* as an object of aesthetic merit that is also intimately linked to Duchamp's thought and work. Robert Motherwell proclaimed that "the bottlerack he [Duchamp] chose has a more beautiful form than almost anything made, in 1914, as sculpture."[59] Ulf Linde sees it as a "kind of torso" and has indicated convincing ties to the *Large*

Glass, while Schwarz–rightly, I think–has underscored "the phallic symbolism of this item" with its "multiplication of the erect phallus-like spikes," which fulfill their function only when they have received and drained bottles.[60] The female element, merely implied by the missing bottles, may actually be central to this object in the form of the passageway through the core of the drying rack.

While there is no way to "prove" such interpretations of the *Bottlerack,* they are not implausible subjective views forced on the object. To the contrary, such interpretations are consistent with the basic themes and attitudes present in Duchamp's art and notes from such major paintings of 1912 as *The Bride* and *The Passage of the Virgin to the Bride,* to the *Large Glass* and all works related to it. It is not possible here to explore those works and writings. I must instead rely on the knowledge of the reader and indicate that the themes and attitudes I have in mind include (1) the omnipresence of sexuality as a driving but unfulfilled or unfulfilling force–whether male and female are bound together, as in the *Large Glass,* or fused, as in the *Bottlerack;* (2) a love of irony, exhibited in the *Large Glass,* for example, by use of almost exaggerated reason, geometry and quasi-scientific/engineering procedures for seemingly absurd ends; (3) a use of mechanical forms (and manufactured objects) that simultaneously challenge conventional art, recognize the significance of machines and technology in contemporary life, and reinforce the elements of sexuality and irony–employing mechanical forms and procedures, for example, to deal with what are conventionally conceived as the most intimate male/female relationships; and (4) the stimulation of spectator participation via a mental image of the functioning of the *Large Glass,* or by spinning the *Bicycle Wheel* or placing a bottle on the drying rack.

The readymades are quite varied and certainly all of them do not conform to the concerns or elements described above–but *Fountain* does appear to fit those attitudes and, given the preceding course of Duchamp's work for at least four years, the role of indifference or chance seems all the more remote in the selection of the urinal.

Urinals were not a sudden discovery or revelation to Duchamp in 1917. As early as 1914–in *The Box of 1914*–he had written: "One only has: for *female* the public urinal and one lives by it."[61] The precise meaning of his comment is obscure, but it associates a female form with an object for a male function–an object, moreover, which involves injection of fluid from a male into a uterine-like shape. It is also tempting to think that the name of the Mott company appealed to him, but regardless of the plumbing manufacturer patronized, contemporary showroom photographs and sales catalogues indicate that Duchamp had choices in the Mott shop between a variety of urinals (Fig. 8), actual fountains, tubs, basins and fixtures of all kinds, some of which suggest anthropomorphic forms that would have been noticed by Duchamp. Many of those objects may be interesting to us today, but–insofar as I can see–few would have yielded to the transformation wrought by Duchamp in the urinal he selected. Later in his life Duchamp vigorously resisted the existence of a personal taste implied by my argument;[62] however, it seems to me that the issue is not so much one of personal taste but of a keen

eye and mind which perceive visual properties of very diverse sorts that are recognized as fulfilling aesthetic/intellectual needs. The difference may seem slight, but I think it is significant.

As photographed by Stieglitz following a long discussion with Duchamp, *Fountain* quietly exudes sexuality. A masculine association cannot be divorced from the object because the original identity and function of the urinal remain evident, yet the overriding image is that of some generic female form—a smooth, rounded organic shape with flowing curves. This perception of femaleness seems reinforced by Duchamp's comment in *The Box of 1914* and by the photograph of his studio with a (the?) urinal suspended from the ceiling—*"le pendu femelle."* *Fountain* also abounds in irony—not only in the male/female exchange, but as an object whose hard, chilly surface belies the sensuousness of the form. There is irony, too, in the function, which was changed from a receptacle for waste fluid to a dispenser, a fountain of life-giving water, or, in the eyes of Duchamp's friends, a manufactured object whose function was transformed from serving the dirty biological needs of men to suggesting a serene seated Buddha or a chaste, veiled Madonna. Even the signature participates—scruffy in form in contrast to the pristine elegance of the urinal, and evocative not of Buddhas and Madonnas but of the popular cartoon characters, Mutt and Jeff.

Perception of Buddhas and Madonnas introduces a religious dimension which does not seem commensurate with Duchamp's major concerns, and it may represent the views of Duchamp's friends rather than his own intentions. It should be noted, however, that Duchamp did not censor those observations and that his larger concept of readymades includes all kinds of

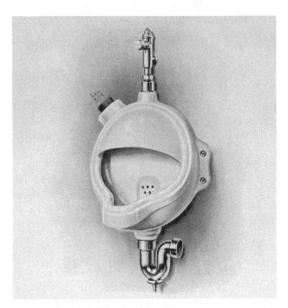

Fig. 8 Heavy vitro-adamant urinal, 838-Y from the J. L. Mott Iron Works, *Marine Department Catalogue "Y,"* New York, 1902.

"givens" beyond the control of the artist – some of which point to the ultimate unknowns and/or mysteries of life which involve a spiritual dimension.[63]

That veiled, mysterious, iconic quality of *Fountain* is inseparable from the photograph, and the role of Alfred Stieglitz must be considered at this juncture. To what extent did he control the photograph – hence our image of the original *Fountain* – and to what extent did Duchamp influence Stieglitz's work? Curiously, no negative has ever been found in the Stieglitz estate and *Fountain* has not figured in publications on Stieglitz – while it always appears in publications on Duchamp. The absence of a negative for *Fountain* has been a factor in publications on Stieglitz, but it is also a unique, unexpected work in his career at that time, both as subject matter and as a commission. We know Stieglitz emerged from a lengthy discussion with Duchamp proclaiming the aesthetic virtues of *Fountain,* and it seems reasonable to attribute a significant role in the photograph to Duchamp. Yet, in the final analysis it remains a superb Stieglitz photograph. It was Stieglitz who elected to place *Fountain* in front of a Marsden Hartley painting with fortuitous visual and intellectual links. Stieglitz also chose to place *Fountain* exactly at our eye level, bringing it close, magnifying its presence, rotating it slightly on its axis to set up just a touch of tension, and lighting it from above so that it is dramatically isolated against its setting yet also softly veiled, moody and mysterious. Moreover, through his friendship with Picabia, Stieglitz was familiar with the symbolic use of common manufactured items in art, and during that very spring of 1917 he was championing a young photographer, Paul Strand, whose dramatic close-up photographs of common objects were to make a substantial impression on Stieglitz and photography in America. It is generally believed that Picabia and Duchamp were instrumental in the development of Strand's vision, but much is still unknown about the interchange of Duchamp, Picabia, Stieglitz and Strand. It is my hunch that Stieglitz's photo of *Fountain* will be a significant piece in that puzzle whenever it is worked out.

Whereas Stieglitz contributed to the iconic and vaguely spiritual appearance of *Fountain,* another artist, Brancusi, may be relevant for its sleek formal properties and sexual suggestions. The exhibition of Brancusi's sculpture at De Zayas's Modern Gallery during the fall of 1916 included both the marble and polished brass versions of *Princess X* (Fig. 9), which were purchased by John Quinn and Walter Arensberg respectively during 1917.[64] The brass version was exhibited at the 1917 Independents' exhibition and reproduced in the catalogue as *Princesse Bonaparte.*[65] Accordingly, Duchamp was surely familiar with both sculptures. Brancusi's sensuous abstraction of the princess into a featureless face, long, curving neck, and full, rounded breasts was too abstract for most critics, although one was offended by the artist's sly incorporation of a phallic form:

We are not of the class that favors drapery for the legs of the piano stool, but phallic symbols under the guise of portraiture should not be permitted in any public exhibition hall, jury or no jury . . . America likes and demands a clean art.[66]

It is most unlikely that Duchamp missed the female/male fusion of forms in Brancusi's *Princess X.* Indeed – the distinctions between *Fountain* and *Prin-*

cess X notwithstanding – the affinities between these works are sufficient to raise the possibility that *Princess X* contributed to the conception of *Fountain*. The interplay of male object and suggestive female form has only recently emerged in commentary on *Fountain*, although the androgynous element of Duchamp's work is established in the literature for other objects.[67]

One further witness remains to be called to testify to the particular taste at that moment for objects – both manufactured and handmade – which are characterized by sleek, simple shapes that suggest anthropomorphic forms with sexual connotations. Picabia's mechanomorphic images changed significantly soon after he returned to New York in April 1917, just in time for the Independents' exhibition. The meaning of his earlier drawings had been keyed to the *function* of the machine forms that he employed, but his drawings of manufactured objects datable from April to June 1917 present suggestive forms and ironic titles similar to what we have encountered in *Fountain*. One of the drawings, *Ane* (*Ass* or *Donkey*, Fig. 10), represents the propeller of a ship, but its softly rounded blades, radiating from a central shaft with an orifice, evoke generic female forms – and the meaning of this "handmade readymade" seems to involve a risqué bilingual play on its title combined with the form, function, and location of the ship's screw from which it was copied.[68]

Regrettably, Picabia's letters at the time contain no reference to *Fountain* or to his own works, which I think reflect it and the interests of the entire

Fig. 9 Constantin Brancusi, *Princess X,* 1916, marble. Sheldon Memorial Art Gallery, University of Nebraska, Lincoln. Gift of Mrs. A. B. Sheldon.

Fig. 10 Francis Picabia, *Ane* (*Ass* or *Donkey*), 1917, cover for *391*, no. 5, New York, June 1917. Location of original drawing unknown.

circle around Arensberg and Duchamp. The situation is not unique. After May 1917, no references to *Fountain* have been found in the letters or records of anyone associated with the lively debate during April and early May of that year – not even in the records of Arensberg, who supposedly purchased it. It is almost as though all discussion of *Fountain* was deliberately suppressed. Moreover, the object itself disappeared again and has never reappeared. This second disappearance is doubly mysterious inasmuch as *Fountain* was supposedly then in friendly hands. Other than the few days it was available for viewing at 291, *Fountain* was never exhibited, and almost thirty years passed without a publication that included either significant commentary on it or a reproduction of Stieglitz's photograph.

This astonishing silence that descended upon *Fountain* precluded a discussion of issues it had raised, but those issues reappeared with a vengeance in the context of the tumultuous art scene of the 1960s. It was in the context of such controversial movements as junk sculpture, the "New Realism" of Europe, Pop Art, Minimal Art and Conceptual Art that *Fountain* again became a center of attraction. Different viewpoints of the readymades abounded, but those who proclaimed *Fountain* to be an object of anti-art or aesthetic indifference dominated critical opinion, obscuring and displacing the historical conditions of 1917. Duchamp himself confounded critical debate with conflicting comments on the readymades and the authorization of various replicas of them. Indeed the reemergence of the readymades in the 1960s and their critical reception is a phenomenon that merits a study of its own, and a secondary aim of this article is to offer a new perspective on that criticism. For over twenty-five years we have looked back at *Fountain* with eyes and minds shaped by conditions in the sixties and seventies. In this article I have sought to look at *Fountain* itself and the context in which it came into being. In that context neither Duchamp nor his friends said anything about anti-art or aesthetic indifference. Duchamp simply referred to *Fountain* and other readymades as "sculpture"; his friends – probably reflecting his attitude – spoke of pleasing forms with anthropomorphic associations. The comments and conditions of 1917 deserve to reenter our consideration of *Fountain:* they suggest that we should not ignore the visual properties of other readymades.

Notes

1. For the claims of Duchamp and Marlor see Pierre Cabanne, *Entretiens avec Marcel Duchamp* (Paris: Belfond, 1967), 99, and Clark S. Marlor, "A Quest for Independence: The Society of Independent Artists," *Art and Antiquities* (March–April 1981), 77.

2. In conjunction with an exhibition of Duchamp's work, the Menil Collection in Houston will publish a modified version of this article as part of an extended text on the history and criticism of *Fountain* after 1917.

3. In the fall of 1972 a memorable group of students at Rice University confirmed these perceptions and encouraged this article. Those students were James Courtney, Dean Haas, Robert Hilton, Van Jones, William McDonald, Herta Glenn (Merwin), and Virginia Ralph. I dedicate this article to Herta Glenn.

4. For the most thorough and reliable account of the first exhibition of the Society of Independent Artists see Francis Naumann, "The Big Show: The First Exhibition of the Society of Independent Artists," parts I and II, *Artforum* 17 (February 1979), 34–39, and (April 1979), 49–53. Naumann has provided photographs, friendly criticism, and numerous references regarding the Independents' exhibition and *Fountain*. Special thanks are due for his unstinting generosity. See also Clark S. Marlor, *The Society of Independent Artists. The Exhibition Record 1917-1944* (Park Ridge, New Jersey: Noyes Press, 1984).

5. See the anonymous interview with these four artists in the *New York Tribune*, "French Artists Spur on an American Art," 24 October 1915, Section iv, 2–3. This interview has been reprinted in Rudolf E. Kuenzli, ed., *New York Dada* (New York: Willis Locker & Owens, 1986), 128–35.

6. Duchamp exhibited two readymades at the Bourgeois Gallery, New York, *Exhibition of Modern Art*, 3–9 April 1916.

7. For an excellent account of the Arensbergs see Francis Naumann, "Walter Conrad Arensberg: Poet, Patron, and Participant in the New York Avant-Garde, 1915–1920," *Philadelphia Museum of Art Bulletin* 76, no. 328 (Spring 1980). I am also much indebted to Naomi Sawelson-Gorse, a graduate student preparing a thesis on the Arensbergs, and to Mrs. Elizabeth S. Wrigley, president of the Francis Bacon Foundation, Claremont, California.

8. Quinn's friendship and his efforts to secure employment for Duchamp are evident in Duchamp's letters to Quinn (John Quinn Collection, The New York Public Library). See also the catalogue for an exhibition organized by Judith Zilczer for the Hirshhorn Museum, Washington, D.C., *The Noble Buyer: John Quinn, Patron of the Avant-Garde*, 15 June–4 September 1978.

9. In Walter Pach's correspondence with John Quinn, the Independents' project is first mentioned on 9 October 1916, although it is clear that organizational work had begun earlier (John Quinn Collection, The New York Public Library). The certificate of incorporation dated 5 December 1916 is published as Appendix A in Marlor, *The Society of Independent Artists*, 53–54.

10. The initial notice of the Society of Independent Artists, Inc., listed the directors as George Bellows, Homer Boss, John R. Covert, Katherine S. Dreier, Marcel Duchamp, Regina A. Farrelly, Arnold Friedman, William J. Glackens, Ray Greenleaf, John Marin, Charles E. Prendergast, Maurice B. Prendergast, Man Ray, Mary C. Rogers, Morton L. Schamberg, Joseph Stella and Maurice Sterne. Walter Arensberg's name was added to that list in the exhibition catalogue. A list published by Clark S. Marlor (*The Society of Independent Artists*, 58) includes the names of Arthur B. Frost, Jr., Albert Gleizes, Francis Picabia, John Sloan and Jacques Villon. The three French artists, Gleizes, Picabia and Villon, were added at Marlor's initiative because they were involved in the planning of the Society (letter to the author, 2 December 1986).

11. Announcement entitled "The Society of Independent Artists, Inc.," undated, in the Archives of the Société Anonyme, The Beinecke Rare Book and Manuscript Library, Yale University, New Haven, Connecticut.

12. Roché, an author, private art dealer and friend from Paris, arrived in New York during November 1916. Beatrice Wood was a young actress who met Duchamp in September 1916 through the French composer, Edgar Varèse. Roché and Wood contributed most of the texts for *Blindman* no. 1, which is dated 10 April 1917 but seems to have appeared a few days later. Wood first recorded the Arensbergs' response to it in her diary on 16 April. For the relationships of Roché, Wood and Duchamp see Beatrice Wood, *I Shock Myself* (Ojai, California: Dillingham Press, 1985).

13. Covert wrote Katherine S. Dreier on 9 March 1917 to urge her attendance at an important meeting of the directors on 13 March in Arensberg's studio at 33 West 67th Street (Archives of the Société Anonyme).

14. These terms and others are specified in a "Notice to Exhibitors" (n.d.) mailed to artists over the names of William Glackens and John Covert at the latter's address, 20 West 31st Street, New York, N.Y. (Archives of the Société Anonyme).

15. For extensive clippings on the Independents' exhibition see Katherine S. Dreier's scrapbook, vol. I (1915–1917) in the Archives of the Société Anonyme. See also Francis S. Naumann, "The Big Show."

16. Unsigned review, "His Art Too Crude for Independents," *The New York Herald*, 14 April 1917, 6. Several contemporary references in the press to "J. C. Mutt" probably represent a simple error in reporting. Inaccuracies were compounded when an anonymous writer for *American Art News* confused *Fountain* with Beatrice Wood's entry *Un Peu d'eau dans du savon* and claimed it was signed "Jeff Mutt" (*American Art News* 15, no. 27 [14 April 1917], 1). More puzzling are several contemporary references to a painting entitled *Tulip Hysteria Co-ordinating* supposedly submitted by Duchamp to the Independents. No such painting has ever appeared, and no further mention of it has been found in documents relating to Duchamp and his friends. Naumann suggests it was a rumor circulated intentionally to mislead the public ("The Big Show," part I, 37 and 39).

17. Franklin Clarkin, "Two Miles of Funny Pictures," *Boston Evening Transcript*, 25 April 1917. No further mention of a damage suit has been found, but the identification of "R. Mutt" as "Richard Mutt" correctly reflects Duchamp's intention, and associations of R. Mutt with Mutt and Jeff were prevalent. Harry Conway ("Bud") Fisher's popular cartoon strip on Mutt and Jeff was carried in New York by *The World*.

18. Clark S. Marlor, letter to the author, 2 December 1986. A. S. Baylinson (1882–1950) was a Russian-born artist who became a student of Robert Henri and an early member of the Independents. The fire which destroyed his studio is frequently dated 1930.

19. Arturo Schwarz, *The Complete Works of Marcel Duchamp* (New York: Harry N. Abrams, Inc., 1979) 466.

20. Otto Hahn, "Passport No. G 255300," *Art and Artists* (July 1966), 10. Other accounts for the inscription "R. Mutt" have been offered. Jack Burnham claims it "is a pun or partial homonym for the German word '*Armut*,' meaning poverty" ("The True Readymade?," *Art and Artists*, February 1972, 27). Duchamp rejected that interpretation, initially attributed to Rosalind Krauss (Otto Hahn, 10). Ulf Linde observed that "Mutt" is similar to a mirror reversal of *Tu m'*, Duchamp's painting of 1918 which includes shadows of readymades (Walter Hopps, Ulf Linde and Arturo Schwarz, *Marcel Duchamp. Ready-Mades, etc. 1913–1964* [Milan: Galleria Schwarz, 1964], 63). Rudolf Kuenzli has suggested that "R. Mutt" could refer to "mongrel art" based on the association of "R" with the French word "*l'art*" and "Mutt" with American slang for a mongrel dog (conversation with this author, 24 September 1987).

21. The main plant of J. L. Mott Iron Works (founded 1828) was located in Trenton, New Jersey, but it had outlet stores from coast to coast, including major showrooms in Philadelphia and in New York at Fifth Avenue and 17th Street. See the J. L. Mott Iron Works catalogues, *Modern Plumbing for Schools, Factories, etc.*, New York, 1912, and *Marine Plumbing, Catalogue "M,"* New York, 1918. Naumann has identified an outlet at 718 Fifth Avenue, probably the same location ("The Big Show," part I, 39).
 Those rare catalogues were made available to the author by courtesy of Mr. Francis

Kelly, recently retired from J. L. Mott, and Laurie H. Sullivan, president of the company, which now specializes in marine plumbing products.

Unfortunately, no company museum or cemetery of old products exists, but among the few remaining catalogues urinals like the one chosen for *Fountain* are illustrated in Mott's *Marine Department Catalogue "Y,"* volume II (New York, 1902), 58, and *Mott's Plumbing Fixtures Catalogue "A"* (New York, 1908), 417. The latter example (Fig. 2) was first reproduced in George Basalla's excellent article, "Transformed Utilitarian Objects," *Winterthur Portfolio* 17 (Winter 1982), 194. The 1902 model is described in the catalogue as a "Heavy Vitro-adamant Urinal, 12 × 15 inches, with nickel-plated supply valve, with key stem and 1¾ inch nickel-plated trap" arranged for a continuous flush and retailing for $11. Although several of the wall-hung urinals have shapes compatible with *Fountain,* few models have flushing rims and ears or lugs for attaching the urinal to the wall which resemble those features on the urinal selected by Duchamp.

22. This seldom-noted photograph was reproduced in an article by Nicolas Calas, "Cheat to Cheat," *View* 5, no. 1 (21 March 1945), 20. It appears also in Robert Lebel's *Marcel Duchamp* (New York: Paragraphic Books, 1959), pl. 84.

The apartment in the photograph is the one at 33 West 67th Street occupied by Duchamp from October 1916 to August 1918. Although this photograph could conceivably have been made after the Independents' exhibition, it is curious that no mention of it has ever emerged in interviews or the correspondence of Duchamp's closest friends, including Arensberg, Beatrice Wood, Louise Norton, Man Ray, H. P. Roché and others. Duchamp said he lost track of *Fountain* after the Independents. If this photograph was made around late March or early April 1917, then a more precise date can be attributed to *Hat Rack.*

To date, the original photograph and identity of the photographer have not been found.

23. I am indebted to Francis Naumann who pointed out the existence of Beatrice Wood's diary and made his copy available, and to Beatrice Wood for her permission to quote from it. Punctuation and spelling in the diary have been retained.

24. Beatrice Wood, *I Shock Myself,* 29–30. Beatrice Wood is the only eyewitness to this event who has published an informative account of the argument between Bellows and Arensberg. She has, in fact, contributed several accounts, published and unpublished, which vary in some details but remain consistent in the essentials. The earliest version known to this author appears in Wood's letter to Louise Arensberg on 10 August 1949 in the Beatrice Wood Papers, Archives of American Art, Washington, D.C., roll no. 1236, frames 989–90. A similar version, transformed into a dialogue between Bellows and Arensberg, was sent to this author in June 1962. Another version substituting Rockwell Kent for George Bellows was published by Francis Naumann, "I Shock Myself: Excerpts from the Autobiography of Beatrice Wood," *Arts* 51 (May 1977), 134–39.

25. Anonymous review, "His Art Too Crude for Independents," *The New York Herald,* 14 April 1917, 6.

26. Marcel Duchamp to Suzanne Duchamp, 11 April 1917 (Archives of American Art, Smithsonian Institution, Washington, D.C.). This letter and others from Duchamp to his sister and his brother-in-law, Jean Crotti, have been published in English translation with commentary by Francis M. Naumann, "Affectueusement, Marcel," *Archives of American Art Journal* 22, no. 4 (1982), 2–19:

> Tell this detail to the family: The Independents have opened here with immense success.

One of my female friends under a masculine pseudonym, Richard Mutt, sent in a porcelain urinal as a sculpture; it was not at all indecent – no reason for refusing it. The committee has decided to refuse to show this thing. I have handed in my resignation and it will be a bit of gossip of some value in New York (p. 9).

27. Images of Duchamp's female alter ego, Rrose Sélavy, first appeared in 1921, but an androgynous element has been attributed to Duchamp's earlier work as well, most notably by Arturo Schwarz, "The Alchemist Stripped Bare in the Bachelor, Even," in Anne d'Harnoncourt and Kynaston McShine, eds., *Marcel Duchamp* (New York: The Museum of Modern Art, 1973), 81–98.

28. Charles Demuth to Henry McBride, undated (c. 10–14 April 1917), Archives of Henry McBride, The Beinecke Rare Book and Manuscript Library, Yale University. The "e" added to Mutt in this letter could possibly have been intended to suggest a female identity or, if associated with the "R" of R. Mutt, *Mutter*, the German word for "mother."
Either Morton Schamberg and/or Charles Sheeler could have served as the Philadelphia contact since both lived there and were friendly with Duchamp. However, no documents have yet been discovered to link them to the Richard Mutt affair.

29. Schuyler 9255 is the number listed in the 1917 Manhattan telephone directory for Mrs. Louise McC. Norton. She and her husband were co-editors of the avant-garde magazine *Rogue*. They separated in 1916 and she later married Edgar Varèse, but during 1916–17 she was one of Duchamp's closest friends. In several interviews and letters this author was not successful in eliciting new information regarding *Fountain* from Louise Varèse.

30. Marcel Duchamp to Katherine S. Dreier, 11 April [1917]; Archives of the Société Anonyme.

31. Katherine S. Dreier to Marcel Duchamp, 13 April 1917; Archives of the Société Anonyme.

32. Katherine S. Dreier to William Glackens, 26 April 1917; Archives of the Société Anonyme. These quotations are from a carbon copy. The Archives also contain the letter in a typed form with changes made in ink.

33. The claim that *Fountain* was smashed by William Glackens stems from Glackens's son, Ira (*William Glackens and the Ashcan Group* [New York: Crown Publishers, Inc., 1957], 187–88), who recounts Charles Prendergast's story about a problem posed for the Independents' executive committee by the submission of two works, Duchamp's *Fountain* and a "tastefully decorated" chamber pot by an unnamed artist. According to Prendergast, William Glackens solved the problem by dropping the "disputed 'objet d'art'" and breaking it. Although it is not clear if the broken item was *Fountain* or the chamber pot, Clark S. Marlor claims that Glackens broke *Fountain* ("A Quest for Independence: The Society of Independent Artists," 77). Marlor quotes the Prendergast story again in *The Society of Independent Artists*, 5, as one version of what happened to *Fountain*, but he believes that to be the accurate version (letter to the author, 2 December 1986).

34. Rudi Blesh, *Modern Art USA* (New York: Alfred A. Knopf, 1956), 79. Discrepancies in Duchamp's own memory of the event have clouded specific points. In a late interview with Pierre Cabanne (*Entretiens avec Marcel Duchamp*, 98), he mistakenly recalled that *Fountain* was concealed behind a partition "pendant toute la durée de l'exposition, [et] je n'ai pas su où elle était."

35. Beatrice Wood, unpublished diary, 13 April 1917.

36. Beatrice Wood, *I Shock Myself*, 30.

37. Alfred Stieglitz to Henry McBride, 19 April 1917, Archives of American Art, McBride Papers, microfilm roll 12, frame 445. To date no McBride response has been found to the letters of Demuth and Stieglitz, suggesting perhaps the reluctance of even sympathetic critics to engage issues raised by *Fountain*.

38. Carl Van Vechten, *The Letters of Gertrude Stein and Carl Van Vechten, 1913–1914*, edited by Edward Burns (New York: Columbia University Press, 1986), 58–59. This undated letter is attributed to April 5, apparently on the basis of events in the life of Van Vechten and his wife, the actress Fania Marinoff. Though April 5 is plausible in that context, it conflicts in the context of Stieglitz, and in my opinion the letter must date after April 13. This recent edition of the Van Vechten-Stein correspondence was brought to my attention by Francis Naumann.

39. Alfred Stieglitz to Georgia O'Keeffe, Archives of Georgia O'Keeffe, The Beinecke Rare Book and Manuscript Library, Yale University. Restrictions on these archives, recently placed at Yale, preclude access to this letter. Owing, however, to the forthcoming publication of this letter in the selected correspondence of Georgia O'Keeffe, Sarah Greenough and Juan Hamilton graciously informed me of some of its contents and authorized a brief paraphrase. I am grateful to be able to indicate some points in this important document. Stieglitz was also led to think that the urinal had been submitted by a young woman, probably at the instigation of Duchamp.

40. When informed of the Marsden Hartley reference, Francis Naumann identified *The Warriors*. I am grateful for his quick eye and for permission from the present owner of *The Warriors* to reproduce it with a diagram indicating as accurately as possible the portion of the painting covered by *Fountain* as photographed by Stieglitz. The shape of *Fountain* cannot be made to fit on a standard, frontal reproduction of *The Warriors* without distortion, indicating that the camera lens, the urinal and the painting were not aligned in parallel planes when Stieglitz made the photograph. Diagram by James Tiebout.

41. In her diary Beatrice Wood records the appearance of *The Blind Man*, no. 2, on 5 May 1917.

42. Beatrice Wood has described this event in her autobiography, *I Shock Myself,* 31– 32. The initials on the cover refer to the three editors, P [Pierre Roché], B [Beatrice], and T [Totor or Duchamp]. Because Roché and Duchamp were not American citizens, they asked Beatrice to stand alone as publisher. She accepted, but her father was appalled by the magazine and warned her she might go to jail if such "filth" went through the mail. She consulted Frank Crowninshield, editor of *Vanity Fair* and supporter of *The Blind Man*. Though they could not understand the reaction of Beatrice's father, they decided not to risk bad publicity for such distinguished backers as Mrs. Harry Payne Whitney and distributed *The Blind Man* by hand.

43. Beatrice Wood claims she wrote this editorial (*I Shock Myself*, 31). In response to questions posed by Serge Stauffer (*Marcel Duchamp, Die Schriften*, vol. 1 [Zürich: Regenbogen-Verlag 1981], 280) Duchamp said that "The Richard Mutt Case" was by the editors of *Blind Man*. Alice Goldfarb Marquis thinks Arensberg was probably the principal author (*Marcel Duchamp: Eros, c'est la vie. A Biography* [Troy, New York: Whitston Publishing Company, 1981], 164).

44. Comments to this effect were made by Duchamp in an unpublished interview with Peter Bunnell in 1961 (letter to the author, 5 August 1986). Jean Clair in *Du-*

champ et la photographie (Paris: Editions du Chêne, 1977), 69, refers to the ready-mades as three-dimensional "snapshots."

45. Louise Norton, "Buddha of the Bathroom," *The Blind Man*, no. 2 (5 May 1917), 5-6.

46. A generation ago, one had to search diligently for passing mention of the visual properties of *Fountain*. More recently, unequivocal comments on the aesthetic properties have been made by such authors as Kermit Champa ("Charlie Was Like That," *Artforum* 12, no. 6 [March 1974]); William Tucker ("The Object," *Studio International* [February 1973], 66–70); and Alice Goldfarb Marquis (*Marcel Duchamp: Eros, c'est la vie*, 155–56).
It is not known who initiated the association of *Fountain* with a seated Buddha, but Asian art was important for some of Duchamp's friends and acquaintances. Beatrice Wood knew Ananda Coomaraswamy, who was in New York in April 1917 (Beatrice Wood's unpublished diary, entry for April 28), and Stieglitz's former associate Agnes Ernst Meyer had begun collecting Asian art with the encouragement of Charles Lang Freer.

47. H[enri] P[ierre] Roché, "Souvenirs of Marcel Duchamp," in Robert Lebel, *Marcel Duchamp* (New York: Grove Press, 1959), 87.

48. Nicola Greeley-Smith, "Cubist Depicts Love in Brass and Glass: 'More Art in Rubbers Than in Pretty Girl!,'" *The Evening World* [New York], 4 April 1916, 3. Reprinted in Rudolf E. Kuenzli, ed., *New York Dada*, 135–37.

49. Guillaume Apollinaire, "Le cas de Richard Mutt," *Le Mercure de France*, 16 June 1918. Reprinted in "Echos et anecdotes inédits," *Cahiers du Musée National d'Art Moderne*, no. 6 (Paris, 1981), 15. Documentation by Pierre Caizergues. Roché probably mailed a copy of *The Blind Man* to Apollinaire. In a postcard of 8 May 1917, Apollinaire thanks Roché for receipt of *The Blindman*, that is, issue no. 1 of April (Henri-Pierre Roché Archives, in the Carlton Lake Collection of the Humanities Research Center, The University of Texas at Austin).

50. This photograph (4¼" × 7") came to the Philadelphia Museum with the Arensberg Archives in 1950. It is described by the associate curator of photographs, Martha Chahroudi, as probably a photograph from the original negative. It is on photographic stock consistent with the period but not really consistent with Stieglitz's photographs. At one time it was mounted on a page from *291*, no. 3, May 1915. I am grateful to Ms. Chahroudi for making this information available, and to Naomi Sawelson-Gorse who told me of the existence of the cropped photograph.

51. Marcel Duchamp, "Apropos of 'Readymades,'" talk delivered by Duchamp as a panel member of the "Art of Assemblage" symposium at the Museum of Modern Art, New York, 19 October 1961. Published in *Art and Artists*, (July 1966), 47, and reprinted in *Salt Seller. The Writings of Marcel Duchamp (Marchand du Sel)*, ed. Michel Sanouillet and Elmer Peterson (New York: Oxford University Press, 1973). Duchamp made other comments on the readymades in dialogue with the moderator, William C. Seitz, and panel members Roger Shattuck, Charles R. Huelsenbeck, Robert Rauschenberg and Lawrence Alloway (unpublished but copyrighted transcript of the symposium).

52. Hans Richter, *Dada Art and Anti-Art* (New York: McGraw-Hill, 1965), 207–8.

53. Robert Lebel, "Marcel Duchamp maintenant et ici," *L'Oeil*, no. 149 (May 1967), 18–23, 77.

Among all the comments of those close to Duchamp in April 1917 I have found only one, never-quoted sentence which suggests something other than the dominant references to the aesthetic properties of *Fountain*. In *The Blind Man* (no. 2, p. 12), the poet Mina Loy concludes an untitled and rather enigmatic poetic commentary on Louis Eilshemius with the seemingly unrelated sentence: "Anyhow, Duchamp meditating the levelling of all values, witnesses the elimination of Sophistication." That comment may refer to the primitivist paintings of Eilshemius "discovered" by Duchamp at the Independents' exhibition, but it is tempting to associate it with *Fountain* as well.

54. Dora Vallier, interview with Fernand Léger, "La Vie dans l'oeuvre de Fernand Léger," *Cahiers d'Art* 29, no. 3, (1954), 140.

The Salon de la Locomotion Aérienne was held in the Grand Palais, Paris, 26 October–10 November 1912. Guillaume Apollinaire was expressing similar views at about the same time: ". . . Je pense que le style moderne existe, mais ce qui caracterise le style d'aujourd'hui on le remarquerait moins dans les façades des maisons ou dans les meubles que dans les constructions de fer, les machines, les automobiles, les bicyclettes, les aéroplanes." ("La Renaissance des Arts Décoratifs," *L'Intransigeant*, Paris, 6 June 1912). The date and circumstances of this event are not firmly fixed. See Dickran Tashjian, "Henry Adams and Marcel Duchamp: Liminal Views of the Dynamo and the Virgin," *Arts* 51 (May 1977), 103.

55. Marcel Duchamp to Suzanne Duchamp, 15 January 1916 (Archives of American Art, Smithsonian Institution, Washington, D.C.), translated with commentary by Francis M. Naumann, "Affectueusement, Marcel," 5.

56. Arturo Schwarz, *The Complete Works of Marcel Duchamp*, 442.

57. Some of the more interesting analyses have been published by Ulf Linde, "La Roue de bicyclette," in *Marcel Duchamp abécédaire* (Paris: Centre Georges Pompidou, 1977), 35–41; Jean Clair, *Duchamp et la photographie*, 64–74; and Craig Adcock, *Marcel Duchamp's Notes from the 'Large Glass'* (Ann Arbor, Michigan: UMI Research Press, 1983), 102–3. For a summary and commentary on several viewpoints see Francis M. Naumann's catalogue *The Mary and William Sisler Collection* (New York: Museum of Modern Art, 1984), 160–65, and John Moffit's text "Marcel Duchamp: Alchemist of the Avant-Garde" in Los Angeles County Museum of Art, *The Spiritual in Art: Abstract Painting 1890–1985*, 23 November 1986–8 March 1987, 257–71, ed. Maurice Tuchman.

58. Like many students of Duchamp, Harriet and Sidney Janis ("Marcel Duchamp, Anti-Artist," *View* 5, no. 1 [21 March 1945], 23) struggled with a dilemma, namely, their recognition that Duchamp intentionally disregarded esthetic results and their personal experience that "a high esthetic quality stamps all that he [Duchamp] touches. . . ." They concluded that this was "the result, not of intention, but of Duchamp's high degree of sensibility."

At the same time that Duchamp was transforming manufactured objects into readymade sculptures, his friend Brancusi was making furniture for his own studio which he chose to exhibit as sculpture/bases for his sculpture a few years later, most notably the *Bench* now in the Arensberg Collection at the Philadelphia Museum of Art. Intriguing parallels and differences between Brancusi and Duchamp are explored in the excellent article of Edith Balas, "Brancusi, Duchamp and Dada," *Gazette des Beaux Arts* 95 (April 1980), 165–74.

59. Robert Motherwell, ed., *The Dada Painters and Poets: An Anthology* (New York: Wittenborn, Schultz, 1957), xvii.

60. For Linde's comment see Walter Hopps, Ulf Linde and Arturo Schwarz, *Marcel Duchamp. Ready-Mades, etc. 1913–1964,* 56. For Schwarz's comments see *The Complete Works of Marcel Duchamp* (New York: Harry N. Abrams, 1970), 449. Duchamp confirmed in a letter to Schwarz that his interpretation of the *Bottlerack* was correct, but as Schwarz thoughtfully observed to this author, "There are many different levels of meaning to every single symbolic object. My interpretation does not exclude other interpretations, it merely adds one little piece to the puzzle" (Letter to the author, 26 January 1987).

61. Marcel Duchamp, *Salt Seller,* 23.

62. In an interview with Katherine Kuh (*The Artist's Voice,* [New York: Harper & Row, 1960], 92), Duchamp said:

> I consider taste – bad or good – the greatest enemy of art. In the case of the Ready-Mades I tried to remain aloof from personal taste. . . . Of course . . . many people can prove I'm wrong by merely pointing out that I chose one object rather than another and thus impose something of my own personal taste. Again, I say man is not perfect. . . .

63. In the interview with Katherine Kuh (*The Artist's Voice,* 90) Duchamp said:

> The curious thing about the Ready-Made is that I've never been able to arrive at a definition or explanation that fully satisfies me. . . . There's still magic in the idea, . . . [a] man can never expect to start from scratch; he must start from ready-made things like even his own mother and father.

64. For Brancusi's exhibition at the Modern Gallery (New York, 23 October–11 November 1916), see Marius de Zayas, "How, When, and Why Modern Art Came to New York," *Arts* 54, no. 8 (April 1980), 107, introduction and notes by Francis M. Naumann.

65. The Society of Independent Artists, *First Annual Exhibition,* Grand Central Palace (New York, 10 April–6 May 1917), no. 167, and illustrated in the catalogue.

66. W. H. de B. Nelson, "Aesthetic Hysteria," *The International Studio* (June 1917), ccxxi–ccxxv.

67. Arturo Schwarz has written extensively on androgyny in Duchamp's work. For a concise account see his "The Alchemist Stripped Bare in the Bachelor, Even," *Marcel Duchamp,* (New York: Museum of Modern Art, 1973), 81–98. Kermit Champa has commented most cogently on *Fountain* in "'Charlie Was Like That,'" 58:

> What the *Fountain* finally constituted more than anything else was the brilliant discovery within the world of the Readymade and the everyday of the perfect Freudian symbol, flagrantly obvious and stimulating once it was discovered, but utterly untranslatable and, as a result, perversely pure. Phallic? Vaginal? It was a man-made female object for exclusive male functions. Yet, who could characterize it precisely?

The masculine assumption of female biological functions in Picabia's *La Fille née sans mère* (1915) and Apollinaire's *Les Mamelles de Tirésias* (1917) are two contemporary works not specifically related to *Fountain* but relevant to broad themes of artistic production, sexual reproduction, machine products and god-like activity which set a context for Duchamp's contributions. See Katia Samaltanos, *Apollinaire: Catalyst for Primitivism, Picabia, and Duchamp* (Ann Arbor, Michigan: UMI Research Press, 1984), 72–73.

68. *Ane* was the cover for Picabia's magazine *391,* no. 5 (New York, June 1917). For a discussion of these images in *391* see William A. Camfield, *Francis Picabia:* (Princeton: Princeton University Press, 1979), 104.

The *Tzanck Check* and Related Works by Marcel Duchamp

Peter Read

A long and varied series of works by Marcel Duchamp seems to indicate a deeply rooted fascination with the subject of hair: his newspaper cartoon on the art of the parting, *La Critique est aisée mais la raie difficile* (1910); *Peigne* (1916); *Apolinère enameled* (1916–17, where the reflection of the girl's hair is added to the mirror); *Tonsure* (1919, where Duchamp's star-shaped tonsure may refer to "La Tête étoilée," last section of Apollinaire's *Calligrammes*, and/ or to the "head-light child," "a comet with its tail in front," in the 1912 text "The Jura-Paris Road"); *L.H.O.O.Q.* (1919); *Obligations pour la roulette de Monte Carlo* (1924, where face and hair are covered with shaving foam); *Rrose Sélavy, oculisme de précision, poils et coups de pied en tous genres* (1939, volume of puns); *Moustache et barbe de L.H.O.O.Q.* (1941, frontispiece for Georges Hugnet's poem, "Marcel Duchamp"); *L.H.O.O.Q. rasée* (1965); *Étant donnés: 1° la chute d'eau, 2° le gaz d'éclairage* (1946–1966, where the girl's pudenda are bare, perhaps shaved). Duchamp wears a wig as Rrose Sélavy, a false beard as Adam in *Relâche,* and the list may be lengthened by inclusion of the hair's-breadth capillary tubes, attributes of the Bachelors, over which hang the razor-like scissors in the *Large Glass.*

This leitmotif, hair and its absence, may be symptomatic of a concern Duchamp mentioned in a letter to Jean Crotti in March 1919: "I was losing my hair some time ago but a powerful treatment of Yvonne's and a crew-cut seem to have saved it *for a while."*[1] This could also of course be a running joke with the balding Crotti, who crowned his 1915 wire portrait of Duchamp with a particularly bushy head of hair.[2] Certainly Duchamp's art, like certain poems of Baudelaire and Mallarmé, displays a particular sensitivity to the erotic qualities of hair, associated more particularly in his case with androgyny and adolescence, the growth of sexuality. Freud confirms the sexual significance of hair, but in *The Interpretation of Dreams* (1900) writes: "To represent castration symbolically, the dreamwork makes use of baldness, hair-cutting, falling out of teeth and decapitation."[3] The symbolism of baldness and hair-cutting seems appropriate to Duchamp's work, and *Fresh Widow* (1920), because of its links with the guillotine,[4] is associated with decapitation. Significantly, given the connection decapitation/castration, this was the first work Duchamp signed using a female pseudonym, "Rose Sélavy." The teeth to which Freud refers may be represented by *Peigne,* and indeed the choice of this readymade dog comb was prompted by a note in *The Green Box,* dated September 1915:

Use, as a proportional control, this comb with broken teeth, on another object made up, also of smaller elements (smaller so that it can accommodate this control). For example, lead wires more or less thick, laid one against the other in one plane (like hair).[5]

It seems likely, as William Camfield has suggested, that the teeth of this readymade were intended to comb the wire hair of Crotti's portrait of Duchamp.[6]

The association of teeth and hair is present also in *L.H.O.O.Q.*, where the sitter's mouth becomes a *"vagina dentata,"* embellished by her *"abominables fourrures abdominales."* Again according to Freud, "tooth dreams involve a transposition from a lower to an upper part of the body."[7] So she threatens castration, looking pious as a praying mantis. Furthermore, Duchamp's short 1919 stay in Paris gave birth not only to *L.H.O.O.Q.*, in October,[8] but also to the *Tzanck Check*, dated December 3rd 1919, made by Duchamp for his dentist, just as Mallarmé once composed a witty quatrain for his barber Emile. Having restored the health of his hair, Duchamp sees to his teeth, and, fortunately, whatever subconscious obsessions may be revealed, both teeth and hair trigger creativity.

Because of the *Tzanck Check*, Duchamp's dentist has slipped into the history of art. Until now, however, little has been known of him, a gap which can here be filled.[9] Daniel Tzanck (1874–1964) was born in Tiflis but in 1886 left his Caucasian homeland with his family, refugees from a wave of pogroms. Settled in Paris, they founded a successful business manufacturing kefir, a fizzy milk drink, and in 1896 Daniel, the eldest son, qualified as a dentist. His brother Arnault (1886–1954), close friend of Marie Laurencin, would become a great doctor, pioneer of blood transfusions in France. Daniel Tzanck (Fig. 1) set up home and surgery at 177 boulevard Saint-Germain and soon counted poets and painters among his friends and patients, attracted by his enthusiasm for modern art and his willingness to be paid in kind with books, drawings and other works. He was very close to Jean Crotti, for example, a friendship which would last many years; and Guillaume Apollinaire, his neighbor at 202 boulevard Saint-Germain, would refer to Tzanck in the *Paris-Journal* of 24 July 1914 as "the well-known Parisian art-lover, President of the Odontological Society of France."[10] Apollinaire gave Tzanck several signed first editions of his work (*Le Bestiaire, Alcools, Méditations esthétiques, Le Poète assassiné*) as well as a water-color he painted in 1916.[11]

After the Great War Tzanck was well known as the founder and spokesman of the S.A.C. (la Sociéte des Amateurs d'Art et des Collectionneurs), whose directors also included Paul Guillaume, André Salmon and Crotti.[12] In her memoirs, Berthe Weill recalled those days:

A society of collectors is formed, presided over by M. Tzanck, the dentist. The speeches he makes move and excite the members of the society and so they grow to love the work of *young* painters. M. Tzanck has the brilliant idea of setting up a little exhibition which we label the "salon de la folie dentaire."[13]

The first "Salon de la folle enchère," to give the exhibition its true name, took place in November 1923 and presented a retrospective of 8 Impressionist

paintings and 183 works by contemporary artists, including Crotti, Derain, Dufy, Suzanne Duchamp, Laurencin, Léger, Picabia, Picasso, Van Dongen, and Villon.[14] The show was successful and became an annual event until 1931, exhibiting works lent by private collectors and members of the society, including Henri-Pierre Roché, Rolf de Maré, Paul Poiret, Maurice Girardin, and Tzanck himself. Judging from the illustrated catalogues, the exhibitions of January 1925 (110 pictures by 19 artists) and February 1930 (juxtaposing important early and recent works by artists such as Picasso, Léger and Matisse) were the most spectacular. The S.A.C. would relaunch these annual salons in 1947.

The presidency of the S.A.C. provided Tzanck with a platform for his ideas and opinions, and he used the press to castigate the artistic atavism of the French authorities, referring to the Paris College of Art as "that necropolis," protesting that "you have to go to Moscow if you want to see a representative collection of recent French painting" and proposing the creation of a museum of modern art in Paris.[15] In July 1928 the society launched its own glossy monthly periodical, the *Bulletin de la S.A.C.*, which included articles

Fig. 1 Daniel Tzanck as medical officer, September 1916.

by Crotti, Tzanck, Salmon, and Raynal, and reproductions of modern paintings, reports of sales and exhibitions and of all the society's activities, including Saturday outings to artists' studios and private collections, and dinner parties where artists and collectors could meet. This was a tradition in the S.A.C., whose annual dinner of 1924 included a prize drawing for works of art and "witty speeches" by Tzanck and Crotti, who had also "decorated the room beautifully." In the summer of 1924 another dinner party took place on the grounds of the house of Paul Poiret, couturier and collector, and guests included Raoul Dufy, Fernand Léger, Kees Van Dongen, and Pierre MacOrlan, as well as Tzanck and many others.[16]

Daniel Tzanck's own collection was of course impressive, and Maurice Raynal, for example, in his *Anthologie de la peinture en France de 1906 à nos jours,* published in 1927, often mentions Tzanck among the great collectors of the day. He had an eye for a bargain and in 1921, at the second of the four Kahnweiler sales in Paris, when prices were low, he acquired several works by Braque, Léger, and Vlaminck. Often he would resell at a later date, so a Marie Laurencin, for example, *La Famille du poète,* dated 1908, bought by Tzanck at the Hôtel Drouot auction house on 29 April 1927 for 3950 francs, was resold there on 2 March 1929, acquired for 6500 francs by Helena Rubinstein.[17] Tzanck's fortune was in fact comparatively modest but his collection was in a state of constant renewal. The records of the two great auction sales of works from the Tzanck collection at the Hôtel Drouot, 4 June 1925 and 23 May 1949, indicate that he tried to collect works representing all the tendencies in twentieth-century French painting.. The 1925 sale included 111 works by 54 artists, including Van Dongen, Dufy, Modigliani, Picasso, Soutine, and Vlaminck, with the highest prices attained by Derain and Utrillo, while the 1949 sale, which was equally varied, also included works by Ernst, Picabia, Severini, and Villon.[18] The June 1925 sale was one of the first large auctions in France of modern art from a single collection, and its success, after the disappointing prices reached in the Kahnweiler sales (13–14 June and 17–18 November 1921, 4 July 1922, and 7–8 May 1923) and in the Éluard sale (3 July 1924), did much to establish modern art as a recognized value in the French market, a fact which the art establishment would have to start taking into account.

Tzanck's major assets seem to have been his energy and enthusiasm. Paul Guillaume would say in 1927, for example, "At the age of 35 I feel that my old ardor has disappeared. I just don't have the unfailing youthfulness of Dr. Tzanck, disconcerting as it is."[19] For Francis Carco a good deal later, Tzanck was still "the most enthusiastic and clear-sighted art-lover you can imagine."[20] In 1919 these qualities must have amused Duchamp when he was introduced to Tzanck, probably by Jean Crotti, now married to Suzanne Duchamp. Crotti was himself best known in New York, according to Francis Picabia, as the "mischievous dentist" (*"dentiste malicieux"*).[21] Tzanck's earlier friendship with Apollinaire must also have created a bond; and of course Duchamp, fascinated by the precision of scientific experimentation, had always counted among his friends such medical men as Ferdinand Triboul, a pioneer of radiology in France, and R. Dumouchel, whose portrait Duchamp had painted with a halo around his left hand.

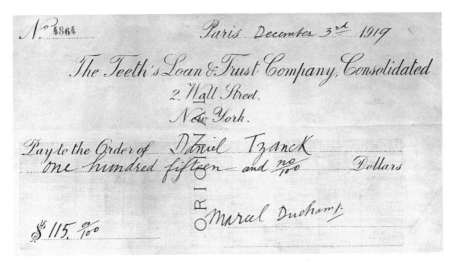

Fig. 2 *Tzanck Check*, December 3, 1919. Collection Arturo Schwarz, Milan.

Tzanck owned two works by Duchamp, the *Tzanck Check* and a *Monte Carlo Bond*. It was probably the pleasing alliterative coincidence of the words "Tzanck" and "Check" which originally sparked the idea for the first of these two works. The *Tzanck Check* (Fig. 2) is a slightly larger-than-life facsimile which looks printed but was in fact hand drawn, apart from the background to the lower half of the document, which was stamped with the phrase "the teeth'sloanandtrustcompanyconsolitated" [*sic*], endlessly repeated in tiny lettering and in perfectly regular lines. A rubber stamp of the phrase was made specially to be used on this one occasion and the result corresponds to the complicated patterns printed on bank notes and other official documents in order to discourage forgery. Similarly the word "ORIGINAL," vertically printed across the check in red capitals, is intended to emphasize the authenticity of this fake check which thus, like the earlier readymades, raises once more the question underlying so much of Duchamp's thinking: how does one define and differentiate an authentic work of art? The check is hand-made, not ready-made, and the artist has painstakingly applied his skill to the manual imitation of an item which modern techniques of mass production would normally print out in an instant. Man mimics machinery, and this functional amalgam of human and mechanical is a new aspect of the anthropomorphic figuration which typifies many works of this period, including those of Dadaists Duchamp, Picabia, and Ernst.

Published in the first issue of Francis Picabia's short-lived periodical *Cannibale*, 25 April 1920, the *Tzanck Check* was there given the title *Dada Drawing* (*Dessin Dada*). This title is justified in that Duchamp, working with patient dexterity from a preliminary blueprint, produced an article which, again like the readymades, stands outside the accepted parameters of artistic creation. Apollinaire in *The Cubist Painters* had described Duchamp as an artist already "detached from aesthetic preoccupations," and the *Tzanck*

Check indeed undermines traditional aesthetic values by rendering useless most of the criteria which could normally be applied to the judgment of a work of art. In response to Pierre Cabanne's question "What have you done to escape taste?" Duchamp would reply, "Mechanical drawing. It upholds no taste, since it is outside all pictorial conventions."[22] At the same time the work makes an implicit statement on the inextricable association of art and money in Western culture. Where others sign a check to obtain cash, an artist may sign a drawing. In the *Tzanck Check* the two gestures coincide.

Robert Lebel quotes a 1921 letter from Duchamp to Tzara, suggesting the production of Dada necklaces:

> The *act* of buying this insignia would consecrate the buyer as Dada. . . . the insignia would protect against certain diseases, against the numerous annoyances of life, something like those Little Pink Pills which cure everything. . . . Nothing "literary" or "artistic," just straight medicine, a universal panacea, a fetish in this sense: if you have a toothache, go to your dentist and ask him if he is a Dada. . . .[23]

Writing to Tzara, Duchamp doubtless remembered Tzanck. According to Lebel, by accepting and keeping the fake check, Tzanck himself became a Dada dentist.

The *Tzanck Check* was created immediately after the iconoclastic *L.H.O.O.Q.*, whose title may be read as "Look" in English or in French as an irreverent explanation of the lady's enigmatic smile. Whatever Freudian significance may link the two works, Duchamp suggested to Pierre Cabanne that in both of them similarly amusing word-games may be decoded.[24] The transatlantic nature of the apparently American check, made out in dollars to a Parisian dentist, suggests that such puns are again likely to be bilingual. The title *Tzanck Check* – in French *Chèque Tzanck* – certainly suggests, by homophonic association, "blank check" or, in French, *"chèque en blanc."* Indeed, though it is made out for the sum of $115, Duchamp informed Arensberg in a letter of 16 July 1940 that he could buy the check from Tzanck for $50.[25] Then Duchamp would tell Pierre Cabanne that he himself "bought it back twenty years later for a lot more than it says it's worth!"[26] So the Tzanck check really is a blank check: being "artist's money," like any work of art it has no fixed value. The check was issued by "The Teeth's Loan and Trust Company," punning on the trust between patient and dentist. In French "teeth" translates as *dents,* which may in turn suggest *dons,* meaning "gifts," and so this becomes the only bank making gifts as well as loans, "The Gifts Loan and Trust Company."

Duchamp is also probably punning on the artistic and commercial definitions of the verb "draw" and its French equivalent *tirer.* One may draw a picture or draw a check (in the sense that one draws a salary). With this *Dessin Dada* Duchamp has literally drawn a check for a man whose profession it is to draw teeth. Coincidentally, "to draw" may also mean "to render into another language or style of writing, to translate" (*Oxford English Dictionary*) and Duchamp has translated into dollars a dental bill incurred in France. Similarly Duchamp apparently enjoyed punning on the word *tirer.* The chimney-top ventilator, a lost readymade, was inscribed *"Tiré à quatre épingles,"* literally "Pulled at four pins" but meaning "Dressed up to the nines,"

and the *Monte Carlo Bonds* are redeemable by *"tirages artificiels,"* tirage here meaning "draw" in the sense of "prize-drawing" or "lottery." The pun on *tirer* implied by the *Tzanck Check* is effective because, as in English, so in French one may *tirer un trait, un portrait* and *tirer un chèque. Tirer* may also mean "to print," as in the artist's mark of approval *bon à tirer;* Duchamp had even worked as a printer in 1905.[27] So in this case the phrase *tirer un chèque*, as well as having a commercial meaning, refers to a work which was both printed (the fine background lettering) and drawn, with the drawing itself an imitation of printing.

In 1965 Duchamp produced two documents known as the *Czech Check* and the *Chèque Bruno*, which have been described thus:

> The first consisted of his signature added to a membership card for John Cage in a Czech mycological society, which Duchamp wittily entitled *Czech Check;* the second was a signed blank check made payable to "Philip Bruno," for an "unlimited" amount, drawn on the "Banque Mona Lisa."[28]

Amusing items in their own right, these works may also be seen as footnotes confirming underlying traits in the original *Tzanck Check:* the importance of bilingual homophonic coincidence; the check's status as a blank check and an art object of unlimited value; and the association with *L.H.O.O.Q.*, the Mona Lisa being the archetypal example of a "priceless work of art." The two 1965 checks continue a game begun in 1919, the same year that Duchamp began to pursue a more serious interest in another activity which he had known since childhood. From Buenos Aires on 9 March 1919 he wrote to Jean Crotti: "I have thrown myself into the game of chess. I belong to the local club and, out of twenty-four hours in a day, I spend a good number there."[29] In 1919 he launched into both chess and checks, *jeu d'échecs* and *jeu des chèques.*

The *Monte Carlo Bond (Obligations pour la roulette de Monte Carlo)* (Fig. 3) owned by Daniel Tzanck was number seventeen from a series of thirty. Dated November 1st 1924 it is also both a work of art and a parody of a financial document, inspired in part by family background. Of his father, a notary in Normandy, Duchamp would say, "I remember my father's legal papers; the language was killingly funny."[30] The ambiguous nature of the document again implies humorous comment on the purchase of art as investment — though Duchamp himself was not above a little wheeling and dealing in Brancusi sculptures — and also illustrates his belief that the fame and fortune of an artist depend largely on Lady Luck. He explained this view to Jean Crotti in a letter of 17 August 1952:

> Artists throughout history are like gamblers in Monte Carlo and in the blind lottery some of them are picked out while others are ruined. . . . It all happens according to random chance. Artists who during their lifetime manage to get their stuff noticed are excellent commercial travellers, but that doesn't guarantee a thing as far as the immortality of their work is concerned.[31]

The bonds were issued in order to raise sufficient funds for Duchamp to test a formula he had devised to turn the odds at roulette in the player's favor, pitting the logic of chess against the luck of the gaming tables. Indeed

101

he wrote to Jacques Doucet: "Don't be too skeptical, since this time I think I have eliminated the word chance. I would like to force roulette to become a game of chess."[32] Having integrated the results of his controlled experiments with chance into the *Large Glass*, Duchamp contrives permutations in red and black which challenge Mallarmé's assertion that "a throw of the dice will never abolish chance."

The bond itself is a colored lithograph representing the surface of a roulette table with a photograph of Duchamp's head, covered with shaving foam, his hair pulled up into the horns of a faun or devil, stuck onto the roulette wheel which forms a surrounding circle, similar no doubt to the halo which, in Henri-Pierre Roché's eyes, Duchamp always wore.[33] Cut out (decapitated) from a larger photo by Man Ray, Duchamp's head resembles that of John the Baptist, presented on a plate. With his erect horns of hair ready to be shaved off, the male falls victim to both Salome and Delilah – a powerful recurrence of serrated symbolism. On three sides the bond is framed by the

Fig. 3 *Monte Carlo Bond, no. 17*, 1924. Private collection, France.

uninterrupted phrase, printed 150 times in small green letters, "*Moustiques-domestiquesdemistock,*" and all thirty copies of the bond were individually numbered, then signed and countersigned "Rrose Sélavy," "Marcel Duchamp." They were to be sold at five hundred francs each with a guarantee of twenty percent interest, but only those bearing an initialled fifty-centime stamp next to the photocollaged head of Duchamp were to be considered as legally certified shares in the company. Tzanck's copy of the bond is one of the very few examples of the original issue stamped in this way and should be added to the four copies identified to date.[34] Tzanck held onto the bond throughout his life and it seems unlikely that he ever claimed his twenty percent interest. This was however a particularly appropriate investment for him, given that the tool of his trade, a dentist's drill, is known in French as a *roulette.*

Some thirty years later Duchamp returned to dentistry with his *Wedge of Chastity* (*Coin de chasteté*). In fact the title *Chastity Wedge,* echoing "chastity belt," would be a better English equivalent of the French *coin de chasteté,* which echoes and resembles *ceinture de chasteté.* Made in 1951–52 and inscribed "Pour Teeny 16 Jan. 1954" as a wedding gift for his wife, Alexina Sattler,[35] this small sculpture comprises a wedge of dark galvanized plaster gripped by a piece of glistening pink dental plastic, the contrast in color and texture of the interlocking materials adding interest to the obvious sexual connotations of the work, which indeed may be seen as a sado-masochistic alternative to a chastity belt or, equally, as a new variation on the "*vagina dentata.*" A further expression of Duchamp's unrelenting fascination with the grip of Eros on the human psyche, it fuses male and female principles into an androgynous unity which again recalls *L.H.O.O.Q.* as well as Duchamp's own masquerading as Rrose Sélavy. There is a certain phonetic concordance between the titles *Chèque Tzanck* and *Coin de chasteté,* and it is certainly possible that memories of Daniel Tzanck lay behind this first use of dental plastic in modern art.

In Duchamp's work willful polyvalence and lucid artistic control are apparently subverted by the play of chance and the intervention of subconscious fears and desires, expressed through a group of recurring symbols. It is however debatable whether such a sophisticated surrealist as Duchamp could long have remained innocent of the significance of these symbols as they continued to appear in his work. The longer one contemplates a sample selection of his apparently disparate artifacts (with one eye for nearly an hour should perhaps suffice), the clearer it becomes that a complicated web of cross references, operating at several conscious and possibly subconscious levels, binds these works into a singular conceptual coherence and continuity. It also becomes possible to propose that to the list of Marcel Duchamp's many occupations, from printer to pataphysical dignitary, should perhaps be added the titles of capillary artist (from *artiste capillaire,* French for "hairdresser") and practitioner of dental art (from *art dentaire,* French for "dentistry").

Notes

1. Francis M. Naumann, "'Affectueusement Marcel': Ten Letters from Marcel Duchamp to Suzanne Duchamp and Jean Crotti," *Archives of American Art Journal* 22, no. 4 (1982), 12.

2. *Tabu Dada: Jean Crotti and Suzanne Duchamp, 1915–1922*, ed. William A. Camfield and Jean-Hubert Martin (Bern: Kunsthalle; Paris: Centre Georges Pompidou; Houston: Houston Museum of Fine Arts; Philadelphia: Philadelphia Museum of Art, 1983), 93.

3. Sigmund Freud, *The Standard Edition of the Complete Psychological Works*, translated from the German under the editorship of James Strachey, vol. 5 (London: Hogarth Press, 1953–1971), 357.

4. Jean Clair, *Marcel Duchamp: Catalogue raisonné* (Paris: Centre National d'Art et de Culture Georges Pompidou, 1977), 98. Clair refers to guillotine windows and reminds us that *veuve* ("widow") is French slang for guillotine.

5. Marcel Duchamp, *Salt Seller* (New York: Oxford University Press, 1973), 71, quoted by William Camfield, "Jean Crotti and Suzanne Duchamp" in Camfield and Martin, *Tabu Dada*, 14.

6. Camfield and Martin, *Tabu Dada*, 14.

7. Freud, *Standard Edition*, vol. 10, 316.

8. Pierre Cabanne, *Dialogues with Marcel Duchamp* (London: Thames and Hudson, 1971), 62.

9. I am indebted to André Tzanck, himself a painter, born in May 1899, who was able to supply a great deal of information on the life and work of his father, Daniel Tzanck.

10. Guillaume Apollinaire, *Chroniques d'art,* texts collected, annotated and edited by L. C. Breunig (Paris: Gallimard, 1960), 518. Translations of this and other quotations by the author.

11. For further details, see Peter Read, "Gestes et opinions du Docteur Tzanck, défenseur de l'art moderne, virtuose de l'art dentaire, ami de Guillaume Apollinaire, étude suivie de la publication en collaboration avec Gilbert Boudar d'une correspondance inédite entre Apollinaire, Marie Laurencin, et Daniel Tzanck," *Que vlo-ve? Bulletin international des études sur Apollinaire,* series 2, no. 20 (October–December 1986), 3–25.

12. *Les Arts à Paris* 7 (January 1923), 8.

13. Berthe Weill, *Pan! dans l'Oeil, ou trente ans dans les coulisses de la peinture contemporaine, 1900–1930* (Paris: Librairie Lipschutz, 1933), 274.

14. *Catalogue. Salon de la Folle Enchère. Exposition de Cent Peintures* (15–30 November 1923) (Paris: Hôtel de la Chambre syndicale de la Curiosité, 1923).

15. *L'Art vivant,* no. 68 (15 October 1927), 855; letter to René Jean, *Comoedia,* 1 March 1925, 4.

16. *L'Intransigeant,* 13 April 1924, 2; *Les Nouvelles littéraires artistiques et scientifiques,* 28 June 1924, 4.

17. Malcolm Gee, *Dealers, Critics and Collectors of Modern Painting: Aspects of the Parisian Art Market between 1910 and 1930* (New York and London: Garland Publishing, 1981), part 2, 53, 61, 85, 156.

18. See the catalogues of the two sales, published by the Hôtel Drouot, and, for the result of the 1925 sale, *Le Journal des arts chronique de l'Hôtel Drouot* 47, no. 51 (4 July 1925), 2.

19. E. Tériade, "Nos enquêtes: Entretien avec Paul Guillaume," in "Feuilles volantes," 1, supplement to *Cahiers d'Art* 2, no. 1 (January 1927), 1-2.

20. Francis Carco, preface, *André Tzanck oeuvres récentes*, exh. cat., 15-30 June 1945 (Paris: Galerie Bosc, 1945).

21. Pharamousse [Francis Picabia], "Odeurs de partout," *391* 1 (25 January 1917), 4.

22. Cabanne, *Dialogues*, 48.

23. Robert Lebel, *Marcel Duchamp* (New York: Paragraphic Books, 1959), 96-97.

24. Cabanne, *Dialogues*, 63.

25. Francis M. Naumann, *The Mary and William Sisler Collection* (New York: Museum of Modern Art, 1984), 193.

26. Cabanne, *Dialogues*, 63.

27. At the end of his printer's apprenticeship Duchamp sat for and passed an examination: "The jury was composed of master craftsmen, who asked me a few things about Leonardo da Vinci" (Cabanne, *Dialogues*, 20). This creates a further possible cross reference between *L.H.O.O.Q.* and the *Tzanck Check*.

28. Naumann, *Sisler Collection*, 192-93.

29. Naumann, "Affectueusement Marcel," 12.

30. Cabanne, *Dialogues*, 103.

31. Camfield and Martin, *Tabu Dada*, 8.

32. Naumann, *Sisler Collection*, 202-3.

33. H. P. Roché, "Souvenirs of Marcel Duchamp," in Lebel, *Marcel Duchamp*, 79.

34. Naumann, *Sisler Collection*, 203, n. 10.

35. This date of fabrication is proposed by Anne d'Harnoncourt and Walter Hopps, "'Etant donnés: 1° la chute d'eau, 2° le gaz d'éclairage': Reflections on a New Work by Marcel Duchamp," *Philadelphia Museum of Art Bulletin* 69, nos. 299 and 300 (April–June and July–September 1969), 35, 38.

Duchamp's Silent Noise/
Music for the Deaf

Carol P. James

Une boîte de Suédoises neuve qu'on
vient d'acheter est plus légère qu'une
boîte entamée parce qu'elle ne fait pas
de bruit.[1]

The verbal-visual complications Duchamp invites his regardeur[2] to explore must be understood also to encompass the aural dimension. The regardeur is as well an ear-eur listening to a music, not of the spheres, but of the ready-made world. Duchamp's crashing into the scene of traditional lines of discourse, that is, into the representation-centered dialogues of painting and literature, forces a shift in the consideration of how art functions and gets meaning. When we realize that Duchamp's jumble of words and images forms a corpus which is neither painting nor literature, we understand that his musical clasms also fall into a non-place as far as critical canons are concerned. Musical composition seems to occupy a minor status in the oeuvre of one known for keeping quiet most of the time,[3] but a closer look reveals Duchamp's constant and penetrating preoccupation with sound.[4] His earliest drawings and satirical cartoons include several references to bourgeois salon music. Among his rare stage performances were two musical events: his brief December 1924 appearance during Satie's ballet *Relâche* as Adam in a *tableau vivant* of Cranach's *Adam and Eve,* and, during the last year of his life, chess games with his wife Teeny and John Cage on a board wired for music.[5]

Aiguiser l'ouïe (forme de torture)[6]

Written small, very small, on the vast surface of the painting *Tu m',*[7] a signature-sound, "A. Klang," becomes one of the artist's numerous aliases.[8] In English an onomatopoeia, in German meaning sound, tone, timbre, a "klang" rings both strange and clear. Clear because the name and hand are easy to decipher. Strange because, among the shadows of readymades and other forms that fill this modernist equivalent of the artist's studio painting, the signature sounds off, *sonne faux,* as it bypasses the "true" artist and hits a note of irony, a work commissioned by an artist himself on commission to a patron.[9] The "Klang" signature puts the entire endeavor between quotes, the title saying to the clang, *"tu m'apostrophes," "you* address *me,* put *me* in

quotes." The tiny quiet aural element disappears completely when the regardeur looks over toward the left edge to read Duchamp's signature. The finger points to the right, away from the signatures. The three signers (hand, "A. Klang," "Marcel Duchamp") speak in silence, in an unknown key signature. A "signer" communicates with the deaf by gestures, but here the multiple signers paint the difference between gesture and text, the divorce between painter and signature. Who signs? The regardeur/ear-eur must finish off the work with an other signature, one's own. Duchamp's question "Can one hear listening . . . ?" (DDS 276)[10] would have (at least) two answers: first, that the audial lacks a self-critical or meta dimension; second, that, like the visual and the textual, the audio can be translated into another mode. Duchamp's "ideal" ear-eur is deaf, hears nothing at all: hearing/understanding his music is a critical participatory practice rather than a physical skill. Better to put one's ear to the silently turning *Bicycle Wheel* than into a torturous sharpener.[11]

To practice turning a deaf ear, Duchamp suggests "Exercices de musique en creux pour sourds." [12] *Avoir du creux* means to have a good resonant bass voice, but for the deaf the space is hollow, *creux*. To speak into the "hollow" (*dans le creux de l'oreille*) is also to speak confidentially, up close, telling "what must be heard by the right ear" or "what must be heard with the left ear." This note from the *White Box* refers to an audio element of the Bachelor Apparatus, the "Crash–Splash" for which "one could find a series of things to hear (or listen to) with only one ear."[13] "Hollow paper" (N 17, 19) carries on the notion and suggests the sort of ruled music paper Duchamp used for his drawing *Avoir l'apprenti dans le soleil* (Fig. 1), from the *Box of 1914*, and the pun collection from the *Boîte en Valise, Morceaux moisis / Written Rotten* (Fig. 2).[14]

One posthumous note defines more specifically the hollow music exercise: "Given an agreed/conventional number of music notes, 'hear' only the group of those which are not played."[15] This principle guided Duchamp in his various musical compositions, most of which are based on linear series of notes "used up" as the piece progresses. An example: "from a (tune) group of 32 notes e.g. / on the piano / no more emotion, but *enumeration* by cold thought of the 53 other notes which are missing" (N 181).[16] To act deaf, one forgets the notes heard and cerebralizes, counts up, those missing. Where ordinary listening distinguishes notes by pitch and length, seeking out similarities and considering differences as variations or detours away from a key, these pieces ignore such conventions and instead require the ear-eur to assign value to silences, the choice being limited to those notes not already used. These exercises in hollow music, or "gap music" as Pierre Matisse has translated it,[17] eliminate sound as a basis of pattern because no note is repeated.

Deaf music, then, is more closely related to numbers than to tonal affinities and differences; it recalls the close association of music and arithmetic that goes mostly forgotten today, except among neurologists who puzzle over the fact that child prodigies – and idiot savants – usually excel in music or mathematics. Even systems like the twelve-tone scale do not work on a numerical principle such as this. Duchamp's longest musical piece, *La Mariée mise à nu par ses célibataires, même / Erratum musical*, specifying that the "virtuoso intermediary [be] suppressed," and "performance useless any-

Fig. 1 *Avoir l'apprenti dans le soleil.* Philadelphia Museum of Art, Louise and Walter Arensberg Collection.

way,"[18] further undercuts the idea of what constitutes music. Singing ("le chant") figures among the "small energy sources wasted" (*DDS* 272, *N* 187). Without performance, music is text, readable by anyone knowing the code, deaf or hearing. Eliminating performance also cuts off the public's "empathy" for the plight of the performer and the interpretational choices of performers whose personal style and virtuosity define an additional space heavily colonized by the Romantic criticism Duchamp tried to escape with his "precision and beauty of indifference" (*DDS* 46). Duchamp's musical diversions formed part of his program to pull art, kicking and screaming,[19] out of its conventions and judgments based on taste.[20]

Duchamp's radical experiments in sound were also part of his escape from the visual[21] and really had little to do musically with the compositions of experimenters like Satie or Stravinsky, whose 1913 *Sacre du printemps* coincided in notoriety with the *Nu descendant un escalier.* Duchamp found in

music a highly conventionalized, overly mythologized form of art ready to be opened up. He had more in common with the chance procedures that were to come much later in the work of Cage. But where Cage uses silence as a listening tool, an expansion of what can be "music," Duchamp used music to show how to silence it, how an art form can cut into itself and still be, or be even more so, art.[22]

Duchamp's first *Erratum Musical* (Fig. 3) (*DDS* 52–53, Cat. 196), dated 1913 and included in the *Green Box,* randomly arranged a sequence of twenty-five notes from F below middle C up to high F. A parallel use of chance was the dust breeding (*DDS* 77, Cat. 269) he let happen for the coloration of the sieves on the *Large Glass: faire des poussières* (make dust) means "hit clinkers." Two versions of the *Erratum* are labeled "Yvonne" and "Magdeleine" for his sisters; the third or "Marcel" part relocates the five highest notes to the octave below middle C to make the piece singable for male voice. The notes are written in standard fashion on staff-ruled paper with treble and bass clefs and the necessary sharps and flats, but without a key signature. Each note is an accidental in the musical sense as well as by the mode of composition. The lack of a time signature or measure markers leaves the piece a-rhythmic. There is no indication that the three parts should be sung separately, simultaneously, or as a canon. Using *all* the notes in a given range in a random order, bypassing the usual compositional choices of key, rhythm, tonal complexity, and variation of loudness, Duchamp erases the

Fig. 2 *Written Rotten,* from *Box in a Valise.* Reproduced with permission of Mme A. Duchamp.

ear-eur's listening habits and leaves as the only guide a guessing game about what the next note will be. As chance narrows the field, only the last note is predictable. One may as well be deaf because the piece works more like a game of Old Maid than a tune formed of repetitions and returns of tones and rhythms.

Duchamp's err-song displaces the art song. In his usual punning sense he interchanges R and art, using the French and English pronunciation of each.[23] The "musical R-atum" opera-tes his later transferral into the excess R/art of Rrose Sélavy whose *Belle Haleine* perfume (Cat. 271) echoes Offenbach's *La Belle Hélène* whose *airs* (arias) parody the grand traditions of opera.[24] Though using the tonal gradations common to Western music, *Erratum* of course contains no actual errors, following its own method to the end. It sounds like noise, mistakes, because it violates the established method of perceiving music as melodious sequences.[25] Its visual avatar is the *3 Standard Stoppages* (Cat. 206) where the air on three strings erased the standard meter and produced three versions of the measure more in tune with non-Euclidean geometry, the "canned chance" (*du hasard en conserve*, DDS 50) or "diminished meter" (*DDS* 36) taught at a conservatory of pataphysical music. Each note of the *Erratum* is a quarter note or stop, and each series of notes drawn from the hat will designate a unique profile for each version; this too, then, has a visual rather than an audial meter. Musical measure is an ideal or arbitrary time defined as the reoccurrence of small units (measures) within which a certain note in the sequence is louder or longer than the others. To bend meter in music, *Erratum* actually straightened it out, giving each note the same time value. Having no difference of length in relation to each other, the notes have no real time at all; all are equally hollow. The *Erratum,* which lacks the rhythmic and harmonic repetition that defines "Cartesian" music, steps radically away from the music of its time in spite of its simple composition.

The words Duchamp set to the music, a definition of "to print" chosen "at random" in a dictionary, must be squeezed into the twenty-five available notes by eliminating several mute e's: "Faire une em-prein-te mar-quer des traits u-ne fi-gure sur une sur-face im-pri-mer un sceau sur ci-re" (*DDS* 52–53).[26] The assonances of gure/sur/une/sur and the alliteration of sceau/sur/cire graft onto the music certain effects of repetition the music itself lacks. The last word, wax, may stop the song and the ear, but its phonetic form enables the *Erratum* to multipun on sound, sight, and silence in a way which would jolt the champion of the arbitrary sign, Saussure, who is "accidentally" in the piece, *sceau sur.* The *ci* of *cire* twice corresponds with C notes and the key of C, by default the piece's signature. The method of composition of the "musical misprint," and the sounds' rebus-like fit with the words, join in the further irony that this piece is one that one sees, seeing hearing. The hearer is a see-er (seer/sear/*cire*/*scieur* [sawyer]), always the regardeur who scores through the word, hears through the visual. The *Rotoreliefs* (Cat. 294) turn silently in place of a record, presenting to the see-er illusions of colorful three-dimensional designs.[27] The erratum taken as R/art will always have as its function to sear, "burning all aesthetics" (*DDS* 104). The medium of early musical recordings, wax, took the imprint of sound, transforming it

into a three-dimensional space that turned round and round upon itself.

The text of *Erratum* cannily repeats the processes of reproduction of meaning, be they the printing of alphabetic letters, the visual traces codified as representations of meaning, i.e., writing, or the do-re-mi ("mi sol fa do ré"[28]) of the musical code recorded in wax. In one sense, musical representation is performance or individual reproduction and interpretation within certain traditional limits of "expression." In another sense music represents syntactically a certain example of a genre or mode (for example, a symphony in C). But as music was Cartesianized, came to be understood as the expression of an individual mind and soul, it followed that music would have semantic meaning. No casual listener today would deny being able to distinguish "happy" from "sad" music, and much criticism remains strongly attached to judgments based on mimetic qualities. Music's capacity to "live" comes from the notion that harmony is a form of natural existence, an idea the eighteenth and nineteenth centuries recast so that music as a heavenly manifestation or natural phenomenon was replaced by music as one form of representation of the scientific order.[29] Duchamp's music by error patapositivistically

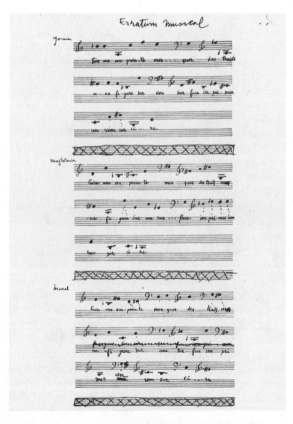

Fig. 3 *Erratum Musical,* from *The Green Box.* Reproduced with permission of Mme A. Duchamp.

replaces the harmonic order of the scale, twisting the re of do-Re-mi into the err/art of notes that cannot be repeated; this harmony is sub-audible, music for the deaf.

In the verbal domain, punning will always disrupt the harmonies of sound and sense because a twist away from the order of good sense must be operated. For Duchamp, the alphabetic do-Re-mi can just as well be read visually, letterally, in the manner of *L.H.O.O.Q.* The recently published notes contain pages of such letter games, where the entire panoply of Duchampian objects and thematics can be read, from short—"OR Auer," "RO héros," "LMRE Elle aime errer" (*N* 266) – to monumental, "LHIÉAUKQITNMKBCQFS Elle a chié avec acuité (?) et n'aime qu'à baisser cul et fesses" (*N* 267).[30] His word plays and spoonerisms, like those musty pieces, *Morceaux moisis*, operate alterations in sound as the interval of humor. His example of two pieces of corduroy rubbing against each other as the "auditory infra-thin" (*N* 11) sounds like the musical shorts he concocted in the pun "Caleçons de musique (abréviation pour: leçons de musique de chambre)" (*DDS* 155, *N* 288).[31] Among the captioned cartoons from his early career is one of a young man in tails, bowing slightly, asking "Miss, would you like to again?" " – New words for an old song" (Cat. 104). Puns on "piano à queue / piano aqueux" (grand piano / watery piano), which Duchamp will use again and again, occur in at least two cartoons. The first, titled *Flirtation*: "She – Would you like me to play 'On the Blue Waters'; you'll see how well this piano renders the impression suggested by the title? He (witty) – There is nothing surprising about that, Mademoiselle, it's a 'watery' piano" (Cat. 80). In the other, *Up All Night*, a woman in underwear, seated at a table in front of a bed, turns away from a fat bald man in shirtsleeves: "She – I don't want anything. Leave me alone. He – A piano? A grand piano?" In another, *The Maestro at Work*, a violinist performing for a couple comes to the end of the piece: "To end up [*mourir*] in a pianissimo."[32] And finally, in *Musique de chambre* (Fig. 4), a woman having what might be construed as a "caleçon de musique" says to a young man, "Button your jacket, here's the maid."[33] These drawings put the music in words, and the sexual allusions play on the Romantic sentimentality that turn-of-the-century music was saturated with. The "watery" piano turns upside down the notion of representation in music.

Other examples of music pictured include a drawing of Suzanne Duchamp seated at the piano (Cat. 77) and the 1911 paintings *Dulcinea* (Cat. 172) and *Sonate* (Cat. 171), in which Duchamp was experimenting with Cubist composition and the rendering of successive movement. Dulcinée, the heroine of Massenet's *Don Quichotte*, premiered in 1910, is *mise à nu*, unoperatically stripped of her clothing by Duchamp in three successive images. In *Sonate* his mother and sister Suzanne watch the two other sisters play piano and violin. (Madame Duchamp was quite hard of hearing and may or may not have enjoyed this music for the deaf.[34]) The same year he did a series of illustrations for poems by Jules Laforgue, a poet who especially attracted him: "'Le soir, le piano' – no one else could have written that at that time" (*DDS* 170). Two of the three pencil drawings that survive, *Médiocrité* (Cat. 173) and *Sieste éternelle* (Cat. 174), contain abstracted musical motifs: treble clefs, piano keys, what looks like the profile of a saxophone. The poem "Sieste éter-

Fig. 4. *Musique de chambre,* from *Le Courrier Français,* 1909–10.

nelle" uses a musical metaphor: "Et comme un piano voisin rêve en mesure / Je tournoie au concert rythmé des encensoirs."[35] These early visual musical references gave way to Duchamp's own compositions, and more verbal than visual play on music.

Avoir l'apprenti dans le soleil falls between the two categories of composing and picturing music, and it also combines the musical motif with the ready-made, in this case the *Bicycle Wheel.* The apprentice is in the *sol,* the sun or the key of G, the treble clef. These turning wheels, going up the musical staff or incongruously whirling on a seat, recall the wheeled instrument Duchamp saw in the performance of Raymond Roussel's *Impressions d'Afrique* in 1911 or 1912. A glass box on the platform contained fantastic thermal instruments made of the Rousselian metal "bexium."[36] Duchamp's "stripping naked in the form of a piano" (*N* 153, 250, 251, 252, 255) is the glass *Bride,* musical with litanies (*DDS* 82) and ear-shattering canons (*DDS* 54, 55, 119), and bisexual like the piano whose shape is both curvacious like the cartoon ladies and "à queue," with a tail. In place of bexium there might be Duchamp's "métal aqueux" (*DDS* 114) and machinery like the "collecteurs

... forme escargot ou lyre" (*N* 114) (snail- or lyre-shaped collectors). The stripped nude of *Etant donnés* is indeed contained within a box shape, reposing in silence. The mechanism that lights the waterfall behind her, making it look like flowing sparkling water, is a kind of music-less music box in which light from a fluorescent ring shines through holes in a turning disk. A music box works similarly with nubs on a disk which strike a kind of comb. All these wheels turn in place, repeating their monotonous tunes.

Sound and shape combine in an idea for a sculpture to be heard: "Musical sculpture / Lasting sounds coming from different points and forming a sound sculpture which lasts" (*DDS* 47), and this elaboration:

... a line of identical sounds can turn about the listener in arabesques (to the right/ left/ over/ under). . . . To develop: one could, with training of the listener's ear, manage to draw a profile which resembles and is recognizable – with more training make large sculptures where the listener would be at the center – E.g. an immense Venus de Milo made with sounds around the listener – That probably presupposes training the ear from childhood and for several generations. (*N* 183)

These operations turn around the playful rhetoric Erik Satie used in naming such operations as "3 Pieces in the Form of a Pear,"[37] but Duchamp's musical shapes keep to the pataphysical, unrealizable dimension. Satie's titles and annotations cross into the visual and literary realms and display a very Duchampian sense of displacement, wit, and even iconography. One collection proposed such titles and performance indicators as "Agreeable despair (calm / very sad / with a contagious irony / slow down [*retarder*])," "Poetry (rather blue / cloisterly / whiter / ad libitum / . . . on the water," "Canine prelude," "Depth," "Hollow dream," [*Songe creux*].[38] *Sports et divertissements,* composed in 1914 to accompany drawings by Charles Martin, includes further reminders of Duchamp: "Unappetizing chorale" ("surly and cantankerous"), "Le Flirt" [Flirtation], "Le Traîneau" [The Sled], "Le Water-Chute" ("If you have a solid stomach, you will not be too sick. . . . Don't change color"), and "Le Réveil de la Mariée" (The Bride's Awakening – "guitars made with old hats . . . a dog dances with its fiancée").[39] These "entertainments" are also to look at, to read (*lire* the lyre) with such effects as a five-measure fall in "Le Water-Chute" preceded by the word "Attention!"

Satie's *Musique d'ameublement* (furnishing music) includes "Wrought-iron Wallpaper" and "Phonic Floor Tile." This music relies on repetitions of thematic segments, like a music box or a decorative pattern, and, according to musicologist M. Bredel, "one would say that by repetition Satie tries to decompose music into sounds."[40] Satie subtitled *Relâche* "instantaneist ballet in two acts with cinematographic intermission and 'dog's tail,'" and Bredel characterizes the music for these events: "*Relâche* is a weaving of refrains; as for 'Entr'acte,' it is the pure state of furnishing music."[41] For *Relâche* Duchamp stepped out of his role as artist to be *in* a painting, acting like a piece of furniture to Satie's music of stasis. In 1967 Duchamp wrote for a friend's catalogue a dedication which puts the painter between the composer and Rrose, the lady who rhymes, who sounds like

Après "Musique d'ameublement" d'Erik SATIe
voir "Peinture d'ameublement" de Yo SAVY alias Yo Sermayer

Rrose SelAVY alias Marcel Duchamp
(*N* 214, *DDS* 250–51)

Also that year he reproduced his appearance in the ballet as *Selected Pieces After Cranach and "Relâche,"* one of the series of humorous erotic etchings called *Morceaux choisis* (Cat. 398), the final echo of the musty pieces so tastefully calligraphed on musical staves.

Satie's decompositions, however clever, kept within the realm of establishment music, and his verbal annotations lie in the same textual stratum as Duchamp's cartoon captions. In terms of composition Duchamp has more in common with Cage's serious play with chance than with Satie's whimsy. Like Cage, he sought ways to bypass taste and virtuosity in favor of surprise and change. But where Cage is Zen, Duchamp remains pataphysical. In 1913 he had suggested a form of mechanical music that replaces distinguishable tonal gradation with audial "forms":

Construct one and several precision musical instruments which *mechanically* give the *continuous* passage from one tone to another in order to be able to register without hearing them shaped sound forms (against virtuosism and the physical division of sound recalling the uselessness of physical color theories) (*DDS* 107).

The paradoxical "without hearing them" both indicates an infinitude of intertones and reiterates music for the deaf. The opposite extreme of a-semiotic tonality comes with the exactitude of perfect pitch, simply an alternate form of non-music:

The tuner – Have a piano tuned on the stage – EEEEEEEEEEEE – or make a movie of the tuner tuning and synchronize the tones on a piano or rather synchronize the tuning of a hidden piano – or Have a piano tuned on stage in the dark. Do it technically and avoid all musicianship – (*N* 199)

Unlike some postmodern music which valorizes those minimal differences of tone, Duchamp uses the tuning to display the non-difference between music performed and not performed. Cage's prepared piano works in a parallel way, replacing one's expectations of a certain sequence of sounds with an expectation of surprise. As *Relâche* and "Entr'acte" turn around the expectations generated by the titles, a tuning, normally signaling a performance to come, leaves an impression of non-art.

The avoidance of musicianship in these works relates them to readymades in that the artist's "paw," the individuality of creation, and the criteria of taste, accomplishment, and uniqueness give way to chance, standard manufacture, and duplicability. The second *Musical Erratum,* also dated 1913, the one titled *The Bride Stripped Bare by Her Bachelors, Even* (*DDS* 53), uses chance in an elaborate process of composition. The musical notation consists of numbers and letters, without conventional musical symbols, jotted on music paper followed by explanatory notes and diagrams. The version noted is an incomplete example of the process as defined,[42] appropriately so because "the order of succession is (on a whim) interchangeable" and the piece is "unfinishable." The execution is to be mechanical: "for a specific musical instrument (player piano, mechanical organ, or other new instruments where the virtuoso intermediary is suppressed)." The diagram shows a funnel resembling the "cylindre sexe" (*DDS* 70) which drops numbered balls, lotto-like, into wheeled wagons that move below it. Presumably the

wagons pass by again and again until all eighty-nine balls have fallen. A final sentence of the text explains the purpose of the exercise: "another vase = another period = the result of the equivalence of periods and their comparison results in a kind of new musical alphabet allowing *model descriptions* (to be developed)." This alphabet parallels the one whose "letters would be formed using the Standard Stoppages and is suited only for the writing of this painting very probably" (*DDS* 48). The "equivalence of periods" is like the "diminished meter" (*le mètre diminué*) (*DDS* 36) of the Standard Stoppages: all have the same numbers of notes or centimeters but are distorted, uneven, in the time or space occupied. Writing, painting, music are all codified by models of measure and succession; their various alphabets, whose "rigorous signification" and "ideal continuity" are challenged by the logic of the Standard Stoppages and Musical Errata, which demonstrate that each element is the same, *tout de même*. To be fruitful, looking, reading, and listening must borrow from each other: the *aires* (fields) must be heard as songs and the music read as (rotten) puns. For this, our *marchand du sel,* sandman, provides us with closed eyes and *portugaises ensablées,* clogged ears,[43] to properly appreciate his music for the deaf.

Duchamp attempted to duplicate semantically the rigorous and tiresome syntactic procedure of the funnel and wagons with the texts *The* (*DDS* 256) and *Rendez-vous du dimanche 6 février* (*DDS* 254–255) wherein the grammar works but the words are strange sounds coming from meanings not normally juxtaposed. The "moins de grelots" (fewer jingle bells) of *Rendez-vous* and the "four dangers near *listening place*" in *The* push back toward silence. These texts parallel the nonsense inscriptions on object readymades of that time, notably *Comb* (Cat. 237) and especially *With Secret Noise* (Cat. 238), the first "semi-readymade," a ball of heavy twine screwed between two brass plaques. A second readymade, an unknown object, was placed inside by Duchamp's *ficelle* (chum or string) and patron Walter C. Arensberg. The noisemaker remains tightly wound within the unfallen, unmeasured, cord. *With Secret Noise* borrows its material of tight strings and unmeasurable chords from the "presse raquette."[44] The *Green Box* describes this object as a "'Tirelire ou (conserves) . . .'"[45]: another lyre, a *tirelire,* a pull-lyre or pull-read. Did it also come from the conservatory? Each plate has three lines of engraved French and English words, some of whose letters are missing.[46] Establishing a text involves a game of filling in the blanks by finding an appropriate letter above or below, but the resulting messages, like *The* and *Rendez-vous,* have less verbal than noise value.

Comb is another instrument of musical potential whose noise is known to every child. Its title may be an incitement to visual activity ("peigne" = may she/he paint), but it is also called a "crécelle" (*DDS* 101–02, written in pink-red). This kind of toy noise-maker or folk instrument has wooden or metal flaps that rotate at the end of a stick to make an infernal racket. A 1980 note with a sketch of the "cri cri ou crécelle" (cricket or noisemaker) suggests that one "Look for the 4 dimens'l noisemaker" (*N* 166) which defines or generates space. These "musical" readymades work like the silent music box of *Etant donnés,* and even the *Fountain* (Cat. 244), dry of splashing liquids, in refusing

harmony or audial pleasure. The ear-eur is left with a racket of chance and randomness working toward the silence of spatial dimension.

Cessez le chant / laissez ce chant (*N* 249)[47]

The 1980 posthumously published notes definitively establish the musical facture of the *Large Glass* and *Etant donnés*. Five long notes (*N* 250–252, 255, 256)[48] consist of lists of elements of these works interspersed with puns, "laws," and unrealized projects. The first three mention "musique en creux" and "mise à nu en forme de piano," as well as other musical references. Note 251 (Fig. 5) features a large treble clef at the top and a bass clef at the bottom.

Fig. 5 Note. 251. From *Notes,* 1980. Reproduced with permission of Mme A. Duchamp.

The successive numbering of the lines or paragraphs in these notes contrasts with the randomness of the notes in the boxes, notes which in a way these lines summarize. About this same time Duchamp was putting together *Etant donnés* and the notebook, *Approximation démontable,*[49] which shows in text and photographs the strict order for the set-up. His late penchant for precision and putting things in order was noted by Cage: "The only thing he said in the last years, and it was almost like a refrain in his conversation, was that he thought it would be interesting if artists would prescribe the distances from which their work should be viewed."[50]

This refrain and these lists, with their musical symbols, are remarkable because they reinsert the elements that had never made it onto the *Large Glass* and the sequence invisible from behind the door of *Etant donnés.* All the noise in the texts is kept secret from the regardeur, shattering any mystique of the regardeur who could understand completely. To imagine the completion of the act of stripping, the ear-eur must open the Green and White Boxes to listen to the song of the Benedictine bottle (*DDS* 89), *Avoir l'apprenti dans le soleil,* "as a '*commentary*' on the article Slopes" (*DDS* 76), and the Bride's rounds or *canons,* the nine holes drilled on the marks of toy cannon shots (*DDS* 54–55, 119).[51] The 1980 lists explicitly enumerate the musical elements, and the pictorial elements of the *Large Glass* and *Etant donnés* become indistinguishable: "10 on the slopes apprentice in the sun . . . / 17 Tympanum absorbing the dew [*rosée*] . . . / 19 the perfect cord (?) / 20 inaccentuation . . . hollow music" (*N* 250); "12 Stripping bare in piano form accompanied by the 3 crashes and childhood memories of lighting gas" (*N* 252, 255).[52] The silent Crash Splash, the secret of the waterfall with its light hidden in a cookie tin, the Rrose water or "Eau de Voilette," and the waterless *Fountain* and *Bouche Evier* (sink stopper/mouth) (Cat. 371) are all manifestations of a revolutionary approach where indirection is necessary, where not listening is the way to understand the music. After all, the ideal bathroom would have "an original revolutionary faucet . . . which stops dripping when you're not listening" (Cat. 370), also the first item of *Written Rotten,* a piece of music with words but no music. Duchamp made a visual experiment analogous to this hollow music when he provided only one possibility – for only one person from only one perspective to look into *Etant donnés.* The voyeur holes look onto an erotic dimension; such a scene realizes the hollow music of "Hollow paper / infrathin interval . . . female measuring device" where a flat item changes dimension, a piece of paper is slashed and slightly bent, "one cuts and one inserts the thing" (*N* 19), demonstrating how, if only we listen with a different ear, the sound of laughter can come into music, the most measurable and canonizable of art forms.

Où il y a Chaliapine (*N* 232, 265)

The paradoxes of Duchamp's proposals to sharpen hearing by training the ear for musical sculpture and music for the deaf fit the "Principle of Contradiction" (*N* 185, 250) by which any concept contains its opposite: "by grammatical simplification, one ordinarily understands principle of contradic-

tion, exactly: principle of *non* contradiction" (*N* 185). The only part of this note not crossed out is the final section, "Nominalisme [littéral],"[53] which describes the "plastic existence of the word" as the way out of the contradiction / non-contradiction conundrums of conceptualization where there is "no more conceptual value for abstract words. The word also loses its musical value. It is only readable (being formed of consonants and vowels), it is visually readable and little by little takes on a form of plastic significance. . . ." One might say Duchamp spent his life trying to escape the Principle of Contradiction, looking for literal nominalism. He uses music to pull visual art beyond its conceptual boundaries and in the process expands the horizons of music. The corollary *"plastic being* of the word (by literal nominalism)" is not to be considered aesthetically, the purpose being to generate elements which *"finally* no longer express a work of art (poem, painting, or music)" (*N* 186). When words are deprived of their musical value and music can no longer be semantically interpreted, we are left with the literal letter shapes and sound values, zero degrees of signification, a state of openness wherein a urinal occupies the same plane as the Trevi Fountain by virtue of nominalism, of being named *Fountain*.

Just as that small "Klang" asked "who signs?" it also asks "who hears?" Whose is the deaf ear all this falls upon? The invention of Rrose as alter-id has given us to understand that Duchamp was constructing an autobiographical dialogue, "a little game between 'I and me,'"[54] but sent out over the air/R to the other, the ear-eur in general. As Derrida has remarked, an autobiography is constructed by the ear of the other hearing the statement, "Listen to me because I am so-and-so,"[55] at some subsequent, indeterminable time. The autobiographer is always, in effect, already dead: "Performance quite useless anyway" (*DDS* 53). Duchamp's "Epitaph / And moreover it's always others who die"[56] leaves the autobiographer alive and the ear-eurs dead. The Principle of Contradiction would indicate one cancels the other, but literal nominalism lets the two exist in separate dimensions where the letters can sound concretely, non-idealistically.

Etant donnés is invisible until sought out, always silent. A large sheet of grilled paper, unique in the collection (*N* 181), combines the musical and the visible (Fig. 6). A treble clef and double colon mark the lines at top left, preceding the text, as on a musical staff: "without nuances [crossed out], uniformity of rhythm, anaccentuation. / Chance." The description of a "Race between two mobiles A and B" combines musical and automobile terms:

(. . . uniform interval between two "measures"). A and B are described spatially, that is, A is decked out with all the traffic accidents, B is also exposed in a different state: in this race there is no rivalry between A and B. . . . To differentiate A and B, A for ex. may be the piano, B, the violin, (not important)

The movement of the mobiles or instruments, determined by magnets, wanders on either side of a straight line. The magnets' force on A is determined by "the notes accompanying the nucleus A at each moment of the stretch" because "A and B are really the only types of indifference which, as such, are the fodder of the magnets [*la pâture des aimants*], *the subject* of discord among all these outside forces." Although there is no indication of what

Fig. 6 Note 181. From *Notes,* 1980. Reproduced with permission of Mme A. Duchamp.

the musical value or notes are, or how they attract magnets, the result is a pun, the painting of the lovers [*la peinture des amants*]. The drawing, in its resemblance to *Cols alités,*[57] which superimposes hills across the "garment" (*DDS* 95), or "3 planes on the horizon" (*DDS* 93) of the Bride, serves as a crossing point between the *Large Glass* and *Etant donnés,* inserting the element of musical composition into both. The final paragraph, on the reverse side and in a different color, reinserts *"Hollow music"* to close this perhaps archetypical note on music, a composition that speaks in musical terms but cannot help hearing the possibilities of puns that redirect its emphasis as it goes along. One ear hears the similar or same, *même,* of the tune and the other hears what's not hearable, the various signifieds evoked.

All of Duchamp's references to music pull on the ear, bring it into the visual domain of the artist, in effect putting a crimp on the regardeur, removing its consonants to rewrite it as (h)ear-eur. Only the R is left as *con-sonne,*

sound-with, cunt-sound: the wee-wee or little g, or the *oui-oui* of positivism, is gone in the R-eur, error of art/R. The R at the beginning of *regardeur*, the built-in reflection or repetition, is replaced by the silent h/*hache*, hatchet, cutting off sound. The missing H and the *ouïe*, the sense of hearing or, metaphorically, understanding, stand out by their absence. All ears, "tout ouïe," the ear-eur looks into *Etant donnés* unaided, *non-E.D.*, by any aural explication. The parts of the ear, outer, middle, and inner [*pavillon, tympan, labyrinth*], stand represented by the work: its state as a little house [*pavillon*], its quiet music box (waxy, blocking sound, "La crasse du tympan, Le Sacre du printemps"[58]), and its inner secrets, the missing head, chess board floor, electric lights. Around the "stripping in piano form . . . central part of the stripping: Labyrinth" (*N* 153), the mist rises from the valley and "the tympanum absorbs the dew [*rosée*]" (*N* 152). The silence of this fracas of the bride in piano form astounds the ear-eur and reinforces the regardeur's isolation before the one-at-a-time viewing post. One has the impression the whole thing goes off if no one is looking.

Duchamp's transformations of musical motifs, the "leitmotif pink" [*rose*] (*DDS* 116), into off-color humor, from the piano-shaped ladies of the cartoons to the pun on Chaliapine,[59] pass through the *messagerie* Rrose[60] of the erotic/earotic, a form of communication where irony makes the receiver formulate the message. Our task as ear-eur is to add the consonants, to *consonne*, sound along, to understand *Etant donnés* as both the picture and the sound of words, the "involuted orificality," as Derrida calls it,[61] the orifice, *oreille/fesse* (ear/buttocks), or as Duchamp quite simply put it, "musique en creux."

Notes

1. "A new box of matches one has just bought is lighter than an opened box because it doesn't make any noise." Marcel Duchamp, *Notes,* arrangement and translation by Paul Matisse, first published Paris: Centre Georges Pompidou, 1980 (Boston: G. K. Hall, 1983), Note 262. Subsequent note number references will be in the text preceded by *N.* A slightly different version of this note was published in Duchamp, *Duchamp du signe: écrits* (Paris: Flammarion, 1975), 156. Subsequent page references will be in the text preceded by *DDS.* Translations throughout are mine; none will be given for obvious cognates. Both the original and a translation will be provided where possible to help elucidate puns. Slashes indicate an unconventional change of line in a text.

2. His well-known formula, "It is the REGARDEURS who make the pictures" (*DDS* 247), engaged the bilingual reader/looker (not overlooking the two senses of *looker*), and, as I discuss below, the field of the regardeur stretches to include the ear.

3. Duchamp made no formal response to a tract, "We don't EAR it that way," sent to him in 1960 to protest his invitation to Dali to participate in the exhibition *Surrealist Intrusion in the Enchanter's Domain* he and Breton organized at the D'Arcy Galleries in New York. Jacqueline Chénieux-Gendron, *Le Surréalisme* (Paris: PUF, 1984), 225.

4. An incomplete but useful listing of Duchamp's musical references can be found in Gavin Bryars, "Notes on Marcel Duchamp's Music," *Studio International* 984 (1976), 274–79.

5. During the intermission of *Relâche* Duchamp could be seen in the Clair/Picabia film *Entr'acte* playing chess with Man Ray. The musical chess board performance took place at the Ryerson Polytechnic High School Auditorium during *Reunion*, a musical performance organized by Cage in Toronto, 5 February 1968; the chess board was designed by Cage. See Arturo Schwarz, *The Complete Works of Marcel Duchamp* (N.Y.: Abrams, 1969), 66, for details.

6. "Sharpen hearing (form of torture)" (*DDS* 156). A pun works on the resemblance of *ouïe* and *aïe* (ouch).

7. (Cat. 253). Catalogue numbers refer to the "Critical Catalogue Raisonné" by Arturo Schwarz in his *Complete Works*, 372–582.

8. Mr. Klang was a sign painter Duchamp hired to execute the pointing hand.

9. The painting was made to fit a space above bookshelves in the library of Katherine S. Dreier. See the photograph in *Marcel Duchamp*, ed. Anne d'Harnoncourt and Kynaston McShine, (New York: Museum of Modern Art, 1973), 20.

10. "Peut-on entendre écouter . . . ?" The first published version of this idea, "On peut regarder voir; On ne peut pas entendre entendre," (*DDS* 37) was included in the *Box of 1914*. The question form appeared in 1948, casting doubt on the statement expressed in the maxim of 1914.

11. In explaining his concept of the readymade as something enjoyable, Duchamp mentioned a pencil sharpener: "Something to have in my room the way you have a fire, or a pencil sharpener, except that there was no usefulness. It was a pleasant gadget, pleasant for the movement it gave." Interview with Calvin Tompkins in *The Bride and the Bachelors* (New York: Viking, 1968), 26.

12. "Hollow music exercises for the deaf," *N* 181, 250, 253, and 255. *En creux* can mean hollowed out, with gaps.

13. ". . . à mettre dans le Fracas – éclaboussure. . . ." The references to listening with one ear are coupled with parallel references to using one eye:

Thing to look at with one eye
– – – – with the left eye
– – – – – – right –

What must be heard with one eye
– – – – with the right ear
– – – – – – the left – (*DDS* 107–108)

The painting on glass *To Be Looked at Up Close with One Eye for Nearly an Hour* (Cat. 256) actualizes the visual reference in the note. There is no specific object to listen to with one ear, but an ear pressed to one of the holes in the door of *Etant donnés* (Cat. 392) hears the faint sound of fluorescent tubes and perhaps (it is hard to be sure) the turning of the motor operating the waterfall.

14. This was an original piece for the box, not a miniature or reproduction of a previous work as were the other items in the box. Hollow paper also enters the geometry of the "infra-thin," the pataphysical dimension whose measurements are precise but indeterminate: "Hollow paper (infra-thin space but without there being two sheets)" (*N* 17).

15. "Etant donné un nombre / convenu / conventionnel de notes de musique n''enendre' que le groupe de celles qui ne sont pas jouées. . . ." (*N* 253).

16. Most modern pianos have eighty-eight keys, but eighty-five include seven full octaves, beginning and ending on the same tone.

17. *Notes,* in the translation following the facsimiles, n.p.

18. The manuscript was first reproduced in *Marcel Duchamp,* d'Harnoncourt and McShine, 263–65. The text also appears in *DDS,* 53.

19. With "coups de pieds en tous genres" (all kinds of kicks / kicks at all genres) as on Rrose Sélavy's calling card (*DDS* 153).

20. "The intention with me was to avoid emotion, to have the driest possible feeling toward it. Taste is a form of emotion in a way. I mean, it translates itself into emotion in the end." Unpublished interview with Harriet and Sydney Janis, 1953.

21. "My intentions as a painter . . . were directed toward the problems of an 'aesthetic validity' obtained principally in the abandonment of the visual phenomenon, as much from the point of view of retinal relationships as from the anecdotic point of view." Letter to Michel Carrouges, 1950, in Carrouges, *Les Machines célibataires,* new edition (Paris: La Chêne, 1976), 49.

22. For a detailed look at Duchamp and Cage's collaborations and influences, see George Bauer's presentation, "Cage and Duchamp," at the Midwest Modern Language Association (Chicago, 1986). See also Cage and Alain Jouffroy, "Entendre John Cage Entendre Duchamp," *Opus International* 49 (1974), 58–67, and Cage, "26 Statements re Duchamp," in *A Year from Monday* (Middletown, CT: Wesleyan Univ. Press, 1969).

23. I have explored Duchamp's use of R and the error in "Duchamp's Pharmacy," *Enclitic* 2.1 (1978), 65–80, and "Reading Art Through Duchamp's Glass and Derrida's *Glas,*" *Sub-stance* 31 (1981), 105–28.

24. Any R-atum is also R-*Atem,* air-breath. The perfume bottle label "Eau de Voilette" replaced "un air qui enbaume" on the original label. *La Belle Hélène* premiered in 1864. Duchamp may have also known airs from Amilcare Ponchielli's opera *La Gioconda* (1876), aurally related to *La Joconde* of *L.H.O.O.Q.* (Cat. 261). *Air de Paris,* the glass ampoule of 50 cc of air, is another empty bottle-song.

25. See Susan McClary, "The Politics of Silence and Sound," an afterword to Jacques Attali, *Noise: The Political Economy of Music,* trans. Brian Massumi (Minneapolis: University of Minnesota Press, 1985). She describes the major shift in musical composition and understanding marked by Rameau's *Traité de l'harmonie* (1722): "Rameau, in a striking reworking of Descartes' *Cogito* manifesto, declared [the] earlier tradition moribund and, in seeking to build a musical system from reason and science, hailed the triad as the basis of music. . . . Mathematical certainty and the acoustical seal of approval are bought at the price of silence and death, for text, continuity, color, inflection, expression, and social function are no longer relevant issues" (151).

26. "Make an imprint mark traits a figure on a surface print a seal on wax."

27. Probably attracted by the name of the occasion, Duchamp exhibited this display of silent music at the Concours Lépine inventors' fair. "Concours Lépine" plays on the same sort of pun as "Chaliapine" (see below).

28. Duchamp wrote this little tune version of the artist's name for the exhibition of Michel Cadoret at the Galerie Norval, New York, 1960.

29. In his study of society's uses of music, Jacques Attali characterizes the shift to positivism in music: "Thus in the eighteenth century, reason replaced natural order

and appropriated harmony as a tool for power, as proof of the link between well-being and science. To those who have availed themselves of it, music made harmony audible" (*Noise*, 61). Attali notes the logical development of opera as the positivist form *par excellence:* "The link between harmony and representation is . . . clearly evident: harmony presupposes represented dialogue; it leads to the Opera, the supreme form of the representation by the bourgeoisie of its own order and enactment of the political" (p. 60).

30. Auer is the type of gas lamp the nude of *Etant donnés* holds. Héros = heroes. LMRE = she likes to err, wander. LHIÉ . . . = She shit with acuity and likes only to lower ass and buttocks.

31. "Musical undershorts (abbreviation for: chamber music lessons)."

32. These two cartoons were published in *Le Courrier Français,* 1909–1910, and recently reproduced in *Marcel Duchamp,* Gloria Moure, ed. (Madrid: Caja de Pensiones, 1984), 99. These cartoons work on standard *double entendre* puns. Consider the resemblance between *une nuit blanche* (a sleepless night) and *un mariage blanc* (an unconsummated union), and between *mourir* and *la petite mort* (orgasm).

33. This cartoon is reproduced in *The Essential Writings of Marcel Duchamp,* ed. Michel Sanouillet and Elmer Peterson (N.Y.: Oxford University Press, 1973), 109.

34. Alice Goldfarb Marquis, *Marcel Duchamp: Eros, c'est la vie: A Biography* (Troy, N.Y.: Whitson, 1981), 71.

35. "And as a near-by piano dreams in measure / I whirl to the rhythmic concert of the censers." Jules Laforgue, *Oeuvres complètes.* I (Paris: Mercure de France, 1922), 22.

36. The novel describes the scene: "The chemist Bex made his entry pushing an immense glass cage set on a walnut platform with four low wheels. . . . The movement was smooth and perfect thanks to thick tires on the silent wheels whose fine spokes seemed newly nickel plated. . . . The glass cage enclosed an immense musical instrument including brasses, strings, circular bows, mechanical keyboards of all kinds and a rich array of drums" (Raymond Roussel, *Impressions d'Afrique* [Paris: Pauvert, 1963], 39–40).

37. Satie composed these pieces in 1903 after being rebuked by Debussy for having no "form" in his music, that is to say, no pieces in "sonata form," for example.

38. Erik Satie, *Six Pièces de la période 1906–1913* (Paris: Editions Salabert, 1968).

39. Erik Satie, *Twenty Short Pieces for Piano,* facsimile edition (New York: Dover, 1982).

40. "*Furnishing Music* is characterized by obsessional repetition of the same theme. No event in these pieces, but a single cell which seems recorded on an endless band. By dint of continual refrain it succeeds in turning attention away from the melodic line" (M. Bredel, *L'Oeuvre de Satie* [Paris: Mazarine, 1982], 132).

41. Bredel, 135.

42. The use of numbered balls seems to have been abandoned after the third vaseful and the notes are simply sequentially ordered. The percussionist Donald Knaack has performed and recorded the piece using glass instruments – wind chimes, xylophones, maracas – of his own design (New York: Finnadar Records, 1977).

43. Literally, "oysters full of sand."

44. "Long live clothes and the racket press!" (*DDS* 36).

45. "Piggyback (or canned goods). Make a readymade with a box enclosing something unrecognizable from its sound and solder the box. Already done in the semi Readymade with copper plaques and ball of string" (DDS 49).

46. [Bottom] [Top]
.IR. CAR.É LONGSEA \longrightarrow P.G. .ECIDES DEBARRASSE.
F.NE, HEA., .O.SQUE \longrightarrow LE. D.SERT. F.URNIS.ENT
TE.U S.ARP BAR.AIN \longrightarrow AS HOW.V.R COR.ESPONDS
(DDS 257)

47. "Cease the song / leave this song."

48. These notes, written on standard American-sized yellow legal pads, can be presumed to have been written quite late. Notes 252 and 256 include a description of the 1957 readymade vests (Cat. 342). Notes 255 and 256 appear to be reworkings in a neater hand of Note 252 verso and recto.

49. *Approximation démontable exécutée entre 1946 et 1966 à N.Y. . . . : ETANT DONNÉS: 1° LA CHUTE D'EAU 2° LE GAZ D'ECLAIRAGE.* Handwritten MS. with drawings, diagrams, and numerous photographs, about 50 pages. The Philadelphia Museum of Art published it in 1987. A photograph of the title page and several photographs of the inside of the installation appear in *Marcel Duchamp* (Madrid), 160 and 164.

50. "John Cage on Marcel Duchamp: An Interview," by Moira Roth and William Roth, *Marcel Duchamp in Perspective,* ed. Wm. Maschek (Englewood Cliffs, N.J.: Prentice Hall, 1975), 155. Cage believes the notebook works musically: "It looks a lot like modern music. Because there are directions for taking something down and putting it up. And a great deal of avant-garde music consists of directives to "do" something. That's the underlying principle of music: tell someone, in writing, how to do something." (Cage and Jouffroy, "Entendre John Cage Entendre Duchamp," 62).

51. The drawing of the procedure for creating the nine shots (DDS 54) is labeled as *Erratum musical, 1912* in "Entendre John Cage Entendre Duchamp," p. 64. I have not found this designation elsewhere.

52. The "childhood memories" include a 1903–04 drawing of a bec Auer at the Ecole Bossuet in Rouen (Cat. 19).

53. Literal nominalism also figures at the top of the list of Note 251: "1–Redo literal nominalism."

54. "My intention was always to get away from myself, though I knew perfectly well that I was using myself. Call it a little game between 'I and me'" (Interview with Katherine Kuh, in *The Artist's Voice* [New York: Harper and Row, 1962], 83).

55. "Ecoutez-moi car je suis un tel. . . ." Jacques Derrida, *L'Oreille de l'autre: otobiographies, transferts, traductions.* Textes et débats avec Jacques Derrida, sous la directions de Claude Lévesque et Christie V. McDonald (Montréal: vlb, 1982), 21.

56. "Epitaphe / et d'ailleurs c'est toujours les autres qui meurent" (N 256).

57. "Bed-ridden mountain passes," read literally, or, *causalité,* heard (nearly) homophonically (Cat. 351). A "col" is not a barrier, "mountain," as Schwarz has translated it (*Complete Works,* 459, 535), but a place where one can cross the mountains.

58. "Ear drum/tympanum dirt, The Rite of Spring" (N 225). Slightly different versions of this pun on Stravinsky's title can be found in DDS 155 and N 231.

59. "Où il y a Chaliapine" (where there's Chaliapine) = *où il y a chat il y a pine* (where there's pussy there's prick).

60. *Les messageries roses* (pink message services) is the generic term currently used to refer to the electronic network exchange services offered to Minitel users in France who want to have intimate but anonymous contact with others.

61. "Orificalité involutée," *L'Oreille de l'autre*, 53.

Duchamp's Ubiquitous Puns

George H. Bauer

In 1959 at Cadaquès, Marcel Duchamp did three works that point again to the central role that language plays in his imagination. They are food notes and footnotes to the whole of his work and keys to *la langue verte* and saucy greenness of his recipes for art. Their titles reinscribe an insistence on the untranslatable: *with my tongue in my cheek, TORTURE-MORTE, sculpture-morte* (Figs. 1, 2, 3). The first and the last of the three are scripted in lower-case letters; the right foot of *TORTURE-MORTE* is seen through capital letters of white paint at its bottom left as a printed footnote. The imprint as *empreinte* (a print, an impression) echoes the French *emprunt* and the notion of debt or borrowing and the *emprunté* of constraint and gaucheness. His references are both artistic and linguistic, both to his own art and to that of others. This *rigor mortis* of painted plaster and flies seen as *faux pas* against the backdrop of *faux bois* is an Italic impression cropped from Mantegna's *Dead Christ* (Fig. 4) as a footnote to the writing of art history. The part seen from an unfamiliar view is an embodiment of an important step where Duchamp uses the instep as architectural vault for painted sculpture and the now insufferable body of the *Word*. The slip from painting to sculpture relies on the absent *piédestal,* now replaced by letters that support the work of pun, pain, and paint in the essential lay-over of different media and difference in language, art, and letters. In this self-portrait, a plaster of Paris trace against the grain, the delay of his tortoise (TORTUE) aesthetics is covered in the second absent *R* in a paced race against the hare on the shifting sands of language and art as page, as p(l)age, and playgiarism. This foot as TORTURE returns us to his headpiece, *TONSURE* of 1919, in which he shaved his hair to create a starred asterisk *en tête* (his own) as text where *étoile* becomes a *toile,* his canvas and web.

From the pedestal *copyright* of *Fresh Widow* covering French Windows, inscription and deletion are essential footnotes and supports where the letter *N* slips, with other letters, in and out of sight, in endless citation. These slips of the tongue, these displaced letters, not absent-minded letters, are strategic moves in his language game. His return to pedestal and footnotes in these three pieces is an uncovering and a recovering of the sculptured, cultured language of his art. Without the tongues in which he speaks his right foot cannot be read or his heads of hair seen. His work here is suspended; up-ended letters, to be seen in a new perspective, fall from his Fountain of found *N*s and his alphabet box of fonts and founts of lead (PB). He is the painter become typographer. In his play of language, abbreviations permit us to expand his footnotes and to relate them finally to his marzipan, al-

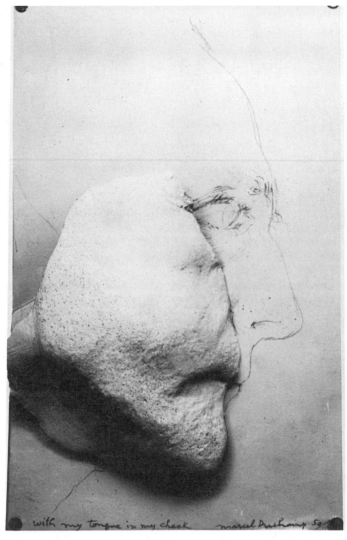

Fig. 1 *with my tongue in my cheek*, 1959. Collection Robert Lebel, Paris.

mond-scented, food note. He reminds us of the object as word. He reminds us, as he tints and dyes, pains and paints, of the object as letter and the letter as object.

TORTURE-MORTE shows us what is underfoot: thirteen flies rest on the imprint of the right foot left. From Mantegna's dialogue, in which the painter would triumph over sculptural art, Duchamp resurrects the old competition between painter and sculptor through the pun of still life and *nature morte*. The art Duchamp draws in this self-portrait is the same that he has drawn from the letters of his own name now multiplied. Art is taken to the *N*th dimension as he applies the ultimate make-up from his cosmetic box. Beauty

128

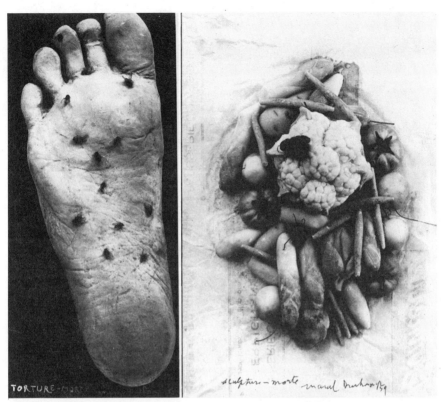

Fig. 2 *TORTURE-MORTE,* 1959. Collection Robert Lebel, Paris.

Fig. 3 *sculpture-morte,* 1959. Collection Robert Lebel, Paris.

spots are French flies—*des mouches.* The shock of the foot is only a tickle of tonsure and torture as the work buzzes with the smelly attraction of bilingual puns and untranslatable turns of phrase. The trompe-l'oeil of art joins Duchamp's cheeky tongue to produce an in-joke on the arched instep of the French *PAS.* The word *pas* was concrete in its origin as a step before it turned abstract and was generalized in negation when coupled to the *ne* as in "n'est-ce pas?" A parallel history is that of the latin *rem* (something, some thing) transformed into the French *rien* and, both when coupled and alone, now stands for no thing, for nothing. This at first glance and whiff looks and smells funny, but Duchamp's etching of 1959 to illustrate *Première lumière,* a poem by Pierre André Benoit (PAB), consists of three capital letters, seen under cellophane, printed in black and blue. In the beginning that word was and is *NON* (Fig. 5). *TORTURE-MORTE* is re versed. The Non as Pas becomes name and noun and doubled PAS-PAS DADA. In *Première lumière* the word, like its letters acidly etched in left-right, right-left palindromic step, points to the way in which the work of word was made in mirrored reversion and the game of reversis. Its added dimension is that it reads the same even if you are standing on your head. In *TORTURE-MORTE* the foot stands

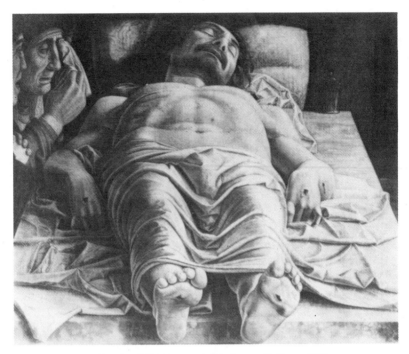

Fig. 4 Mantegna. *The Dead Christ,* ca. 1480. Brera Gallery, Milan.

in between the portrait heads. The object becomes a word; its letters seen, then said.

Duchamp insists on the importance of the word, the phrase, and the letter as key elements in his work. His word play is not mindless, but a demonstration of language and the mind at work. He uncovers, recovers, and uncovers again the dead masters of the Italian Renaissance and of nineteenth-century French painting and sculpture. Mantegna, Leonardo da Vinci, Arcimboldo (like Ingres, Courbet, and Rodin) are incorporated through body borrowings of letters and fragments of their images and imaginations. Duchamp's step, his artistic "undertaking," is consistently one of resurrection and movement by the artist who uses A. Klang of tangled language to this end. His move is to defy – in marchpane, in chalk, in acid, in plaster, in dies – the expression in which the artist's tongue is held in check: *"bête comme un peintre."* This he does not do by writing sonnets, as Michelangelo did, but by making language play an integral part in his game. The most obvious example is the interplay and overlay of the *Green Box* and the *Large Glass,* where *vert* of green and *verre* of glass homonymously play with the word seen to lose and gain meaning; the read (red) for local color when coupled with RRose for scent(s), black and blue for tortured grilling and pain(t) are only some of his alphabetical Rimbaud colors in the spectrum of alchemical search.

"Stupid as a painter" haunts him from his first step. His first *pas*/NON project was to change PB into OR/AU by using his Venus lead pencil in either/or research for gold. The poet and the painter fuse in *First Light* of NON. The

130

non/nom is a NO to the passive mindlessness of the langorous vacancy of the center of art – the NUde. The capital *piédestal*, "NU DESCENDANT UN ES-CALIER," as painted *la-dit* inscription, is becoming letters of assenting steps descending. It moves him into a new kind of rivalry with his friends and brothers, not only painters but writers and poets as well.[1] The nude becomes a naked lady who no longer declines silently before the stupid male who paints her. The Lazarus PAS of resurrection breathes new life into old works, and this "explosion in a shingle factory" (as Teddy Roosevelt saw it) becomes a woman who walks through the type of Duchamp's letters and words.

Fig. 5 *Première lumière,* 1959.

In Duchamp's *Verbal Disc No. 1* of his *ANÉMIC⌐CINÉMA* we see and read a dozen extended capital-lettered words: BAINS DE GROS THÉ POUR GRAINS DE BEAUTÉ SANS TROP DE BENGUÉ. The "grains de beauté" as beauty spots, as "mouches" and "mouchoirs" (handkerchiefs and kerchoos of sneeze and why not "elle achoom" and my niece is cold) become "grossièreté" to call into question the nude of the Nude and the Bath. The "T"/"thé"/-"té" tint and steep us in the modernity of tubes of Bengué. New hues of blue and black are seen as an art balm for the anemic disease of pain and paint. In his use of language, Duchamp invites us to voice words and letters seen and to wince at the words of painted pun or retch at the sight of the objects of an acidly etched rebus (TOUTALÉGOUTSONTDANSLANATURE/flushing-theW.C.isapigs tale/ALLTASTESAREINNATURE). The cool Bengué application slowly turns up the heat. The slip of consonants (GRAINS DE BEAUTÉ/BAINS DE GROS THÉ) on this first breast of his anagrammatic ANÉMIC⌐CINÉMA lays bare the technique of *Ort* and *Wort.* Read corpuscles are seen and hurt regenerators.

131

In his "The Great Trouble with Art in This Country," an interview with James Johnson Sweeney, he resurrects and places on a pedestal the names of two men who were footnotes and joins their names to other men of letters. Because of its capital importance in translating Duchamp's language, I copy it in its own right and will read it as a kind of found RRosetta stone.

Brisset and Roussel were the two men in those years whom I admired for their delirium of imagination. Jean-Pierre Brisset was discovered by Jules Romains through a book he picked up from a stall on the quais. Brisset's work was a philological analysis of language – an analysis worked out by an incredible network of puns. He was a sort of a Douanier Rousseau of philology. Romains introduced him to his friends. And they, like Apollinaire and his companions, held a formal celebration to honor him in front of Rodin's *Thinker* in front of the Panthéon where he was hailed as *Prince of Thinkers.*

But Brisset was one of the real people who has lived and will be forgotten. Roussel was another great enthusiasm of mine in the early days. The reason I admired him was because he produced something I had never seen. That is the only thing that brings admiration from my innermost being – something completely independent – nothing to do with the great names or influences. Apollinaire first showed Roussel's work to me. It was poetry. Roussel thought he was a philologist, a philosopher and metaphysician. But he remains a great poet.

It was fundamentally Roussel who was responsible for my glass. *The Bride Stripped Bare by Her Bachelors, Even.* Even from his *Impressions d'Afrique* I got the general approach. This play of his which I saw with Apollinaire helped me greatly on one side of my expression. I saw at once that I could use Roussel as an influence. I felt that as a painter it was much better to be influenced by a writer than by another painter. And Roussel showed me the way.

My ideal library would have contained all Roussel's writings – Brisset, perhaps Lautréamont and Mallarmé. Mallarmé was a great figure. This is the direction in which art should turn: to an intellectual expression, rather than to an animal expression. I am sick of the expression "bête comme un peintre" – stupid as a painter.[2]

BATHES OF GROSS TEA FOR GRAINS OF BEAUTY WITHOUT TOO MUCH BENGAY takes the French PAS down American steps with the cool pace of the Tortoise. Brisset's "incredible network of puns" is a refusal of still-life and *nature-morte*. STILL TORTURE (still painting) replaces *TORTURE-MORTE. Still Sculpture* stands to the side to frame the French *sculpture-morte.* The idiomatic *tongue in cheek* is another aside yet to be translated. Philological analysis and delirium place us "au pied de la lettre" – at the foot of the letter confronted with the literal, the literary, the littoral edge of "Lits et rature" (beds and caoutchouc rubber; rosy read nature of cheeky erasure and gumming). Achoo!

Raymond Roussel, as Jeanine Plottel, in an unpublished food note, "Rissolé Russets à la Roussel," insists that for RR "imagination was everything." The "impression" is central. The word, the *Wort,*

appears in at least two of his titles, a sign that stress was to be placed upon the act or process of impressing, of bearing upon, and of stamping. The accent is on the mark that embosses or imprints. Just as dye must be extricated from each imprint, so the writer of impressions needs to extract from each word as much meaning as can be forced out. Roussel carried this out to an extreme; he impregnated enough meaning in certain words to generate an entire book, for example "billard" and "pillard" and *Im-*

pressions d'Afrique. The goal was to manipulate words in themselves without regard to significant representation of any subjective emotions or responses to objects or events pertaining to the author's inner experiences.

Roussel's much admired *Impressions d'Afrique* is generated by the consonantal slip of *P* and *B* of an earlier tale. In his *Comment j'ai écrit certains de mes livres,* Roussel recounts this *procédé* already intuited by Duchamp in touch with his theater and books.[3] As I have noted in "La Jolie Roussel brisée: les vairs du chant" and "Roussel-Duchamp,"[4] Duchamp was struck not only by the *Impressions* and Roussel's generative process but by the initials of his name – RR – and the way in which letters and names, like expressions fixed in the mother and foreign tongues, can be fragmented as generators, as progenitors.

In this game of naming, I return to *TORTURE-MORTE* and to *Verbal Disc No. 1* to accentuate the black and blue dye and the dyeing of letters. *Torture* and *Mort* are signature allusions to Duchamp as Totor, short for Victor, as he was nicknamed. The P. B. T. initials of the cover of *The Blind Man* (May 1917), done with Beatrice Wood and Henri-Pierre Roché, recover the cronies' names with capital letters. The "T" is a stand-in for TOTOR that stands in turn for Victor displacing Marcel. Pierre remembers him one evening, as he recounts in his "Souvenirs de Marcel Duchamp": "He appeared so victorious (I didn't know his first name then), that by three A.M. I found myself inadvertently calling him 'Victor,' then towards dawn familiarly 'Totor.' He answered without wincing to both these names, and the familiar one is used between us even now."[5] *Torture* is a painful invitation to talk and to reveal more secrets that flirt with the game of *mort* as noun becomes *morte* as feminine adjective, or *mourir* as verb. But the die here is not death but the dies of his sugar cubes of *Why Not Sneeze?* and the dies of walk-through boxes of type; individual letters are capitalized as sign and doubled signature, mirroring the scripted lower case of "marcel duchamp 59." His "D D" said in French are *des* as in *Un Coup de dés* of Mallarmé. In American we read the French *dis-dis* aloud as "say-say." But the consonant *D* is the unvoiced *T* (unheard in *mort,* the mute *e* of the feminine makes it heard). Three steps then: the silent seen, the heard, the voiced. Duchamp's Baby Doll for old bachelors (*BéBé marcheur*) early on inscribes the *BB* as *bébé* as a walking doll for old bachelors. The capital letters of her skirt are deciphered. "I walk, you talk – Je marches, tu par(l)es – I walk, you leave." *Faire marcher* is French for pulling your leg. To make a leg is to take a bow. Duchamp depends on us to give him a leg up with all of the fixed expressions we know. He is an original Black Leg who works with his many aliases from George W. Welch, Bull, and Pickens to RROSE SELAVY as he advertised in his *WANTED/$2000 REWARD* of 1923 – unsigned. The voiced NON is heard as NOM, the name of the artist, or as NOMS NONS, the names of the artist.

T/B Tid bits. Tit bits.

His life as con man, entrepreneur, and player of games is akin to that of his cousin the Mad Hatter on trial. In the famous trial ("Who Stole the Tarts") re-

counted by Lewis Carroll in *Alice in Wonderland* the problem of the letter stands out.

"Give your evidence," the King repeated angrily, "or I'll have you executed, whether you are nervous or not."

"I'm a poor man, your Majesty," the Hatter began in a trembling voice, "and I hadn't begun my tea – not above a week or so – and what with the bread-and-butter getting so thin – and the twinkling of the tea – "

"The twinkling of *what?*" said the King.

"It *began* with the tea," the Hatter replied.

"Of course twinkling begins with a T!" said the King sharply. "Do you take me for a dunce? Go on!"

His name in letters began with his full name rarely seen or heard: Henri-Robert-Marcel Duchamp. But it is Henri and Robert that have slipped from sight; the Marcel and Duchamp have until now been the ocular focus, the name of the game.[6] Robert is at the center of other lost or hidden inscriptions and letters, phrases and texts behind which the *air(t)ist/air(t)ist/air-buste* stands and lies – Robustly. The conflicts of the art object in reproduction, and titles given, play a central role in any reading of his work. Authenticity is in the letters of the object and of the name.

This is evident in the first drawing of an object by Duchamp, a signal beginning and a green light. *La Suspension* (*Bec Auer*) (Fig. 6) is the title of this charcoal drawing (*fusain*) on which he inscribes "Ecole Bossuet M.D. circa 1902." Growing up in Flaubert's Rouen, he read Gustave's works at the age of

Fig. 6 *Bec Auer*, ca. 1902. Collection Mme Marcel Duchamp, Villier-sous-Grez. With Bec Auer poster by G. M. Mataloni, 1895.

134

sixteen. Both Charles and Emma Bovary were very much a part of his youthful boredom at the Ecole Bossuet. In this drawing Robert Duchamp hides in plain sight his anagrammatic ROBERT in the BEC AUER hanging gas lamp. He draws it as a *cul-de-lampe,* a tail piece. It hangs in there and hides the sexiness of the bare-breasted woman of the ubiquitous Bec Auer advertisements beckoning and enlightening him with the illuminating gas of letters coupled with the stripped female anatomy. *Etre le bec dans l'eau* is a French expression for suspense and uncertainty. *Tomber sur un bec de gaz* is an encounter with an unforeseen obstacle, a kind of trap. Duchamp alludes to this *"bec de gaz"* years later in his *Trébuchet* of 1917. Its dimension as a trip-wire of phrase of *tomber sur un Bec Auer,* an object named, lie in wait. It should not floor us. The trap is one of name. Duchamp looks up in dictionaries, atlases, and books. He looked up in the Ecole Bossuet. This is always done from the perspective of names given and borrowed in the tradition of Rouen's own Corneille and *Le Cid* and Flaubert and his Madame Bovarys, and of course, the difficulties of the Duchamp family of artists and notarized signatures. His art is based on the strategy of turning leaden names into gold. The flight from name by marriage (Suzanne Crotti), by hyphen – not hymen – (Duchamp-Villon), and by letters etched by Robert's other BRO Duchamp as Jacques Villon is noted by Henri-Robert-Marcel in his *Dialogues with Pierre Cabanne.* Cabanne asks him for the most poetic word. He says that he didn't have one handy, but that poetic words should be words distorted by their sense as in word games – assonances, for example. Cabanne comments that "even the word 'Duchamp' is very poetic." Duchamp repartees: "Yes. Nevertheless, Jacques Villon didn't waste any time changing names, not only 'Duchamp' into 'Villon,' but also 'Gaston' into 'Jacques!' There are periods when words lose their salt." Cabanne's observation that he was the only brother to keep his name evokes a cunning response: "I was sort of obligated to. One of us had to!"[7]

Robert, who alone retains and plays with his name, takes it with a grain of salt and sells it. He hides his ROB in the *robinet* ("faucet" here is dimpled *fossette* of his cheek covering his tongue) and in ROBE of feminine ending. The B as *Bée* of *bouche bée* slips into and out of the *bec* and beak-er, the bird's nib and bill that give a peck *(donner un coup de bec)* and in this alteration and altercation of names serves as *un prise de bec.* Duchamp with fresh air window names – Marcelle, Haleine, Polly, Rrose, and Roberte – robs and hides *(dérobe)* in pleated letters the tale of La Fontaine and ROB's *Fountain.* The foxy *renard* seduces the wily bird to open the beak and talk. The cheesy fromage flips out of his nib and rolls on its way.

RETARD/REWARD/RENARD

In 1958, the year before this *triptyque* under discussion, he created another cover for a catalogue, *Le Dessin dans l'Art Magique* (Fig. 7). The calligram, printed in red, is a mechanical eye-breast that is a fountain of letters coming from his *Coffee Mill* of 1912 where words fragmented turn. The hub and nipple, in raspberry red, is MAGES waiting to be touched, coupled, read, and connected to the rim of letters bespoken. The oval of his *sein* (breast)

frames in words and becomes *des seins* (drawings) in revealing slips seen through the iris of the I-eye magi. HOM-I-DOM-FRO-RA-PLU- is a *maquillage* attracting us with false sees, *faux cils,* and words winking as eyelashes. They draw the eye to the breast and the tongue to the cheek with a whisper of *Prière de toucher (Please Touch)* of 1947 and the 1919 con joke on *La Gioconda* read as Mona Lisa. Lise! Read it! *"Lis ça";* his lilies offered, are a floral invitation of body parts made whole through voicing and reading: "Hommages, Images, Dommages, Fromages, Ramages, Plumages." This P/B rotating letter generator, coming from the *Coffee Mill* and the *Chocolate Grinder* and the doubled art, the doubled R of Raymond Roussel, is an impressionistic homage to Roussel's *La Chiquenaude* as a flip of impulsive letters. But the image and the hand-lettered capitals and dashes reproduce La Fontaine's type of fable in phoenix overlay to be re-read with a different *effet de lumière,* a light effect.

> Maître corbeau, sur un arbre perché,
> Tenait en son *bec* un *fromage*
> Maître renard, par l'odeur alléché,
> Lui tint à peu près ce *langage:*
> "Hé bonjour, Monsieur du Corbeau.
> Que vous êtes joli! que vous semblez beau!
> Sans mentir, si votre *ramage*
> Se rapporte à votre *plumage,*
> Vous êtes le phénix des hôtes de ces bois."
> A ces mots, le corbeau ne se sent pas de joie;
> Et, pour montrer sa belle voix,
> Il ouvre un large *bec,* laisse tomber sa proie.

HOMMAGE FROMAGE PLUMAGE LANGAGE

The role reversal is already inscribed in that other HOMage: *FOUNTAIN.* There the visible letter of the *O* as *eau* and its hidden plural *Os* as *eaux* place the *haut* en bas, the top as bottom and pedestal. Ladies, as foxes and birds, as fonts and found *aines,* are no longer polite parrots (*Polly Perruque*) bewigged. This turn of the *haut,* the *eau,* the *eaux* of the *Fountain's* open mouth *O* and the wheeling *O* of the bicycle is a new shimmy of alchemical slip and trip of phrase.

Robert drew the Bec Auer from below and then took the letters *O* and *R* from the genie of the lamp to use with other letters to do his light art. He has spoken of the physical qualities of that light as well but the *vert/verre* of green glass is never lost from sight. He speaks of his *Chess Players* of 1910: "It was a tempting experiment. You know, that gaslight from the Aver [*sic*] jet is green; I wanted to see what the changing of colors would do. When you paint in green light, and then, the next day, you look at it in daylight, it's a lot more mauve, grey, more like what the cubists were painting at that time. It was an easy way of getting a lowering of tones, a *grisaille.*"[8] In *TORTURE-MORTE* the *grisaille* of Mantegna's gray-green bodies becomes antic sculpture painted in pun-ishment. "It's the light that illuminated me." But that light, that green light that turned him on was more than physical first light. As in the posted advertisements of BEC AUER that made concrete and vis-

136

ible the letter coupled with the inspiring, desirable woman, the real attraction of that light was the word itself – the unity of word heard, then seen in difference of letters: VERS, VERRE, VERT, and VERS. "Toward, Glass, Green, Worm, and Verse" are always seen and said with his "langue verte-green tongue" of slang and off-color joke and pun behind. The regenerative power of the letter, the word, of words, of literature and quotation turns him toward a mathematical, scientific perspective of transparency to create a new status for tail pieces. "I was mixing story, anecdote (in the good sense of the word), with visual representation, while giving less importance to visuality, to the visual element, than one generally gives in painting. Already I didn't want to be preoccupied with visual language."[9] Visible language, not visual language.

Fig. 7 *Le Dessin dans l'Art Magique,* cover, 1958.

The precision of his mechanical drawing of the Bec Auer as *Cul de lampe* takes us to the book again. His Latin, weighty Latin, first books and his chemistry manuals left their mark, their *empreinte.* Chemistry lessons lead to his pseudo-pharmaceutical (of Duchamp off the farm) and his pseudo-medical (out of M.D.) experiments, but they are engineered and grounded in the alchemy of letters of his names. The givens (*étant donnés*) of this experiment are formulaic letters, numbers, abbreviations, and signs. The letters given and taken are many, but *ROB*s, *B*s, *O*s, *R*s, *T*s and silent, mute *E*s and absent *L*s, seen and pronounced in the green light of *grisaille,* are drawn in

137

PB lead pencil to be read in the light of auric aura. Coming from the *robinet* of the kitchen, the farm, and the laboratory, they, as letters, are the air and water of his ocular *expériences* in *R* art. The game of *Chess Players* is now one of breast and chest players as Robert juxtaposes literary gleanings, chemical equations, mechanical drawings, musical notes, formulas, prescriptions, and chance letters of name and *erratum* with right copying, and redrawing of language now seen and heard.

Another name read in the green light of the Bossuet School lamp is Vergil; not only the *Eclogues,* not only the *Georgics,* but the *Aeneid.* The adolescent artist and schoolboy on the verge can only delight in the *verge* as *baguette* in which his *verge* as *membre viril* is covered in *braguette* and punctuated *virgule.* But it is in Marcellus and the Agricola of the *Georgics* and the *Aeneid* that the non name, the AKA's found in letters past, are put back into play. The echoes of these names bounce back and forth throughout his experiments. In late 1967 and the beginning of 1968 he etched a series to illustrate a two-volume work called *The Large Glass and Related Works.* Reading the image as word is critical; coupling titles and signatures underscores his mixed media strategy. The *causalité* (*"cols alités-necks abed"*) of attraction is the disappearance of the I (eye) from the French *aimants* to become *amants.* "Do not touch" is changed to "Please Touch" and the museum objections/works are changed into pleasing, pleased touches of a "con" artist. Magnets slip into lovers in word and image to illustrate the necessity of reading pictures, letters, and words tainted by Duchamp as Tintoretto—the Little Dyer. The majority of these prints have *"Morceaux choisis"* in the title, a term normally reserved for a literary collection of textual excerpts: "d'après Ingres, I," "d'après Ingres, II," "d'après Courbet," "d'après Rodin," "d'après Cranach et Relâche" signal intermission not only in earlier art but in his own: "Bec Auer," "La Mariée mise à nu . . . ," and "King and Queen."

One of the nine (new-neuf), *Morceaux choicis d'après Ingres, I,* is signed in Latin capital letters: MARCELLUS D (Fig. 8). The figured erotic dimensions of the artist as musician are voiced in the expression we must supply; *violon d'Ingres* is another untranslatable phrase pointing to an artistic activity practiced "unprofessionally." *Violon* is also slang for prison as in *passer la nuit au violon. Payer le violon* formerly meant to *offrir un bal à une belle,* but now is "paying the bill to no end." The pump of secondary artistic activity, whether literature or music, is primed and the waters (*eaux*) and his airs are raised by Duchamp to another level. Robert's water music (*Erratum musical*) is not unlike that of Eric Satie's *La Chute d'eau,* but where Satie's notations are seen and read as waterfalls, Duchamp's selections are attractions that draw on unheard music sung, and words read, in an apparently silent image seen. His chest pieces are extracts from Ingres's *Turkish Bath* and his *Virgil Reading the Aeneid to Livia, Octavia, and Augustus.* The *on viole* of *viol-on* is absent, but the Sultan's favorite plays her lute inviting (through *lutte* as struggle and *luth* of Musset's "Poète, prends ton luth" and "Tortue luth" as (fake tortoise) a reading; the "lu T" is a new kind of sight reading and recitation. Auguste Rodin is echoed in Augustus through another of the plates in the problematic title of his *Kiss* as noun or verb, and *Baiser* as peck and pecker are torqued. But it is Marcel as Marcellus D. who leads us back to octaves and August heroes who

Fig. 8 *Morceaux choisis d'après Ingres, I,* February 1968. Second state.

name and sing of Augustus and the two Marcels in the imagination of Aeneas. Marcellus, like the *tortue luth* of lyre and *lire,* plays second fiddle even here. Through his Latin name, Marcellus inscribed, the inevitable "'Tu Marcellus Eris" is voiced. We revise; we look back on a visit to an underworld where portraits painted by Vergil are hung as shadows seen. If Duchamp's readymades (*art-dis maids*) display his gallery of poets (*Fountain* of La Fontaine, *In Advance of the Broken Arm* of Mallarmé and Brisset, *Apolinère Enameled* of Guillaume Apollinaire, *Air de Paris* of Arensbergs, *Tonsure* of Raymond Roussel, for example), these nine etchings take us through the shades and shading of objects recollected and dead—objects that have lost their salt and odor—including his own dead and collected glas-sy, gl/assy past.

Erra tu m'

Already in 1918, in his largest and last "conventional" painting done with A. Klang and a secret noise for the library of Katherine S. Dreier (Fig. 9), he

Fig. 9 *Tu m'* in the Katherine Dreier library.

cunningly took the space as challenge. He situated Aeneas and the *Tu m' apostrophe* of name and shades and readymades to use the bottle brush as *pinceau* for a *tabula rasa*. The books and the painting are M-printed invitation. This was and is his much ado, his *adieu*, a step into art as no-thing. His art is not verb, not noun, but pronominal. It is, like Marcellus, an apostrophe of incompletion. *Tu m'* is not only an open-ended expression asking for "tu m'aime," "tu m'emmerdes,"[10] "tu m'ennuies,"[11] for completion. As Marcel teased in dialogue with Cabanne, "the title made no sense. You can add whatever verb you want, as long as it begins with a vowel, after 'Tu m'. . . .'"[12] Hmm. French verbs flirt, but do not cover up the signature cut short of the Latin Marcellus, coming from Vergil, as the French *virgule* raised to new heights as punctuation pokes through the canvas—a bottle brush for green glass *culs de bouteilles*. "Tu Marcellus eris." The absent "arcellus" becomes *arceau* in French, an arch connection, support and *trépied* on which this painting is suspended. In its "wicket" sense, *arceau* returns us to his three M croquet box: *Trois Stoppages-Etalon*. The M.D. medical meaning is a technicality: a frame placed on a patient's bed to keep the covers from touching a fractured member. Seen in *TORTURE-MORTE*, the uncovered foot is broken up into instep, arch, toes (*doigts de pied*), heel (*talon*), and footprint. The *talon* noun become verb is both a rugby kick and a detective's nose following the scent doggedly. Here we mind our p's and q's ("pieds et queues-steps and

140

wigs") to add Henri's *H* of H/air and that other French name become English verb – that is marcel, or to have one's hair marcelled. In Mallarmé's *Les Mots anglais* Henri is properly named "Henry, ou le Maître, qui fait Harry." Harry slips to verb to harry us as Marcel with his aspiration and unseen *H* – exceptional consonant that competes with vowelled initial verbs: *tu m'harcelles* ("you harry me, you hassle me, you torment me to death, you tail me too close, you shadow me") is the tortuous link with *tu me talonne*. HARCELLES/MARCELLES. ARS. ARSE. SELS. ELLES. Elle H au Q. L H_2O Cul. In this space of Dreier's library, in a new litany of letters, we now look up at the painting out of the future of painting. We look up in Vergil's "morceaux choisis-choice morsels" before nibbling on the Marchpane.

Nouns. Names. "Nunc, age expediam dictis, quae floria dinde sequatur Dardanium prolem, qui nepotes maneat de Ialaâ gente, illustres animas que ituras in nostrum nomen et docebo te tua fata. . . . Tum haec nomina, nunc sunt terra sine nomine" ("Now, come, I will unfold *by words* what glory hereafter shall follow the Trojan [Dardanium-Dard/D'art] race, what descendants remain from the Italian nation, illustrious souls, and about to go to our *name*, and I will teach you your own fates. . . . Then these shall be their *names*, now they are *lands without a name*" [emphasis added]).[13] In the *gris léger*, emphasized by Duchamp in the *neuf* prints from older art, shadows are cast by the Bec Auer school lamp and Bossuet's panegyrics for Henriette d'Angleterre, the read is deflected in the green light of Vergil. Robert went in search of a golden bough and found MARCELLUS spelled out, then erased. The diacritical mark of *Tu m'* is not painted by Marcel Duchamp but by a sign painter, Q.LANG., reproducing typographical font as image – not letter, not vowel, not consonant. The finger of the hand as pilcrow signature points to critical markings in letters and words. It is sign of signature alias to cue us in. Duchamp as typographer uses letters and names to resurrect the now dead *objets d'art* to give them new life. Ars longa, Vital Breath. *La Belle Haleine* Q.E.D. is Vergil rewritten on the Q.T. Pencil, typography, and print are the way out of the gates of horn/gates of ivory. The *Q*-ed lady as scent is now on a different staircase.

The descent into the nether world of word and literature in quest of the article *la* as pronominal, palindromic *elle* and the letter *L* as "the" takes him to Le The and Le/the. The waters of this river must be tasted by all the shades who no longer breathe. It is said to run near the Champs Elysées. This *the* becomes "the" in Duchamp's first crossing over into English. *The* (1915) requests the substitution of *"le mot* 'the'" each time the asterisk appears in the MS. The Latin *astericus* (little star) of *Tonsure* is Hank's reminder to "harceler – to harry" and to "asticoter" in the familiar but pointed sense of jargon, contradiction, and boredom. The *Q* ass to risk (*astérisque*) is cousin to the green *Q cul de lampe*, and the handy pilcrow of Robert as typographer. The either *O R* of AU and golden bower, the H_2O doubly aspirated oxygen measured in cc's, the *R*s (air-art-hair, ars, arse, error, aire) are grounded in Robert's Georgian fields, where the silent *T* (*thé*, the) is doubled and sipped in other drawing rooms of *Dasein*. The mirror return of name and letters reflects, and does not let us forget, the bucolic and arboreal letters read in green gaslight. German BAUER and GEORG and Latin AGRICOLA and M/

ARCELLUS are drawn on; he shades in other letters; he stencils in other letters drawn from Jean Brisset's *Grammaire logique* and uses the *Impressions d'Afrique* (*impressions de fric*) as capital in letters (PB RR). He will emerge from the Vergilian landscape to cast his shadows and drop the *T* and *T*s of painted oblivion and *cul de sac*. The ar(t)ist will become an air-tist and a new kind of hair stylist, not a chiascuro Rem/brandt (no thing burned on a ready-made ironing board), but a living breather and f/art artist (*Elle lâche au cul*) whose *pneumatique* letters are tired of the P.T.T. The *T* of Robert is silent. "'Tr' is very important."[14]

The TT of TOTOR goes quiet too. Victor foreshortened to Totor drops the teased H/AIR of victory in doubled *O*s and *R:* O/O R. His *oculaire* (eau-cul-aire OO Q L R) vision places the doubled *L* of *elle* in the center of the ring (La Bagarre d'Austerlitz – La Bague art d'eau stare lits) to play with doubled RR and OO to create new spectacles and G L A S S E S. In an interview with Katherine Kuh, translated into French, his reflections on letters doubled reads: "Je trouvai très curieux de commencer un mot par une consonne double, comme les L dans Lloyd."[15] The palindromic *elle* is green vers/ed re-versed. "Elle est" and "LHOOQ" are two of L.A.'s most fabled silent bumper "asticots" as signalling devices of letters, but as aerialist inscribed in Laforgue's title, "Encore à cet astre," Duchamp hides his unicycle in a string of letters and upended spokes. "I like living, breathing, better than working."[16]

The broken arm and fractured French re-verse foot come from Brisset and Mallarmé. Remarkably few re-cyclers of Duchamp have looked into Robert's fascination with the "philological analysis of language." A very fine example from Brisset's primer – a chapbook for chapmen – is his reflection on the letter *R* in all of its permutations:

Première *ère* est celle de la formation du sexe, c'est de la création. Le cri se modifiait suivant les circonstances et l'*air* variait sans cesse: l'air du visage se conformait à l'*air* de la chanson. Je n'aime pas son *air* et son *nerf*. Ces idées *sonnèrent* ensemble. Celui qui avait un *nerf terrible*. Quand on offert le manger à ce cri *ès-reu* et *en l'ère* – en le BEC, en l'air, où volaient les mouches et les insectes. Ce cri désigna le manger et l'*air* est l'aliment par excellence, celui dont on ne peut être privé même momentanément. Les mères offraient le manger à leurs petits dans des nids qui furent appelés *aires,* ainsi que les endroits où l'on préparait l'*aire*. A celui qui ne savait pas obéir au cri aire, on disait: *erre,* tu *erres*.[17]

Robert took as his *enseigne* (his ensign) the hidden cachet of the letters of the BEC AUER. That *cul de lampe* also became his hidden *blason* emblazoned and hidden in full sight as purloined letters of poets. His de-light in stumbling across Brisset after Mallarmé should be remarked in BEC, in AIRS sung, in AIR breathed, in nested AIRIES for young falcons heralding the absent *L* and *elle* of *faux con* (*Morceaux choisis d'après Courbet*). Curiously he found that guarantee as well in the sixteenth-century French poet Clément Marot's *Blasons* on parts of the female anatomy with the breast as *sein* and *tétin* doubly inscribed at the center.

Duchamp's own "breast-plate" was not painted or etched but created from air-blown rubber (caoutchouc as onomatopoetic ACHOO). It is a cousin (*cousein*) kept abreast as cushion (*coussin*) to the eye sign *sein* discussed above (Fig. 7). In 1978, before I had uncovered Duchamp's passion for *les mots*

Brisset-Brisés, I touched on that work reworded through Ingres in auto-quotation and ocular perspective. At the time of the celebration of the Franco-American Alliance of 1778, I penned "Duchamp, Delay, Overlay":

In 1947 Duchamp does a cover, O yes, a cover in foam rubber and velvet for a surrealist catalogue in an edition of 999 and inscribed it with *Prière de toucher:* it is a female breast. The fake and the real as art object, or more precisely as creative act, again centers on the present absence of the letter. *Pri-ère* becomes an R, literally in French air (the foam rubber) that has been *pris,* caught but falsely fixed as *objet d'art,* an R object. This numbered breast is but one of a series. This singular *sein* (breast) loses its singularity in reproduction and becomes *des seins,* breasts, 999 of them – hence, *dessins,* drawings. The airy object, *cousine* to the hairy object, provokes the viewer's reflexions on art, on the act of drawing, of making the *objet d'art.* The falsie joke inserted in the *histoire d'art* (*histoire d'air*) as air history dare presents us with the R's of art, but plays as well upon the breast in the form of the letter 'O' become 'O's in their plurality. *Ose, oser* (to dare) is the optic provided by the letter *O* doubled in the L.H.O.O.Q. through which we must look at *Art osé* (daring work), become darling with its absent L; the water H_2O of Leonardo's *Mona Lisa* made literal by Duchamp is the occular (o/cul/air) device by which the art of the past as R is lightened by the R (air) and R (hair) and gives us a work of letters O, Q, R.[18]

Written in intuitive *naïveté* as *briseur d'images* (I-con-o-claste), these *Worte* are now revised in the context of Duchamp's relation with Brisset and the arts and letters of the sixteenth and nineteenth centuries.

Like Brisset's "poetry," Duchamp's tongue-in-cheek portrait and his *TORTURE-MORTE* are, as I have sketched, plays with words untranslatable because over-drawn. Arturo Schwarz in his extraordinary *The Complete Works of Marcel Duchamp* complicated things with incest. My perspective is different, but I would like to draw on his evidence of the foot's importance in Duchamp's complex Oedipus and his Sphinx (Figs. 10 and 11) as relative to Duchamp's Mantegna-Vergil foot as *TORTURE-MORTE* and lame joke. The anxiety of the swollen foot is shared by both. Schwarz sees the sphinx as the female component of Oedipus and points to his bisexual nature evident in the fact that they share the same profile. Duchamp's earlier *démarche* of walking doll and talking man can already be seen and read in Robert's *Bébé marcheur* where he drew on her robe: "Je marche, tu par(l)es." That verbal enigma hides her letter *L* in her fussy doll skirts and walking for *vieux célibataires.* Say, read, flap your wings (*ailes*). The *Dollfuss* and the *Oidipous,* German and Greek, are strange fruits of a later-day Brisset from whose work Schwarz quotes. Thass-Thienemann points to the anxiety of walking through the Greek tongue: "This interpretation may sound strange to our understanding, but it would not be for the Greek mind, because in Greek *pedza,* 'foot'; *pedilon,* 'sandal'; *pedon,* 'ground, earth'; *pedion,* 'a plain, uncultivated field' as well as 'female genitals'; and *pedao,* 'to constrain, trammel, shackle,' were so closely associated in their meaning with one another that they all developed from the same phonemic pattern."[19] What strikes me here (Fig. 10) is that there is no trace of her wings (*L*s), their "queues as *Q*s, their *pedis P*s, or that enigmatic right dead foot borrowed by Ingres from Mantegna's *Dead Christ* to stand for all the men who could not answer the riddle:

Fig. 10 *Morceaux choisis d'après Ingres, II,* February
1968. Second state.

What goes on four feet, on two feet, and three,
But the more feet it goes on the weaker it be?

Duchamp's solution is the pun of easel and tripod and triptych that replace
the painted man and the man painter with different taste buds. His artful an-
swer to the enigma is a re-*touché* etching of a pinched breast and absent feet.

Here *aqua fortis* waste paper (*papier de rebut*) rebuses a new *ars poetica*
through Brisset's *La Grammaire logique* and *Les Origines humaines.* Out of let-
ters and primary questions, Robert, like Brisset, places sex at the center of
his questioning of painting as art. The erotic dimension of "he wrote it" touch
on the h-eroes teat and titties. Duchamp's Oedipus touches the *O* of the
breast and takes the *"sein"* of Brisset drawn departure to its logical end with a
pinch from his salt cellar. I return to Brisset's *Les Origines humaines,* subtitled
"Les Zoos rient, j'inhume aines." On drawing: "Le nombre cinq vient du sein.
. . . *D'ai sein,* dessein, dessin. Le premier dessin eut le sein en vue. Bé à sein,
bassin. *Sue qu'ai sein, suc-sein,* succinct. *T'ai haut queue sein, toque sein,*
tocsin." We are painfully and seriously led through his fracturing of French
underbrush. On painting: *"Pins, pein, peins, pin, pain. Pein ou pin ça haut,* pin-
ceau, *peins sot.* Le sexe fut le premier *pin* et *peint. Peux in seau,* le sot mit son
pinceau dans le seau. *Pein ture,* sur la *ture* du *pein* se vit la *peinte ure* et la pein-
ture. Le pein, peint au non, fut le pain des anges, le premier pain. Y c'est fait,
pein ç'ai, il s'est fait pincer. *Pein t'ai, pins t'ai, peinte ai,* pinter *Queue à le pein,*

144

calpin. *Queue l'ai en pein,* clampin. *L'ai à pin,* lapin."[20] Brisset notes in his "L'Apparition du sexe" that the ancestors had no apparent sex, but when it appeared "la parole commença à se développer."[21]

In the series of etchings of the *Morceaux choisis,* the *sein* as sign and the hand as pen and *pinceau* come together to restore the erotic dimension in order to breathe new life into old works. In an interview with Harold Rosenberg, "Duchamp reflected on how long the stimulating power of the work of art itself can last. Discussing the 'short life of a work of art,' he declared that a painting possesses an esthetic 'smell or emanation' which persists for twenty to thirty years, after which it dissolves and the work dies."[22] By 1968 not only Rodin's *Baiser* and the works of Ingres, Courbet, Mantegna, and Cranach, but his own *Bec Auer, King and Queen,* and *The Bride Stripped Bare* were ready for a new air. In each case, the chaste original is redrawn, re-colored by his *langue verte* in the light of off-color letters and words. These cunningly collected pieces rely on the 1959 triptych and his reworded da Vinci masterpiece of ass. Mantegna's foot uncovered again in Ingres is at the center of these altered pieces. But the profile portraits of the Renaissance as recoined phrases come from Piero della Francesca to enclose right and left, top and bottom, back to front this new air in print (Figs. 1, 2, 3).

Fig. 11 Ingres. *Oedpius and the Sphinx,* 1808. Louvre, Paris.

The Italian footnotes are indicated in Marzipan food-notes in color of almond paste. This dead pan Arcimboldo recovers not only the manbook/ bookman *Bibliothécaire* painted rhetoric but one of the most famous examples of profile portraiture diptychs in art. In these two portraits by Piero della Francesca of the Duke and Duchess of Urbino, Duchamp sees a number of his own reflections on language in its relation to painting and sculpture. The unity of the work is four-fold in that the reverse sides have painted allegorical triumphs and Sapphic stanzas to complete the picture (Fig. 12). Totor uses the dubbed and daubed to create a different *arc de triomphe*. It is language that reverses the left to right shift and the recto-verso seeing to negate the frontality and centrality of images painted. The Dead Pan poem comes from the tradition of the cry of grief that swept across the land at the time of the crucifixion and silenced the oracles for ever: "Great Pan is dead." The death of Battista Forza provoked the commission of these portraits by her widower, Federigo II da Montefeltro. *TORTURE-MORTE* and *sculpture-morte* seen through the funeral orations of Bossuet and Piero's pain of paint commissions are enlivened by Duchamp's tongue. "If you make a panegyric, it's ridiculous. Everyone isn't a Bossuet."[23] The solemnity surrounding the painted act and the controversy of portraits based on death masks invite us to razz the painting. In 1965 Duchamp returns to his Joke-Con-Da (*L.H.O.O.Q. rasée*) and plays another card in his game with the Italian masters. No *barbouillage* here. The barb of hair is gone when he scripts *rasée* to shave and save the victorious da Vinci's piece and inscribe an unvoiced Latin *tabula rasa*. This is his stratagem of erasure and reinscription with della Francesca's lady game. RI-DIS-CUL/E.

Vergil's Marcellus can only be resurrected by pun of Italian *marzapane*, of French *massepain*, and English marchpane on *papier glacé* and *papiers collés* and *papier de rebut*. He restores his see-through pane by basing it on paste and foodstuff receipts. The chassis is nearly read. We do not have to turn it over, but are invited to see through his OR watermarked letters. This anamorphic still life embodies Marcel's recomposition of masterpieces and recollects his fascination with Arcimboldo and Piero di Cosimo, both of whom stand behind Marcel's Piero della Francesca's face. Critics – Venturi, for example – have seen the Sforza profile as a death mask and note the Sapphic Latin past tense of her Triumph in contrast to the Duke's present tense inscription. The other two pane/ls of the triptych make manifest their plaster of Paris, but here the plate of art is a bonbon word delight that leaves behind the shades of *grisaille* and black and white Vergil's prediction of "Tu Marcellus eris." Death is replaced by breath (Haleine and Air) as we see through the glassy pastry-shop-paper wrapping on which a new Battista Sforza lies – before rebusing the mannered art of legumes and fruits. Bonnevie, written large in blue, names the past(r)ies and con-fections of this *patisserie/ confiserie* of Perpignan and pignoration. The pawn and the con artist pinch the Italian painting to peddle the wares inedible. In all three panels of the triptych letters and words as objects stand out in relief where foot and mouth join tongue and cheek, head and toes, to write out MARCELLUS FECIT in 3-D.

On this bas-relief pignon *chignon* Marcel sculpts new reversible NON-

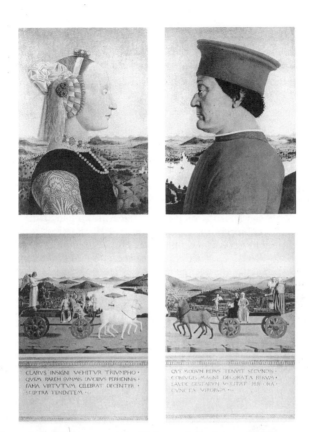

Fig. 12 Piero della Francesca. *The Duke and Duchess of Urbino,* ca. 1469. Uffizi, Florence (4 panels).

sense. He displaces Battista's coiffure with a *chou-fleur* of floral display and adorns it with a Bee to be seen from his *Abcédaire*. "Tu Marcellus eris! Manibus date lilia plenis." Vergil's lilies become achoo!fleur, radis-maids, Adam's apples, PB plums, *Tonsured* asterisked tomatoes, mirabelle stems as *Q*s, hairy-cots verres. Letters fall out everywhere from his typographical bonbonnière and sprout to life as letters are read through a pastel passe partout in the new green light of off-colored tongue. Handmaiden life as "Bonne V" forces a run up the plate and a left typographical return to Marcel's recast and redrawn Federigo II da Montefeltro *To be looked at (From the other side) Close to, For almost an hour*. The eye, the visual problem is relegated to the background. The cheek covering the tongue comes to the fore. The Duke, in a match, lost his right eye, broke his nose, a nose now out of joint. Duchamp here as in his *Blindman* cover of 1917 highlights his sense—his taste for language to *"tâter"* and rebut the fixed expression of *"bête comme un peintre."* He asks us to see and read his pâté Brisset as raised Braille art object: MontefelT RO ensign bared on the field of Henri-Robert-Marcel Duchamp—a Breather.

147

Notes

1. Guillaume Apollinaire is a very fine example, as I have discussed in "Enamouring a Barber Pole," *Dada/Surrealism* 12 (1983), 20–36.

2. Marcel Duchamp, *Salt Seller: The Writings of Marcel Duchamp* (New York: Oxford University Press, 1973), 126.

3. Raymond Roussel, *Comment j'ai écrit certains de mes livres* (Paris: Jean-Jacques Pauvert, 1963).

4. George H. Bauer, "La Jolie Roussel brisée: les vairs du chant," *Mélusine* 6 (1984), 179–87; and "Roussel-Duchamp," *La Quinzaine littéraire* 470 (15–31 October 1983), 13–14.

5. Henri-Pierre Roché, "Souvenirs de Marcel Duchamp," quoted by Arturo Schwarz in *The Complete Works of Marcel Duchamp* (New York: Abrams, 1970), 586.

6. See the excellent work of Carol James in her unpublished dissertation, "The Writings of Marcel Duchamp in the Development of His Poetics," written under my direction at the University of Minnesota (1978), and her recent articles coming from that work. The most extensive consideration of the name in Duchamp's work is André Gervais's wonderful *La Raie alitée d'effets* (Quebec: Editions Hurtubise HMH, 1985), where he opens up the "triptych" in a different light: "Du stiptyque du cadavre à caisettes," 47–51.

7. Marcel Duchamp in Pierre Cabanne, *Dialogues with Marcel Duchamp*, trans. Ron Padgett (New York: Viking, 1971), 90.

8. Ibid., 27.

9. Ibid., 39.

10. Schwarz, *Complete Works*, 471.

11. Calvin Tompkins, *The Bride and the Bachelors*, rev. ed. (New York: Penguin, 1976), 43.

12. Cabanne, *Dialogues*, 60.

13. Vergil, *Works*, trans. Levi Hart and R. Osborn (Philadelphia: McKay: 1882), 757.

14. Cabanne, *Dialogues*, 29.

15. Katherine Kuh, "Marcel Duchamp," quoted in *Duchamp du signe: écrits* (Paris: Flammarion, 1975), 152.

16. Cabanne, *Dialogues*, 72.

17. Jean-Pierre Brisset, *La Science de Dieu ou la création de l'homme* (Paris: Tchou, 1972), 248.

18. George H. Bauer, "Duchamp, Delay, Overlay," *Mid-America* 60, supplement (April 1978), 64–65.

19. Theodore Thass-Thienemann, *The Subconscious Language* (New York: Washington Square Press, 1967), 40, quoted in Schwarz, *Complete Works*, 573.

20. Jean-Pierre Brisset, *Les Origines humaines* (Paris: Edition Baudouin, 1980), 223.

21. Ibid., "L'Apparition du sexe," 105.

22. Harold Rosenberg, *The Anxious Object: Art Today and Its Audience* (New York: Horizon Press, 1964), 89.

23. Cabanne, *Dialogues*, 87.

Duchamp's Eroticism:
A Mathematical Analysis

Craig Adcock

Eroticism was fundamental to Marcel Duchamp's artistic production. His use of sexual innuendos, including those of the bizarre mechanical workings of his masterpiece, *The Bride Stripped Bare by Her Bachelors, Even,* are at least part of the reason for the notoriety of his works and their impact on twentieth-century art. The eroticism of his paintings and sculptures made them interesting. Through their sexual iconography, he could shock his audience into paying attention and then allow the *double-entendres* to carry an important part of his meaning. Duchamp said that everyone understands eroticism, but no one talks about it, and that through eroticism one can approach important issues that usually remain hidden.[1]

One of Duchamp's most famous artistic stratagems involving sexuality was his adoption of the character of Rrose Sélavy in 1920 or 1921. In this early performance work, he dressed as a woman and was photographed so attired by his friend Man Ray (Fig. 1). The resulting images were retouched, Duchamp's fingers made to look more slender, etc., in order to enhance his feminine "look." As a portrait, the photograph has its amusing Dada overtones, but beyond the rakish humor, it has, I believe, some interesting geometrical implications. During the late teens, at the time when Duchamp decided to dress up as a woman, he was becoming increasingly interested in speculative mathematics, particularly n-dimensional geometry and the fourth dimension. He was then actively working on the geometrical notes for the *Large Glass,* later included in the *Green Box* and *A l'Infinitif.* A central aspect of his involvement with geometry had to do with the results of rotating something through a higher dimensional realm: if a three-dimensional object takes a *demi-tour* through the fourth dimension, it returns mirror-reversed and turned inside out. It seems possible that Duchamp's assumption of a female personality was connected with his notions of the fourth dimension.

Duchamp's source for the notion of taking a *demi-tour* through the fourth dimension was the work of the mathematician Esprit Pascal Jouffret.[2] He discusses what happens when objects are so rotated and at one point footnotes a short work by H. G. Wells entitled "The Plattner Story."[3] In Wells's science fiction, Mr. Plattner is accidentally translated into the fourth dimension and returns with his handedness reversed, his heart on the wrong side of his chest, etc. In short, Mr. Plattner returns from his trip through the fourth dimension as a mirror image of his former self.[4] It is possible that Du-

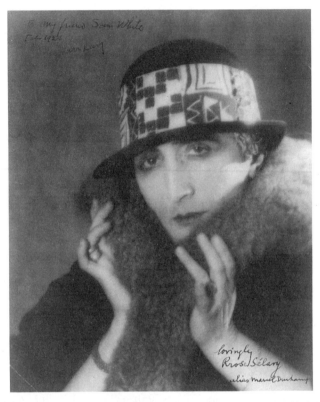

Fig. 1 Man Ray, Marcel Duchamp as Rrose Sélavy, 1920–21. Philadelphia Museum of Art. The Samuel S. White and Vera White collection.

champ was thinking along these lines when he chose a female alter ego. By becoming Rrose Sélavy, the artist undergoes an even more dramatic change than Mr. Plattner, becoming radically transposed and inverted.

How this particular transsexual geometry would work is suggested by a diagram from Jouffret's *Traité élémentaire de géométrie à quatre dimensions* (Fig. 2). Referring to this illustration, the mathematician explains that "two symmetrical tetrahedrons, which it is impossible to superpose in three-dimensional space, just as it is impossible to put on one hand the glove from the other hand," can be superposed if rotated through the fourth dimension. He begins by showing that two obtuse triangles, *abc* and *a'b'c'*, cannot be placed directly on top of one another if they are only rotated within the plane they are drawn on, that is, if they are only moved about on their surface world. But if one of the triangles is rotated *through space* around the axis *AC* then it is quite easy to superpose the two triangles. Jouffret extends his arguments to the two tetrahedrons *abcS* and *a'b'c'S'*. These solids could not be superposed by any sort of rotation within three-dimensional space, even if they could freely interpenetrate. But if one of the tetrahedrons is rotated *through the fourth dimension* around the fixed plane *aSc* – a plane that would

150

Fig. 2 Illustrations from E. Jouffret, *Traité élémentaire de géométrie à quatre dimensions* (Paris: Gauthier-Villars, 1903), p. 40.

act like the linear axis *AC* between the triangles – then the two tetrahedrons can be superposed. In the process, one would be turned inside out and mirror-reversed. A rotation involving symmetrically placed left- and right-hand gloves, as Jouffret also explains, would result in one of the gloves being turned inside out, the left becoming the right, or vice versa.[5] In similar terms, he explains that when a sphere is rotated through the fourth dimension it too is turned inside out: if the inside of the sphere is painted one color and the outside another, these colors are reversed by the rotation.[6]

The geometrical implications of Duchamp's transformation into Rrose Sélavy begin to make sense when the sexual changes are considered in relation to the other objects he produced during this same period. Among the important works contemporary with Rrose Sélavy are *L.H.O.O.Q.* (Fig. 3) and *Fountain* (Fig. 1, p. 65). Both of these can be interpreted in ways that are consistent with his interests in the transformational nature of four-dimensional rotations. The mathematics is serious: it gives Duchamp a way of underlying his surface changes, his humorous Dada superficiality, with deeper significance; it allows him to extend the dimensions of his Dada insight into the philosophical realms of art and aesthetics.

The *Fountain* can be taken as both a shocking object and a geometrical object, and it seems clear that Duchamp wanted to embroil the readymade urinal in a Dada scandal while simultaneously using it as a mathematical metaphor that would necessitate the reconsideration of certain aesthetic assumptions. Among other things, it challenged the importance of originality and the role of personal involvement in artistic production. In purely formal terms, the *Fountain* is an elegant geometrical object; it is symmetrical, smoothly curved, and suggests such mathematical constructs as Klein bottles. Moreover, it is in many ways an archetypal emblem of modernity and mechanical perfection. These aesthetic qualities, of course, in no way diminish the contentious nature of submitting an appropriated men's-room fixture to an unjuried art exhibition.[7] Duchamp wanted to shock people, in-

151

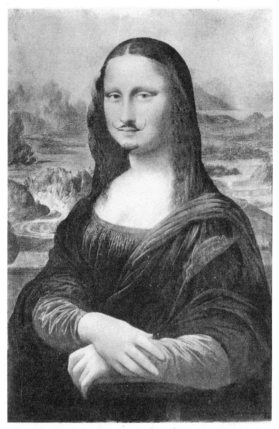

Fig. 3 Marcel Duchamp, *L.H.O.O.Q.*, 1919. Private collection, Paris.

cluding his supposedly avant-garde American associates, and his choice of the urinal was clearly implicated in the generally disputatious position he took in regard to matters of art.

In addition to being both geometrically likable and aesthetically unlikable, the *Fountain* is one of the earliest instances of Duchamp contradicting himself in relation to his own stated principles. The urinal is not an indifferent object, and we should recall that his avowed method of choice involved a system of aesthetic indifference: the readymades were supposed to have been chosen because he neither liked them nor disliked them. Thus, the choice of the urinal, one of the first readymades, contravenes his own stated criteria for selecting found objects. Far from being embarrassed by his self-contradiction, Duchamp uses the difficulty of maintaining a consistent position to further substantiate his opinions about the arbitrariness involved in making an aesthetic choice in the first place. He turns his own principle back

upon himself and his own system. It was a rule that contained its own denial. Duchamp's procedures for choosing readymades – and their collapse – become self-reinforcing methods for being contrary. As Duchamp uses it, the urinal is both an art object and a non-art object, both ugly and beautiful. He argues that few people could like a urinal, but then likes it because of its very loathsomeness. The object's inescapable insolence was directly to his point. He replaces "aesthetic delectation" with "geometrical delectation" and reinforces his beliefs about the provisional nature of making an aesthetic choice by using the urinal to refer subtly to the conventional nature of choosing any given geometry over any other. In other words, viewers can look at the *Fountain* as being either Euclidean or non-Euclidean, just as they can look at it as being either art or non-art.[8]

When the *Fountain* is dissociated from the implications of its useful function – which is not easily done – its geometrical qualities become quite apparent. The purely isometric aspects of the fixture suggest meanings that supersede its traduction of normal artistic practice. A central part of the *Fountain's* geometry is its inversion – a rotation that changes it from a drain into a fountain. Moreover, its 90° rotation can be taken as a reference to the flip-flops involved in four-dimensional rotation. As we have seen, such a rotation through the fourth dimension results in a left-right reversal and an inside-outside transformation. If an object such as the *Fountain* were so rotated, it would undergo, at least in metaphorical terms, a concavity-convexity transposition. Duchamp's enigmatic statement in the *Box of 1914* that "one only has *female* for the pissotière and one *lives* by it"[9] probably alludes to the "femaleness" of concave shapes in the sense that one speaks of connections in machinery as being either "male" or "female." That one must live with this fact about urinals may refer to the impossibility of carrying out four-dimensional rotations in normal three-space. In other words, the *Fountain* can only be rotated ninety degrees; it cannot take a full *demi-tour* through the fourth dimension and thereby have its "female" concavity transformed into "male" convexity.

In even more metaphorical terms, the placement of the *Fountain* can be taken as a reference to the aesthetic transformations involved in Duchamp's general strategy of using readymades. His chosen objects came out of their rotation – out of their revolution – through the art world transformed and reversed. They began as useful objects that could be bought in hardware stores and ended up as useless art objects commanding the same kinds of prices asked for the traditional sculptures found in museums and galleries. During this process, the readymades reversed themselves and confounded our ability either to accept them or deny them. On the one hand, useful objects became useless as works of art, and, on the other hand, the readymades could not really become works of art because they were still potentially useful. Of course, Duchamp himself neither claimed the readymades were works of art nor admitted they were not. They were simply readymades – objects that occupied an area outside either category.[10] In a sense, they operated in a different dimension where the conventional polarities were no longer valid.

Duchamp's system of choosing readymades and then watching them become works of art requires the viewer's acquiescence, and the viewer's own

choices are therefore implicated in the process. Such acts are unavoidable. For Duchamp, the epistemological problem involves what he called the "art coefficient" – the "you and me" or the "tu et me" of the artist/audience interchange. It was this notion of mediation between the artist and his audience that formed one of the central aspects of Duchamp's entire *oeuvre*, and it brings to mind one of his most important paintings, *Tu m'*. This complex work uses the French pronouns for "you" and "me" as its title, and in it, there are a "you" and a "me," but no mediating verb – a fact that suggests the indeterminate nature of the artist's ability to get a message across to the audience that looks at his work.

Tu m' has as its subject matter the geometric transformation of readymades: three-dimensional objects become two-dimensional shadows stretched out across the surface of the canvas. In addition to this simple kind of transformation – a basic form of projective geometry – Duchamp was also concerned with more complex categories of n-dimensional operation that result in left-right reversals and interdimensional inversions. The fact that the title of *Tu m'* was a left-right reversal of the name he had used to sign the *Fountain* in the previous year surely did not escape him, especially since he continued to be interested in such mirror-reversed names for the next few years and associated them with the fourth dimension. In one of his posthumously published *Notes*, he shows a sketch for the design of the mirror-reversed title of his film *Anémic/Cinéma* – a design later used for the title frame (Fig. 4). The two reversed words meet in what appears to be a corner

Fig. 4 Marcel Duchamp, Title frame from *Anémic Cinéma*, 1926 (filmed with the collaboration of Man Ray). The Museum of Modern Art, New York. Film Stills Archive.

where two mirrors intersect at right angles. Written at the top of the note is the following: "The cutting edge of a blade and transparency and X-rays and the fourth dimension."[11] The sketch is thus associated with the fourth dimension and other aspects of Duchamp's quasi-mathematical category of "infra-thin."[12] The mirror reflection of the film title results in a palindrome

Fig. 5 Photograph of Marcel Duchamp taken with a hinged mirror, 1917.

(almost) and can be compared with the Mutt/Tu m' reversal just mentioned.

In 1917, the year he chose the *Fountain* and just before he began work on *Tu m'*, Duchamp had a trick photograph of himself made using two mirrors hinged together (Fig. 5). This arrangement is similar to the mirror corner suggested in the *Anémic/Cinéma* title frame.[13] In the photograph, the effect of the mirrors meeting at an angle and the resulting reiteration of Duchamp's image makes it seem as if he is being translated around an axis of rotation. It suggests the complexity, the multi-directionality, and outward expansion of the four-dimensional continuum away from normal space.[14] Perhaps more important than the spatial metaphors evident in the photograph are the visual metaphors: the angle of incidence of the perpendicular mirrors multiplies Duchamp's image, giving him a multiple point of view, or a "view of the whole," something he posited would be necessary to "see" four-dimensional objects. Note, however, that he is not looking at any such object, but rather at an "infra-thin" axis of rotation. Simultaneously, the multiple reflections seem to translate him, in geometrical terms, outward along a complex set of axes. Again, the divergence of his image within its mirror world can be understood as a metaphor for the far more intricate and multifarious involvements of the fourth dimension.

Despite the many conceptual difficulties, these were precisely the kinds of speculations Duchamp was concerned with in the notes he was writing for the *Large Glass* during the late teens and early twenties. Because he was interested in such mathematical operations and was using film and photography to deal with them in symbolic terms, it seems reasonable to suppose that he was also concerned with what would happen to his own person if he were rotated through the fourth dimension. Would he be reversed in the manner of Mr. Plattner in the H. G. Wells story? Would he be turned inside out in the manner of Jouffret's tetrahedron or sphere? Or would he undergo

155

the male/female transpositions implied by his adoption of the character of Rrose Sélavy?

Duchamp's intentions can perhaps be clarified by discussing other aspects of Rrose Sélavy and the works associated with her. By becoming Rrose, the artist changes his identity; he changes his name. The gesture can be seen as an example of what Duchamp called "pictorial nominalism."[15] He believed that naming something transforms it. Calling a manufactured object a ready-made turns an ordinary thing into something uncomfortably like art; adopting a female name and character changes Duchamp himself into a woman. Thus, it seems, Rrose Sélavy is at least part ready-made (maid). She, like the *Fountain*, functions according to the rules of Duchamp's "name-ism."[16] He later explained that his decision to use the female name "Rrose" was prompted in part by his amusement with the name "Lloyd."[17] The double letters in both set up a kind of echo, an iterative "elementary parallelism" that begins to suggest their reverberation into other dimensions.

In geometry, a "rose" is a figure that expands outward from a center. A "rose" is, of course, also a flower and a woman's name. The notion of "blossoming"—the French word is *épanouissement*—figures prominently in the iconography of the *Large Glass*. It implies not only outward expansion, but also sexual awakening. In his notes, Duchamp refers to the amorphous, cloud-like form in the upper panel as an *"épanouissement cinématique."* This "kinematic blossoming" operates on several levels: it suggests flowering, going through puberty, and expanding into the fourth dimension.[18] The word *épanouissement* is generally translated as "blossoming," but it can also be translated as "expansion." When a flower blooms, it opens and expands outward from a center, much as Duchamp seems to flower and expand outward, multiplied around a common center of rotation in the trick photograph. Like a highly complex blossom, the four-dimensional continuum opens and expands outward from normal three-dimensional space along axes not contained within three-dimensional space. It is in just this sense that Jouffret uses the word *épanouissement:* in one of his discussions of a particularly complex four-dimensional figure, he explains that a "trihedron of the second type" is a figure consisting of three half-planes "issuing from the same line but not situated in the same space." This strange figure is "only the beginning of an expansion [*épanouissement*] into fields of superior degree that become more and more intricate."[19] The *épanouissement cinématique* in the upper panel of the *Large Glass* can stand for the Bride's four-dimensional characteristics. She expands outward from a center into realms that are ninety degrees away from any direction that exists in normal space. It is a cloud-like concept. Indeed, in this kind of speculative domain, a four-dimensional *épanouissement* might also involve the fundamental sexual changes that Duchamp approaches metaphorically by adopting the character of Rrose Sélavy. In his calculations, "Rrose" equals "Eros."

Duchamp tends to conflate human and non-human categories. He mixes geometrical and human attributes in his readymades and ready-made gestures just as he transposes human sexuality into the mechanical workings of the *Large Glass*. His purposes are in part humorous and in part philosophical. In the words of Octavio Paz, "the *Large Glass* is the painting of a recrea-

tive physics and of a metaphysics poised, like the Hanged Female [the Bride], between eroticism and irony."[20] Duchamp combines affective and geometrical eroticism and irony in ways that disclose the fallibilistic nature of either approach to discourse: the artist seems to feel that talking emotionally (non-scientifically) or geometrically (scientifically) are both provisional and open to question.

Duchamp's method can be examined further by looking at another work closely associated with Rrose Sélavy, the readymade aided *Why Not Sneeze?* This small birdcage filled with marble cubes is signed by Rrose herself. The title at first seems nonsensical, and, in part, it probably is, but it also sets up a pattern of associations. A sneeze is physiologically similar to an orgasm, or so commonplace wisdom would have it. A sneeze thus resonates on a connotative level commensurate with one of the meanings of the term *épanouissement*. The cage with its randomly dispersed geometrical units also suggests a number of mathematical meanings. The cubes are arranged in a way that recalls the diverse orientations of the fourth dimension. They recall both the

Fig. 6 Marcel Duchamp, Poster for the Third French Chess Championship, Nice, September 2–11, 1925. The Museum of Modern Art, New York. Purchase Fund.

diagrams in Jouffret's books and the chess poster Duchamp designed for the 1925 French chess championship at Nice (Fig. 6). The poster depicts the squares of a chessboard expanded into three-dimensional cubes, perhaps after having undergone some kind of four-dimensional *épanouissement*. This interpretation takes on force when we recall that the French word for a square on a chessboard is *case* and that the word also has a specialized mathematical meaning. In geometry, *case* means "cube" or "cellule" and is often used in just this sense by both Duchamp and Jouffret.[21] Jouffret repeatedly sets up geometric systems in which *cases* are projected from various four-dimensional figures onto three-dimensional figures that can in turn be represented by two-dimensional diagrams. One of these "diverse projections" (Fig. 7) represents an aspect of the four-dimensional tesseract, or, as Jouffret calls it, the octahedroid. The diagram has randomly clumped *cases* that are conceptually similar to Duchamp's poster for the chess tournament and to the marble cubes in *Why Not Sneeze?* In Jouffret's diagram, the *cases* are diversely oriented in relation to the axes of the fourth dimension. The complex arrangement of this speculative hyperspace is suggested by the coordinates at the bottom of the drawing. The dotted line is meant to represent an extra axis or a fourth coordinate perpendicular to each of the normal directions of three-space. Like this strange coordinate system, Duchamp's four-dimensional world folds back upon itself in infinitely complex ways.

Fig. 7 "Les huit cases hexaédrales qui limitent l'octaédroïde." From E. Jouffret, *Traité élémentaire de géométrie à quatre dimensions* (Paris: Gauthier-Villars, 1903), p. 120.

Rotation is a way of transforming n-dimensional objects into $(n + 1)$-dimensional objects, and Duchamp implicitly transforms three-dimensional chess into four-dimensional chess with the poster for the French chess championship. The direction of any such rotation would be, by necessity, highly ramified—as is perhaps suggested by the random dispersal of the two-dimensional *cases* of the chessboard after they have become three-dimensional *cases* or cubes. Duchamp developed the poster from a photograph of building blocks lumped together in a sack made of netting. The blocks and their arrangement can be interpreted as three-dimensional *cases* projected from four-dimensional space. They are geometrical precursors to the hypercube and are possibly related to an interdimensional *épanouissement*. They are like the marble cubes replicated over and over again in *Why Not Sneeze?*—a work whose title overtly implicates geometrical forms and sexual activity. In Duchamp's etching *King and Queen* (Fig. 8), a late work derived from the chess poster, the randomly dispersed *cases* form a geometrical *épanouissement* between the male and female chess pieces.

Another work associated with Rrose Sélavy is *Belle Haleine, Eau de Voilette,* one of Duchamp's most famous uses of Man Ray's photographs. Duchamp redesigned the label from a Rigaud perfume bottle, using a logo "R.S." (for Rrose Sélavy) with the "R" written backwards—a rotation that implies mirror reversal. The perfume bottle's other iconographical associations—

Fig. 8 Marcel Duchamp, *King and Queen,* 1968. Collection Mme Marcel Duchamp, Villiers-sous-Grez.

beautiful Helen, beautiful breath, veil water, toilette water, etc. – suggest various aspects of an *épanouissement*. Moreover, the wafting fragrance of the perfume expands outward, invisibly, as if following the axes of a four-dimensional coordinate system. It recalls both the nature of a flower's scent as an attractant and the pheromonal characteristics of perfumes as used in human mating rituals. These aspects of the work turn the perfume bottle into a matrix of erotic associations, part human and part geometric. Robert Lebel's early characterization of Duchamp's interest in the fourth dimension is correct as far as it goes: the fourth dimension was for Duchamp an "erotic embrace."[22]

In addition to his work with and by Rrose Sélavy, Duchamp made several other gestures concerned with changing genders. The best known is his infamous Dada blague *L.H.O.O.Q.* (Fig. 3). By adding a goatee and mustache to a small reproduction of the Mona Lisa, Duchamp transformed Leonardo's smiling lady into a demure gentleman. Duchamp and Leonardo share artistic characteristics and their work is similar, particularly in terms of the scientific cast of their perspective studies and notes.[23] In transforming *La Joconde*, Duchamp was no doubt aware of the Freudian echoes her masculinization would set in motion.[24] He once explained that his "landscapes begin where da Vinci's end."[25] In terms of the geometry, he may have meant by this statement that Leonardo's studies of scientific perspective, some of which are very much like his own, deal only with ordinary landscapes – with the observable three-dimensional world – while his own go beyond this world into the fourth dimension. Perspective projections from the fourth dimension, as Duchamp had seen in the complex diagrams of Jouffret, require numerous rotations and involutions in relation to the coordinates of normal three-dimensional space. One must look at four-dimensional objects again and again from multiple points of view. Some of these projections and rotations turn things inside out. In order to discuss such peculiar geometrical events, Duchamp apparently invented his radically altered alter ego. The sexual transformation involved in his becoming Rrose Sélavy can be taken as a metaphorical reference to the convexity-into-concavity transformation involved in taking a *demi-tour* through the *étendue*. And of course, in just these terms, the Mona Lisa's mustache indexes what would happen if Leonardo's "perspective" were rotated through the fourth dimension. The "look" – the perspective – of Duchamp's rectified Mona Lisa suggests the potential consequences of his n-dimensional modification of Leonardo's *vetro piano*.

For Duchamp, a "plane of glass" was more than a Renaissance window opening onto the perspective of ordinary space. It was an "infra-thin slice" that contained projections not only from the three-dimensional world but also from the four-dimensional world that lies beyond it. From this point of view, the Bride in the *Large Glass* is "four-dimensional." She is a *retard en verre*, a "delay in glass." The pun here may be on *envers*,[26] as in the expression *à l'enverse*, or "inside out," implying that she is a frozen projection from the fourth dimension, rotated around a stationary plane like the tetrahedron in Jouffret's diagram (Fig. 2). The transparency of the *Large Glass* makes the four-dimensional rotation at least theoretically visible, since we can walk

around the Glass and look through it from the *envers*, the reverse side, an operation that turns its various elements inside out.

The general theme of inside/outside reversal also recalls Duchamp's last major work, now installed in the Philadelphia Museum of Art, *Etant donnés: 1° la chute d'eau, 2° le gaz d'éclairage*. The nude torso seen through the peepholes in the door can be connected with Rrose Sélavy and her bearded antitype, the Mona Lisa in *L.H.O.O.Q.* The almost overly explicit reworking of the "Bride Stripped Bare" in *Etant donnés* becomes yet another *n*-dimensional reincarnation of Duchamp's androgyne. The male/female qualities of the mannequin-like figure are not explicit, but it is significant that Duchamp made two castings from her—one female and one male.[27] The first of these objects, the *Female Fig Leaf* (Fig. 9), was cast directly from the pudendum of the figure; like the *Fountain*, it suggests a concavity/convexity transformation with geometrical implications that go beyond its shock value. Francis Naumann has pointed out that "although the mold was never used for the casting of a positive form, in 1956 [for the cover of *Le Surréalisme, même*] Duchamp had the work specially photographed so that through the control of light he might create an illusion of seeing the sculpture inside out and upside down."[28]

The second of Duchamp's late erotic objects also involves an inside/outside reversal, but one even more in keeping with his interest in changing sexuality. The *Objet-Dard* (Fig. 10) was made from a piece of broken plaster

Fig. 9 Marcel Duchamp, *Female Fig Leaf,* 1950. Philadelphia Museum of Art.

161

Fig. 10 Marcel Duchamp, *Objet-Dard*, 1951. Philadelphia Museum of Art.

used as a brace underneath the figure's arm. Given this fortuitous origin, the female/male inversions here take on a kind of scriptural cast. Naumann points out that "according to the biblical account, Eve was created from Adam's rib. Similarly, in the making of the *Objet-Dard*, an emphatically male symbol was created from an internal reinforcement located precisely in the anatomical position of the figure's rib. In other words, just as he freely shifted sexual identities with the creation of Rrose Sélavy, Duchamp has here symbolically created 'man' from the rib of a female figure."[29]

The mold/cast, negative/positive reversals and the inside/outside transpositions involved in these late "readymades" are relevant to the discussion of four-dimensional rotation. They invoke the male-to-female changes of Rrose Sélavy and the female-to-male changes of the Mona Lisa in *L.H.O.O.Q.* It is worth repeating Duchamp's statement that his own "landscapes begin where da Vinci's end." Both the landscape in *Etant donnés* (a hand-painted photograph of a Swiss hillside) and the rolling hills behind the Mona Lisa show running water. This iconographic detail rotates these images into an interpretive frame embracing a number of Duchamp's other works. It recalls in particular an important precursor to the nude figure in *Etant donnés:* the mannequin in the window display that Duchamp designed for the Gotham Book Mart in New York in 1945 on the occasion of the publication of André Breton's *Arcane 17* (Fig. 11). This showcase also involves running water and, like *L.H.O.O.Q.* and Rrose Sélavy, can be taken in terms of a male-female transformation.[30] To the thigh of the mannequin used in the display, Duchamp attached a faucet that functions as an analogue for the "Waterfall" in the *Large Glass* and *Etant donnés*. The window arrangement also shares characteristics with the *tableau-vivant* nature of *Etant donnés:* both are like dioramas. The window design is called "Lazy Hardware," and it suggests the best-known alternate reading of Rrose Sélavy: *"arroser la vie."*[31]

The celebratory "drink-it-up" connotations of this expression carry it toward the "watering" nature of maleness. Robert Lebel points out that "if the term [the pun on Rrose Sélavy and *arroser la vie*] is always so flexible, it verges, so to speak, toward the masculine by emphasizing this time the servitude of the 'malic' function."[32] The faucet on the mannequin is an obvious phallic symbol and transforms the female figure into a male, much as the addition of a goatee and mustache in *L.H.O.O.Q.* transforms the Mona Lisa, or Man Ray's photographs transform Duchamp. Moreover, the title, "Lazy Hardware," alludes to one of the salacious puns of Rrose Sélavy: "Parmi nos articles de quincaillerie paresseuse, nous recommendons le robinet qui s'arrête de couler quand on ne l'écoute pas."

The sexual overtones of this spiraling play of words, which first appeared in Duchamp's film *Anémic/Cinéma*, are largely lost in the English translation: "Among our articles of lazy hardware, we recommend the faucet that stops running when no one is listening to it."[33] One of the best-known photographs of "Lazy Hardware" shows Duchamp and Breton reflected in the glass of the storefront window. They are, of course, mirror-reversed and rotated by the reflection, and that can be taken as a reference to the more abstract rotation of the two-dimensional imagery of the *Large Glass* around the stationary

Fig. 11 Marcel Duchamp and André Breton, Window installation for the publication of Breton's *Arcane 17* at the Gotham Book Mart, New York, 1945. Collection Mme Duchamp, Villiers-sous-Grez.

plane of an old door into the three-dimensional imagery of *Etant donnés*. The year after he completed the window display, Duchamp designed a cover for Breton's collection of poetry, *Young Cherry Trees Secured Against Hares*.[34] By replacing the face of the Statue of Liberty with that of Breton, Duchamp submits his friend to a male/female transformation. The lamp held aloft by the Statue of Liberty suggests the lamp held aloft by the nude figure in *Etant donnés*. These iconographic details serve to interrelate both "Lazy Hardware" and *Young Cherry Trees Secured Against Hares* with Duchamp's earlier work and his subsequent conceptualization of the last piece.

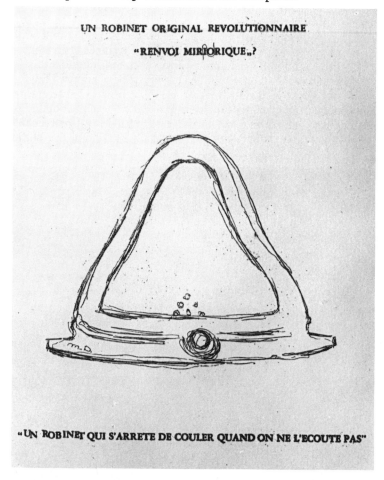

UN ROBINET ORIGINAL REVOLUTIONNAIRE

"RENVOI MIRIORIQUE„?

"UN ROBINET QUI S'ARRETE DE COULER QUAND ON NE L'ECOUTE PAS"

Fig. 12 Marcel Duchamp, *Mirrorical Return*, 1964. Collection Arturo Schwarz, Milan.

That these various associations do in fact converge in an interpretation consistent with the sexual consequences of a rotation through the fourth dimension here proposed is reinforced by one of Duchamp's last works: a 1964

etching of the urinal (Fig. 12), whose title incidentally implies a mirror reversal since a *Fountain* can be thought of as a drain turned inside out. On this work Duchamp wrote the following: "An Original Revolutionary Faucet: 'Mirrorical Return?' 'A faucet that stops dripping when no one is listening to it.'" Thus Duchamp himself associates Rrose Sélavy and her puns, his readymade *Fountain,* "revolution," and the geometrical notion of mirror-reversal and "mirrorical return" – and does so at a time when he was working in secret on *Etant donnés.*

Duchamp's subjects are in general sexual and erotic. Many of his most important works deal with nudes that are, in one way or another, geometrical. Reciprocally, the majority of his geometrical readymades have a strange nakedness about them. Duchamp's use of Rrose Sélavy as a purveyor of alternate approaches is a related activity. She was his alter ego and also his alternator, a kind of desire magneto that allowed him to shock his audience. In many instances, Duchamp treats his subjects and activities ironically. His whimsical view of human behavior allowed him to remain detached, and the erotic undercurrent of his work, its sexual echo, gave it a delicious wickedness that kept him interested. It accounts as well for at least some of our own interest. The surface humor of Duchamp's work would have soon paled were it not for the more profound levels that it masks. The eroticism, like the readymades, is first funny and then ironic and then epistemic. Duchamp's bizarre erotic games are intermeshed with other systems of thought, with mathematics and epistemology, and at those levels they are profound. Without the eroticism, the subsequent impact of his work on late twentieth-century art practice would have been less dramatic and less wide-ranging.

Notes

1. See Duchamp's statements to Pierre Cabanne, *Dialogues with Marcel Duchamp,* trans. Ron Padgett (New York: Viking, 1971), 88–89.

2. Duchamp was familiar with Jouffret's *Traité élémentaire de géométrie à quatre dimensions et introduction à la géométrie à n dimensions* (Paris: Gauthier-Villars, 1903); and also its sequel, *Mélanges de géométrie à quatre dimensions* (Paris: Gauthier-Villars, 1906). For a more complete discussion of Duchamp's mathematical sources, see Craig Adcock, *Marcel Duchamp's Notes from the Large Glass: An N-Dimensional Analysis* (Ann Arbor, Michigan: UMI Research Press, 1983), 29–39.

3. Jouffret, *Mélanges,* 192.

4. The Wells story was first published in 1897; for a pertinent passage, see *The Short Stories of H. G. Wells* (London: Ernest Benn Ltd., 1927), 328: "Mathematical theorists tell us that the only way in which the right and left sides of a solid body can be changed is by taking that body clean out of space as we know it, – taking it out of ordinary existence, that is, and turning it somewhere outside space. This is a little abstruse, no doubt, but anyone with a slight knowledge of mathematical theory will assure the reader of its truth. To put the thing in technical language, the curious inversion of Plattner's right and left sides is proof that he has moved out of our space into what is called the Fourth Dimension, and that he has returned again to our world."

5. Jouffret, *Traité*, 40–41; see also *Mélanges*, 192 ff.

6. Jouffret, *Traité*, 85–88. In *Mélanges*, Jouffret refers to this passage, reminding us that "dans le *Traité élémentaire* nous avons appliqué le calcul au cas d'une sphère creuse et montré qu'un demi-tour dans l'étendue, ou tout mouvement équivalent, a encore pour effet de la retourner, sa surface intérieure devenant extérieure, et réciproquement" (p. 194).

7. In his interview with Otto Hahn ("Marcel Duchamp," *L'Express* [Paris], no. 684 [July 23, 1964], 22; quoted in Arturo Schwarz, *The Complete Works of Marcel Duchamp* [New York: Abrams, 1970], 466), Duchamp hints that he intentionally chose the urinal because it was disagreeable: "[choosing the urinal] sprang from the idea of making an experiment concerned with taste: choose the object which has the least chance of being liked. A urinal – very few people think there is anything wonderful about a urinal."

8. For Duchamp's use of geometrical conventionalism, see Craig Adcock, "Conventionalism in Henri Poincaré and Marcel Duchamp," *Art Journal* 44 (Fall 1984), 249–58.

9. Marcel Duchamp, *Salt Seller: The Writings of Marcel Duchamp* (*Marchand du Sel*), ed. Michel Sanouillet and Elmer Peterson (New York: Oxford University Press, 1973), 23.

10. Recall Duchamp's often-quoted remark that "for me there is something else that is different from *yes, no,* or from *indifferent* – for example, *absence of investigation in this area.*" Quoted in Octavio Paz, *Marcel Duchamp, Appearance Stripped Bare*, trans. Rachel Phillips and Donald Gardner (New York: Viking, 1978), 70.

11. Marcel Duchamp, *Notes*, trans. Paul Matisse (Boston: G. K. Hall, 1983), No. 189.

12. For a discussion of Duchamp's use of "infra-thin" and its geometrical implications, see Adcock, *Marcel Duchamp's Notes*, 48–55.

13. For a discussion of the four-dimensional aspects of this film, including the mirror-reversed title frame, see Adcock, *Marcel Duchamp's Notes*, 170–86.

14. Dalia Judovitz, in "Anemic Vision in Duchamp: Cinema as Readymade," *Dada/Surrealism* 15 (1986), 51, has suggested that the title frame for the film, particularly the way the words meet, seems to imply a reversed perspective with the vanishing point occurring in the viewer rather than in the image. In the rotational photograph of Duchamp, the involuted perspectives and the geometrical reverberations suggest the complex nature of the fourth dimension. The linear perspective reversals of the *Anémic Cinéma* frame also seem to be concerned with turning things inside out along four-dimensional lines.

15. See Duchamp, *Salt Seller*, 77; Duchamp, *Notes*, Nos. 185 and 186.

16. See Adcock, *Marcel Duchamp's Notes*, 19–27.

17. See Duchamp's statement quoted by Katherine Kuh in "Marcel Duchamp," *20th-Century Art from the Louise and Walter Arensberg Collection*, exhibition catalogue (Chicago: The Art Institute of Chicago, 1949), 17.

18. For a discussion of the mathematical implications of the term, see Adcock, *Marcel Duchamp's Notes*, 153 ff; see also Matisse in his "Translator's Note" to Duchamp's *Notes*, n.p.

19. Jouffret, *Traité*, 62–63.

20. Paz, *Marcel Duchamp, Appearance Stripped Bare*, 50.

21. For a discussion of their use of the term, see Adcock, *Marcel Duchamp's Notes,* 61–63.

22. This is Octavio Paz's rendition of Lebel's statement (Paz, 42). See Lebel, *Marcel Duchamp,* trans. George Heard Hamilton (New York: Grove Press, 1959), 27–28: "As usual [Duchamp] started with a very simple observation: A three-dimensional object casts a shadow in only two dimensions. From that he concluded that a three-dimensional object must in its turn be the shadow of another object in four dimensions. Along these lines he created the image of the *Bride* as the *lunar* projection of an invisible form. Yet this transcendental conception was reinforced by his very tactile idea of the fourth dimension, since he considers the sexual act the pre-eminent fourth-dimensional situation."

23. For discussions of the relationships between Duchamp and Leonardo, see Theodore Reff, "Duchamp & Leonardo: L.H.O.O.Q.-Alikes," *Art in America* 65 (January–February 1977), 82-93; Jean Clair, "Duchamp, Léonard, La Tradition maniériste," in *Marcel Duchamp: tradition de la rupture ou rupture de la tradition?,* Colloque du Centre Culturel International de Cerisy-la-Salle, ed. Jean Clair (Paris: Union Générale d'Editions, 1979), 117–44.

24. See Duchamp's remarks in his interview with Herbert Crehan, "Dada," *Evidence* (Toronto), no. 3 (Fall 1961), 36–38.

25. Interview with Francis Roberts, "I Propose to Strain the Laws of Physics," *Art News* 67 (December 1968), 63.

26. The possibility of Duchamp's punning between *"en verre"* and *"enverse"* was suggested to me by Charles Stuckey in conversation, April 1987.

27. For a mathematical discussion of these objects from a topological point of view, see Jean Clair, "Sexe et Topologie," *Abécédaire,* exhibition catalogue (Paris: Centre Georges Pompidou, 1977), 52–59.

28. Francis M. Naumann, *The Mary and William Sisler Collection* (New York: The Museum of Modern Art, 1984), 214.

29. Ibid., 216.

30. For a discussion of this window, see Charles F. Stuckey, "Duchamp's Acephalic Symbolism," *Art in America* 65 (January–February 1977), 94–99.

31. Duchamp used the pun in this way in conjunction with his signature on Francis Picabia's painting *The Cacodylatic Eye* in 1921.

32. Lebel, *Marcel Duchamp,* 46.

33. Duchamp, *Salt Seller,* 106. For a discussion of Duchamp's puns, see Katrina Martin, "Marcel Duchamp's *Anémic-Cinéma,"* *Studio International* 189 (January– February 1975), 60. For an analysis of the sexual implications of the film, see also Annette Michelson, "'Anemic Cinema,' Reflections on an Emblematic Work," *Artforum* 12 (October 1973), 64–69.

34. The relationships between "Lazy Hardware" and the cover for *Young Cherry Trees Secured Against Hares* are discussed by Stuckey, 98.

Duchamp's Etchings of the *Large Glass* and *The Lovers*

Hellmut Wohl

Duchamp's major works are *The Bride Stripped Bare by Her Bachelors, Even,* known as the *Large Glass,* and *Etant donnés: 1° la chute d'eau, 2° le gaz d'éclairage.* The first was begun in 1915 and left incomplete in 1923, and has as its subject the stripping of the Bride. The second, which shows the Bride stripped, was executed in secrecy between 1946 and 1966, and was installed next to the *Large Glass* at the Philadelphia Museum of Art in 1969, the year following Duchamp's death. In the *Glass* the Bride is suspended above the compartment containing what Duchamp called the Bachelor Apparatus. In *Etant donnés* she is spied through two peepholes in a closed door, headless, holding a gas lamp, and opening herself to our gaze on a bed of twigs before a landscape containing a waterfall. From a note Duchamp wrote in 1912,[1] as well as from his painting *Network of Stoppages* of 1914,[2] we know that he had the scenario of *Etant donnés* in mind even before the *Large Glass* was begun.

A recurrent theme throughout his work is allusions and references, written as well as visual, to the passage between the two.[3] In *Cols alités* (1959), a drawing by Duchamp, for example,[4] the *Glass* has been moved to an arid mountain landscape. The invisible waterfall that activates its water wheel, and thus sets into motion the process leading to the Bride's electrical stripping, has evidently dried up. In order to obtain an alternate supply of energy the Bachelor Apparatus has been hooked up to a telegraph pole. Yet the discontinuous, sketchy contours of both the Bachelor Apparatus and the Bride suggest that this may be of little avail, and that the erotic machinery of the *Glass* is faltering. The hills in front of which it has come to rest, however, announce the reincarnation of the Bride in a new landscape setting.

Although corroded, the great work is still intact in this drawing. Six years later it was taken apart, reassembled, and even completed, in a series of nine etchings that Duchamp made for the first volume of Arturo Schwarz's *The Large Glass and Related Works.*[5] Each of the principal executed elements of the *Glass* – the Nine Malic Molds, the Glider, the Seven Sieves, the Chocolate Grinder, the Oculist Witnesses, the Bride, and her Cinematic Blossoming – as well as the work as a whole as Duchamp left it in 1923, are replicated in three versions: a first state on Japan vellum in the form of a line etching, a pencil study on handmade paper with additions in watercolor of uniform tones of gray, and a second state on Japan vellum incorporating the gray tonalities indicated in the pencil study. The ninth member in the series is a colored etching in but a single state of the *Large Glass Completed* (Fig. 1).

The fact that of each of the eight etchings of the existing, unfinished *Glass*

Fig. 1 *Large Glass Completed,* 1965–66. All reproductions of these etchings courtesy of Arturo Schwarz.

there are three versions, and of the work as it would be if completed only one version, reflects Duchamp's conception of the number 3. "For me it is a kind of magic number," he said, "but not magic in the ordinary sense. Number 1 is the unity, number 2 is the couple, and 3 is the crowd. In other words, 20 million or 3 is the same for me."[6] Duchamp thought of *The Bride Stripped Bare by Her Bachelors, Even* as a delay in glass, a delay, he wrote, "in the most general way possible, not so much in the different meanings which delay can take, but rather in their indecisive reunion."[7] He used the number 3, which he associated with randomness and chance, "as a kind of architecture of the *Glass,*"[8] and he used it again for the replications of the work as it was when he abandoned it in 1923, leaving its eventual destiny open-ended between conception and realization. For the etching of the *Large Glass Completed,* in which Duchamp gave the work the final form that he had conceived for it, the appropriate number of replications is one.

While the etchings of the *Large Glass* appear to put the work into moth-balls, they in fact contain new thoughts on the "indecisive reunion" mean-

169

ings. The three versions of each etching are identical except for the additions of grays in the pencil study and the second state. Their monotonous, mechanical, meticulous execution follows from the fact that they are assisted readymades, rectified replications of already existing forms. When James Johnson Sweeney asked Duchamp how he had managed to avoid falling into the trap of either good or bad taste, Duchamp answered: "By using mechanical techniques. A mechanical drawing has no taste in it."[9] Instead, it leads to the objective that Duchamp called "painting of precision, beauty of indifference."[10] In shape and placement the Seven Sieves in the etching of 1965 follow exactly the geometric study Duchamp made for them in 1914: they are two-dimensional surfaces generated by rotating a line around a point, and they themselves rotate around a circle.[11] In the drawing of 1914 the lower rims of Sieves 2–7 appear clear and sharp behind the tips of the Sieves that reach into them. This is also the case on the *Glass* itself, where the Sieves were executed by fixing with varnish several months' gathering of dust between lead wires. This surface still adheres to Sieves 5, 6, and 7. Remnants of it stick to Sieves 2, 3, and 4, and it has disappeared from Sieve 1. The Sieves in the etching have been rectified in two respects: they have all been evenly filled with gray, and the lower rims of Sieves 2–7 are covered by the tips of Sieves 1–6. They have been transformed into flat images of solid cones, no longer capable of receiving the illuminating gas transmitted to them from the Malic Molds.

Similar rectifications and shifts of meaning occur in the other six etchings of the *Glass*'s component parts. In the work itself the Malic Molds recede in perspective behind the Glider. They are hollow containers encased in armatures of lead wire painted with a provisional color of red lead while waiting to receive their eventual color through chance and natural oxidation. In the etching they have lost their encasing armatures, and in the pencil study and the second state they are flaccid, lumpy, flat, and gray throughout, shadows of their former selves or, in the terminology of Duchamp, apparitions of their earlier appearances. In notes published in 1967 under the title *A l'infinitif,* Duchamp wrote that the appearance of an object "will be the sum of the usual sensory evidence enabling one to have an ordinary perception of that object. Its apparition is the mold of it. . . . the surface apparition (for a spatial object) is like a mold, but the mold of the form is not itself an object, it is the image in $n-1$ dimensions of the essential points of this object in n dimensions. The three-dimensional appearance comes from the two-dimensional mold of it."[12] Just as the Sieves in the series of etchings can no longer receive gas from the Bachelors, so the undifferentiated, two-dimensional Malic Molds, apparitions of their three-dimensional appearances in the *Glass,* are no longer capable of generating it.

The three-dimensional appearance of the Bachelor Apparatus in the *Glass* is established not by modeling its forms in light and shade, but by rendering them in linear perspective. In the domain of the Bride it is the opposite. On the right side of the *pendu femelle,* the Bride's largest form, and of the flask-shaped sex cylinder next to it, as well as along the rim of the Bride's Cinematic Blossoming, Duchamp has applied dark shading that produces the effect of relief. From his notes on the *Large Glass* we know that he con-

ceived of the domain of the Bride as a four-dimensional realm, and of her rounded, three-dimensional form as the apparition of her invisible four-dimensional appearance.[13] The etchings of the Bride and her Cinematic Blossoming have in turn become two-dimensional apparitions of their visible three-dimensional appearances. No darkening at the edges relieves the Blossoming's flatness, and no shading throws into relief the Bride or her sex cylinder. They have become images and nothing more.

In the etching of the unfinished *Large Glass* as a whole, its parts are reassembled exactly as they are depicted in the seven etchings that precede it. In the *Large Glass Completed*, Duchamp added to these the planned but unexecuted trajectory of the splashes spouting from the Sieves, as well as the Boxing Match and the Juggler of Gravity above the Oculist Witnesses, as he had worked them out in a drawing of 1913.[14] In the section of *A l'infinitif* on the subject of appearance and apparition we find the following proposal: "Given *The object,* considered in its physical appearance (*color, mass, form*). Define (graphically, i.e., by means of pictorial *conventions*) the *mold* of the object."[15] Using the most conventional pictorial vocabulary imaginable, this is precisely what the etchings of 1965 accomplish in relation to the *Large Glass.* They are its molds, or apparitions.

On the occasion of an exhibition of his work in January of the year in which these etchings were made, Duchamp pasted an unrectified reproduction of the *Mona Lisa* on a dinner invitation, and in reference to his famous assisted readymade of 1919, inscribed it *rasée/L.H.O.O.Q.*[16] Sometime earlier he had said that, although he had put a moustache and goatee on the Mona Lisa's face "simply with the idea of desecrating it, the curious thing about that moustache and goatee is that when you look at it the Mona Lisa becomes a man. It is not a woman disguised as a man; it is a real man, and that was my discovery, without realizing it at the time."[17] What he did not say is that by virtue of the five letters he placed under the image, the Mona Lisa also became an allusion to the Bride in the *Large Glass,* who through the Draft Pistons in her Cinematic Blossoming issues commands to the Bachelors to commence her stripping. Like the rectified Mona Lisa, *elle a chaud au cul* (L.H.O.O.Q.). In the unassisted readymade of 1965 the Mona Lisa is once more a woman, and with her new title Duchamp has created a new thought for her: she announces the Bride of *Étant donnés,* desirous, in a landscape setting, and *rasée.*

Among other works of Duchamp's later years that have a bearing on the passage between the *Large Glass* and *Étant donnés* are a second series of nine etchings made in New York between December 1967 and March 1968 for the second volume of Schwarz's *The Large Glass and Related Works.*[18] The series of *The Lovers* has been concisely described by Anne d'Harnoncourt and Walter Hopps as "the result of Duchamp's recent interest in a literal treatment of the human figure, but the figures are mostly borrowings from the Old Masters of recent advertisements. Duchamp used his sources (including his own sculptured figure from *Étant donnés*) as readymades to be rectified or assisted with details that emphasize their erotic aspect or with reference to his own earlier work."[19] Seven of the series, like the etchings of the *Large Glass,* exist in three versions identical in design: a first state, a pen-

cil study with pencil or watercolor indications of gray, and a second state that reproduces these additions.

The etching with the replication of the Bride from *Etant donnés* is entitled *The Bec Auer*, after the manufacturer's name of the gas lamp that the figure holds in her left hand (Fig. 2). As in the series of 1965, Duchamp's technical procedure is mechanical, meticulous, and monotonous, as if he were drawing with a stiff wrist. Shapes are defined by unmodulated lines and without indications of interior substance or structure. In the pencil study Duchamp added gray to the hair of the man, distinguishing it from the color of flesh, and left instructions for the printer to make a correction (Fig. 3). In the first state the lower line of the thumb of the hand that holds the gas lamp is extended all the way to the wrist. In the pencil study Duchamp repeated the inept line, and then marked it to indicate by exactly how much it should be shortened. The source for the figure of the man cradling his head in his hands was, according to Schwarz, an advertisement.[20] The man's raised arms repeat the shape of the Bride's parted legs; his left elbow covers her head so that she is in effect headless, as in *Etant donnés*, and his arms fit into her body as if they were part of it.

Throughout his life Duchamp composed and was inspired by puns and anagrams. In devising them he approached words as readymades: when rectified by the inversion or displacement of letters or syllables, they reveal new and previously unsuspected meanings. In his anagram on the word *ruiner* (*uriner*) he simply transposed the word's first two letters.[21] In a more

Fig. 2 *The Bec Auer*, 1968. First state.

Fig. 3 *The Bec Auer,* 1968. Second state.

complex invention he displaced and recombined the syllables of the name Pierre de Massot (*De Ma/Pissotière/J'aperçois/Pierre de Massot*).[22] The anagram of *bec auer* is *berçeau,* which means both "cradle" and "arbor," and thus alludes to the Bride in the *Large Glass,* whom Duchamp designated as the "arbor-type."[23] It is up to the spectator to make the connection, for it is he, Duchamp maintained, who completes the creative act.[24]

At the lower left of the pencil study for the sixth etching in the series, *The Bride Stripped Bare . . .* (Fig. 4), Duchamp wrote the inscription: "Encore une mariée/mise à nu," and he said to Arturo Schwarz that "the bride has finally been stripped, here."[25] The figure's self-protecting attitude was not Duchamp's invention but was chosen, so Schwarz tells us, from a photographic advertisement.[26] The piece of furniture on which she kneels is a prayer bench like the one in Picasso's *First Communion* of 1896 (Museo Picasso, Barcelona), in which the communicant, like a young bride, wears the traditional long white dress and white veil reaching from head to floor. Duchamp first identified the Bride with a communicant as early as 1909 in a drawing on the menu for the first communion dinner for Simone Delacour.[27] Six decades later, in the pencil study and the second state for the etching of 1968, the stripped Bride/communicant is inside an irregularly drawn oval that drifts

173

Fig. 4 *The Bride Stripped Bare . . . , 1968.* Second
state.

diagonally across a gray ground. "Le nu," Duchamp wrote at the top of the
pencil study, "est à l'interieur du voile de la Mariée." In shape as well as in
meaning, the veil in the form of an aureole is the reincarnation of the Cine-
matic Blossoming in the *Large Glass,* about which Duchamp wrote that it
"expresses the moment of stripping."[28] In the etching, as in *Etant donnés,* that
which was invisible the *Glass* has been made explicit. But the veil/aureole in
the etching is also an allusion to *Etant donnés,* for its shape is repeated in the
opening in the brick wall that frames the Bride holding a gas lamp, not turn-
ing away from us and closed in upon herself as in the etching, but displaying
her sex with unchecked factual candor.

 The first etching in this series is a pastiche of Cranach's *Adam and Eve* (Alte
Pinakothek, Munich), not of the painting directly, but by way of a reenact-
ment of it as a *tableau vivant,* staged by Francis Picabia and René Clair at the
Theatre des Champs-Elysées on 31 December 1924, in which Duchamp ap-
peared as Adam; Francine Picabia, under the alias "Brogna Perlmutter,"
played the part of Eve (Fig. 5).[29] Man Ray, who took the photograph of this
performance that Duchamp used as his source for the etching, recalled that
"at one moment of the production the theatre was in complete darkness,
then a few flashes gave one the impression that he saw a living tableau of

Fig. 5 *Selected Details After Cranach and "Relâche,"* 1967. Second state.

Fig. 6 *Selected Details After Courbet,* 1968. Second state.

Adam and Eve in the garden of Eden. It was a striptease in the most literal sense."[30] Whoever has seen *Etant donnés* at the Philadelphia Museum of Art will not have forgotten that this is not unlike the impression one has when looking through the two peepholes in its closed door.

The ninth etching has on the pencil study the inscription *Morçeaux choisis d'après Courbet* (Fig. 6) and shows yet another striptease. Its source is Courbet's *Woman with White Stockings,* which Duchamp could have seen on exhibition in Paris in 1919 and 1922 before it entered the Barnes Collection, and of which there are reproductions in monographs of 1929 and 1931 on Courbet.[31] Duchamp's rectification of the painting consists of turning the woman's gaze away from the spectator to her stocking, and the addition of a bird at the lower right. "He's curious," Duchamp said of the bird, "and furthermore he's a falcon, which in French yields an easy play on words."[32] A *faucon* is also a *faux con*. In *Morceaux choisis d'après Courbet,* Duchamp said, "you can see a *faux con* and a real one."[33] The etching is one of many examples in Duchamp's work – *The Bec Auer* from the series of *The Lovers* is, as we have seen, another – in which the images that contribute to the free play of associations and meanings are not only visual, but also linguistic and acoustical.[34] The relation of the woman removing her stocking to the Bride in *Etant donnés* requires no elaboration, especially in view of the fact that the meticulous instructions that Duchamp prepared for the installation of the work include the directive that light "must fall vertically, exactly, *sur le con.* "[35]

Duchamp's derivation of this etching from Courbet has given rise to specu-

lations that paintings by Courbet also inspired the mannequin in *Etant donnés*. One candidate is Courbet's *Origin of the World*, which was painted for a client who installed it in his bathroom and liked to show it to his guests after dinner. The picture was taken to Hungary about 1910, returned to Paris after World War II, and sold at auction in Paris in 1955. Its whereabouts are unknown. But Duchamp could have seen a reproduction of it in Edward Fuchs's *Die grossen Meister der Erotik*, published in Munich in 1930.[36] The other painting by Courbet that has been connected with the nude in *Etant donnés* is the *Woman with a Parrot*, which Duchamp could have seen at the Metropolitan Museum of Art in New York beginning in 1929.[37] For Duchamp to have chosen Courbet at all is ironic. Courbet, he said to Sweeney in 1946, "had introduced the physical emphasis in the nineteenth century. I was interested in ideas – not merely in visual products. I wanted to put painting once more at the service of the mind."[38] Even though in the year of that interview Duchamp began *Etant donnés* and reintroduced the physical into his own work, the derivation of his *rasée* nude from Courbet is at best an open question. Is she not also a descendant of the nude holding aloft a flaming vessel in Titian's so-called *Sacred and Profane Love*, and is she not – open-legged, one-armed, and headless – an ironic sequel to Rodin's *Iris, Messenger of the Gods*, which was intended to hover over the Victor Hugo monument as a personification of glory?[39]

The third etching is in fact *Morçeaux choisis d'après Rodin* (Fig. 7). *The Kiss* was at first intended as an illustration of Dante's story of Paolo and Francesca, and was later meant to represent Faith on the *Gate of Hell*.[40] Duchamp approached the work with tongue in cheek. "After all," he said to Schwarz in reference to his displacement of the man's right hand, "that must have been Rodin's original idea. It is such a natural place for the hand to be."[41] Because in the sculpture flesh and hair are both of marble, Duchamp did not add gray to the lovers' hair. There is no pencil study, and the first and second states of the etching are identical.

The fifth and seventh etchings are *Morçeaux choisis d'après Ingres* (Figs. 8 and 9). The female figures in both are from the *Bain Turc* of 1862. The source of the man in the fifth etching is Augustus in the reduced version of *Virgil Reading the Aeneid to Livia, Octavia, and Augustus* in the Musée des Beaux Arts at Brussels, in which the poet is heard but not seen. Although this would have been sufficient ground for Duchamp to have chosen the painting, there are others: the contrast between cool, smooth flesh and lustrous, sharply pleated drapery; Livia's look as she cradles in her hand the head of the sleeping or swooning Octavia; and Augustus's posture – he raises his right hand while with his left he grasps Octavia's arm, lending the picture the air of an erotic initiation. Further, in combining Ingres' figure of Augustus with the seated musician from the *Bain Turc*, Duchamp has placed in Augustus's lower hand, its position unchanged, the neck of her lute, which in this new context is also Augustus's phallus. But there is yet another reason. The listeners are shown at the moment when Virgil is reaching the passage in which Anchises foresees the early death of Octavia's son and Augustus's nephew Marcellus.[42] All three versions of the etching bear the signature in Roman capital letters: MARCELLUS D.

Fig. 7 *Selected Details After Rodin,* 1968. Second
state.

The woman from the *Bain Turc* in the seventh etching is the bather cup-
ping her breast at the lower right. The reason for Duchamp's selection of the
Bain Turc as a source for both *Morçeaux choisis d'après Ingres* is less obvious
than it may seem. In an unpublished dissertation, John Connolly has written
that

what constituted Ingres' concept of eroticism centered on his expectation that an edu-
cated spectator would embrace the erotic image with his intellect no less than with
his senses. For this reason, the erotic images that Ingres created are fully erotic only
to those who recognize that the cliché accompanying the primary image covertly con-
tradicts its overt message. To Ingres, the erotic was that which is recognizable and de-
sirable, but known to be unattainable, and therefore all the more desirable. The
monumental *Bain Turc* is just such a painting. To the uninitiated it is a hedonistic
wallow; but to those who suspend disbelief to discover the artist's intent it is the
masterpiece of a lifetime search to create an allegory of the senses wherein the spec-
tator is the living personification of sight.[43]

For Duchamp too, eroticism was a *cosa mentale.* His approach to it, however,
was ironic and detached. It took the form of a refusal of eroticism.[44] For him
as for André Breton the difference between poetic emotion and erotic
pleasure was but a difference in degree.[45]

Fig. 8 *Selected Details After Ingres, I,* 1968. Second state.

Fig. 9 *Selected Details After Ingres, II,* 1979. Second state.

When in 1922 Duchamp published his first collection of erotic and sala-cious anagrams, Breton praised them for their "mathematical rigor in the shifting of a letter and the exchange of a syllable between two words."[46] It is in this spirit that we should consider the anagram in English for *Bain Turc.* Bringing into play inversion and displacement as well as homophony, the French words become "bair cunt." This anagram too is not found among Du-champ's published writings. But its relevance to *Etant donnés* and to Ingres' painting – as well as to the *Mona Lisa rasée* – hardly requires that it should be.

The breast of Ingres' bather in the seventh etching is cupped by a hand, not her own but the hand of Oedipus from Ingres' *Oedipus and the Sphinx* in the Louvre.[47] In the painting, the gaze of Oedipus as well as the extended finger of his left hand are pointed at the sphinx's erect breasts, metallic and pol-ished like projectiles. To touch them, paraphrasing what Duchamp said about the displaced hand in his etching after Rodin's *The Kiss,* would be the natural thing to want to do. Instead, Duchamp has substituted for the for-midable breasts of the sphinx the pliable, available breast of the odalisque from the *Bain Turc.* The thought for the etching can be seen as a sequel to the pink foam-rubber breast, taken from a pair of falsies, that Duchamp affixed to the front cover of the exhibition catalogue *Le Surréalisme en 1947,* on the back cover of which he pasted a label with the legend PRIÈRE DE TOUCHER.[48]

Duchamp entitled the eighth etching in the series *King and Queen* (Fig. 10),

178

after his painting *King and Queen Surrounded by Swift Nudes* of 1912,[49] whose protagonists, he told Sweeney, were "a chess king and queen."[50] In the etching, where they are the king and queen of a portable chess set that Duchamp made in 1943,[51] the space between them is about to be filled by a cluster of sixteen cubes, expansions into the third dimension of two of the chessboard's eight rows of two-dimensional squares. These can be read either as solid and closed, or as hollow and open. In one case we see the cubes' exterior form, in the other their interior. How is it that the metallic, streamlined forms of the nudes in the painting of 1912 have been replaced by a cluster of cubes? We shall approach the question in a roundabout way.

The etching replicates the cube cluster in a poster that Duchamp designed for a chess championship in Nice in 1925.[52] There are two explanations for the cubes' arrangement. Sixteen blocks were thrown into a net bag and photographed, and from an enlargement of the photograph a drawing was made that was then reproduced against the image of a chess king.[53] However, the identical arrangement is found in the illustration of "the projections made by a cube in traversing a plane" in Claude Bragdon's *A Primer of Higher Space (The Fourth Dimension)*, published in Rochester, New York, in 1913, and this was undoubtedly Duchamp's source.[54] His use of it is yet another

Fig. 10 *King and Queen,* 1968. Second state.

example of the importance in his thought of mathematics. His approach to eroticism too was mathematical. In 1951 he made an erotic object that had originally been part of the mold under the breast of the mannequin in *Etant donnés* and called it *Objet-Dard,* a play on the homophony of "Art Object" and "Dart Object," as well as on the double meaning of the French *dard,* which is both "dart" and "phallus."[55] The exterior form of this phallus can, however, also be the interior of the vagina. Whether it is one or the other is the result of the laws of Euclidean geometry. However, in the fourth, non-Euclidean dimension, Duchamp wrote in a note of 1912, "the interior and the exterior can receive a similar identification,"[56] or, as Jean Clair has put it, "vagina and phallus lose their distinction."[57] If sexual differentiation is a topological accident of the Euclidean definition of three-dimensional space, then cubes that can be read as either exterior or interior forms may indeed take the place of nudes.

There are no precise correspondences between the etchings of the *Large Glass* and of *The Lovers.* Yet in their allusions to the passage between Duchamp's two major works—each series in its own way—they are like two sides of a coin. The etchings of the *Large Glass,* by reducing the three- and four-dimensional conception of that work to two-dimensional images, render its machinery incapable of functioning and bring its unconsummated gyrations to an end. They thus clear the way for the new incarnation of the waterfall, the illuminating gas, and the Bride in *Etant donnés.* The etchings of *The Lovers,* executed in the last year of Duchamp's life, restate in a figurative vocabulary that he rarely employed after 1910 many of his most cherished beliefs, and prepare us for the new work. Their neutral, monotonous, mechanical execution affirms that "denial of sensual value in art" that had been his objective ever since he abandoned what he referred to as "retinal painting" in 1912.[58] They document his approach to art and language as mathematical systems of signs whose vitality resides in the interplay between the given and chance. They point to the central role in Duchamp's thought of chess, which like language depends on choices that the player is free to make within the framework of the game,[59] and they thus remind us of the fact that the floor on which Duchamp built the tableau of *Etant donnés* has the pattern of a chessboard. The last plate in *La Vie illustrée de Marcel Duchamp,* published on the occasion of the Duchamp exhibition at the Centre Georges Pompidou in 1977, shows him standing on it, cigar in hand.[60] In the course of the Duchamp exhibition at the Pasadena Museum in 1964, Walter Hopps staged a photograph of Duchamp playing chess with a flesh-and-blood stripped Bride.[61] It was one of the artist's favorite photographs of himself. Four decades earlier he had adopted the name Rrose Sélavy, a pun on the cliché *Eros c'est la vie.* Duchamp's conception of eros, however, had the "precision, the beauty of indifference" of chess.

Notes

1. Marcel Duchamp, *Salt Seller: The Writings of Marcel Duchamp* (New York: Oxford University Press, 1973), 27 (hereafter, *Salt Seller*).

2. See Anne d'Harnoncourt and Kynaston McShine, eds., *Marcel Duchamp* (New York: The Mueum of Modern Art, 1973), 30.

3. For discussion of this theme, see Anne d'Harnoncourt and Walter Hopps, *"Etant donnés: 1. La chute d'eau, 2. Le gaz d'éclairage.* Reflections on a New Work by Marcel Duchamp," *Philadelphia Museum of Art Bulletin* 64, nos. 299–300 (April–September 1969); Octavio Paz, "Water Writes Always in *Plural," in d'Harnoncourt and McShine, eds., *Marcel Duchamp,* 149–57; Arturo Schwarz, *The Complete Works of Marcel Duchamp* (New York: Harry Abrams, 1970), 557–62 (hereafter, *CW*); Hellmut Wohl, "Beyond the *Large Glass:* Reflections on a Landscape Drawing by Marcel Duchamp," *Burlington Magazine* 119, no. 869 (November 1977), 763–72.

4. See Wohl, "Beyond the *Large Glass"*; Robert Lebel, "Marcel Duchamp et l'electricité en large," in *Electra* (Paris: Musée d'Art Moderne de la ville de Paris, 1983), unpaginated. *Cols alités* is also reproduced in d'Harnoncourt and McShine, eds., *Marcel Duchamp,* 310.

5. Schwarz, *CW,* cat. nos. 382–90.

6. Ibid., 131.

7. *Salt Seller,* 26.

8. Schwarz, *CW,* 130.

9. Ibid., 134.

10. Ibid., 30.

11. Ibid., cat. no. 217.

12. *Salt Seller,* 85.

13. See Jean Clair, *Marcel ou le grand fictif* (Paris: Flammarion, 1975).

14. Schwarz, *CW,* cat. no. 200.

15. *Salt Seller,* 136.

16. Schwarz, *CW,* cat. no. 375.

17. Ibid., 477.

18. Ibid., cat. nos. 398–406.

19. d'Harnoncourt and Hopps, *"Etant donnés,"* 55, n. 9.

20. Schwarz, *CW,* 569.

21. Michel Sanouillet, ed., *Duchamp du signe* (Paris: Flammarion, 1975), 160.

22. Ibid., 161; Schwarz, *CW,* cat. no. 359.

23. *Salt Seller,* 42. The anagram does not appear among Duchamp's published writings.

24. Ibid., 140.

25. Schwarz, *CW,* 571.

26. Ibid.

27. Jean Clair, *Marcel Duchamp: Catalogue raisonné* (Paris: Musée National d'Art Moderne, 1977), 27.

28. *Notes and Projects for the Large Glass,* ed. Arturo Schwarz (New York: Harry Abrams, 1969), 24. See Jindřich Chalupecký, "Rien qu'un artiste . . . ," in Jean Clair, ed., *Marcel Duchamp: abécédaire: approches critiques* (Paris: Musée National d'Art Moderne, 1977), 24.

29. William A. Camfield, *Francis Picabia* (Princeton: Princeton University Press, 1979), 213.

30. Man Ray, *Self-Portrait* (Boston: Little Brown, 1963), 238. Man Ray's photograph is reproduced in Schwarz, *CW,* 565. See *Marcel Duchamp: Notes,* ed. Paul Matisse (New York: Harry Abrams, 1983), note 193.

31. See Robert Fernier, *La Vie et l'oeuvre de Gustave Courbet* (Lausanne: Bibliothèque des Arts, 1977–78), vol. 1, cat. no. 285.

32. Schwarz, *CW,* 576.

33. Ibid.

34. See Jacqueline Chénieux, "L'Erotisme chez Marcel Duchamp et Georges Bataille," in Jean Clair, ed., *Marcel Duchamp: tradition de la rupture ou rupture de la tradition?* (Paris: Union Générale d'Editions, 1979), 198.

35. Clair, *Marcel Duchamp: Catalogue raisonné,* 147.

36. See Fernier, *La Vie et l'oeuvre de Gustave Courbet,* vol. 2, cat. no. 530.

37. Clair, *Marcel Duchamp: Catalogue raisonné,* 143; *abécédaire,* 53–54.

38. *Salt Seller,* 125.

39. Georges Grappe, *Catalogue du Musée Rodin: I-Hotel Biron,* fourth ed. (Paris 1944), no. 248.

40. Ibid., cat. no. 91.

41. Schwarz, *CW,* 568.

42. *Aeneid,* VI, 882–83.

43. John L. Connolly, "Ingres Studies: Antiochus and Stratonice: The Bather and Odalisque Themes," Ph.D. diss., University of Pennsylvania, 1974, 52–53.

44. See Chénieux, "L'Erotisme," 198.

45. Clair, *abécédaire,* 59.

46. Schwarz, *CW,* 131.

47. Another version is in the Walters Gallery in Baltimore.

48. Schwarz, *CW,* cat. no. 328.

49. Ibid., cat. no. 189.

50. *Salt Seller,* 125.

51. Schwarz, *CW,* cat. no. 318.

52. Ibid., cat. no. 189.

53. Hubert Damisch, "La Défense Duchamp" in Jean Clair, ed., *Marcel Duchamp: tradition de la rupture ou rupture de la tradition,* 97.

54. Craig E. Adcock, *Marcel Duchamp's Notes from the "Large Glass": An N-Dimensional Analysis* (Ann Arbor: UMI Research Press, 1983), 62, fig. 29.

55. Schwarz, *CW,* cat. no. 335.

56. *Salt Seller,* 29.

57. Clair, *abécédaire,* 58–59.

58. See Richard Hamilton, *The Almost Complete Works of Marcel Duchamp* (London: Tate Gallery, 1966), 68.

59. See K. C. Smith, "Semiotic Theory and the Epistemological Basis for Marcel Duchamp's Approach to Art," Ph.D. diss., Brown University, 1983.

60. Jennifer Gough-Cooper and Jacques Caumont, *La Vie illustrée de Marcel Duchamp* (Paris: Musée National d'Art Moderne, 1977), pl. facing p. 28.

61. Reproduced in d'Harnoncourt and McShine, eds., *Marcel Duchamp,* 130.

Rendezvous with Marcel Duchamp: *Given*

Dalia Judovitz

> Besides it's only the others that die.
> Duchamp
>
> No need for birds and bees to tell us that.
> Byron

Rendezvous with *Given:* Cul-de-Sac

Most critical discussions of Marcel Duchamp's last work, *Given: 1. The Waterfall, 2. The Illuminating Gas (Etant donnés: 1° la chute d'eau, 2° le gaz d'é-clairage)* (1946–1966), considered as his artistic testament, begin at the threshold, as if one were looking at a painting:

At the end of a narrow, underlit room, little more than a corridor, stands an ancient weather-worn door of wood, arched and encased in a surround of bricks. One senses at once that the door cannot be opened but one is drawn towards it as if by a magnet, and as one comes closer one becomes aware of two small holes, at eye level, drilled through the wood. Beyond the door lies an extraordinary sight.[1]

The description of the door (Fig. 1), the first *given* of John Golding's description, is an echo of Anne d'Harnoncourt's catalogue description, which is repeated by many others because the work could not be photographed.[2] Invariably, an account of the door is followed by the story of *what* is given, of what one sees beyond the door, as if this obstacle did not really exist. Octavio Paz has noted the material obstacle of the door. He observes: "The door sets its material doorness in the visitor's way with a sort of aplomb: dead end."[3] But this dead end becomes for him, as for Golding and many others, merely a pretext, the invitation to step through the threshold of the door into the scene beyond the door. This door, "a real condemned door" (to use Paz's words), "magnetically" (Golding) invites transgression, that is to say, it provokes looking beyond it, and thus challenges its objective inviolability. Paz sees this door as different from Duchamp's previous door, *Door: 11, rue Larrey* (1927), described by Arturo Schwarz as a "three dimension pun: A door which permanently opens and shuts at the same time."[4] The door of *Given* is for him "the opposite of hinges and their paradoxes," that is, a door whose objective reality condemns further problematization or unhinging.[5]

However, it is exactly upon the door that the narrative of the spectator hinges. Such a narrative presupposes another unspoken *given,* that of the enlightened spectator or the informed critic. What Golding's and Paz's inter-

Fig. 1 *Etant donnés: 1° la chute d'eau, 2° le gaz d'éclairage (Given: 1. The Waterfall, 2. The Illuminating Gas),* 1946–66. Exterior view. Philadelphia Museum of Art, Gift of the Cassandra Foundation.

pretations forget to take into account is the difficulty the viewer might have in finding the door and the peepholes in the first place in a narrow underlit room. Rather than being "magnetically" (Golding) attracted by the door, the first-time observer has trouble identifying the room as a site for art, since an underlit room does not correspond to our expectation of what constitutes *dis-*

play in a museum. The darkened room, upon which we stumble as if by an accident, is often disregarded, despite the label of a work not visible within its confines. The only thing that can draw us into the room is the image of other spectators like us, looking. Their look initiates us into the possible experience of looking at that which others deem worthy of looking at, those who have been initiated. Conspiratorially, we join them, since after all we are intended to look in a museum. Unless the viewer is already initiated, "ready-made" by the discourse of the museum, s/he risks missing out entirely on the experience, intoxicated as one is with visibility, the conviction that the museum is the archive for the consumption of monuments.

By contrast, the initiated critic comes to the museum informed. S/he "knows" that *Given* is Duchamp's last and most mysterious work and thus rediscovers only *that which is already given as looked for*—the *raison d'être* of the museum as a readymade. Before the question of visibility, of what we see in *Given*, can even begin to be posed, Duchamp has already fragmented our point of view by repositioning us through this "hinge" experience, within the institutional space of the museum. Detouring us from simply looking, Duchamp's *Given* makes us stumble upon the idea of the museum, upon which "hinges" the reality of a work of art. The idea of the museum is no less opaque than the door of *Given*, guarding a mythical testament, that of the visible immortality of works of art. However, this visual immortalization supplants the mortality of the artist by substituting itself for it.[6] The "visibility" of a work of art becomes the "cemetery" of the artist, since it objectifies and perennially simulates the gesture of creation as the illusion of life. Before we can ever begin to experience a work of art, we are "unhinged" by the realization of the "ready-made" character of all art: the tautological logic of the institutional conventions that establish the legitimacy of the museum as a cemetery of authority, of "uniforms and liveries" (to use Duchamp's terms in the *Large Glass*).

This experience of encountering the door to *Given* is prefigured by the experience of Duchamp's readymades. Before arriving at the doorway of *Given*, we have already been initiated into the fate of readymades as "givens." The *Bicycle Wheel* (1913) and *Trap* (1917) (coat rack nailed to the floor) problematize the status of the transformation of an ordinary object into an *objet-d'art*, that is to say, the split that we experience as spectators in a museum, before the elevation of an ordinary object through the artist's nomination (a rendezvous, in Duchamp's words) into something different—an art object. The readymade is the perfect copy of the object, since it *is* the object itself. Roger Dadoun understands Duchamp's materialist intervention in terms of this dissociation that marks the visible character of the object as "a sign which expropriates the object of its proper character."[7] This expropriation of the object marks the contextual character of the readymade as a sign that makes visible its ambiguous character as an object and/or art object. The visible appearance of the object, its "objective nature," thus emerges as an "art-object" through its reiteration, that is, its apparition as a pun.

The contextual mode of the visible appearance of a readymade is further bracketed by its title, whose poetic lucidity "illuminates," as it were, the clar-

ity of vision through slippage: the movement engendered through linguistic puns. What we see is thus modified by the linguistic frame of reference. The viewer must learn to "hear with eyes," to quote Shakespeare, that is, to understand that sight belongs to "love's fine wit." In other words, the ready-made stages the translation of the mechanical character of everydayness into a play, where wit engenders the anagrammatic movement of eros. Eros becomes the anamorphic or unwitting figure of wit. The readymade thus emerges as a "hinge" – the doorway between the visible and the discursive, whose "objective" character is merely the construct of this interplay, as a "delay" effect.[8] The door that the viewer literally stumbles upon in h/er effort to see beyond, is not merely the obstacle, but rather the medium through which the always extraordinary dimension of the visible is figured. The problem is not merely that the visible is "ready-made," constructed through the logic of the museum, but also that the act of looking involves a construct (as that which gives itself to sight – the peep show) of varied modalities that combine the image and its discursive frames of reference.

Looking at Looking, Even

> The mystery of the world is the visible,
> not the invisible.
>
> Oscar Wilde
>
> The spectator makes the picture.
>
> Duchamp

Once we are upon the threshold of the door to *Given,* an "extraordinary" sight confronts us (Fig. 2). Looking through two small holes at eye level, as if we were in a "peep-show," we are surprised and rewarded by a display more daring than we could ever hope. Golding summarizes this sight as follows:

On a plane parallel to the door and some few feet beyond is a brick wall with a large uneven opening punched through it. Beyond and bathed in an almost blinding light is the figure of a recumbent woman modelled with great delicacy and veracity but also slightly troubling because the illusion of three-dimensionality is strong but not totally convincing (the figure is in fact in about three-quarter relief). She lies on a couch of twigs and branches and she opens her legs out towards the spectator with no false prudence or sense of shame.[9]

Before examining this scene, I will briefly consider the voyeuristic context in which it takes place – the way in which the gaze of the viewer is set up. The problem with the scene is its "hyperreality," its excessive realism, which stages eroticism as a "too" obvious spectacle. The diorama-like character of the scene is further emphasized by the presence of an almost blinding light, an excess of illumination. The enigma that *Given* presents to the viewer is like no other. What mystifies the viewer is exactly the overdetermined "explicitness" of *Given,* its hyper-visibility. The excessive clarity of the scene makes us question the unquestionable: "What then is less clear than light?"[10] This scene problematizes one of the major givens of the Western pictorial

Fig. 2 *Etant donnés: 1° la chute d'eau, 2° le gaz d'éclairage (Given: 1. The Waterfall, 2. The Illuminating Gas)*, 1946–66. Interior view. Philadelphia Museum of Art, Gift of the Cassandra Foundation.

and philosophical tradition: the equation of reason and light, since light here functions as the sign of doubt. The excessive illumination of the scene makes us uncomfortable, breaking up the structure of voyeurism, its raison d'être – as the equation of sight and pleasure.[11]

The perspective of the viewer is fragmented by the hyperreality of the image, by its overdetermined character. The illumination of the scene problematizes our gaze, refracts it, in effect disrupting the coincidence of vision and the reality of sex. Thus the verisimilitude of the scene, the reduction of the body to reality, is derealized, since vision itself is fragmented by being staged through the peep-hole apparatus. The scene presented to the spectator is not one that one can either anticipate or participate in. The problem is that the traditional structure of spectatorship is dislocated, since the viewer cannot simply identify him(her)self through looking, that is, take

188

pleasure in "making" or appropriating the picture by inscribing his (her) own desire. The image here "unmakes" its viewer. The authority and the legitimacy that Western "retinal" painting confers upon its spectator is here undone, since the eroticism of the image challenges the act of looking. The coincidence of the eye and the "I," represented in the notion of perspective as a point of view, is irrevocably disrupted.[12] This *tableau vivant* which travesties itself as a *nature-morte* becomes in Duchamp's terms a *Sculpture-morte* (1959), or more explicitly, a *Torture-morte* (1959). Both these assemblages, contemporary to *Given,* problematize the dead-end character of visual illusion as it attempts to replicate the real. Because of their "realistic" nature, these assemblages are false doorways to the "real," insofar as they problematize the indexical nature of vision, since their simulated reality here cannot be resumed in the order of demonstration.

In order to explore this deconstruction of the "reality-effect" of *Given* through the displacement of indexical relations, I will examine two of its major "hinges," the body and the landscape, both traditional sites in the history of painting for the mimetic "sight" or creation of "reality." In so doing, I will consider the androgynous nature of this nude figure (the "last nude," to echo Lyotard), whose ambiguous passively and/or aggressively bared genitals are echoed by the pointed gesture of a raised arm assertively clasping a gas lamp. The analogies between *Given* and *The Bride Stripped Bare by Her Bachelors, Even* (the *Large Glass*) (1915–23) have been extensively covered by critical literature, so that our discussion will focus on aspects not yet alluded to.[13] Although much has been said about the androgynous character of the nude (manifest in the deictical gesture of the raised arm with the gas lamp), little has been said about the "dead" or "mechanical" character of the nude figure. The sexual ambiguity of the nude is compounded by a more profound ambiguity, that of the reality of its "life." Before examining some of Duchamp's explicit references to nudes in a series of lithographs based on Courbet, I will briefly consider his allusion to René Magritte's painting *The Menaced Assassin* (1926), a painting that Alain Robbe-Grillet recreates literally in his novel *Topologie d'une cité fantôme* under the revised title *The Mannequin Assassinated.*[14]

In addition to presenting a mannequin (a "dead nude"), the painting by Magritte also stages the problem of the structure of voyeurism in painting, since the ambiguous "assassin" and/or "policeman" in the foreground are conflated with the gaze of the viewer. The painting represents the fragmentation of the painterly perspective or point of view through the multiplication of figures of assassins, policemen, and/or witnesses within the frame of the painting. The two "assassins/policemen" in the foreground are conflated in the figure of the man listening to the gramophone, as witnessed by three men in the background, surveying the scene from behind the balcony. These three figures look at us looking. The painting sets into motion a delirium of vision, an infinite variety of spectators – potential assassins and policemen, organized around the spread-eagled nude. Magritte's painting, like Duchamp's *Given,* stages both the transgressive (assassin) and the rationalizing (policing) dimensions of the gaze. The victim at the center of the scene, the nude as both text and pretext of representation, embodies the "deadening" or even

"murderous" character of the gaze, as it objectifies (and thus "kills") the body offered to be viewed. The body of the nude thus emerges merely as residue, the "dead torture" (*torture morte*) of the gaze that has immortalized it in the history of painting, and thus, paradoxically, killed a mannequin, an already ready-made figure.

Duchamp's allusion to Courbet's paintings, the representative figure of "retinal painting," are no less problematic. The lithograph *Selected Details After Courbet* (*Morceaux choisis d'après Courbet*) (March 1968) reproduces Courbet's famous painting in the Barnes Collection, *Woman with White Stockings*, with one remarkable difference. At the bottom of Duchamp's lithograph is the additional figure of a falcon (in French, *faucon*, the homonym of *faux con*), which disrupts our perspective of the visual field since the falcon in the foreground is smaller, even though it is closer to our field of vision. The literal inscription of the *"faux con"* (false sex, in translation) displaces our attention to the "true sex" (*vrai con*) of the woman, her bared genitals. The "reality effect" of the reproduction stages the anamorphic and anagrammatic reality of sexuality, of genitality as a pun, a joke engendered through displacement.

The punning reference to the genitals of the nude can also be seen in another lithograph from the same series as *Selected Details After Courbet* entitled *The Bec Auer* (January 1968), executed when *Given* was still a secret. In this lithograph depicting a nude clasping a gas lamp in the same position as in *Given* is superimposed the figure of a male companion whose hairy head decenters our gaze from the woman's genitalia onto this simulated "false" sex that resituates the nexus of the image. Rather than considering this lithograph merely as another visual allusion to the *Large Glass*, its meaning can be deciphered in terms of its punning function, the wordplay inscribed in the title. *The Bec Auer* can also be translated into English as a pun "The Beak (Our)," that is, as a metonymic allusion to the falcon (*faux con*). In other words, the visual pun of the falcon becomes through this metonymic displacement the figure of desire. The gaze as the figure of desire is transcribed literally as visual delectation, an eroticism evoked through puns: the falcon and its beak pecking at favorite morsels, *"morceaux choisis."* The failure to penetrate the "truth" of sexuality either through the gaze or through language is thus thematized explicitly through this visual and verbal play.

Duchamp's allusions to eroticism in *Given* parody its "reality" through his anamorphic and anagrammatic "reproductions" of Courbet. The "sexuality" of the nude is depicted as it is being "reproduced," assembled and taken apart, realized and derealized, at the same time. Thus the pictorial representation of sexuality emerges as merely a decoy, an object that simulates the illusion of life by acting mechanically as lifelike. The nude in *Given* derives her eroticism from her mannequin-like character: her lifelike semblance stages life hyperrealistically – more successfully than life itself.

The discourse of eroticism in *Given* is thus revealed transitively, not as an attribute of appearance but as a movement, the declension of an apparition (recalling Duchamp's famous *Nude Descending a Staircase* [1912]). The absence of pubic hair on the sex of the nude, rather than merely revealing the naked sex, also alludes to the pictorial tradition throughout which the fe-

male sex had been dissimulated and thus outlined even more emphatically. Duchamp's allusion in his notes to the veiled sex, the "Abominable abdominal furs" (Notes, 232) becomes a pun on fur (fourrure) as mad-laughter (fou-rire) (Notes, 272).[15] This pun stages the ambiguous meaning of genitalia in Given. It designates the recognition that sexual organs may be only the "indirect" index of gender, and consequently no more reliable than a joke, the false mustache and beard added to Leonardo's Mona Lisa, Duchamp's rectified readymade L.H.O.O.Q. (1919) or "Elle a chaud au cul."[16] instead of veiling the female sex in Given, Duchamp displaces the veil, so that it surrounds the nude copiously as the field of twigs in which the figure appears to be embedded. Sexuality is thus presented as a movement, the imperceptible visual and linguistic slip (the fake striptease) that enacts through the anamorphosis of a pun the transitional character of eroticism.

The construction or "assemblage" of eroticism as a movement can also be seen in Duchamp's implicit reference in Given to Albrecht Dürer's Draftsman Doing Perspective Drawings of a Woman, from De Symmetria Humanorum Corpum (Nuremberg, 1532). In this print, between the eye of the spectator and his view point (which corresponds to the sex of the woman) is interposed a stylus, a machine for the organization of perspective, at whose edge or point the viewer adjusts his eye. At some distance, there is a small gate through which are projected the visual rays of the body spread out. Jean Clair, in Marcel Duchamp et la tradition des perspecteurs, describes the scene in similar terms, without, however, exploring its meaning.[17] The figure of the body viewed through the stylus elucidates the nature of eroticism in Duchamp as a rhetorical operation.[18] In the Dürer etching, the stylus, which is normally a writing utensil, doubles as a visual utensil for the construction of the body, designating eros as the site (sight) of "coi(t)ncidence" constituted through both writing and vision.

By analogy to Dürer, sexuality thus emerges in Duchamp's Given as a construct, not unlike the construction of the body in the history of perspective. Rather than representing merely an anatomical destiny, eroticism emerges as the figure of passage, the movement of style, marking it simultaneously as a site of composition and decomposition – in other words, life and death, Eros and Thanatos. The transitive nature of this movement cannot be embodied and figured through the body; rather, the body becomes the "hinge," the undecidable frame of reference of sexuality, considered as the figure of style. For Duchamp the logic of appearance is expressed by the style (Notes, 69), indicating his recognition that form is merely conditional (Notes, 71). This is why the transgressive aspects of voyeurism in Given appear as a short-circuit. Eroticism cannot be reduced to the gaze that isolates sexual difference from its metonymic position, its circuit of signification. Since sexual difference in Duchamp's works is conditional it can also be assimilated to indifference. These terms are not set in opposition to each other. Rather, their anagrammatic coincidence marks a repetition whose difference emerges not as a set term, ontologically grounded, but as the declension, the descending nude outlining the trace of the figurative movement of style.

Casting: The Die of Eros

The transitive nature of the nude in *Given,* its "passage," is made explicit once
we examine the nude in the context of the scene, framed by the brick wall
through which we perceive it. The brick wall further brackets our view
through the peep-holes of the scene in *Given.* This wall marks the site of an
ambiguous passage, since it is not clear whether this break in the wall acted
as a kind of "doorway" for the nude or whether the nude itself is a "cut-out"
projected into the space of *Given.* This ambiguous perception is staged in a
lithograph contemporary to *Given,* from the same series mentioned above,
entitled *The Bride Stripped Bare . . .* (February 1968). In this lithograph a fe-
male nude crouches, looking as if it had been cut out following the perimeter
of its (auer)a, rendering its outline undecidable, as far as questions of fore-
ground of background. This allusion to the (auer)a of the figure can also be
seen as a discursive pun to the lithograph in the same series entitled *The Bec
Auer.* These two lithographs thus allude through visual and discursive puns
to the aura or shape outlined in the wall that frames our vision of *Given.* This
opening acts as a doorway whose cut-out shape frames and thus brings the
visible into view, as if through a screen, while at the same time cutting it off.

The aperture carved out and into the wall brings to mind yet another ex-
ample of Duchamp's doors, his *Door for Gradiva* (1937), a glass door for
André Breton's gallery, destroyed at Duchamp's request when the gallery
closed down. A drawing of this door, Sketch of *Door for Gradiva,* depicts the
outline as if in a cut-out of a couple of enlaced lovers. This door presents yet
another instance of a "hinge," since its transparence outlines the passage of
two lovers. This glass door thus functions as a visual pun that affirms incom-
patible realities. It acts as a hinge demarking the play of the door as both
opening and closure, a transparent surface which opens onto a space only to
prevent our entry into it. The outline of the two figures enlaced, its décou-
page, confuses our perception by its reversible character, since it is impos-
sible to distinguish the inside from the outside and depth from surface.
Moreover, this glass door which frames our field of vision, like the brick
wall in *Given,* brings the visible into view only to draw attention to its
limited character.

Door for Gradiva thus acts as a "hinge" whose liminal surface alludes to Du-
champ's exploration in his *Notes* of the "infrathin" (*infra mince*) principle.
(*Notes,* 9 and 10). The "infrathin" is defined as a surface acting both as a sep-
arating interval and a screen: "infrathin separation – better/ than screen, be-
cause it indicates/ interval (taken in one sense) and/ screen (taken in another
sense) – separation has the 2 senses male and female –" (*Notes,* 9). The infra-
thin is both a surface and an interval whose deictical character points in two
different directions at the same time. Its ambiguous character prefigures the

192

role of eroticism in *Given* as the "index" mark of the androgynous sexuality of the nude pointing in two different senses or sexes (male and female) at the same time.[19] The opening in the brick wall in *Given* can thus be understood according to the logic of the "infrathin" principle, as acting as the hinge to what is seen (a pun on "thin") in *Given*. This hinge opens in two directions on the erotic scene of *Given*, like Duchamp's *Door: 11, rue Larrey*, indicating that sexuality is "hinged" upon the reversibility of the male and female positions.[20] Sexuality is thus presented as an interplay whose ambiguous indexical character resituates the notion of sexual difference and its equation with visibility.

Duchamp's definition of the "infrathin" also suggests that this principle may also be applied to the nude in *Given*, insofar as it is a mold. Commenting on molds, Duchamp observes the same principle of infrathin separation: "2 forms cast in/ the same mold (?) differ/ from each other/ by infrathin separative/ amount" (*Notes*, 35). The molded character of the nude (its lifelike sculptural dimension) erases the separation between life and death through an imperceptible, artificial difference.[21] This difference that marks the nature of the mold is summarized by d'Harnoncourt as follows: "The paradox of an impression taken from life, captured in lifeless material, works to create a form of realism that seems highly artificial, so intimately related to the real thing and yet so remote."[22] This artificial separation between life and death stages their difference as "hinged" upon the principle of their "infrathin" separation. The mold is "the (photographic) negative," a negative impression "from the perspective of form and color," as Duchamp observes in his notes to the *White Box (In the Infinitive)*.[23] The photographic aspects of the molded nude in *Given* thus allude to its artificiality not merely as an object, but also as an art object. In so doing, Duchamp is playing with the concept of art, insofar as its modes of impression (apparition), photographic or sculptural, highlight the contrived "look" of the nude, its hyperreality.

This analysis of the nude as a mold is reinforced by Duchamp's implicit allusion to molds in *Door for Gradiva*, since the imprint of Gradiva's existence, the trace of her apparition, is preserved in a mold. The notion of the mold is embedded in the reversible hinge character of the wall in *Given*, thus serving as a further reflection on the transitive nature of the eroticism of the nude. The nude is a mold, and thus a "readymade," a form molded upon another, the same and different from itself. The "infrathin" separation between the model and its copy becomes the site (here a pun on "sight") of the fragile interval that separates a body from its impression, life from art, a work of art from its copy, summarized in *Given* as the deceptive and reversible interval of sexual difference.

Duchamp's obsession with molds captured in such objects as *Female Fig Leaf* (1950), *Objet-Dard (Dart-Object)* (1951) and *Wedge of Chastity* (1954) can be seen as yet another exploration of his theories elaborated through the notion of the "infrathin." These figures turn eroticism inside out like a glove. Sexuality emerges as the obverse trace of the female sex molded negatively by the imprint of the female body, as we can see it in *Female Fig Leaf*, whereas in *Objet-Dard* the protrusive presence of the "dart" (simulated rib-like phallus) suggests the outward projection of an absence of a positive shape. Clair observes that *Objet-Dard* suggests that gender is envisaged as a break

(*coupure*), as a division within being, as a lack which is but the *effect* of three-dimensional space, of a four-dimensional projection. In other words, that gender is merely the effect of an ironic causality, that of the laws of Euclidean geometry.[24]

The conjunction of the male and female positions is made explicit by Duchamp in *Wedge of Chastity* (*Coin de chasteté*), where both shapes are embedded in each other. The concavity of "femininity" is welded to the convexity of "maleness" in the outline of the wedge, yet another "hinge" by which Duchamp marks the liminal character of sexuality. The two shapes emerge as reversible molds of each other, an interpenetration of forms that informs their interpretation. This visual and discursive ambiguity in the interpretation of sexuality is made explicit in Duchamp's clarification to Cabanne of the *Wedge of Chastity* as "the meaning of the wedge driven in, (like a nail) not the place (*"le sens du coin qui s'enfonce, pas le lieu"*).[25] The word *enfoncer* also means "breaking open the door," thus referring explicitly to the ambiguous character of the door in *Given*, which is both broken open and shut with nails at the same time. The wedge as a corner (*coin*, in French) becomes the mark of sexual difference through coitus (*coit*, in French), a turning point that through reiteration marks the objective "coin(t?)cidence" of the male and the female positions.

This pun on eroticism as a wedge, corner, and turning point is made explicit in Duchamp's *Anemic Cinema* (1926), where the anagram on the rotary disk "Have you ever put the marrow of the sword into the stove of the loved one?" (*"Avez vous déjà mis la moëlle de l'épée dans le poêle de l'aimée?"*) captures through the spiraling movement of the disk the visual and literary convergence of the male and female positions, a pun on the "penis/sword" and the "stove/cunt." The figure of sexuality is here dubbed through further word plays on *le poêle* as a sheet that covers the dead, thereby inscribing within eros death as its obverse.[26] Commenting on the effect of the movement of the spiral on the viewer, Duchamp remarks that "the spiral at rest doesn't give/ any impression of relief/ (or at least only imagined/ psychologically) (*Notes*, 170). Duchamp's observation confirms the vertiginous conflation of sexuality and death, as motion (life) and rest (death) converge.

In the quotation above, Duchamp also suggests that the spiraling movement of the rotorelief is connected with the visual illusion of relief, thereby suggesting through motion its affinity to both molds and photographic negatives. Likewise, the punning wordplays on *la moëlle de l'épée* and *le poêle de l'aimée* converge anagrammatically, signifying the reduction of sexual difference to indifference.[27] This punning visual and literary play in *Anemic Cinema* helps elucidate the status of eroticism in *Given*. It suggests that sexual difference cannot be understood as a difference intrinsic to the body, as a set visual and discursive signifier, but rather that "difference" is merely the illusory effect of movement, that is to say, shifts in the rotation of the body as a punning "hinge." Thus sexual difference in *Given* emerges not as an anatomical fact but rather as the projection of the gaze of the spectator which attempts to "fix" and thus put to rest the androgynous appearance of the nude by denying its "hinge" character, which swings back and forth like a pun between the male and female positions. Consequently, *Given* stages the gaze as

a mechanical illusion whose "truth" is no more real than the reality of puns.[28]

The visual seduction operated by the nude in *Given* can be considered as the "collapsible approximation" (one that can be taken to pieces, dismantled) (*l'approximation démontable*), that is, a seduction that is undone by the very nature of the way in which it is set up. As Duchamp specifies in his instructions to *Given:* "By approximation I mean a margin (or edge) of *ad libidum* (a play on libido and male genitalia) in the dismantling (dismounting) and the remantling (remounting)" (*"Par approximation j'entends une marge d'ad libitum dans le démontage et remontage"*). The gaze of the viewer is dismantled by the very spectacle that stages it as an assemblage of puns that simulate sexuality. The sexual (con)notation of the work is undone by its (con)textual character, the fact that the nude is merely a "hinge," an assembled context of visual and literary puns, rather than a static object. *Given* presents an assemblage (*montage*) of visual, literary and institutional "givens," whose play as contextual frames of reference dismantle the reality of vision, bringing out its approximate nature as the "hinge" between appearance and apparition.

Given: The Delayed Snapshot

> An *oeuvre* by itself doesn't exist. It's an optical illusion.
>
> Duchamp

> To make a painting or sculpture as one would wind a reel of cinematic-film.
>
> Duchamp

Having examined the nude and its function in *Given,* I will now focus on the illusionistic landscape that frames it, on its "startlingly naturalistic and eerily unreal character," to invoke d'Harnoncourt's description.[29] The background landscape in *Given* is a photograph retouched by hand—yet another readymade—that alludes to the general photographic illusionism of the work. Duchamp's references to photography, and particularly chronophotography, in works such as *Nude Descending a Staircase,* express his interest in the ready-made character of photography. This interest is already manifest in *Pharmacy* (1914), an early readymade of a calendar-print landscape retouched through the addition of a red dot and a green dot, which when seen through special red and green glasses tend to overlap and produce the illusion of relief. Considered as an early instance of Duchamp's experiments with anaglyphic vision, *Pharmacy* thus anticipates both the photographic aspects of *Given,* as well as, anaglyphically, its play with the illusion of a figure in relief or sculpture.

This double allusion to photography and sculpture can also be seen in another of Duchamp's later works, *Moonlight on the Bay at Basswood* (1953), a work contemporary to *Given* which is partly drawn from life and partly from a photomural. Two different gestures are thus simultaneously conflated in one image. The traditional role of painting as a mimetic rendering of reality is subverted, since this drawing also takes as its point of reference a photo-

mural. The traditional relation of landscape, painting, and the artist is here displaced by photography. Photography subverts the painterly tradition, since it substitutes itself for it, displacing artisanal production through mechanical reproduction (its "ready-made" nature), and thus redefines artistic creation.

Moreover, *Moonlight* is no ordinary drawing, since it includes a variety of materials: ink, pencil, crayon, *talcum powder* and *chocolate* on blotting paper. The addition of such unusual materials as talcum powder and chocolate to the drawing of the landscape modifies our painterly and photographic expectations.[30] Their inclusion suggests the intrusion of material ingredients from everyday life. Both of these materials are associated with molds: talcum powder is applied to the body, acting metaphorically as the paste of a "mold," and chocolate is often molded. The landscape of *Moonlight* thus presents the allusion to relief, inscribed this time not visually (anaglyphically), but literally, insofar as these elements are part of the mold of the image. They inscribe anamorphically the trace of the body into the image, like the negative imprint of a body in a mold.

This inscription of photography and indirect allusion to sculpture in the landscape of *Given* is echoed in Duchamp's own gesture of drawing a landscape into the *Large Glass* in *Cols alités* (1959) and in his literal association of readymades and photography in his note entitled *Without glue (Sans colle)*: /Make an assembly of/ "ready mades" balanced/ one on top of the other/ and photograph them/ (Jackstraws so to/ speak) (*Notes*, 167). This statement clarifies the contextually assembled, superimposed (photographically) and ready-made character of both the nude and the landscape in *Given*. The reference to "jackstraws" provides the clue to the game that *Given* sets up. It tells us that no element in the scene can be singled out (picked up) without disturbing all the others.[31] Duchamp's reference to "jackstraws" suggests that *Given* as an assemblage of readymades cannot be deciphered in any way but strategically, as a way of preserving the contextual character of the elements, since each element is merely a "hinge."

Likewise, the photographic and sculptural references in *Given* do not provide stable frames of reference as distinct modes of artistic representation. Their instability is prefigured in *Tu m'* (1918), Duchamp's "assemblage" of his readymades in a painting. In *Tu m'* Duchamp does not depict the readymades directly; rather, the shadows of the bicycle wheel, the hatrack and a corkscrew are projected on the canvas. A realistically painted hand points the index finger at a slash in the canvas held together by safety pins and a brush (used to clean a bottle or a lamp) that sticks out perpendicular to the field of vision of the viewer. Rosalind Krauss interprets the case of the shadows as "signifying these objects by means of indexical traces." Her argument relies on the pointing finger as further evidence for the indexical character of the image, which she interprets as a photographic allusion.[32]

However, *Tu m'* cannot be reduced to a photographic allusion, since the photographic character of the readymade is also equated by Duchamp with the act of nomination, that is, language. Although Duchamp summarizes his operation on the readymade in photographic terms, as a matter of timing, this "snapshot" effect is analogous to the temporal and performative dimen-

sion of nomination, which is involved in the production of the readymade. Duchamp explains: "The important thing is just/ this matter of timing, this snapshot effect, like/ a speech delivered on no matter/ what occasion, but at *such and such an hour.*"[33] The process of production establishes the analogy of the photograph and the readymade, since both involve a "snapshot effect" triggered by the push of a button, either of the shutter or of language. In either case, the indexical gesture is turned inside out, since the pointing gesture of the hand or of language is turned back upon itself. The photograph and the readymade thus present the reification of the artist's hand: they negate its intervention in the creation of the object.

Duchamp summarizes the ambivalent nature of his artistic intervention when he comments in his interviews with Cabanne: "It's fun to do things by hand. I'm suspicious, because there's the danger of the 'hand' (*la patte*) which comes back, but since I'm not doing works of art, it's fine."[34] The danger of the "hand" (literally the "paw," but also a homonym of "paste," an allusion to the mold, in French) brings together references to the indexical character of the hand, only to suggest the erasure of its imprint (the mold). The readymade is doubly marked by a process analogous to both photographic impression and molding, both of which, however, paradoxically derealize the object by pointing to it (indexically). The gesture of pointing (demonstration) thus signifies their ambiguity as modes of representation. The indexical character of *Tu m'* and of *Given* points to the ready-made reality of the artistic object, the fact that its very "illusion negates the process that went into its artistic creation." The pointing hand is erased gesturally by the ambiguous indexical inscription of the readymade, which points towards the object, photographically and sculpturally, only to elide the intervention of the hand through verbal intervention.

This play on the index is already suggested in the text of the "Preface" to the *Large Glass,* which also establishes the major formal elements of *Given:*

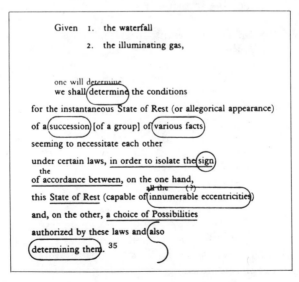

For Krauss, this language of rapid exposures, which produces a state of rest as an isolated sign, is the language of photography. She finds this process implied in the subtitle of the *Large Glass,* which is *Delay in Glass.*[36] However, this insight is complicated, as we have already shown, by the ambiguous nature of the indexical sign in Duchamp's *Tu m'* and in *Given.* The photographic illusion of *Given* is merely an appearance, the construct of the index, as a mode of determination. *Given* can no more be reduced to a photograph than to a readymade.

The impossibility of reducing *Given* to a photographic allusion is prefigured in the ambiguity of the indexical gesture in *Tu m'.* The index finger in *Tu m'* points toward pictoriality, to the brush and away from it, since the brush conflates both gestures in the "readymade." In one sense, *Tu m'* presents itself as a kind of photograph, the impression of the shadows cast by the readymades. However, in another sense, by alluding literally to the readymades (the brush sticking out of the painting), Duchamp also undoes the very gesture of painting, since the brush (a sculptural ready-made object) points to itself as the instrument that constructs the appearance of objects in painting. *Tu m'* thus stages undecidably the play of painting, photography, sculpture, and language as different modes of "impression." Painting as a retinal imprint is mimicked by the photographic negative, which as the cast of shadows and the brush constitutes a kind of "shadow sculpture" or mold. But as a sculptural mold, *Tu m'* lapses into language, capturing its deictical fold. *Tu m'* thus inscribes both literal allusions to *Given,* the brush as the indexical mark of the gas lamp, but also formal allusions to its mixed-media character as an assemblage of painting, photography, sculpture and language.

However, neither painting, photography, sculpture nor language functions traditionally. In each of these cases, the hand of the artist is elided by a mechanical procedure. The painter's brush is displaced by the camera, the photograph as a negative imprint or mold threatens to become sculpture, sculpture is undermined by the readymade object, and the object is derealized through its title. Visual meaning thus dissolves into linguistic pun. This movement through the visual arts into language and back in *Tu m'* and in *Given* demonstrates that all lifelike illusion is captured through mechanical procedures. Both visual and discursive reproductions suppress the artist's hand, the artisanal intervention, only to draw attention to it, a gesture analogous to the readymade.

The "assembled" character of *Tu m'* gives us a clue to the contextual character of *Given,* its compounded modes of determination. *Given* is but an "allegorical appearance," a work whose anamorphic and anagrammatic character is "excentric," that is, a work whose meaning cannot be situated analogically (put to rest), but which is constituted through movement, the delayed, (collision or even assault, to use Duchamp's terms in the *Avertissement* following the *Préface*) of all determinations. The problem of determination that *Given* poses and erases at the same time through its assembled structure figures Duchamp's desire, his "love," the inscription of eroticism into mechanical works. Duchamp himself mentions his desire to have all his works assembled together in one museum by stressing that his "love translates itself

in that form" ("cette amour se traduisait sous cette forme-là")[37] Thus the automatic production of works of art, their ready-made character within the structure of the museum, destabilizes the authorial persona: it delays the artist, encrypting him in a snapshot, postponing his life and death in the illusory temporality of the future-perfect, the post-modern.

Epitaph: Cenotaph: Epigraph

> The/ future can give an ironic tone
> to/ the sentence.
>
> Duchamp

Duchamp's last joke, the epitaph on his grave ". . . AND BESIDES/IT'S ONLY THE OTHERS THAT DIE," affirms the factuality of death as an impossible experience, impossible if only because we can only witness the death of another and not our own. The evidence of the grave before our eyes is contradicted by Duchamp's testamentary statement. His epitaph evokes his undeniable lifelike presence, an illusion reinforced by the indication that only others die. This statement, which appears as an act of denial, thus emerges as the site of the eternal affirmation of death and/or life at the same time. It is as if the shadow of life is engraved and thus molded following the very traces of his death. Duchamp's last performance, enacted through the testament of death (an allusion to Villon's literary testament), transforms his grave into a cenotaph, that is, a grave without a body.[38]

This cenotaph points to another cenotaph, to his *Given,* the lifelike assemblage of the "last nude," the immortal mannequin that simulates life in the artificial confines of the museum, the "cemetery" of visual artifacts. If *Given* holds its viewer at a fixed distance, this distance becomes the infrathin interval that marks the separation and/or continuity of life and death. It is the last "hinge," the sign of "Life on credit" (*Notes,* 289), to use Duchamp's own words. *Given,* an apparent "snapshot" of life, is engraved with the imprint of its negative, of death obversely reiterating its outline. Within it is inscribed the figure of the artist in movement, the double signature *Rrose Sélavy* alias *Belle Haleine: Eau de Voilette,* androgynous embodiments of the art of "heavy breathing": "*Eros c'est la vie*" and Duchamp's self-definition, "I am a breather" ("*je suis un réspirateur*").[39] Delayed in the interval between these signatures, Duchamp "breathes," he lives (*Sélavy* or *c'est la vie*) not as himself, but as an alias, ready-made for the last rendezvous with the telegram that announces and commemorates his death: "Cher Marcel, à bientôt," or simply "A bientôt!".[40]

Notes

1. John Golding, *Marcel Duchamp: The Bride Stripped Bare by Her Bachelors, Even* (London: Allen Lane Penguin Press, 1973), 95.

2. Anne d'Harnoncourt and Walter Hopps, "*Etants donnés: 1° la chute d'eau, 2° le gaz d'éclairage:* Reflections on a New Work by Marcel Duchamp," *Philadelphia Museum of Art Bulletin* 64 (April–June, July–September 1969), 6–58.

3. Octavio Paz, *Marcel Duchamp: Appearance Stripped Bare*, trans. R. Philips and D. Gardner (New York: Seaver Books, 1981), 95.

4. Arturo Schwarz, *Marcel Duchamp* (New York: Harry N. Abrams, 1975), illus. 130.

5. Paz, 95. Taking as a point of departure Paz's emphasis on the "hinge," in the reading that follows I will explore the many ways in which it appears both in Duchamp's visual as well as literary work.

6. For an excellent analysis of Duchamp's challenge of the institutional space of the museum, see Marc Le Bot, "Margelles du Sens: ou les musées de Marcel Duchamp," *L'Arc* (59), 8–15. The museum as site of "immortality" for the work of art will be further elaborated in the conclusion to this article.

7. Roger Dadoun, "Rrose Sschize: Sschize d'un Portrait Théorie de Marcel Duchamp en Jésus Sec Célibataire," *L'Arc* (59), 25.

8. For a more detailed analysis of the visual, discursive and photographic (cinematic) character of the readymade, see my "Anemic Vision in Duchamp: Cinema as Readymade," *Dada Surrealism* 15 (1987), 46–57; reprinted in *Dada and Surrealist Film,* ed. Rudolf E. Kuenzli (New York: Willis, Locker and Owens, 1987).

9. Golding, 26.

10. Paz, 96.

11. Duchamp anticipates the feminist critique of the male gaze by deconstructing the structure and, by extension, the ideology of male spectatorship. His choice of a female signature as artistic alias and androgynous photograph (Rrose Sélavy – *éros c'est la vie*), represents an analogous gesture in the effort to displace traditional notions of authorship and gender.

12. The coincidence of the point of view and the viewing subject implied in perspective is designated by Viator as "subject."

13. Cf. Paz, "Water Writes Always in Plural," in *Marcel Duchamp,* 91–178; Jean-François Lyotard, *"Etants donnés:* Inventaire du dernier nu," *Marcel Duchamp: Abécédaire,* ed. Jean Clair (Paris: Centre National d'Art et de Culture, Georges Pompidou, 1977), 86–110; Alain Jouffroy, "Etant donné Marcel Duchamp 1) individualiste révolutionnaire 2) réspirateur," *Opus International* 49 (Paris, 1974); and René Micha, "Etant donné *Etant donnés,"* in *Marcel Duchamp: Tradition de la rupture ou rupture de la tradition?,* ed. Jean Clair (Paris: Union Générale d'Editions, 1979), 157–75.

14. As far as I can tell, this reference to Magritte has not yet been elaborated upon in the critical literature on Duchamp. It is also interesting to note that Robbe-Grillet's literary "translation" of Magritte's image involves puns similar to those that we find in Duchamp's work.

15. These references are from *Marcel Duchamp, Notes,* trans. Paul Matisse (Boston: G. K. Hall, 1983), designated in the text as *Notes* and note number.

16. For an analysis of Duchamp's rectified readymade of the reproduction of Leonardo's Mona Lisa, its status as a work of art, and the institution of the museum, see Thierry de Duve, "Les Moustaches de la Joconde: Petit exercise de méthode," in Clair, *Marcel Duchamp: Tradition de la rupture ou rupture de la tradition?,* 403–17.

17. See Clair, *Abécédaire,* 158–59.

18. Cf. Jacqueline Chénieux's critique of transgression in "L'Erotisme chez Marcel Duchamp et Georges Bataille," in Clair, *Tradition,* 196–218. Although Chénieux al-

ludes to the rhetorical status of eroticism in Duchamp, she does not elaborate it in visual terms by examining its figurative structure.

19. For an analysis of the reversible topology of the male and female position, see Jean Clair, "Sexe et topologie," in *Abécédaire*, 52–59.

20. My interpretation of the nude in relation to the brick wall challenges the suggestions of Lyotard, 102, and Golding, 99, that the nude in *Given* fell from the ceiling, by analogy to its movement in the *Large Glass*, from the upper to the lower regions.

21. This interpenetration of the male and female shape is yet another allusion to Leonardo, to his anatomical drawings, as discussed by Freud in *Leonardo da Vinci and a Memory of His Childhood*, (1910). For an excellent discussion of its implications for sexual difference, see Jacqueline Rose, *Sexuality in the Field of Vision* (London: Verso, New Left Books, 1986), 225–33.

22. d'Harnoncourt and Hopps, 37.

23. Marcel Duchamp, *Duchamp du signe: Ecrits,* ed. Michel Sanouillet (Paris: Flammarion, 1975), 121.

24. Clair, "Sexe et topologie," 58.

25. Pierre Cabanne, *Entretiens avec Marcel Duchamp* (Paris: Pierre Belfond, 1967), 165, my translation.

26. For a detailed exploration of these puns in *Anemic Cinema,* see Katrina Martin, "Marcel Duchamp's Anemic-Cinema," *Studio International* (January 1975), 53–60.

27. Cf. my discussion of sexual difference and indifference in "Anemic Vision," 48–56.

28. Craig E. Adcock discusses in detail Duchamp's experiments with the mechanical problem of projecting four- and three-dimensional figures on a two-dimensional surface, which I consider an analogue to the punning movement of the male and female positions, in *Marcel Duchamp's Notes from the Large Glass: An N-Dimensional Analysis* (Ann Arbor: U.M.I. Research Press, 1983), 118–36.

29. d'Harnoncourt and Hopps, 25.

30. Lyotard considers chocolate as the object upon which the difference between appearance and apparition is thematized, 104.

31. Jackstraws is a game where flattened-out miniature tools, agricultural or otherwise, are piled upon each other. The aim is to extricate with a hook (a kind of stylus) one of the elements without disturbing all the others. This miniaturized assemblage recalls Duchamp's miniature box-museum *La Boite en valise.*

32. See "Notes on the Index: Part 1," in *The Originality of the Avant-Garde and Other Modernist Myths* (Cambridge: M.I.T. Press, 1987), 198–99.

33. See *The Bride Stripped Bare by Her Bachelors, Even,* a typographical version by Richard Hamilton of Duchamp's *Green Box,* trans. George H. Hamilton (New York: Wittenborn, 1960), n.p.

34. Cabanne, 202.

35. Marcel Duchamp's opening paragraph of the preface to the *Green Box, The Bride Stripped Bare . . .* , n.p.

36. Krauss, 205.

37. Cabanne, 139, my translation.

38. It should be remembered that Villon was so admired in the Duchamp household that his brothers added the name of Villon to their patronymic name.

39. For an analysis of Duchamp's signature Rrose Sélavy, see Roger Dadoun, "Rrose Sschize," and, for his second signature, "Belle Haleine," see Arturo Schwarz, "Rrose Sélavy: Alias Marchand du Sel alias Belle Haleine," in the same issue of *L'Arc*.

40. These two greetings are based on Duchamp's telegrams on the occasion of Picabia's death (1953) and Varèse's (1966). As Duchamp explains in his interview with Cabanne: "It's difficult to write to a friend who dies. One doesn't know what to say. One must encounter (*tourner*) the difficulty with a joke. See you soon, isn't it?," Cabanne, 164, my translation.

Marcel Duchamp's Letters to Walter and Louise Arensberg, 1917-1921

Introduction, translation, and notes by
Francis M. Naumann

Although they rarely reveal his innermost thoughts and secrets, Marcel Duchamp's letters to his friends and relatives are of immense importance in our scholarly pursuit of the artist and his work. When he took pen in hand, it was usually with the intention of communicating basic factual information—providing information concerning his whereabouts, his future plans, the activities of friends, and, occasionally, progress reports on his own work. The very process of writing letters bored him, and he only undertook the activity when necessity demanded, or during extremely idle moments (of which, it turns out, he had many, for by the mid to late teens, he had consciously sought to distinguish himself from the prolific artists of an earlier tradition). Yet even when free time presented itself, the artist preferred simply to relax in his studio, usually by playing chess, or by reviewing old chess scores. On occasion, he would compile notes for a work in progress, or, more infrequently, he would engage in the slow and painstaking assembly of the work itself.

These and other sundry activities are carefully recorded in Duchamp's correspondence with Walter (1878-1954) and Louise (1879-1953) Arensberg, the wealthy collectors of modern art who, from the time of their first meeting with Duchamp in 1915, developed a friendship and working relationship that would endure for the remaining years of their lives. For Duchamp, the Arensbergs represented his most devoted American patrons; for the Arensbergs, Duchamp was to become their most trusted advisor and confidant. During these early years in New York, their mutually beneficial exchange went even further, effecting, in certain instances, the creative production of both the artist and his patron.[1] Indeed, throughout his life, Duchamp would always warmly recall the time he spent in New York with the Arensbergs. For their part, after they moved to California in the early 1920s, the Arensbergs openly lamented the loss of their friend; Walter, in particular, confessed that he especially missed Duchamp.

Throughout the thirty-five years of their friendship, when distance prevented direct communication, Duchamp and the Arensbergs continued to correspond, either by cable or by letter. The following seven letters (with the fragmentary portion of an eighth) comprise their extant correspondence during these years in New York, from 1917 through 1921. The first letter is addressed to Louise Arensberg, who apparently was away for a brief period in Boston visiting relatives.

To Louise Arensberg, 25 August 1917

(Letter postmarked August 25, 1917, Duchamp to Louise Arensberg, c/o Sydney Stevens, 1 Mason Street, Boston)

1. Transcription

vendredi
Chère Lou,
Il y a bien longtemps que je veux écrire. . . .
Vous recevrez par le même courrier un RongwRong qui se décide à paraître.[2]
 L'été ici se passe absolument comme l'hiver. On boit un peu. J'ai pris quelques cuites; et hier soir, chez Joel's oú nous étions avec Aileen[3] et 3 or 4 de ses amis, la soirée s'est terminée par une bataille. – Des brutes d'une autre table à côté sont venus chanter un peu trop fort près de nous, ils ont aussi voulu embrasser "nos femmes" – Petite discussion d'abord, puis, plus saouls que nous, ils ont flanqué Walter par terre, sans blessure et moi, j'ai reçu un formidable coup de poing dans l'oreille; je saigne encore, et c'est enflé –
Pas grave –
 A part cela, je ne travaille presque pas –
 J'ai quelques leçons.[4]
 Nous nous couchons plus tôt. (3 h. au lieu de 5.)
 Les Picabia sont dans les Catskills.[5]
 Les Gleizes à N.Y.[6]
Helen Freeman[7] m'avait dit qu'elle vous écrirait pour aller vous voir. L'a t'elle fait? –
 Walter a bonne mine.
 Mon atelier a été peint en blanc – c'est très bien.[8]
 Et vous que faites vous?
 Si loin, êtes vous tellement degoutée de N.Y.
 Jouez vous au tennis? Faites vous de l'auto?
 Racontez moi un peu des histoires.
 Et quand revenez vous parmi nous?
 Ecrivez moi une petite lettre.
 Je serais si content.
 A bientôt chèr [sic] Lou
 et très affectueusement
 Marcel –

2. Translation

Friday
Dear Lou,
I've been wanting to write to you for a long time. . . .
You shall receive by the same mail a RongwRong which decides to appear in print.[2]
 Here summer is being spent exactly like winter. We drink a little. I got drunk a few times; and last night, at Joel's where we were with Aileen[3] and 3 or 4 of her friends, the evening ended in a fight. – Some brutes at another table nearby came to sing a little too loudly near us, they also wanted to kiss "our women" – first a little discussion, then, more drunk than we, they knocked Walter down, without hurting him and I got a terrific blow to the ear; I'm still bleeding and it's swollen –
Nothing serious –
 Apart from that, I hardly work at all –
 I have a few lessons.[4]
 We go to bed earlier. (3 instead of 5)
 The Picabias are in the Catskills.[5]

The Gleizes in New York.[6]
Helen Freeman[7] told me that she would write to you about visiting you. Did she?
 Walter looks healthy—
 My studio was painted white—that is very good.[8]
 And you, what are you doing?
So far away, are you so fed up with New York?
 Do you play tennis? Do you drive your car?
 Tell me a little bit of news.
 When are you coming back to us?
 Write me a little letter.
 I would be so happy.
 See you soon dear Lou
 and very affectionately
 Marcel—

To Walter and Louise Arensberg, ca. 20 August 1918

When America entered the war in 1917, Duchamp became eligible for military conscription (a few years earlier, while living in Paris, he had received a health exemption from the French government). Consequently, the artist sought the non-aggressive and friendlier atmosphere of a neutral country. By the summer of 1918, he decided to move to South America, where he knew only the parents of a friend from Paris who ran a brothel in Buenos Aires.[9] After securing passage on a boat that would take nearly a month to make its way from New York to Argentina, Du-

champ packed a few of his belongings—including a sculpture made entirely of rubber bathing caps specially designed for traveling—and, in the company of Yvonne Crotti (the wife of his former studio mate and soon-to-be brother-in-law, Jean Crotti), he set sail for Buenos Aires.[10] On board ship, he wrote the following note to the Arensbergs, explaining, among other things, that he was still working on his papers (a reference doubtlessly intended to reassure the collectors that he had intended to continue work on at least the theoretical aspects of the Large Glass, the masterwork which, upon completion, the Arensbergs were to have acquired in exchange for having paid Duchamp's rent on his apartment in New York).

1. Transcription

([Stationery headed] On board S.S. "Crofton Hall"
Norton Line)
Chers WalterLou
En route depuis une semaine.[11] Ce petit mot repartira pour New York de Barbados le 23 (on s'y arrête quelques heures pour charbon) La mer est très calme, et on ne me donne de la lumière le soir que dans une smoking room très chaude et pas aérée à cause des sous marins— On a vaguement parlé il y a 3 jours d'un oil tanker qu'un sous-marin aurait fait sauter à quelques miles de nous en face Atlantic City—mais je n'ai rien vu—[12]
Pas d'échecs, personne pour jouer—
Je travaille avec mes papiers que j'arrange[13]
Vous cablerai de Buenos Aires dès arrivé (14 Septembre environ)
Pas de mal de mer encore—
Affectueusement à tous deux
Marcel
Envoyé de Barbados 24 Août
très chaud

2. Translation

([Stationery headed] On board S. S. "Crofton Hall"
Norton Line)
Dear WalterLou
Under way for a week.[11] This little note will leave for New York from Barbados on the 23rd—(we are stopping there for a few hours for coal) The sea is very calm, and they only give me light in the evening in a very hot and poorly ventilated smoking room because of the submarines—They spoke vaguely 3 days ago of an oil tanker that a submarine supposedly blew up some miles from us off Atlantic City—but I didn't see anything—[12]
No chess, no one to play with—
I work with my papers which I'm putting in order[13]
Will wire you from Buenos Aires as soon as I arrive (around September 14)
No seasickness yet—
Affectionately to both of you
Marcel
Sent from Barbados 24 August
very hot

To Walter and Louise Arensberg, 8 November 1918

Once he had located a suitable studio, Duchamp and Yvonne Crotti began the relatively slow process of adjusting to life in Argentina. After settling in, Duchamp wrote a number of letters to his family and friends, telling them about the restrictive social conditions and provincial atmosphere of Buenos Aires. He also informed them of his plans to organize an exhibition of Cubism, to—as he put it in a letter to Jean Crotti—"awaken these sleepy dark faces."[14] In writing to the Arensbergs, he took the opportunity to tell them how much he had enjoyed the years he spent with them in New York, and to remind them—once again— that he was still working on drawings and other studies for the Large Glass.

1. Transcription

Buenos Aires 8 November 1918
Cher Walter Chère Lou –
Déjà un vieux Buenos Airien! 2 mois ici. Connais la ville par coeur. – Très province très famille La société très importante et très fermée; Pas d'Healys ou de Reisenwebers et encore moins de Follies –

Au "casino" – genre arcade Building théâtre – on ne voit que des hommes – Les dames bien élevées ne vont pas à ces théâtres gais (ô combien) – pas de vie d'hôtels comme à N.Y. Le "Plaza" ici est un prétexte à réunions familiales du Dimanche pour la Croix Rouge de diverses nations.

Il y a bien l'odeur de paix qui est épatante à respirer et une tranquillité provinciale qui me permettent et forcent même à travailler – De sorte que j'ai loué une chambre loin du confort auquel je fus habitué 67me rue et j'y travaille –

J'ai commencé la partie droite du Verre[15] et j'espère que quelques mois vont me suffire pour terminer entièrement les dessins que je veux rapporter un jour à N.Y. pour finir le Verre –

Je pense souvent à vous et à mes 3 bonnes années près de vous – mon seul plaisir ici est de travailler, ce n'est pas plus mal qu'autre chose, pour un flemmard comme moi –

Mais les bonnes nouvelles m'enchantent

207

Hier 7 Novembre – nous avons eu la fausse nouvelle que l'armistice était signé – aujourd'hui la nouvelle a été démentie –

 Mais quand même, c'est une question de jours maintenant –

Et je pense à vous Walter, à tout ce que paix means to you. Et Allen,[16] j'espère, ne connaitra pas la France.

Vous avez sans doute appris à N.Y. déjà la mort de mon frère Raymond – J'ai reçu ici un câble de ma famille vers le 27 Octobre. C'est une chose affreuse car vous savez combien il m'était proche et cher –[17]

J'ai écrit il y a quelques jours à Barzun lui demandant de réunir des toiles pour une exposition cubiste ici où les gens sont aussi bêtes qu'ignorants[18] – Barzun vous en causera et dites bien à de Zayas, qui en somme serait le plus gros envoyeur, de choisir de bonnes choses, conseillez-le même dans son choix.[19]

J'aimerais tant réunir 30 *bonnes* choses J'ai trouvé des galeries ici, qui à cause de la
· nouveauté de la chose, donneraient les salles pour rien –

Comprenez bien que je ne vous demande de ne rien envoyer de vos toiles, car j'ai recommandé à Barzun qu'il ne soit envoyé que les choses à vendre-il est très possible que ce soit un débouché important pour eux, les marchands.

Moi même n'exposerai rien, selon mes principes – (Il est entendu aussi, n'est ce pas, que vous n'exposerez rien de moi, si vous tenez à me faire plaisir, au cas où on vous demanderait de prêter quelque chose à N.Y. Ceci entre parenthèse –)

Mes projets: si la guerre se termine, je resterai ici jusqu'en Juin Juillet et pense partir en France à ce moment. J'y passerais quelques mois et reviendrais à New York ensuite.

Ce sont des projets!!

Un mot de vous me ferait plaisir, sur vos projets et sur ce que deviendrait N.Y. et les amis.

Miss Dreier est ici depuis un mois. Elle s'occupe d'articles pour le Studio et différentes autres choses – mais elle a à souffrir de la ville – je veux dire Buenos Aires n'admet pas les femmes seules – C'est insensé, l'insolence et la bêtise des hommes ici –[20]

Au revoir, chère Lou et cher Walter ne m'oubliez pas trop – maintenant que les évènements guerriers se precipitent, le temps ne sera pas long avant que nous nous revoyons

très affectueusement à tous deux
Marcel
1507 Sarmiento
Buenos Aires
Argentina

2. Translation

Buenos Aires 8 November 1918
Dear Walter Dear Lou –

Already an old Buenos Airien! 2 months here. I know the city by heart. – Very provincial very family [oriented] The [sense of] community very important and very closed; no Healys or Reisenwebers and even less Follies –

At the "casino" – a kind of arcade Building theatre – you only see men – The well-brought-up ladies don't go to these high-spirited theatres (and how!) – no hotel life as in N.Y. Here, the "Plaza" is an excuse for Sunday family get-togethers for the Red Cross of various countries.

There is the smell of peace which is great to breathe and a provincial tranquility which allow me and even forced me to work – To the extent that I rented a room far from the comforts to which I was accustomed on 67th Street and I'm working there –

I have begun the part on the right side of the Glass[15] and I hope that a few months

will be enough for me to finish completely the drawings that I want to bring back to N.Y. some day in order to finish the Glass.

I often think of you and of the 3 good years I spent near you – my only pleasure here is working, it's no worse than anything else, for a lazy thing like me –

But the good news delights me –

Yesterday November 7th we received the false news that the armistice was signed – today the news was refuted –

But even so, it is only a matter of days now – !

I think of you Walter, of all that peace means to you. And Allen,[16] I hope, will not get to know France.

You have no doubt already learned in N.Y. of the death of my brother Raymond – I received here a cable from my family around October 27th. It's a horrible thing because you know how close and dear he was to me –[17]

Several days ago, I wrote to Barzun, asking him to get together some paintings for a cubist exhibition here where people are as stupid as [they are] ignorant[18] – Barzun will talk to you about it and make sure to tell de Zayas, who would be the biggest lender, to choose good stuff, even advise him in his choice.[19]

I would so much like to gather 30 *good* things. I found some galleries here which would give the space for nothing because of the novelty of the thing.

Please understand that I'm not asking you to send any of your paintings, because I advised Barzun to send only things to sell – it is very possible that it will be an important outlet for them, the dealers.

I myself will exhibit nothing, in accordance with my principles. (It is also understood, isn't it, that you won't show any of my things, if you really want to please me, in the case that somebody would ask you to lend something in N.Y. This between parentheses)

My plans: if the war ends, I'll stay here until June, July and I think I'll leave for France at that time. I would spend a few months there and then return to New York. Some plans!!

I would be happy to hear from you about your plans, about the events in N.Y. and friends.

Miss Dreier has been here one month. She's busy with items for the Studio and various other things – but she suffers from the city – I mean to say that Buenos Aires does not accept unaccompanied women – It's senseless, the insolence and the stupidity of men here –[20]

So long, dear Lou and dear Walter [–] don't forget me – now that the outcome of war is coming very fast, it won't be long before we see each other again

very affectionately to you both

Marcel

To Louise Arensberg, 7 January 1919

Duchamp spent most of the winter of 1918–19 playing chess, at first studying by himself (replaying recorded master games), and then, eventually, engaging the members of a local chess club. In order to facilitate prospects of playing chess by mail, he even designed his own rubber stamp set, enclosing an example for Walter in his next letter. A few days later, however, before posting this letter, Duchamp added a postscript, wherein he laments the death of two friends – both of whom died in the same worldwide Spanish influenza epidemic of 1918 – and he takes the opportunity to relay information he has learned about the activities of a number of other close friends.

1. Transcription

Buenos Aires 7 Janvier [1919]

Chère Lou – j'ai reçu il y a quelque temps déjà votre lettre datée 7 octobre et vous remercie de la lettre incluse –

J'ai été aussi très heureux d'apprendre quelques "happening" de New York – et espère que vous avez un hiver pas trop rigoureux et beaucoup de théatre et musique –

Ici Noël et Jour de l'an par 90° de chaleur sont une nouveauté. Je joins ici pour vous et Walter mes meilleurs souhaits –

Comme mes lettres vous l'ont indiqué, je travaille ici car il n'y a pas moyen de beaucoup s'amuser.

A part quelques tangos, il n'y a rien, ou alors le théatre avec troupes étrangères souvent françaises (qui me rappellent un peu trop que je comprends bien le français).

Je joue aux échecs seul pour l'instant; j'ai trouvé des revues dans lesquelles j'ai découpé une quarantaine de parties de Capablanca que je vais to play over –[21]

Je vais aussi probablement entrer au chess club d'ici, pour m'essayer de nouveau. Je me suis fait faire un "set" de tampons en caoutchouc (que j'ai dessinés) avec lesquels je marque des parties. J'en envoie ici un exemplaire pour Walter.[22]

Par le même courrier, Walter recevra un tableau d'oculiste (avec lequel les oculistes "test" les yeux). Je me suis servi de tableaux d'oculistes ces temps derniers. Et j'espère que celui ci pourra servir à Walter.[23]

Je reçois peu de nouvelles – De ma famille un peu – à cause de la mort de mon frère –

Avez vous vu Barzun, qui maintenant doit avoir ma lettre à propo[s] d'une exposition possible ici. J'attend de ses nouvelles vers 15 Février –

Miss Dreier a passé ici 3 mois et pense repartir à New York en Février.

Je compte rester ici jusqu'en Juin et ensuite partir en France. (Je vous donne ici mon adresse en France en cas d'un évènement imprévu:
M.D.
71 rue Jeanne d'arc
Rouen (S.I.)
Ne me laissez pas sans nouvelles de vous. Avez vous l'intention de voyager l'été prochain. J'aimerais vous voir à Paris.

J'imagine que Walter est devenu champion d'échecs, et qu'Allen doit être de retour du camp et lui sert d'entraineur. A tous deux mes affectueuses amitiés et à bientôt.[24]

<div align="right">
Marcel Duchamp

1507 Sarmiento

Buenos Aires
</div>

10 Janvier

Avant de mettre la lettre à la poste, je reçois votre lettre du 5 novembre –

Je suis vraiment navré de la mort de Schamberg[25] et je me demande d'où vient cette vague de mort. Apollinaire, j'ai appris de France, est mort de la grippe il y a quelques mois déja.[26]

C'est désolant.

Non, je n'ai pas vu Mina et Cravan.[27] Je serais bien etonné qu'ils soient ici sans les avoir rencontrés.

Charlie est très applaudi ici et j'ai revu plusieurs de ses anciens films et j'attends avec impatience Charlie in "Soldier's Life."[28]

Mes amitiés à Dr. Southard et regrets pour lui de n'avoir pas worn out son uniforme.[29]

Amitiés aussi pour jolie Beatrice que je verrai sans doute un jour ici sur l'écran.[30]
Affectueusement à tous deux
 Marcel
Toutes mes félicitations pour votre français qui est excellent –

2. Translation

Buenos Aires 7 January [1919]

Dear Lou – It has already been some time since I received your letter dated 7 October and I thank you for the enclosed letter.

I was also very happy to learn of "happenings" from New York – and I hope that your winter is not too hard and that there is a lot of theater and music –

Here Christmas and New Year's at 90° are a novelty. I add here for you and Walter my best wishes –

As my letters have indicated to you, I am working here because there isn't much of a way to have a good time.

Other than for some "tangos," there's nothing, or else, the theater with companies of foreign actors, often French (who remind me a little too much that I understand French very well).

I play chess alone right now; I found magazines in which I have cut out about 40 games of Capablanca that I am going "to play over – "[21]

I am also probably going to join the local chess club here to try my hand again. I had made up a set of rubber stamps (which I designed) with which I set up the games. I'm sending here an example for Walter.[22]

By the same mail, Walter will receive an eye chart (with which oculists "test" the eyes). Recently I have been using oculists' eye charts. And I hope that this one will be of use to Walter.[23]

I receive little news – a little from my family – because of my brother's death –

Have you seen Barzun, who by now must have my letter regarding a possible exhibition here. I expect to hear from him around February 15th.

Miss Dreier has spent 3 months here and is thinking of returning to New York in February.

I'm planning to stay here until June and then to leave for France. (Here is my address in France in case something unexpected happens:
 M.D.
 71 rue Jeanne d'arc
 Rouen (S.I.)
Don't leave me without news from you. Do you plan to travel next summer. I'd love to see you in Paris.

I imagine that Walter has become chess champion, and that Allen must be back from camp and serves him as coach.[24]

to both of you my affectionate regards and see you soon.
 Marcel Duchamp
 1507 Sarmiento
 Buenos Aires

10 January

Before mailing the letter, I received your letter of November 5th.

I'm really brokenhearted over Schamberg's death[25] and I wonder where this wave of death is coming from. Apollinaire, I've learned from France, died from the flu several months ago.[26]

It's depressing!

No, I haven't seen Mina and Cravan.[27] I would be very surprised if they were here and I didn't run into them

Charlie is highly praised here and I've seen again several of his old films and I can't wait for Charlie in "Soldier's Life."[28]

My regards to Dr. Southard and [my] regrets for his not having "worn out" his uniform.[29]

Regards also to the lovely Beatrice whom I will no doubt one day see on the screen.[30] Affectionate wishes to both of you —

Marcel

All my congratulations on your French which is excellent —

(Included in letter of 7 January 1919)

Cher Walter

Ci joint une fin de partie entre Paulsen et Morphy, que vous connaissez peut-être:

[Dear Walter,

I enclose the end of a game between Paulsen and Morphy, which you probably already know:]

Morphy joue
[Morphy to play]

Paulsen

Red Paulsen	Black Morphy
1.	Q x B !!
2. P x Q	R − KKt3 ch.
3. K − R1	B − R6

212

4. R – Q1	B – Kt7 ch.
5. K – Kt1	QB x P disc. ch.
6. K – B1	B – Kt7 ch.
7. K – Ktl	B – R6 disc. ch. (1)
8. K – R1	KB x P
9. Q – B1	B x Q
10. R x B	R – K7
11. QR – R1	R – K3
12. P – Q4	B – K6!
Resign	

(1) note par Capablanca:

| 7. | B – K5 ch. |
| 8. K – B1 | B – KB4 |

donne un mat plus rapide.
[gives a more rapid mate]

To Walter and Louise Arensberg, end of March 1919

At some point early in the spring of 1919, the Arensbergs must have written to Duchamp requesting his permission to lend a number of his works from their collection to an exhibition of modern French art being organized in New York by Marius de Zayas. Even though Duchamp preferred that his work not be exhibited publicly, he must have responded in the affirmative, for at least one or two of his works from the Arensberg collection were eventually included in the exhibition.[31] *In his next letter to the Arensbergs, he acknowledges receipt of their correspondence, but, curiously, does not take the opportunity to tell them about two events in his personal life that one would imagine he would readily share with such close friends: firstly, that a few weeks earlier, Yvonne Crotti decided to take leave of Buenos Aires and return to Paris; and, secondly, that within a month's time, his sister Suzanne was scheduled to marry his old friend and their former acquaintance from New York, Jean Crotti. Nevertheless, in his customary manner, he does tell the Arensbergs about his contacts and communication with a number of other mutual friends, and, to Walter, he proposes a game of correspondence chess by cable.*[32]

1. Transcription

Buenos Aires, fin Mars – 19
Chère Lou, Cher Walter, Il y a longtemps que j'ai reçu votre letter contenant le chèque que vous avez été si gentils de me faire parvenir. Je vous ai cablé immédiatement, accusant réception de la lettre et répondant à votre "exhibit or not exhibit" ultimatum – Je pense que maintenant l'exposition est ouverte et serais heureux que vous me donniez quelques détails amusants sur l'accueil fait à cette officialisation du cubisme.[33]
Comme vous le savez j'avais trouvé des galeries ici où une exposition aurait pu avoir lieu. Mais l'indifférence de Gleizes et Barzun dont je n'ai eu aucune nouvelles (et à qui j'ai câblé en Février) me font penser qu'elle n'aura pas lieu. –
L'idée de De Zayas est possible mais il faudrait que je voie les officiels d'ici et je le ferai volontiers (ayant de bonnes "connections" pour leur être présenté convenablement) – Dans le cas où l'idée de faire suivre l'exposition ici continuerait, faites moi câbler par De Zayas des instructions. J'irais voir des officiels et vous tiendrais au

courant. Mais dans tous les cas mon impression est que personne ici ne voudra aider pécuniairement et que les chances de ventes sont infinitésimales.

J'ai l'intention de quitter B.A. en Juin (première partie de Juin) – Donc mes démarches ne pourraient aboutir qu'à mettre De Zayas ou autres officiels en rapport avec ceux d'ici.

En plus, les meilleurs mois ici sont Juin Juillet et Août –

Je fais des échecs en masse – Je fais partie du club ici où il y a de très forts joueurs classés par catégories – Je n'ai pas eu l'honneur d'être classé encore et je joue avec differents joueurs de 2me catégorie et 3me perdant et gagnant de temps en temps.

Je prends encore des leçons d'échecs avec le meilleur joueur du club qui enseigne admirablement et me fait faire des progrès "théoriques" –

Donc j'avais pensé qu'à mon retour en France je pourrais peut-être jouer par câble avec Walter – j'ai trouvé dans un livre la manière de jouer par câble réduisant les frais d'envoi –

Je vous en fais une description et vous demande de garder ce papier jusqu'à Juillet – Si vous receviez un cable bizarre de France, ce serait le début d'une partie d'échecs.[34]

Nous jouerons *deux parties* simultanés. Dans mon premier télégramme j'enverrai mon premier coup de la première partie par example: PK 4 sera câble:

one GEGO

Walter me répondra sa résponse comme suit:

one SESOFEFO

Ce qui veut dire 1er coup des Noirs (Walter) de la première partie est SESO (P4R). Et qu'il joue FEFO (PQ4) comme premier coup de la 2me partie (ayant les Blancs).

Je crois indispensable de mettre le numèro one, two, three, etc., indiquant à quel coup on est et évitant les erreurs.

(On a droit à un mot de 8 lettres; c'est sur cette base qu'a été construit ce système de transmission).

Avant d'envoyer je m'informerai si la censure permet l'envoi de cette littérature par câble.

Cette notation est la notation Gringmuth – [35]

Voici une adresse à Paris où vous pourrez toujours m'envoyer les câbles:

Duchamp
22 rue Lacondamine
Paris

Quant au reste, je travaille – Il a fait très chaud, et maintenant l'indian Summer est merveilleux.

Miss Dreier a été retardée pour son retour. Son bateau *Le Vauban* part le 3 avril et vous apportera probablement cette lettre. Elle vous racontera probablement les côtés amusants de B.A.

Au revoir donc, à bientôt; dans 6 ou 8 mois je pense être à New York.

Je viens de recevoir le magazine de Man Ray TNT, que j'ai enjoyed very much J'ai beaucoup aimé la composition de Walter qui, j'espère continue à produire quelques bonnes choses comme ça les seules qu'on puisse lire aujourd'hui (les autres son littérature).

Remerciez Man Ray de m'avoir reproduit le dessin; j'ai l'intention de lui envoyer un petit mot.[36]

Affectueusement à tous deux

Marcel

1507 Sarmiento

B.A.

2. Translation

Buenos Aires, end of March – 19
Dear Lou Dear Walter,
A long time ago I received your letter containing the check that you were so kind to send me. I cabled you immediately acknowledging receipt of the letter and responding to your "exhibit or not exhibit" ultimatum – I think that by now the show must be open, and I would love to hear some of the amusing details with regard to the reception given this officialization of Cubism.[33]

As you know, I had found some galleries here where a show could have taken place. But the indifference of Gleizes and Barzun from whom I've had *no* word (and to whom I cabled in February) makes me think that no show will take place. The idea of De Zayas is possible but it would be necessary for me to see some officials here and I'll gladly do it (having some good "connections" which will allow me to be suitably presented to them) – If the idea of having a follow-up exhibition here continues, have De Zayas cable me the instructions. I would go see the officials and keep you up on what's going on. But in any case my impression is that no one here wants to help financially and that the chances for sales are infinitesimal.

My intention is to leave B.A. in June (first part of June) – Therefore my proceedings could only result in putting De Zayas or other officials in touch with officials here –

Additionally, the best months here are June, July and August. – I'm into chess in a big way – I'm part of the Club here where there are some very strong players classed by category. I haven't had the honor of being classed yet and I play with different players of the 2nd and 3rd rank, losing and winning from time to time.

I'm taking lessons from the Club's best player who teaches admirably and makes me make some "theoretical" progress.

Therefore I had thought that upon my return to France I will be able to play by cable with Walter – I found in a book a way of playing by cable which reduces the cable costs.

I am making you a description of it and ask you to save this paper until July – if you receive a bizarre cable from France, it will be the debut of a chess match.[34]

– We will play *two matches* simultaneously. In my first telegram I'll send my 1st move of the 1st match – for example: PK4. What will be cabled:
one GEGO
Walter will send his response like this:
one SESOFEFO
Which means 1st move of the Blacks (Walter) of the 1st match is SESO (P4R) and that he plays FEFO (PQ4) as 1st move of the 2nd match (having the Whites).

I think it's indispensable to put the number one, two, three, etc., indicating which move one is making & avoiding errors.

(One has the right to one word of 8 letters; it is on this basis that this system of transmission has been constructed.)

Before sending I'll find out if the censor permits the sending of this literature by cable.

This notation is the Gringmuth notation.[35]

Here is a Paris address where you can always send me the cables:
Duchamp
22 rue Lacondamine
Paris

As for the rest, I'm working – It's been very hot, and now Indian Summer is marvelous.

Miss Dreier was delayed in her return. Her ship (Le Vauban) leaves April 3rd and will probably bring you this letter. She will probably tell you the amusing aspects of B.A.

So long, then, see you soon: in 6 or 8 months I'm thinking to be in New York.
I have just received Man Ray's magazine, TNT, which I enjoyed very much. I really liked the composition by Walter, who, I hope, continues to produce some good things like that, the only things one can read these days. (The others are literature.) Thank Man Ray for having reproduced the drawing, I intend to send him a note.[36]
Best to you two,
Marcel
1507 Sarmiento
B.A.

Enclosures in letter of end of March 1919

Pour "castles" – indiquer seulement le déplacement du Roi
par exemple: GAKA
 ou GADA
 ou SAWA
 ou SAPA

[To "castle" – indicate only the displacement of the King
for example: GAKA
 or GADA
 or SAWA
 or SAPA]

Noirs [Blacks]

Blancs [Whites]

216

1. Kt x BP K x Kt
2. Q - R5 Kt - K2
3. Kt - K2 Kt - B4
4. Kt - B4 Q - Kt4
5. Q x Q P x Q
6. Kt x Kt Kt x PQ
7. B x KtP
 avec un P de plus
 [with an additional pawn]

Si 6... K x Kt4
 7. P - K Kt4 regagnant
 la pièce – Mais j'ai perdu la partie!

[If 6... K x Kt
 7. P - K Kt4 would regain the
 piece.
 But I lost the game!]

Position d'une partie jouée contre un fort joueur d'ici –
Partie que j'ai perdue par la suite mais les quelques coups que je donne ici sont une
preuve de mes progrès et de mon plaisir à jouer serieusement!
Le dernier coup des noirs est P - KR3.

[Position of a game played against a strong player from here –
A game which I eventually lost, but the few moves which I indicate here are proof of
my progress and of my pleasure in playing seriously!
The last move of the blacks is P - KR3.]

Blancs. M.D.
[Whites. M.D.]

To Walter and Louise Arensberg, 15 June 1919

In the next letter of their correspondence, Duchamp tells the Arensbergs about the degree of his absolute obsession with the game of chess. He also informs them of his plans to return to Paris.

1. Transcription

B.A. 15 Juin [1919]

Chère Lou cher Walter

Sur mon départ, je commence mes malles – si tout se passe comme prévu, mon bâteau ("Highland Pride" Nelson line) part le 22 Juin et doit arriver à Londres vers 18 ou 19 Juillet –

Je n'ai presque rien fait ces derniers temps, plus préoccupé par le départ; je continue à jouer beaucoup aux échecs –

Vous ai-je dit dans ma dernière lettre que j'avais rencontré Bobby Brown et Rose Watson – [37] Ils m'ont dit que Mina Loy a passé quelques mois ici et est repartie en Angleterre depuis Mars ou Avril – elle n'avait pas de nouvelles de Cravan depuis son départ du Mexique – [38]

20 Juin. La paix va être signé quand je serai au mer[39] – j'espère après 2 ou 3 mois de séjour en France reprendre un bateau pour New York.

Mes malles sont finies. Dimanche 22 à 3 heures je quitte Buenos Aires où l'on travaille très bien si on ne s'y amuse pas beaucoup.

Je me sens tout à fait prêt à devenir le chess maniaque – Tout autour de moi prend la forme du cavalier ou de dame et le monde extérieur n'a pas d'autre intéret pour moi, que dans sa transposition en positions gagnantes ou perdantes –

Au revoir donc de B.A. je vous écrirai dès en arrivant en France –

Donnez-moi un peu de vos nouvelles. Je n'ai rien reçu de vous depuis 2 mois –

A bientôt donc et très affectueusement à tous deux

Marcel

M. Duchamp
71 rue Jeanne d'arc
Rouen
Seine Intérieure

2. Translation

B.A. 15 June [1919]

Dear Lou dear Walter

Upon my departure, I'm starting to pack – If everything goes as planned, my boat ("Highland Pride" Nelson line) leaves June 22 and should arrive in London around the 18th or 19th of July –

I've done practically nothing lately, very preoccupied by the departure; I continue to play a lot of chess –

Did I tell you in my last letter that I had run into Bobby Brown and Rose Watson[37] – They told me that Mina Loy spent a few months here and left for England in March or April – she hadn't received any news from Cravan since he left Mexico – [38]

20 June. The peace will be signed while I'm at sea[39] – and I hope after 2 or 3 months in France to get back on a boat for New York.

My packing is finished. Sunday the 22nd at 3:00 I'm leaving Buenos Aires where you work very well even if you don't have much fun.

I am absolutely ready to become the chess maniac – everybody around me takes the

form of the knight or the queen and the outside world has no interest for me other than its transposition into winning or losing positions –

So long from B.A. I will write to you as soon as I get to France.

Give me some news from you. I've received nothing from you for 3 months.

See you soon then and very affectionately to both of you

Marcel

M. Duchamp
71 rue Jeanne d'arc
Rouen
Seine Intérieure

To Walter and Louise Arensberg, Fall 1921.

Upon his return to Paris, Duchamp must have quickly discovered that things had changed considerably during his four-year absence. A number of his friends had fallen victim to the war, and the vanguard artistic community was overtaken by Dada, the literary movement that had begun a few years earlier in Zurich. While in Paris, he was the house guest of the Picabias. But by December – after only a three-month stay – Duchamp had booked his return voyage to New York. Before his departure, he prepared a small gift for the Arensbergs: he asked a pharmacist to empty a glass ampule of serum and reseal it, entrapping for his American friends a breath of Paris air.

Upon his return to America, Duchamp resumed his close contact with the Arensbergs. It was at this time that he began a period of intensive experimentation with the science of optics (resulting in the production of a large motor-driven machine, intended to compress spatially the impression of separate spinning glass plates). He also saw quite a bit of his old friend Man Ray, and, enlisting his assistance, cofounded with Katherine Dreier the first museum devoted exclusively to the display and promotion of modern art: the Société Anonyme, Inc. He also joined the Marshall Chess Club in Manhattan, and contemplated the possibility of marketing a chess set of his own design. But the riotous gatherings at the Arensberg apartment – which had characterized his earlier stay in New York – had come to an end. "Louise," as Beatrice Wood recalls, "read Walter the riot act."[40] He had gone through his own personal fortune and was now beginning to spend hers. The party was over.

At first, the Arensbergs were reluctant to make a permanent decision about moving from New York. During the late summer of 1920, however, they took the first of what would amount to a series of extended vcations in California.[41] In their absence, Duchamp continued his activities with Man Ray, releasing the first and only publication in the name of Dada to appear in New York. During the summer of 1921, he returned to Paris for six months, this time staying with his sister and brother-in-law, the Crottis. It must have been in this period that he wrote to the Arensbergs, telling them about the writings of Le Comte de Lautréamont, an obscure, though highly influential, French poet whose writings were considered a precursor to Dada.

1. Transcription

[ca. Fall 1921][42]
Les Crotti de toute sorte sont bien et vous envoient des souvenirs[43]
Avez vous les Poésies du Comte de Lautréamont –

219

Ça a été réedité l'année dernière
Ce ne sont d'ailleurs pas les Poésies
Ce n'est qu'une longue préface aux Poésies – qui n'ont jamais été écrites: (car il a du mourir avant)
Je vous l'enverrai – [44]
Vous y verrez toute la semence dada . . .
Ecrivez un peu – affectueusement à tous deux

> Marcel
> 71 rue Jeanne d'arc
> Rouen

2. Translation

[ca. Fall 1921][2]
The Crottis in any case are well and send you their regards.[43]
Do you have the poems of Count de Lautréamont –
They were reedited Last year
Besides these are not the poems. This is just a long preface to the poems – which were never written, (because he must have died before)
I will send it to you – [44]
In it you will see the very seed of dada.
Write a little – affectionately to both of you
Marcel
71 rue Jeanne d'arc
Rouen

To Walter and Louise Arensberg, 15 November 1921

In spite of the fact that he took the time to draw Lautréamont's writings to the attention of the Arensbergs, during his stay in Paris Duchamp quickly tired of the infighting and meaningless antics of Dada. In July, for example, he wrote to Ettie Stettheimer, explaining that the Dadaists had closed one of their exhibitions in protest. "From a distance," he explained, "these movements take on a charm that they do not have close up – I assure you."[45] Nevertheless, a few months later he wrote to the Arensbergs, telling them that he still planned to send the booklet by Lautréamont. In his letter, he expresses his disappointment at the news that they plan to stay for some time in California, but continues to fill them in on his activities in Paris, taking the opportunity to again inform them that he still plans to complete work on the Large Glass, *which he claims is nearly finished.*

1. Transcription

Paris 15 Novembre [1921]
Chère Lou cher Walter
Votre lettre annonce de bien tristes choses – N'allez vous pas revenir à N.Y. du tout? Rester en California?
 Ça me navre –
J'ai déjà assez de Paris et de la France en général – Je dois prendre un bateau dans le milieu de Janvier – je ne sais pas encore lequel, étant à la recherche d'une traversée économique – [46]
A N.Y. j'ai l'intention de trouver un "job" dans le cinéma – pas comme acteur, plutôt comme assistant cameraman.
 J'ai correspondu avec Sheeler à qui j'avais demandé de m'envoyer des photos du Nu – [47]

220

J'ai fait un bout de film, court, que j'emporterai avec moi – [48]
Je continue les échecs, joue avec quelques forts joueurs d'ici et "tiens le coup" –
Que pouvez vous faire pendant 24 heures tous les jours en Californie – la nature doit se répéter bien souvent –
J'espère avancer mon verre encore un peu et peut-être le finir, si ça marche comme je veux – il ne me reste qu'un travail de fils de plomb sans choses extraordinaires.[49] Peut-être ne mourrai je avant qu'il soit fini –
Je vais vous envoyer la petite brochure des poésies de Lautréamont – [50]
Peut être aussi je pourrais vous être utile pour vendre les Picassos – je connais Rosenberg et pourrais lui en parler si vous m'écrivez de le faire – [51]
Donc pas à bientôt mais il n'y aura que 4000 miles entre nous au lieu de 8000 en Janvier
affectueusement à tous deux
Marcel
71 rue Jeanne d'arc Rouen

2. Translation

Paris 15 November [1921]
Dear Lou dear Walter
Your letter announces some pretty sad things – aren't you coming back to N.Y. at all? Staying in California?
Very depressing –
I've already had enough of Paris and France in general – I have to take a boat in the middle of January – I don't know which one yet, since I am looking for an inexpensive crossing – [46]
In N.Y. I plan to find a "job" in movies – not as an actor, rather as an assistant camera-man.
I've been corresponding with Sheeler whom I've asked to send me photos of the Nude – [47]
I made a short bit of film, which I will bring with me – [48]
I continue with chess, I play with some strong players from here and hold my own.
What could you be doing for 24 hours a day in California – nature must repeat itself quite often –
I hope to get a little further with my glass and perhaps finish it, if it goes the way I want it to – all that's left is a little work with threads of lead without anything extraordinary.[49] Maybe I'll die before it's finished –
I shall send you the little pamphlet of poetry by Lautréamont – [50]
Perhaps I could also be helpful to you here selling Picassos – I know Rosenberg and I could speak to him about it if you write and tell me to do it.[51]
So I won't see you soon but there'll only be 4000 miles between us as opposed to 8000 in January
Marcel
71 rue Jeanne d'arc Rouen

Duchamp's offer to help sell the Arensbergs' Picassos must have come in response to their having informed him that, due to certain financial reversals, it was necessary for them to consider selling a number of important works from their collection (in the end, only two or three items were actually sold).

Curiously, and without warning, at this point Duchamp's correspondence with the Arensbergs suddenly breaks off. Some eight years would pass before they were to resume a regular exchange. In May of 1930, Walter Arensberg wrote to his old

friend, telling him how much he had missed his company. "It is still the great la-cuna that I never see you," he wrote."There isn't a day that I don't pass some time with your pictures. They are your conversation."[52] *On more secure financial foot-ing at this point, the Arensbergs were anxious to begin collecting again, and they were in need of Duchamp's numerous contacts in the art world. After telling him that they regretted having had to sell the* Large Glass *(which they sold to Katherine Dreier for $2,000 in 1921), they asked if he would be willing to help them locate a sculpture by Brancusi that was originally in their collection. Not only did he help them to secure the work in question, but over the course of the next twenty years Duchamp became the Arensbergs' principal contact in the acquisition of works for their collection. Over the years, not only did they acquire works by virtually every important European painter and sculptor of the twentieth century, but with Du-champ's help they managed to gather the single largest collecton of his work to be assembled anywhere in the world.*[53] *Even though they saw one another only rarely, with the passage of time Duchamp's friendship with the Arensbergs grew, and eventually he assisted in negotiations to place their entire collection of modern and pre-Columbian art with the Philadelphia Museum, where, to this very day, visitors are invited to contemplate the results of this remarkable exchange.*

Notes

The complete correspondence between Marcel Duchamp and the Arensbergs is pre-served in the manuscript archives of the Francis Bacon Library, Claremont, Califor-nia, the repository established by Walter Arensberg to continue research on matters related to the Bacon-Shakespeare controversy. These letters are published here with the kind permission of the artist's widow, Alexina Duchamp, and the Board of Trustees of the Francis Bacon Library. I am indebted to Mme. Duchamp and to Eliza-beth Wrigley, director of the Francis Bacon Library, for their continued cooperation and encouragement. I should also like to take this opportunity to thank Rudolf E. Kuenzli, who kindly reviewed my transcription and translation of these letters and caught numerous errors. Needless to say, any mistakes – technical or factual – are en-tirely my own. Only slight changes have been made to Duchamp's original composi-tion: spelling errors and grammatical mistakes were not corrected; the text has been transcribed exactly as it was written.

1. Arensberg's involvement with cryptography can be seen to have influenced cer-tain aspects of Duchamp's work, while the ideas underlying Duchamp's conception of the readymade clearly affected Arensberg's more adventurous poetry (see Francis M. Naumann, "Cryptography and the Arensberg Circle," *Arts Magazine* 51, no. 9 [May 1977], 127–33, and Naumann, "Walter Conrad Arensberg: Poet, Patron, and Partici-pant in the New York Avant-Garde, 1915–20," *The Philadelphia Museum of Art Bulletin* 76, no. 328 [Spring 1980], 24–27; unless otherwise noted, all biographical references to the Arensbergs are derived from these sources).

2. Duchamp here refers to the single-issue publication, *Rongwrong,* which he edited with the assistance of Henri-Pierre Roché and Beatrice Wood and released at some point during the late summer of 1917. The precise date of its appearance is unknown, though years later Duchamp mistakenly recalled that *Rongwrong* appeared at some point between the two issues of the *Blind Man* (Pierre Cabanne, *Dialogues with Marcel Duchamp* [New York: Viking Press, 1971], 56), the first of which is dated 10 April 1917 and the second, May 1917. This ephemeral publication, however, must have been re-

leased after 5 May 1917 (the date of a letter printed on the first page of this review), and before 25 August 1917 (the postmark of the present letter).

3. Aileen probably refers to Aileen Dresser, a woman who was Beatrice Wood's landlady and, through her introduction, an occasional visitor to the Arensberg apartment (information relayed in conversation with the author, November 1987). Years later, Wood mistakenly recalled this woman's first name to be Arlene (she is thus identified in the artist's autobiography, *I Shock Myself* [Ojai: Dillingham Press, 1985], 29, 33). Nevertheless, her name is correctly recorded in a diary kept by the artist in these years (Collection of Francis Naumann, New York).

4. Duchamp supplemented his family income by giving occasional French lessons. Among others, his students included the wealthy Stettheimer sisters: Carrie, Ettie, and Florine.

5. Francis Picabia (1879–1953) and his wife, Gabrielle Buffet (1881–1985), arrived for their third sojourn in New York on 4 April 1917 (see William Camfield, *Francis Picabia: His Art, Life and Times* [Princeton: Princeton University Press, 1979], 101).

6. Albert Gleizes (1881–1953) and his wife, Juliet Roché (1884–1979 [?]), had come to New York for their honeymoon in September 1915; they would return to France three years later, in the fall of 1918 (see Pierre Alibert, *Gleizes: Naissance et avenir du cubisme* [Saint-Étienne: Aubin-Visconti, 1982], 120).

7. Helen Freeman (d. 1960) was an actress, and one of Beatrice Wood's closest friends (see *I Shock Myself*, 16).

8. Duchamp's studio was located in the same building as that of the Arensberg apartment, at 33 West 67th Street. It was this apartment the Arensbergs had agreed to rent in exchange for ownership of the *Large Glass*.

9. Reported by Duchamp in an interview with Otto Hahn, *Art and Artists* 1, no. 4 (July 1966), 10.

10. On Duchamp's relationship with the Crottis, see William A. Camfield, "Jean Crotti & Suzanne Duchamp," in *Tabu Dada: Jean Crotti & Suzanne Duchamp, 1915–1922* (Bern: Kunsthalle; Paris: Centre Georges Pompidou, Musée National d'Art Moderne, 1973), 9–25.

11. Duchamp and Yvonne Crotti embarked from New York for Buenos Aires on 13 August 1918.

12. The incident Duchamp refers to is likely the sinking of the American schooner, the *Dorothy Barret*, which was torpedoed by a German submarine and sunk off the coast of New Jersey on 16 August 1918 (see "U-Boat Keeps Up Raid Off Coast," *New York Times*, 16 August 1918, 1). It is possible that he might be referring to a number of other German submarine attacks that took place during this same week: the sinking of the Norwegian freighter, the *Sommerstand*, which took place about twenty-five miles off the coast of New Jersey on 13 August (the very day of Duchamp's departure; see "Sommerstand Sunk Near New York Could Not Escape," *New York Times*, 14 August 1918, 1); or the torpedoing of the *Modrugada*, an American schooner bound for Brazil that was attacked off the coast of Virginia a few days later (see "U-Boat's Guns Set Big Tanker Afire," *New York Times*, 17 August 1918, 1).

13. About a month before his departure, Duchamp wrote to Crotti, explaining that he had planned to take all of his papers with him to Buenos Aires, so that upon his return to New York he could more rapidly complete work on the *Large Glass*, which he referred to as "cette grande saloperie" (letter dated "8 Juillet" [1918], Crotti Papers, Ar-

chives of American Art, Smithsonian Institution, Washington, D.C.; see Francis M. Naumann, *"Affectueusement, Marcel:* Ten Letters from Marcel Duchamp to Suzanne Duchamp and Jean Crotti," *Archives of American Art Journal,* 22, no. 4 [1982], 10).

14. Duchamp to Crotti, 8 July [1918] (for full citation, see previous note).

15. Here Duchamp refers to his study on glass, *To Be Looked at [from the Other Side of the Glass] with One Eye, Close to, for Almost an Hour,* 1918 (The Museum of Modern Art; bequest of Katherine S. Dreier). A few weeks earlier, Duchamp wrote to Jean Crotti explaining that he had begun this small study (letter dated 26 October 1918; Crotti Papers, Archives of American Art; see Naumann, *"Affectueusement, Marcel,"* 11).

16. Duchamp is here probably referring to Allen Norton, a poet-friend of the Arensbergs who had been married to Louise Varèse and, earlier, was editor of the periodical *Rogue.*

17. The sculptor Raymond Duchamp-Villon (1876–1918) was eleven years older than his brother Marcel; he died in a Cannes military hospital on 9 October 1918. In a letter to Ettie Stettheimer dated 12 November 1918, Duchamp explained that his brother died because of recurrent relapses of blood poisoning, which he had been suffering from during the course of the previous two years (Stettheimer Archives, Collection of American Literature, Bienecke Rare Book and Manuscript Library, Yale University, New Haven, Connecticut).

18. Duchamp wrote to the French poet Henri-Martin Barzun (1881–1973), who apparently never responded to the artist's numerous requests for assistance in the organization of this exhibition. On 28 January 1919, Duchamp finally cabled the following message to Barzun: "QUELLES CHANCES EXPOSITION QUAND ENVOI" (H. M. Barzun Papers, Rare Book and Manuscript Library, Columbia University, New York). It is likely that Duchamp was trying to contact Barzun in order to secure the needed financial backing for this exhibition because, earlier, Barzun had supported similar artistic ventures in Paris (he moved permanently to the United States in 1919; see Boyd G. Carter, "Henri-Martin Barzun and the Abbaye de Creteil," *Books Abroad* [Spring 1949], 119–23). Without Barzun's cooperation, Duchamp eventually abandoned plans for this exhibition.

19. In 1918, the Mexican artist and author Marius de Zayas (1880–1961) was part-owner and proprietor of the Modern Gallery, 500 Fifth Avenue, which opened in October 1915 and was intended to be a more commercially geared off-shoot of Alfred Steiglitz's 291 Gallery. On de Zayas, see his own account of these years in New York: "How, When and Why Modern Art Came to New York," intro. and notes by Francis M. Naumann, *Arts Magazine* 54, no. 8 (April 1980), 96–126; and Douglas Hyland, *Marius de Zayas: Conjurer of Souls* (Lawrence, Kansas: Spencer Museum of Art, 1981).

20. The artist, author, and art collector Katherine Sophie Dreier (1877–1952) visited Argentina in 1917 with the intention of writing a few articles about her experiences there; her recollections on the country and its social mores, however, were eventually published in book form: *Five Months in the Argentine: From a Woman's Point of View, 1918 to 1919* (New York: Frederic Fairchild Sherman, 1920).

21. José Raúl Capablanca (1888–1942) was the Cuban grand master player who in 1921 won the world chess championship from Emanuel Lasker.

22. The example Duchamp sent was the match reproduced at the close of this letter, a game played between Louis Paulson (1833–1891) and Paul Morphy (1837–1884), two well-known American chess masters of the nineteenth century (see Anthony Saidy

and Norman Lessing, *The World of Chess* [New York: Random House, 1974], 95, 100, 109).

23. Unfortunately, the eye chart Duchamp sent to Arensberg has been lost. In a photograph taken a few years later in New York by Man Ray, however, of Duchamp's *Rotary Glass Plates (Precision Optics)*, a number of eye charts with foreign letters and text appear attached to the wall of the artist's studio (see Jean-Hubert Martin, ed., *Man Ray: Photographs* [New York: Thames and Hudson, 1982], pl. 14).

24. This is likely the same Allen Norton referred to in the previous letter (see n. 16 above). When he visited the Arensbergs, Norton is reported to have frequently engaged in games of chess with Duchamp (see Lousie Varèse, *Varèse: A Looking Glass Diary* [New York: W. W. Norton & Company, 1972], 203).

25. Morton Schamberg (1881–1918) died on 13 October 1918 (see Ben Wolf, *Morton Livingston Schamberg* [Philadelphia: University of Pennsylvania Press, 1963]; and William C. Agee, "Morton Livingston Schamberg: Color and the Evolution of His Painting," *Arts Magazine* 57, no. 3 [November 1982], 108–19).

26. After a five-day illness, Guillaume Apollinaire (1880–1918) died on 9 November 1918 (see Cecily Mackworth, *Guillaume Apollinaire and the Cubist Life* [New York: Horizon Press, 1963] and LeRoy C. Breunig, "Introduction" to *Apollinaire on Art* [New York: Viking Press, 1972], xxviii).

27. The brilliant English poet Mina Loy (1882–1966) married the notorious ex-boxer and bon vivant Arthur Cravan (b. 1887) in Mexico City in January 1918. Later in the year, Loy left for Buenos Aires via Veracruz, where the couple were supposed to rendezvous; Cravan, however, never showed up, resulting in one of the most mysterious disappearances in the annals of literary history (see Roger Conover, "Introduction" to Mina Loy, *Last Lunar Baedeker* [Highlands, N.C.: The Jargon Society, 1982]; Roger Conover, "Mina Loy's 'Colossus': Arthur Cravan Undressed," *Dada/Surrealism* 14 [1985], 102–19; reprtd. in Rudolf E. Kuenzli, ed., *New York Dada* [New York: Willis Locker & Owens, 1986]).

28. No Chaplin film by this title is known; Duchamp is probably referring to *Shoulder Arms,* a film released on 20 October 1918, wherein Chaplin plays an American soldier on the front (see David Robinson, *Chaplin: His Life and Art* [New York: McGraw-Hill, 1985], 241–45; 722–23).

29. Dr. Elmer Ernest Southard (1876–1920), director of the Boston Psychopathic Hospital, was one of Arensberg's old college friends from Harvard (see Frederick P. Gay, *The Open Mind: Elmer Ernest Southard* [Chicago: Normandie House, 1938]; on his friendship with Arensberg, see Naumann, "Cryptography and the Arensberg Circle," 128; 132, no. 16).

30. Beatrice Wood (b. 1893) had aspirations of someday working in films. Later, during the spring of 1920, several screen tests were taken of her by the noted American photographer Charles Sheeler (diary of Beatrice Wood, 1920–24, collection of the author), but the results were not considered successful.

31. The exhibition was entitled *The Evolution of French Art* and was held at the Arden Gallery from 29 April through 24 May 1919. Duchamp, who was mistakenly identified in the catalogue as "Marcelle Duchamb," was represented in the exhibition by three works, all three of which may have been selected from the Arensberg Collection: *Nude Descending a Staircase* (the hand-colored photographic version of 1916); *Combat de Boxe* of 1913; and an unidentified drawing entitled *The King and Queen.*

32. This letter was published in an English translation by Geoff Young ("A Letter from Marcel Duchamp to Walter & Lou Arensberg," *Work*, no. 1 (May 1975), n.p.).

33. The show was not so much an "officialization of Cubism" as it was an attempt to trace the evolution of modern French art from Ingres and Delacroix to Picasso and Braque (see the catalogue to this exhibition, and "French Art at Arden Galleries," *American Art News* 17, no. 30 [3 May 1919]).

34. Duchamp enclosed the chess schema reproduced at the close of this letter.

35. This notation was introduced in the nineteenth century by D. A. Gringmuth of St. Petersburg, replacing the Uedemann Code (by which name it is also known; see David Hooper and Kenneth Whyld, "Gringmuth Notation," *The Oxford Companion to Chess* [New York: Oxford University Press, 1984], 134–35).

36. *TNT*, dated March 1919, was edited by Man Ray and Adolf Wolff and contained, among other things, Walter Arensberg's prose poem "Vacuum Tires: A Formula for the Digestion of Figments," as well as a reproduction of Duchamp's drawing, *Combat de Boxe*, 1913 (for a reprint of this ephemeral publication, see *Dada/Surrealism* 14 [1985], 147–63; entire issue reprtd. in Rudolf E. Kuenzli, ed., *New York Dada* [New York: Willis Locker & Owens, 1986]).

37. Robert Carlton Brown (1886–1959) was one of the many young experimental poets of this period who contributed to Alfred Kreymborg's *Others* ([Grantwood, New Jersey] 1, no. 2 [August (?) 1915], 28–30), and provided a fascinating visual poem for Duchamp's *The Blind Man*, no. 2 (May 1917). Brown held interests in a gold mine in Argentina and a diamond mine in Brazil. In 1918 he married his second wife, Rose Johnston (d. 1952) in El Salvador, and in 1919 he established *The Brazilian American* in Rio de Janeiro (see "Brown, Robert Carlton," in *The National Cyclopedia of American Biography*, vol. 47 [New York: James T. White & Co., 1965], 597–98). The Rose Watson referred to by Duchamp was probably a mistaken recollection of Brown's wife's maiden name.

38. On Mina Loy and Arthur Cravan, see n. 27 above.

39. The Treaty of Versailles was signed on 28 June 1919.

40. In conversation with the author, 11 August 1976.

41. The precise date of the Arensbergs' departure for California is difficult to determine. From an undated letter to Katherine Dreier, which, on the basis of internal evidence, can be dated to the early summer of 1920, Duchamp mentions that "the Arensbergs [are] leaving N.Y. in August, probably for good"; (Papers of the Société Anonyme, Collection of American Literature, Beinecke Rare Book and Manuscript Library, Yale University, New Haven, Connecticut). During the early 1920s, the Arensbergs returned to New York periodically and only later would make the decision to move to California permanently.

42. This fragment of a letter from Duchamp to the Arensbergs was found in the files of Arturo Schwarz, who secured a copy from the Francis Bacon Library in the mid-1960s when he was preparing his monograph on Duchamp. At some later point, the original document was removed from the file of Duchamp correspondence preserved in the Francis Bacon Library, and it has never been recovered. The fragment has been assigned a date of ca. fall 1921, primarily on the basis of Duchamp's reference to the Crottis – with whom he resided during his stay in Paris – and his indication that the Lautréamont poems were "reedited last year" (the Breton edition was published in the spring of 1919; see n. 44 below).

43. Although Duchamp stayed with the Crottis at 22 rue la Condamine, he made occasional trips to his family's home in Rouen, which explains the return address provided at the close of this letter.

44. Le Comte de Lautréamont is the pseudonym of Isadore Ducasse (1846–1870), an obscure though highly influential French poet whose "Poésies" were discovered by André Breton and published in his magazine, *Littérature* (Parts I and II: nos. 2, 3 [April, May 1919], 2–13; 8–24).

45. Letter preserved in the Stettheimer Papers, dated "6 Juillet Environ" and postmarked 1921 (Collection of American Literature, Beinecke Library, Yale University, New Haven, Connecticut).

46. On 28 January 1922, Duchamp would sail for New York on the S. S. *Aquitania*.

47. In this period, Charles Sheeler (1883–1965), the Philadelphia-born painter and photographer, assisted Marius de Zayas in the operation of his gallery. He also served as a photographer for the Arensbergs, providing pictures of their apartment as well as individual works of art from their collection.

48. The film Duchamp refers to has never been found. In his autobiography, Man Ray explains that shortly after his arrival in Paris (during the summer of 1921), he and Duchamp went out to Jacques Villon's garden home in Puteaux in order to work on a film. He describes this film as one involving spirals, mounted on a bicycle wheel and set into motion (*Self Portrait* [New York: Andre Deutsch, 1963], 117). However, he goes on to identify this film as *Anémic Cinéma*, which was not shot until 1926.

49. It is interesting to note that Duchamp considered the *Large Glass* nearly finished. He would not sign it – in a state of intentional incompletion – until 1923.

50. This is probably the issue of *Littérature* referred to in the previous communication (see n. 44 above).

51. From the time of the First World War, Leonce Rosenberg's Galérie de L'Effort Moderne in Paris held exhibitions of the most important Cubist painters and sculptors. Through his writings about Cubism and his dealings with Cubist pictures, during the 1920s Rosenberg came to be known as the "official spokesman of Paris Cubists" (see J. F. Hanscom, "Cubism Howled from Paris Housetops," *New York Herald Tribune*, 14 June 1925, sec. 7, 3

52. Letter dated 23 May 1930 (Duchamp Folder #1, Arensberg Archives, Francis Bacon Library, Claremont, California).

53. The most extensive account of the Arensbergs and the numerous acquisitions they made after moving to California is provided in Naomi Helene Sawelson-Gorse, "'For the want of a nail': The Disposition of the Louise and Walter Arensberg Collection," unpublished master's thesis, University of California at Riverside, 1987.

Marcel Duchamp's
Des Délices de Kermoune
Jean-Hubert Martin

When asked if one fine day he decided to stop painting for good, Duchamp answered with a touch of amused indignation that his ceasing to paint should not be seen as stemming from any particular attitude or from any formal decision to do so. He confided that he had made only thirty-three paintings because he had had only thirty-three ideas for paintings.[1] Following his series of *Boîte-en-valise* (1941), most of his works (with the exception of *Etant donnés,* which he continued working on in secret) were commissions from publishers or works he made on special occasions. *Moonlight on the Bay at Basswood* is a "watercolor" landscape he is known to have made for his friends the Hubacheks while staying on their houseboat in August 1953. *Des Délices de Kermoune* (Fig. 1), a work of the same kind, was neither exhibited nor published until last year. It was reproduced for the first time in *Rrosopopées* along with an account of his life at the time by Jennifer Gough-Cooper and Jacques Caumont:

August 1958, Ste-Maxime. – The fortnight's holiday with Suzanne Crotti [Marcel's sister] is at an end. Before leaving the villa hidden in a fold of the hills above the town, Duchamp has put the fragile work entitled *Des Délices de Kermoune,* souvenir of his visit and a gift for the owners of the property, Claude and Bertrande Blancpain, in a grey cardboard box and has placed it safely inside the yellow linen cupboard, leaving instructions for his sister to alert Claude Blancpain.

The picture is, indeed, drawn directly from the place itself (Fig. 2): a small blue triangle of transparent watercolour evokes the gleam of water at the horizon visible from the terrace of the house, counter-point to the patches of dabbled earthcolours suggesting the tiled roofs partially masked by the dense vegetation; conjured by its very own needles, the extremities of which pierce the paper and are thus held firm in the characteristic outspread, upreaching form of the tree, an umbrella pine in the garden stands strident across the view to the sea.[2]

Duchamp placed the pine needles (in French *pin,* a homonym for *pain,* meaning bread) on an almost immaculate white (*blanc*) sheet of paper. He went further, placing his gift inside his hosts' linen cupboard (linen is called *"le blanc"* in French) thus celebrating his hosts, Mr. and Mrs. Blancpain.

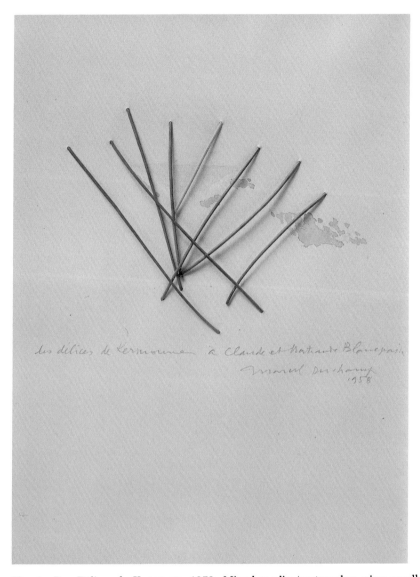

Fig. 1 *Des Délices de Kermoune,* 1958. Mixed media (watercolor, pine needles). Private collection.

Fig. 2　View from the terrace of the villa "Kermoune." Photograph by Jennifer Gough-Cooper and Jacques Caumont.

Notes

1.　*Rrosopopées* 16–17 (28 July 1987), 428.

2.　Ibid., p. 404. I would like to thank Jennifer Gough-Cooper and Jacques Caumont for kindly allowing me to use their research, and the owner of the work for permission to reproduce it here.

III. BIBLIOGRAPHY

Marcel Duchamp: A Selective Bibliography

The following was originally intended to be a comprehensive bibliography of Duchamp; in particular, the compiler had hoped to present a virtually all-inclusive listing of the secondary literature. However, as work proceeded, it became clear that such a comprehensive bibliography was no longer possible within the confines of an appendix to a larger publication. The production of books and articles on Duchamp has increased dramatically since 1968, having grown not only as a result of the re-evaluation of life and oeuvre which is to be expected after any artist's death, but also in response to developments unique to Duchamp. These developments include the surfacing of Duchamp's final masterpiece *Etant donnés* in 1969, the mounting of major retrospective exhibitions in 1974, 1977, and 1984, and Duchamp's emergence as the seminal influence on contemporary art since the 1960s. The result is that a comprehensive Duchamp bibliography would now require a separate publication. The compiler hopes that such a monograph will be the ultimate result of his work on this project. In the meantime, what follows is a selection which attempts to include the most useful publications for Duchamp scholars.

The first section lists separate publications by Duchamp. The first four items are collected editions of Duchamp's writings; these are followed by other monographic works by Duchamp, as well as books which Duchamp translated and periodicals which he edited. The next section is devoted to articles and parts of books by Duchamp which are not included in the English or French collected editions. The third section lists published interviews with Duchamp arranged by the name of the interviewer, or by title if the interviewer is anonymous. The next two sections are devoted to secondary literature on Duchamp: monographs, dissertations, and special issues of periodicals in the fourth section, journal articles and parts of books in the fifth. In most cases, an item is excluded from the article section if it has also been published in a collection of writings by the same author listed in the monograph section. The sixth and final section of the bibliography lists exhibition catalogs. For the most part, this chronological listing has been restricted to catalogs of one-man shows, or in a few instances, exhibitions devoted to two or three artists.

The present work is indebted to the published efforts of previous bibliographers. Particular mention should be made of the bibliographies by Bernard Karpel in *Marcel Duchamp* (ed. D'Harnoncourt and McShine, 1973), Robert Lebel in his *Marcel Duchamp* (1985), Alice Goldfarb Marquis in her *Marcel Duchamp: Eros c'est la vie* (1981), Olivier Micha and Jean Clair in Clair's *Marcel Duchamp: Catalogue raisonné* (1977), Yves Poupard-Lieussou

in *Marchand du sel* (1958), Michel Sanouillet and Elmer Peterson in *Duchamp du signe* (1975), and Arturo Schwarz in his *Complete Works of Marcel Duchamp* (1969). The compiler also wishes to acknowledge the invaluable assistance of Rudolf E. Kuenzli and June Fischer.

Timothy Shipe

Works by Duchamp – Separate Publications

Duchamp, Marcel. *Marchand du sel: Ecrits de Marcel Duchamp.* Ed. Michel Sanouillet. Paris: Terrain vague, 1959. All texts presented in the original language (French or English).

———. *Salt Seller: The Writings of Marcel Duchamp.* Ed. Michel Sanouillet and Elmer Peterson. New York: Oxford University Press, 1973; British ed: *The Essential Writings of Marcel Duchamp.* London: Thames and Hudson, 1975. English language edition of *Marchand du sel,* with the French texts translated.

———. *Duchamp du signe: Ecrits.* Ed. Michel Sanouillet. Paris: Flammarion, 1976. Revised edition of *Marchand du sel,* with the English texts translated into French.

———. *Die Schriften.* Transl. and ed. Serge Stauffer. Bd. 1. *Zu Lebzeiten veröffentlichte Texte.* Zurich: Regenbogen-Verlag, 1981. First of two projected volumes.

———. *A L'Infinitif.* New York: Cordier & Ekstrom, 1966.

———. *The Blindman.* Ed. Marcel Duchamp, Henri-Pierre Roché, and Beatrice Wood. New York: n.n., 1917. 2 numbers; no. 2 called *The Blind Man.*

———. *The Bride Stripped Bare by Her Bachelors, Even: A Typographic Version by Richard Hamilton of Marcel Duchamp's Green Box.* New York: Wittenborn, 1960.

Yale University Art Gallery. *The Collection of the Société Anonyme: Museum of Modern Art 1920.* Ed. Katherine S. Dreier and Marcel Duchamp. New Haven: Yale University Art Gallery, 1950. Includes numerous texts by Duchamp.

Znosko-Borovski, Evgenii Aleksandrovich. *Comment il faut commencer une partie d'échecs.* Original French version rewritten by Duchamp. Paris: Cahiers de L'Echiquier français, 1933; 3rd, expanded ed. Lille: Y. Demailly, 1946.

Duchamp, Marcel. *The Entire Musical Work of Marcel Duchamp.* N.p.: Multipla Records, 1976. Sound recording (phonograph record).

———. *From the Green Box.* Transl. George Heard Hamilton. New Haven: Readymade Press, 1957.

———. *Marcel Duchamp: Letters to Marcel Jean.* Munich: Silke Schreiber, 1987. [Letters in German, English, and French].

———. *Lettre de Marcel Duchamp à Tristan Tzara.* Alès: PAB, 1958.

———. *Manual of Instructions for "Etant Donnés."* Philadelphia: Philadelphia Museum of Art, 1987. Facsimile reproduction of Duchamp's notes.

———. *Marcel Duchamp, Notes.* Ed. Paul Matisse. Paris: Centre national d'art et de culture Georges Pompidou, 1980; U.S. ed.: Boston: G. K. Hall, 1983. French ed. includes color facsimiles of the notes; U.S. ed. includes new preface by Anne d'Harnoncourt. Both editions include original French texts and English transl.

———. *La Mariée mise à nu par ses célibataires, même.* Paris: Editions Rrose Sélavy, 1934. Known as the "Green Box."

New York Dada. Ed. Marcel Duchamp and Man Ray. New York: n.n., 1921; rpt. in: *The Dada Painters and Poets.* Ed. Robert Motherwell. 2nd ed. Boston: G. K. Hall, 1981. Pp. 214–18. Single number of a magazine.

Duchamp, Marcel. *Notes and Projects for the Large Glass.* Ed. Arturo Schwarz. New York: H. N. Abrams, 1969.

————, and Vitaly Halberstadt. *L'Opposition et les cases conjuguées sont réconciliées.* Paris: L'Echiquier, 1932.

————. *Possible.* Alès: PAB, 1958.

————. *Prière de coller.* Paris: L'Etoile scellée, 1953. Broadside.

————. *Quatre Inédits de Marcel Duchamp.* Alès: PAB, 1960.

Rongwrong. Ed. Marcel Duchamp, Henri-Pierre Roché, and Beatrice Wood. New York: n.n., 1917. Single number of a magazine.

Duchamp, Marcel. *Rrose Sélavy.* Paris: GLM, 1939.

————. *Texts.* Augustfehn, West Germany: Audio Edition Augustfehn, n.d. Sound recording (cassette) of Duchamp reading "The Creative Act" and selections from *A l'Infinitif.*

Works by Duchamp – Articles and Parts of Books

Duchamp, Marcel. "Affectueusement, Marcel: Ten Letters from Marchel Duchamp to Suzanne Duchamp and Jean Crotti." Ed. Francis Naumann. *Archives of American Art Journal,* 22, no. 4 (1982), 2–19.

————. "Briefwechsel mit Marcel Duchamp" = "Correspondance." In: Duchamp, Marcel. *Schriften.* Transl. and ed. Serge Stauffer. Zurich: Regenbogen-Verlag, 1981. Vol. 1, pp. 251–78. Letters to and from Serge Stauffer, in French, with German translations.

————. "Combat de boxe." *TNT,* 1919; rpt. in: *Marcel Duchamp.* Ed. Anne d'Harnoncourt and Kynaston McShine. New York: Museum of Modern Art, 1973. P. 267.

————. "Confidences." In: *Huit Peintres, deux sculpteurs et un musicien très modernes.* Caricatures by Georges de Zayas; text by by Curnonsky. Paris: n.n., 1919. Duchamp's reply to an inquiry.

Tzara, Tristan. "Dada vs. Art." Transl. Duchamp. In: *Dada 1916–1923.* New York: Sidney Janis, 1953.

————. "Eye-Cover Art-Cover Corset-Cover Authorization." Transl. Duchamp. *New York Dada,* April 1921.

Duchamp, Marcel. [Four letters, 1922–23, to Francis Picabia]. In: Sanouillet, Michel. *Dada à Paris.* Paris: Pauvert, 1965. Pp. 552–53.

"L'Homme qui a perdu son squelette: Roman." *Plastique,* no. 4 (1939), 2–6; no. 5 (1939), 2–9. Collaborative novel by Arp, Duchamp, Eluard, Ernst, Hugnet, Pastoureau, Prassinos, et al. Schwarz reports that Duchamp denied any part in this work.

Duchamp, Marcel. "Hundert Fragen an M. Duchamp" = "Cent Questions." In: Duchamp, Marcel. *Schriften.* Transl. and ed. Serge Stauffer. Zurich: Regenbogen-Verlag, 1981. Vol. 1, Pp. 279–96. Reply to questions from Stauffer, in French, with German translations.

Arp, Jean. ["I comply with your desire"]. Transl. Duchamp. In *Dada 1916–1923.* New York: Sidney Janis, 1953.

Tzara, Tristan. "Kurt Schwitters, 1887-1948." Transl. Duchamp. In: *Sidney Janis Presents an Exhibition of Collage, Painting, Relief & Sculpture by Schwitters.* Chicago: Arts Club of Chicago, 1952.

Duchamp, Marcel. [Letter, 1947, to Pierre de Massot]. In: *Poésie-prose, peintres graveurs de notre temps, éditions rares, revues.* Paris: Librairie Nicaise, 1964. P. 100.

————. [Letter, 11 July 1967, to Jan Van der Marck]. *S.M.S.,* no. 1 (February 1968).

————. "Une Lettre de Marcel Duchamp." *Medium,* n.s. no. 4 (January 1955), 33. Letter to André Breton, dated 4 October 1954.

————· "Marcel Duchamp à Victor Brauner." In: *La Planète affolée: Surréalisme, dispersion et influences, 1938-1947.* Paris: Flammarion; Marseille: Musées de Marseille, 1986. P. 57. Letter dated 9 May 1942.

————. ["Oh! Crever un abcès au pus lent."]. *Littérature,* n.s. no. 5 (1 October 1922), 13.

————, and Vitaly Halberstadt. "Un Plagio." *L'Echiquier* (Brussels), ser. 2, vol. 4 (September-October 1932), 1810. Letter to the editor, in response to an article of the same title in *Italia scacchistica,* September 1932.

————. [Résumé]. In: *Marcel Duchamp: Das graphische Werk.* Winterthur: Kunstmuseum Winterthur, 1987. Facsimile of a typed biographical questionnaire from Hans Bolliger, with holograph answers by Duchamp, dated 14 July 1950.

Stein, Gertrude. "Stanza 69 from the 'Stanzas of Meditation'" = "Stance 69 des 'Stances de méditation.'" *Orbes,* no. 4 (Winter 1932-33), 64-67. Poem in English, with French transl. by Duchamp. Appeared as preface to catalog of "Exposition de dessins Francis Picabia," December 1932, Léone Rosenberg Gallery, Paris.

Duchamp, Marcel. "Toir." In: *Le Memento universel Da Costa.* Fasc. 2. Paris: Jean Aubier, 1949. P. 16.

————. ["Walter Conrad Arensberg n'a pas encore découvert ce mat"]. *Dada,* no. 6 (*Bulletin Dada*), February 1920.

"The Western Round Table on Modern Art." In: *Modern Artists in America.* First series. New York: Wittenborn Schultz, 1951. Pp. 24-37. Excerpts from the proceedings of a conference held in San Francisco, April 1950. Duchamp was among the participants.

Duchamp, Marcel "Where Do We Go from Here?" *Studio International,* 189 (January-February 1975), 28. Text from a symposium at the Philadelphia Museum College of Art, March 1961. Facsimile of Duchamp's French manuscript, with English translation.

Interviews with Duchamp

"Art Was a Dream." *Newsweek,* 54, no. 19 (9 November 1959), 119-19. Interview with Duchamp, and review of *Marcel Duchamp,* by Robert Lebel.

Ashford, Barbara. "Artists Can't Shock People Today, Marcel Duchamp Says." *Evening Bulletin* (Philadelphia), 10 May 1961, p. 56.

Ashton, Dore. "Interview with Marcel Duchamp." *Studio International,* 171 (June 1966), 244-47.

Bakewell, Joan. "Marcel Duchamp Interviewed by Joan Bakewell, BBC TV 1968." In: *Max Ernst Documentary + Marcel Duchamps* [sic] *Interview.* The Experimental Film Compilation Series, v. 8. New York: New York Film Annex, n.d. Videocassette.

Brady, Frank R. "Duchamp, Art and Chess." *Chess Life,* no. 6 (June 1961), 168–69.

Bright, Barbara. "Geniuslike Artist Has World Against Him, Says Duchamp." *Atlanta Constitution,* 13 April 1960, p. 22.

Cabanne, Pierre. *Entretiens avec Marcel Duchamp.* Paris: Belfond, 1967; rpt. in 1977 as *Ingénieur du temps perdu.* English version: *Dialogues with Marcel Duchamp.* Transl. Ron Padgett. New York: Viking Press, 1971.

"A Complete Reversal of Art Opinions by Marcel Duchamp, Iconoclast." *Arts and Decoration,* September 1915, pp. 427–28, 442; rpt. in *Studio International,* 189 (January–February 1975), 29.

Crehan, Herbert. "Dada." *Evidence,* no. 3 (Fall 1961), 36–38.

D., P. "Duchamp dévoile le cheval majeur." *Tribune de Lausanne,* 3 July 1966.

Deron, Jean-Paul. "Conversation avec Marcel Duchamp: 'Ce qui n'est pas insolite tombe dans l'oubli.'" *Paris-Normandie,* 13 June 1967, pp. 1, 11.

Eglington, Laurie. "Marcel Duchamp, Back in America, Gives Interview." *Art News,* 32 (18 November 1933), 3, 11.

Flemming, H. Th. "Immer spielt Magie hinein: Interview mit Marcel Duchamp." *Die Welt,* 18 October 1965, p. 7.

Glueck, Grace. "Duchamp Parries Artful Questions: At Show of Brother's Work, He Ranges Far Afield." *New York Times,* 26 October 1967, p. 37. Report of a news conference.

Goldaine, Louis, and Pierre Astier. "Marcel Duchamp." In their *Ces Peintres vous parlent.* Paris: Editions du temps, 1964. Pp. 46–48.

Greeley-Smith, Nixola. "Cubist Art Depicts Love in Brass and Glass: 'More Art in Rubbers Than in Pretty Girl.'" *Evening World* (New York), 4 April 1916, p. 3; rpt. in: *New York Dada.* Ed. Rudolf E. Kuenzli. New York: Willis Locker & Owens, 1986. Pp. 135–37.

Hahn, Otto, "Entretien: Marcel Duchamp." *Express* (Paris), no. 684 (23 July 1964), 22–23.

———. "Marcel Duchamp." *VH 101,* no. 3 (Autumn 1970), 55–61.

———. "Passport No. G255300." *Art and Artists,* 1, no. 4 (July 1966), 7–11. Transl. by Andrew Rabeneck.

Hamilton, Richard and George Heard. *Marcel Duchamp: An Interview by Richard Hamilton in London and George Heard Hamilton in New York.* London: Audio Arts, 1975. Sound recording (cassette).

Jouffroy, Alain. "Conversations avec Marcel Duchamp." In his *Une Révolution du regard: A Propos de quelques peintres et sculpteurs contemporains.* Paris: Gallimard, 1964. Pp. 107–24.

———. "Marcel Duchamp: L'Idée de jugement devrait disparaître." *Arts-spectacles,* no. 491 (24–30 November 1954), 13.

———. "Marcel Duchamp nous déclare, 'Il n'est pas certain que je revienne à la peinture.'" *Arts* (Paris), no. 694 (29 October–4 November 1958), 12.

Kreymborg, Alfred. "Why Marcel Duchamps [sic] Calls Hash a Picture." *Boston Evening Transcript,* 18 September 1915, sec. 3, p. 12.

Kuh, Katherine. "Marcel Duchamp." In her *The Artist's Voice: Talks with Seventeen Artists.* New York: Harper & Row, 1962.

Linde, Ulf. "Samtal med Marcel Duchamp." *Dagens Nyheter* (Stockholm), 10 September 1961.

"Marcel Duchamp." *New Yorker*, 6 April 1957, pp. 25-27.

The Marcel Duchamp Interview. Los Angeles: Pacifica Radio Archive, 1986. Sound recording (cassette).

Millier, Arthur. "Painter Hits Art Theory: French Artist Visits City: Marcel Duchamp Views His 'Nude Descending the Stair' in Hollywood Home." *Los Angeles Times*, 16 August 1936.

Norman, Dorothy. "Interview by Dorothy Norman." *Art in America*, 57 (July–August 1969), 38.

———. "Two Conversations: Marcel Duchamp and Tristan Tzara." *Yale University Literary Gazette*, 60, nos. 1-2 (October 1985), 77-80.

"The 'Nude Descending a Staircase' Man Surveys Us." *New York Tribune*, 12 September 1915, sec. 4, p. 2. Interview.

Parinaud, André. "Duchamp raconte Breton." *Arts-Loisirs*, no. 54 (5 October 1966), 5-7.

Rivière, Claude. "Marcel Duchamp devant le pop'art: C'est l'Ennui qui préside actuellement." *Combat* (Paris), 8 September 1966, p. 9.

Roberts, Colette. "Interview by Colette Roberts." *Art in America*, 57 (July–August 1969), 39.

Roberts, Francis. "I Propose to Strain the Laws of Physics." *Art News*, 67 (December 1968), 46-47.

Russell, John. "Exile at Large: Interview." *Sunday Times* (London), 9 June 1968, p. 54.

Sanouillet, Michel. "Dans l'atelier de Marcel Duchamp." *Les Nouvelles littéraires*, 16 December 1964, p. 5.

Schonberg, Harold C. "Creator of 'Nude Descending' Reflects after Half a Century: Marcel Duchamp, at 76, Recalls Days of Original Armory Show between Moves of a Chess Game." *New York Times*, 12 April 1963, p. 25.

Schuster, Jean. "Marcel Duchamp, vite." *Le Surréalisme, même*, no. 2 (Spring 1957), 143-45; rpt. in his *Archives 57/68: Batailles pour le surréalisme*. Paris: Losfeld, 1969. Pp. 7-10.

Seitz, William. "What's Happened to Art?: An Interview with Marcel Duchamp on the Present Consequences of New York's 1913 Armory Show." *Vogue*, 141 (15 February 1963), 110-13, 129-31.

Siegel, Jeanne. "Some Late Thoughts of Marcel Duchamp, from an Interview with Jeanne Siegel." *Arts Magazine*, 43 (December 1968–January 1969), 21-22; rpt. in her *Artwords: Discourse on the 60s and 70s*. Ann Arbor: UMI Research Press, 1985. Pp. 15-21.

Stauffer, Serge. "Du Coq à l'ane mit Marcel Duchamp." In: Duchamp, Marcel. *Die Schriften.* Transl. and ed. Serge Stauffer. Zurich: Regenbogen-Verlag, 1981. Vol. 1, pp. 299-305. Report of a 1960 interview.

Steegmuller, Francis. "Duchamp, Fifty Years Later." *Show*, February 1963, pp. 28-29.

Sweeney, James Johnson. "Marcel Duchamp." In: *Wisdom: Conversations with the Elder Wise Men of Our Day.* Ed. James Nelson. New York: Norton, 1958; rpt. as "Interview with Marcel Duchamp" in: *Dadas on Art*. Ed. Lucy Lippard. Englewood Cliffs, N.J.: Prentice-Hall, 1971. Pp. 141-42.

Tharrats, Juan Josep. "El Arte como necessidad: Coloquio con Marcel Duchamp." *Revista* (Spain), February 1959.

———. "Marcel Duchamp." *Art actuel international*, no. 6 (1958), 1.

Secondary Literature – Monographs, Special Numbers of Periodicals, and Dissertations

Adcock, Craig. *Marcel Duchamp's Notes from the "Large Glass": An N-Dimensional Analysis.* Studies in the Fine Arts. Avant-garde, no. 40. Ann Arbor: UMI Research Press, 1983.

Alexandrian, Sarane. *Marcel Duchamp.* Tr. Alice Sachs. New York: Crown, 1977.

Art and Artists, 1, no. 4 (July 1966). Special Number.

Bailly, Jean Christophe. *Marcel Duchamp.* Paris: F. Hazan, 1984; English transl. by Jane Brenton. London: Art Data, 1986.

Baruchello, Gianfranco, and Henry Martin. *How to Imagine: A Narrative on Art and Agriculture.* New Paltz, N.Y.: McPherson, 1983.

———. *Why Duchamp: An Essay on Aesthetic Impact.* New Paltz, N.Y.: McPherson, 1985.

Bohan, Ruth L. *The Société Anonyme's Brooklyn Exhibition: Katherine S. Dreier and Modernism in America.* Ann Arbor: UMI Research Press, 1982.

Bonito Oliva, Achille. *Vita di Marcel Duchamp.* Rome: M. Marani, 1976.

Burnham, Jack. *Great Western Salt Works: Essays on the Meaning of Post-Formalist Art.* New York: Braziller, 1974.

Cabanne, Pierre. *Les 3 Duchamp: Jacques Villon, Raymond Duchamp-Villon, Marcel Duchamp.* Neuchâtel: Editions Ides et calendes, 1975. English version: *The Brothers Duchamp.* Transl. Helga and Dinah Harrison. Boston: New York Graphic Society, 1976.

Calligaris, Contardo. *Il Quadro e la cornice: Courbet, Manet, Degas, Magritte, Duchamp: Per una Critica della rappresentazione.* Bari: Dedalo libri, 1975.

Calvesi, Maurizio. *Duchamp invisibile: La Construzione del simbolo.* Rome: Officina, 1975.

Clair, Jean. *Marcel Duchamp: Catalogue raisonné.* Paris: Musée national d'art moderne, Centre national d'art et de culture Georges Pompidou, 1977. Published in connection with the 1977 exhibition.

———. *Duchamp et la photographie: Essai d'analyse d'un primat technique sur le développement d'un oeuvre.* Paris: Chêne, 1977.

———. *Marcel Duchamp, ou, Le Grand Fictif: Essai de mythanalyse du "Grand Verre."* Paris: Galilee, 1975.

Costa, Mario. *Sulle Funzioni della critica d'arte e una messa a punto a proposito di Marcel Duchamp.* Torre Annunziata: M. Ricciardi, 1976.

d'Harnoncourt, Anne, and Walter Hopps. *"Etant Donnés: 1° La Chute d'eau, 2° Le Gaz d'éclairage": Reflections on a New Work by Marcel Duchamp.* Philadelphia: Philadelphia Museum of Art, 1987. [Reprint of 1969 essay with additional material].

Dossier Marcel Duchamp: "La Pendule de profile." Ed. Blandine Chavanne. Poitiers: Musée Sainte Croix, 1982. Published in conjunction with an exhibition of "La Pendule de profile" and related works.

Dreier, Katherine, and Matta Echaurren. *Duchamp's Glass, "La Mariée mis à nu par ces célibataires, même": An Analytical Reflection.* New York: Société Anonyme, Inc., 1944. Rpt. in: *Société Anonyme (The First Museum of Modern Art [1920–1944]: Selected Publications.)* New York: Arno Press, 1972; also rpt. in *Marcel Duchamp in Perspective.* Ed. Joseph Masheck. Englewood Cliffs, N.J.: Prentice-Hall, 1975. Pp. 107–09.

Duboy, Philippe. *Lequeu: An Architectural Enigma*. Transl. Francis Scarfe. Cambridge, Mass.: MIT Press, 1987.

"Duchamp et après." *Opus International,* no. 49 (March 1974). Special Number.

Duve, Thierry de. *Nominalisme pictural: Marcel Duchamp, la peinture et la modernité.* Paris: Editions de Minuit, 1984.

Gervais, André. *La Raie alitée d'effets: Apropos of Marcel Duchamp.* Ville La Salle, Québec: Editions Hurtubise, 1984.

Golding, John. *Marcel Duchamp: "The Bride Stripped Bare by Her Bachelors, Even."* New York: Viking, 1973.

Gough-Cooper, Jennifer, and Jacques Caumont. *Plan pour écrire une vie de Marcel Duchamp.* Paris: Centre national d'art et de culture Georges Pompidou, Musée national d'art moderne, 1977. Published in connection with the 1977 exhibition.

————. *La Vie illustrée de Marcel Duchamp.* Paris: Centre national d'art et de culture Georges Pompidou, 1977.

Hamilton, Richard. *The Bride Stripped Bare by Her Bachelors Even, Again: A Reconstruction by Richard Hamilton of Marcel Duchamp's Large Glass.* Newcastle-upon Tyne: Dept. of Fine Art, University of Newcastle-upon-Tyne, 1966; text rpt. in his *Collected Words, 1953–1982.* London: Thames and Hudson, [1982?]. Pp. 210–15.

Hassold, Chris. "The Possibilities of Chance: A Comparative Study of Stéphane Mallarmé and Marcel Duchamp." Diss. Florida State University, 1972.

Henderson, Brian. "Radical Poetics: Dada, bp Nichol, and the Horsemen." Diss. York University, 1982.

Henderson, Linda Dalrymple. *The Fourth Dimension and Non-Euclidian Geometry in Modern Art.* Princeton: Princeton University Press, 1983.

Hommage à Marcel Duchamp. Alès: PAB, 1969. Untitled texts by Man Ray, Gabrielle Buffet-Picabia, Pierre de Massot, Robert Lebel, and Alexander Calder.

Hugnet, Georges. *Marcel Duchamp.* Paris: n.n., 1941. Poem.

Hussakowska-Szyszko, Maria. *Spadkobiercy Duchampa?: Negacja Sztuki w Amerykańskim Artystycznum.* Krakow: Wydawn. Literackie, 1984.

Idea and Image in Recent Art. Chicago: Art Institute of Chicago, 1974. Catalog of an exhibition illustrating Duchamp's significance in relation to contemporary art.

James, Carol Lee Plyley. "The Writings of Marcel Duchamp in the Development of His Poetics." Diss. University of Minnesota, 1978.

Jones, Ronald Warren. "Temporal Metaphors: Samuel Beckett's *Endgame* and Marcel Duchamp's 'Door, 11 rue Larrey.'" Diss. Ohio University, 1981.

Koch, Stephen. *The Bachelor's Bride: A Novel.* New York: M. Boyars, 1986. Fictional text concerning a Duchamp scholar.

Kubota, Shigeko. *Marcel Duchamp and John Cage.* N.p.: Takeyoshi Miyazawa, 1968. Documentation of an event at the Ryerson Theatre, Toronto, 5 March 1968.

Lebel, Robert. *Sur Marcel Duchamp.* With additional texts by André Breton and Henri-Pierre Roché. Paris: Trianon, 1959; rpt. with revisions and additions, but without the texts by Breton and Roché, in his *Marcel Duchamp.* Paris: Belfond, 1985. Pp. 11–133; English trans. under the title *Marcel Duchamp.* New York: Grove Press, 1959; rpt. New York: Paragraphic Books, 1967.

Linde, Ulf. *Marcel Duchamp.* Stockholm: Galerie Buren, 1963.

Lyotard, Jean-François. *Les Transformateurs Duchamp.* Paris: Editions Galilée, 1977.

Marcel Duchamp. Ed. Anne d'Harnoncourt and Kynaston McShine. New York: Museum of Modern Art, 1973.

"Marcel Duchamp." Special number of *L'Arc*, no. 59 (1974).

Marcel Duchamp: Abécédaire: Approches critiques. Ed. Jean Clair. Paris: Musée national d'art moderne, Centre national d'art et de culture Georges Pompidou, 1977. Published in connection with the 1977 exhibition.

Marcel Duchamp: July 28, 1887–October 2, 1968. Philadelphia: Philadelphia Museum of Art, 1973. Collection of facsimiles of newspaper articles, prepared in connection with the exhibition in Philadelphia and New York.

Marcel Duchamp: Tradition de la rupture ou rupture de la tradition? Ed. Jean Clair. Paris: Union générale d'éditions, 1977. Papers from the Colloque de Cerisy, 25 July–1 August 1977.

"Marcel Duchamp, 1887–1968." *Art in America*, vol. 57, no. 4 (July–August 1969). Special number.

Marcel Duchamp in Perspective. Ed. Joseph Masheck. Englewood Cliffs, N.J.: Prentice-Hall, 1975.

"Marcel Duchamp Number." *View*, ser. 5, no. 1 (March 1945).

Marquis, Alice Goldfarb. *Marcel Duchamp: Eros, c'est la vie: A Biography*. Troy, N.Y.: Whitston, 1981.

Massot, Pierre de. *Reflections on Rrose Sélavy*. Paris: Impr. Ravilly, 1924. Includes introduction and untitled poem by Duchamp. Remaining pages are blank except for headings for months of the year. Title on cover: *The Wonderful Book*.

Mezei, Ottó. *Duchamp: 1887–1968*. Budapest: Corvina Kiadó, 1970.

Migliorini, Ermanno. *Lo Scolabottiglie di Duchamp*. Florence: Fiorino, 1970.

Molderings, Herbert. *Marcel Duchamp: Parawissenschaft, das Ephemere und der Skeptizismus*. Frankfurt am Main: Qumran, 1983; rev. 1987.

Mulas, Ugo. *Marcel Duchamp: Dieci Fotografie*. Milan: Multicenter, 1972. Photographs of Duchamp by Mulas.

Naumann, Francis M. *The Mary and William Sisler Collection*. New York: Museum of Modern Art, 1984.

Paz, Octavio. *Apariencia desnuda: La Obra de Marcel Duchamp*. Mexico City: Ediciones Era, 1973. A combined edition of 2 previously published works: (1) *Marcel Duchamp, o, El Castillo de la pureza*. Mexico City: Ediciones Era, 1968. (2) "* Water Always Writes in Plural *." Originally published in English in: *Marcel Duchamp: A Retrospective Exhibition*. Philadelphia: Philadelphia Museum of Art, 1973.

———. *Marcel Duchamp: Appearance Stripped Bare*. Transl. Rachel Phillips. New York: Viking Press, 1978. Translation of *Apariencia desnuda*.

———. *Marcel Duchamp, or, The Castle of Purity*. Transl. Donald Gardner. London: Cape Goliard, 1970. Translation of *Marcel Duchamp, o, El Castillo de la pureza*.

Roché, Henri Pierre. *Victor: (Marcel Duchamp): Roman*. Text established by Danielle Régnier-Bohler; prefaces and notes by Jean Clair. Paris: Musée national d'art moderne, Centre national d'art et de culture Georges Pompidou, 1977. Fictional text, published in connection with the 1977 exhibition.

Rohsmann, Arnulf. *Manifestationsmöglichkeiten von Zeit in der bildenden Kunst des 20. Jahrhunderts*. Hildesheim: G. Olms, 1984.

Roth, Moira. "Marcel Duchamp and America, 1913–1974." Diss. University of California at Berkeley, 1974.

Rrose Sélavy. *Rrose Sélavy à Paris le 28 octobre 1941.* Montreal: Editions de la pleine lune, 1984. "Rrose Sélavy" is the collective pseudonym of 14 writers working in Montreal. Fictional text.

Samaltanos, Katia. *Apollinaire, Catalyst for Primitivism, Picabia, and Duchamp.* Ann Arbor: UMI Research Press, 1984.

Sawelson-Gorse, Naomi Helene. "'For the want of a nail': The Disposition of the Louise and Walter Arensberg Collection." M.A. Thesis, University of California at Riverside, 1987.

Schwarz, Arturo. *The Complete Works of Marcel Duchamp.* New York: H. N. Abrams, 1969.

———. *The Large Glass and Related Works.* Milan: Galleria Schwarz, 1967. Etchings by Duchamp, text by Schwarz.

———. *Marcel Duchamp.* Milano: Fabbri, 1966.

———. *Marcel Duchamp.* New York: H. N. Abrams, 1970.

Smith, Kim Clifton. "Semiotic Theory and the Epistemological Basis for Marcel Duchamp's Approach to Art." Diss. Brown University, 1970.

Spate, Virginia. *Orphism: The Evolution of Non-Figurative Painting in Paris 1910–1914.* Oxford: Oxford University Press, 1979.

Steefel, Lawrence D., Jr. *The Position of Duchamp's 'Glass' in the Development of His Art.* New York: Garland, 1977.

Su Marcel Duchamp. Naples: Framart, 1975. Published for the exhibition held 22 November 1975 to 28 January 1976.

Suquet, Jean. *Le Guéridon et la virgule.* Paris: Christian Bourgois, 1976. On the "Large Glass."

———. *Miroir de la mariée: Essai.* Paris: Flammarion, 1975. On the "Large Glass."

Tabu Dada: Jean Crotti & Suzanne Duchamp, 1915–1922. Ed. William A. Camfield and Jean-Hubert Martin. Bern: Kunsthalle Bern, 1983.

Takiguchi, Shuzo. *Maruseru Dyushan goruku.* Tokyo: Bijutsu Shuppansha, 1982.

Thenot, Jean-Paul. *Cent Lectures de Marcel Duchamp: visualisation d'une sociologique réalisée en 1974.* Crisnée, Belgium: Yellow Now, 1978.

Tomkins, Calvin. *The World of Marcel Duchamp, 1887–1968.* Alexandria, Va.: Time-Life Books, 1977.

Tono, Yoshiaki. *Maruseru Dyushan.* Tokyo: Bijutsu Shuppansha, 1977.

Wendt, Wolf Raine. *Ready-made: Das Problem und der philosophische Begriff des ästhetischen Verhaltens, dargestellt an Marcel Duchamp.* Meisenheim am Glan: A. Hain, 1970.

Wood, Beatrice. *I Shock Myself: The Autobiography of Beatrice Wood.* Ojai, Calif.: Dillingham Press, 1985.

Yale University Art Gallery. *The Société Anonyme and the Dreier Bequest.* New Haven: Published for the Yale University Art Gallery by Yale University Press, 1984.

Zaunschirm, Thomas. *Bereites Mädchen Ready-made.* Klagenfurt: Ritter, 1983.

———. *100 Jahre Marcel Duchamp.* Klagenfurt: Ritter, 1987. Boxed set containing the author's 3 monographs on Duchamp.

———. *Marcel Duchamps unbekanntes Meisterwerk.* Klagenfurt: Ritter, 1986.

———. *Robert Musil und Marcel Duchamp.* Klagenfurt: Ritter, 1982.

Secondary Literature – Articles and Parts of Books

Accame, Vincenzo. "Schwarz-Duchamp." *Le Arti* (Milan), January 1975, pp. 11–19.

Adcock, Craig. E. "Conventionalism in Henri Poincaré and Marcel Duchamp." *Arts Journal*, 44, no. 3 (Fall 1984), 249–58.

———. "Geometrical Complications in the Art of Marcel Duchamp." *Arts Magazine*, 58, (January 1984), 105–09.

———. "Marcel Duchamp's Approach to New York: 'Find an Inscription for the Woolworth Building as a Ready-made.'" *Dada/Surrealism*, no. 14 (1985), 52–65.

———. "Why Marcel Duchamp's Old Hat Still Addresses the Situation to the Nines." *Arts Magazine*, 59, no. 7 (March 1985), 72–77.

Ades, Dawn. "Duchamp, Dada and Surrealism." In *Duchamp*. Barcelona: Fundación Caja de Pensiones, 1984. Pp. 38–51.

———. "Marcel Duchamp's Portable Museum" In: *Marcel Duchamp's Travelling Box.* N.p.: Arts Council of Great Britain, 1982. On the "Boîte en valise."

Aiken, Edward Anselm. "Marcel Duchamp and the Metaphor of the Arcane Pornographic Film." In his "Studies in the Motion Picture and 20th Century Art, 1909–1930." Diss. Northwestern University, 1981.

Amaya, Mario. "Son of the Bride Stripped Bare." *Art and Artists*, 1, no. 4 (July 1966), 22–28.

Antin, David. "Duchamp: The Meal and the Remainder." *Art News*, 71, no. 6 (October 1972), 68–71.

———. "Duchamp and Language." In *Marcel Duchamp*. Ed. Anne d'Harnoncourt and Kynaston McShine. New York: Museum of Modern Art, 1973. Pp. 99–115.

Apollinaire, Guillaume. "Marcel Duchamp." In his *Les Peintres cubistes*. 1913; rpt. Paris: Hermann, 1965. Pp. 90–92; English trans. rpt. in: *Marcel Duchamp in Perspective*. Ed. Joseph Masheck. Englewood Cliffs, N.J.: Prentice-Hall, 1975. Pp. 25–26.

Aragon, Louis. "Lautréamont et nous. II. Les 'Poésies' voient le jour." *Les Lettres françaises*, 8 June 1967, 3–9. On "LHOOQ."

Ashton, Dore. "Marcel Duchamp, bricoleur de génie." *Vingtième Siècle*, n.s. no. 25 (June 1965), 97–99, suppl. Pp. 27–30.

Balas, Edith. "Brancusi, Duchamp and Dada." *Gazette des beaux-arts*, 95, no. 1335 (April 1980), 165–74.

Baldwin, Claude-Marie. "Myth in Butor's *Passage de Milan:* Works of Mondrian and Duchamp as Generators of the Text." *Perspectives on Contemporary Literature*, 13 (1987), 18–23.

Barozzi, Paolo. "La Distanza metafisica di Marcel Duchamp." *Communità*, no. 149–49 (1967), 69–72.

Bartel, Timothy W. "Appreciation and Dickie's Definition of Art." *British Journal of Aesthetics*, 19, no. 1 (Winter 1979), 44–52. On "Fountain."

Baruchello, Gianfranco. "Una Vita segreta una fine discreta." *Percorsi*, April 1981, Pp. 24–27.

Bauer, George H. "Duchamp, Delay and Overlay." *Mid-America*, 60 (April 1978), suppl. Pp. 63–68. On "LHOOQ."

———. "Enamouring a Barber Pole." *Dada/Surrealism*, no. 12 (1983), 20–36. On "Apolinère Enameled."

———. "La Jolie Roussel brisée: Les Vairs du chants." *Mélusine*, no. 6 (1984), 179–87.

Beeren, W. A. L. "Marcel Duchamp." *Museumjournaal*, 10 (1964–65), 85–90. Review of exhibition in Eindhoven.

Beier, Lucia. "Time Machine: A Bergsonian Approach to 'The Large Glass.'" *Gazette des beaux-arts*, series 6, vol. 88 (November 1976), 194–200.

Bensimon, Marc. "Marcel Duchamp: 'Le Grand Verre': Critique manifeste." In: *Le Manifeste et le caché: Langages surréalistes et autres*. Ed. Mary Ann Caws. Paris: Lettres modernes, 1974. Pp. 169–79.

Bill, Max. "Max Bill on Duchamp." *Studio International*, 189 (January–February 1975), 26–27.

———. "Zu Marcel Duchamp." In: *Dokumentation über Marcel Duchamp*. Zurich: Kunstgewerbemuseum, 1960. Pp. 5–11.

Binkley, Timothy. "Piece: Contra Aesthetics." *Journal of Aesthetics and Art Criticism*, 35, no. 3 (Spring 1977), 265–77. On "LHOOQ."

Bloch, Susi. "Marcel Duchamp's *Green Box*. *Art Journal*, 34, no. 1 (Fall 1974), 25–29.

Bohan, Ruth L. "Joseph Stella's 'Man in Elevated (Train)." In: *Dada/Dimensions*. Ed. Stephen C. Foster. Ann Arbor: UMI Research Press, 1985. Pp. 187–219. On the "Large Glass."

Bois, Yves-Alain. "La Marié nue: Du nouveau sur Marcel Duchamp." *VH 101*, no. 3 (Autumn 1970), 62–69.

Bonito Oliva, Achille. "Comportements alternatifs de l'art à Rome." *Opus International*, no. 53 (November–December 1974), 26–29.

———. "La Delicata Scacchiera" = "The Delicate Chess-Board." *Humus*, 1, no. 2–3 (October 1973), 5–10.

———. "Su una Messa in posa di Marcel Duchamp" = "On the Posing of Marcel Duchamp." In: *Su Marcel Duchamp*. Naples: Framart, 1975. Pp. 51–56.

Bonk, Ecke, "Der moderne Künstler steht an der Reling eines Übersee-Liners und hat in seinem Koffer einige Exemplare der neuesten Kunstzeitschriften." *Tumult*, no. 7 (January 1985), 130–40.

Boullier, Renée. "Marcel Duchamp au Centre Beaubourg." *Nouvelle Revue Française*, no. 292 (April 1977,) 123–25.

Breton, André. "Marcel Duchamp." *Littérature*, n.s. no. 5 (1 October 1922), 7–10; rpt. in his *Les Pas perdus*. Paris: Gallimard, 1933. Pp. 141–46; transl in: *The Dada Painters and Poets: An Anthology*. Ed. Robert Motherwell. 2nd ed. Boston: G.K. Hall, 1981. Pp. 207–11.

———. "Par Infra-mince." *Medium*, n.s. no. 1 (November 1953), 15.

———. "Phare de la marié." In: Lebel, Robert. *Sur Marcel Duchamp*. Paris: Trianon, 1959; English transl. under title "Lighthouse of the Bride." *View*, series 5, no. 1, March 1945, Pp. 6–9, 13.

———. "Testimony 45." *View*, series 5, no. 1 (March 1945), 5.

Bryars, Gavin. "Notes on Marcel Duchamp's Music." *Studio International*, 192 (November 1976), 274–79.

Buffet-Picabia, Gabrielle. "Coeurs volants." *Cahiers d'art*, 11, no. 1–2 (1936), 34–43. Rpt. in her *Aires abstraits*. Geneva: P. Cailler, 1957.

———. "Dada et l'esprit Dada." *Preuves*, 2, no. 11 (January 1952), 46–47.

————. "L'Epoque 'pré-Dada' à New York." In her *Aires abstraites*. Geneva: P. Cailler, 1957. Pp. 152-67. Trans. as "Some Memories of Pre-Dada: Picabia and Duchamp" In: *The Dada Painters and Poets*. Ed. Robert Motherwell. 2nd ed. Boston: G. K. Hall, 1981. Pp. 255-67.

————. "Magic Circles." *View*, series 5, no. 1 (March 195), 14-16, 23.

————. "Marcel Duchamp." In her *Recontres avec Picabia, Apollinaire, Duchamp, Arp, Calder*. Paris: Belfond, 1977. Pp. 87-96.

————. "La Section d'or." *Art d'aujourd'hui*, 4, no. 3-4 (May-June 1953), 74-76.

Buren, Daniel. "Standpoints." *Studio International*, 181, no. 932 (April 1971), 181-85. Reply by David Rushton: vol. 182, no. 935 (July 1971), 6-7.

Burnham, Jack. "An Abstract: Duchamp and Kabbalah – Levels of the Mystical Imagination." *Presentations on Art Education Research*, no. 5 (1979), 85-91.

————. "Esoteric Sources of Duchamp's Dual Paradise." *The New Art Examiner*, 8, no. 2 (November 1980), 6-7. On "Paradise."

————. "Huebler's Pinwheel and the Letter Tau." *Arts Magazine*, 49 (October 1974), 32-35. On "Monte Carlo Bond."

————. "The True Readymade?" *Art and Artists*, 6 (February 1972), 26-31.

————. "Unveiling the Consort." *Artforum*, 9 (March 1971), 55-60, (April 1971), 42-51. Reply by J. Schorr: June 1971, p. 10.

Butor, Michel. "Reproduction interdite." *Critique* (Paris), no. 334 (March 1975), 269-83.

Cabanne, Pierre. "Marcel Duchamp: Le Voyage au bout du scandale." *Galerie des arts*, no. 45 (June 1967), 4-7.

————. "Le Trio Duchamp." *Connaissance des arts*, no. 284 (October 1975), 74-81.

Cage, John. "10 Mesostics of 'Mushrooms et variations' on Duchamp." In: *Duchamp*. Barcelona: Fundació Caja de Pensiones, 1984. Pp. 28-29.

————. "26 Statements re Duchamp." *Art and Literature*, no. 3 (Autumn/Winter 1964), 9-10; rpt. in his *A Year from Monday: New Lectures and Writings*. Middletown, Conn.: Wesleyan University Press, 1967. Pp. 70-72.

Calas, Nicholas. "Cheat to Cheat." *View*, series 5, no. 1 (March 1945), 20-21.

————. "Duchamp's Last Work." *Arts Magazine*, 48, no. 1 (September-October 1973), 46-47. On "Etant Données."

————. "The Large Glass." *Art in America*, 57 (July-August 1969), 35-35.

————. "'Etant Donnés': La Dernière Oeuvre de Duchamp." *Opus International*, no. 49 (March 1974), 55-57.

Calvesi, Maurizio. "Codicillo duchampiano" = "Postsript on Duchamp." In: *Su Marcel Duchamp*. Naples: Framart, 1975. Pp. 7-13.

————. "Duchamp and Learning." In: *Duchamp*. Barcelona: Fundación Caja de Pensiones, 1984. Pp. 59-67.

————. "Il Significati del 'Grande Vetro.'" In: *Il Dadaismo*. Ed. Silvia Danesi. Milan: Fratelli Fabri, 1977. Pp. 46-47.

Campos, Augusto da. "Marcel Duchamp: O Lance Dada." *Collóquio: Artes*, 15 (December 1973), 43-49.

Canaday, John. "Iconoclast, Innovator, Prophet." *New York Times*, 3 October 1968, p. 51.

Cardinal, Roger. "Enigma." *Twentieth Century Studies,* no. 12 (December 1974), 42–62. On the "Large Glass."

Carrouges, Michel. "Duchamp révélateur du déjà vu et du jamais vu." *Cahiers de l'Association internationale pour l'ètude de Dada et du surréalisme,* no. 3 (1969), 22–26.

———. "La Machine-célibataire selon Franz Kafka et Marcel Duchamp." *Mercure de France,* No. 1066 (June 1952), 262–81; rpt. as "Marcel Duchamp et Franz Kafka" in his *Les Machines célibataires.* Paris: Arcanes, 1954. Pp. 27–59.

Castelli, Tommaso Trini. "The Mariée Sélavy in the Strategy of the 'Large Glass.'" In: *Duchamp Readymades.* Ed. Jo-Anne Birnie Danzker. Vancouver: Vancouver Art Gallery, 1978.

Caws, Mary Ann. "Dada's Temper, Our Text." In: *Dada Spectrum: The Dialectics of Revolt.* Ed. Stephen C. Foster and Rudolf E. Kuenzli. Madison: Coda Press; Iowa City: University of Iowa, 1979, pp. 207–24; rpt. in her *The Eye in the Text: Essays on Perception, Mannerist to Modern.* Princeton: Princeton University Press, 1981.

———. "Mallarmé and Duchamp: Mirror, Stair, and Gaming Table." *L'Esprit créateur,* 20, no. 2 (Summer 1980), 51–64; rpt. in her *The Eye in the Text: Essays on Perception, Mannerist to Modern.* Princeton: Princeton University Press, 1981. Pp. 141–57.

———. "Partiality and the Ready Maid, or Representation by Reduction." *Journal of Aesthetics and Art Criticism,* 42, no. 3 (Spring 1984), 255–60.

Celant, Germano. "Marcel Duchamp y la Babel de los lenguajes" = "Marcel Duchamp and the Babel of Languages." In: *Duchamp.* Barcelona: Fundación Caja de Pensiones, 1984. Pp. 68–80.

Chaplupecký, Jindřich. "Art et transcendance." In: *Marcel Duchamp: Tradition de la rupture ou rupture de la tradition?.* Paris: Union générale d'éditions, 1979. Pp. 11–35; English translation in *Flash Art,* no. 90–91 (June–July 1979), 3–8.

———. "Marcel Duchamp: A Re-evaluation." *Artibus et Historiae,* no. 11 (1986), 125–36.

———. "Nothing but an Artist." *Studio International,* 189 (January–February 1975), 30–47.

———. "Poustevník Duchamp" = L'Hermite Duchamp." *Vytvarne Umeni,* 18 (1968), 382–89.

———. "Le Ready-made de Duchamp et la théorie du symbole." *Artibus et Historiae,* no. 13 (1986), 153–63, 184.

———. "Les Symboles chez Marcel Duchamp." *Opus International,* no. 49 (March 1974), 40–49.

Champa, Kermit. "Charlie Was Like That." *Artforum,* 12, no. 6 (March 1974), 54–59.

Charbonnier, Georges. "Natural Art and Cultural Art: Conversation with Claude Lévi-Strauss." In: *Marcel Duchamp in Perspective.* Ed. Joseph Masheck. Englewood Cliffs, N.J.: Prentice-Hall, 1975. Pp. 77–83. On the Readymades.

Charles, Daniel. "Cage et Duchamp: Notes sur les '26 Statements re Duchamp' de John Cage." *L'Arc,* no. 59 (1974), 72–79.

Chénieux, Jacqueline. "L'Erotisme chez Marcel Duchamp et Georges Bataille." In: *Marcel Duchamp: Tradition de la rupture ou rupture de la tradition.* Paris: Union générale d'éditions, 1977. Pp. 193–234.

———. "Patience et impatiences chez Marcel Duchamp." *Le Nouveau Commerce,* no. 24–25 (Spring 1973), 73–99.

Christian. "Du Champ outre tombe." *Cahiers de l'Association internationale pour l'étude de Dada et du surréalisme*, no. 3 (1969), 8-19.

Clair, Jean. "L'Adorable Leurre." *Chroniques de l'art vivant*, no. 37 (March 1973), 4-6.

―――. "Duchamp and the Classical Perspectivists." *Artforum*, 16 (March 1978), 40-49.

―――. "Duchamp, Léonard, la tradition maniériste." In: *Marcel Duchamp: Tradition de la rupture ou rupture de la tradition?* Paris: Union générale d'éditions, 1979. Pp. 117-56.

―――. "L'Echiquier, les modernes et la quatrième dimension." *Revue de l'art*, no. 39 (1978), 59-68.

―――. "Une Figure Nouvelle." *L'Arc.*, no. 59 (1974), 1-2.

―――. "La Fortune critique de Marcel Duchamp: Petite Introduction à une hermeneutique du 'Grand Verre.'" *Revue d l'art*, no. 34 (1976), 92-100, 102.

―――. "Jarry." In: *Marcel Duchamp: Abécédaire: Approches critiques*. Paris: Musée national d'art moderne, Centre national d'art et de culture Georges Pompidou, 1977. P. 110.

―――. "Marcel Duchamp et la tradition des perspecteurs." In: *Marcel Duchamp: Abécédaire*. Pp. 124-59.

―――. "Sexe et topologie." In: *Marcel Duchamp: Abécédaire*. Pp. 52-59.

―――. "Les Vapeurs de la mariée." *L'Arc*, no. 59 (1974), 44-51. On the "Large Glass."

―――. "Villon: Mariage, hasard et pendaison." In: *Marcel Duchamp: Abécédaire*. Pp. 201-02.

Clay, Jean. "Marcel Duchamp le dynamiteur." *Réalités* (Paris), June 1967, Pp. 80-84. Review of Paris exhibition.

Coates, Robert M. "The Art Galleries: Marcel Duchamp." *New Yorker*, 40 (30 January 1965), 92-95. Review of exhibition at Cordier & Ekstrom.

Cockburn, Alexander. "Marcel Duchamp." In his *Idle Passion: Chess and the Dance of Death*. New York: Village Voice; Simon and Schuster, 1974. Pp. 182-96.

Coenen, J.P. "Marcel Duchamp: Anémic Cinema." *Jaarboek van het Kononklijk Museum voor schone Kunsten Antwerpen*, 1975, Pp. 279-88.

Compton, Michael. "The Ready-mades, Meaning and Representation in Art." *Vanguard*, May 1978; rpt. in: *Duchamp Readymades*, Ed. Jo-Anne Birnie. Vancouver: Vancouver Art Gallery, 1978.

Conger, Amy. "Edward Weston's Toilet." *New Mexico Studies in the Fine Arts*, 9 (1984), 36-42. On "Fountain."

Cook, Albert. "The 'Meta-irony' of Marcel Duchamp." *Journal of Aesthetics and Art Criticism*, 44, no. 3 (spring 1986), 263-70.

Copley, William. "The New Piece." *Art in America*, 57 (July-August 1969), 36-37; rpt. in *Marcel Duchamp in Perspective*. Ed. Joseph Masheck. Englewood Cliffs, N.J.: Prentice-Hall, 1975. Pp. 112-14. On "Etant Donnés."

Cordier, Robert. "Statue de mot pour Marcel." *Opus International*, no. 49 (March 1974), 37-39.

Crary, Jonathan. "Marcel Duchamp's 'The Passage from Virgin to Bride.'" *Arts Magazine*, 51 (January 1977), 96-99.

Crichton, Eenella. "Paris Letter." *Art International*, 21, no. 2 (March-April 1977), 56-59, 73. Review of Paris exhibition.

Crispolti, Enrico. "Note sur l'usage abusif de Marcel Duchamp." *Opus International,* no. 49 (March 1974), 105-06.

Czartoryska, Urszula. "Konstelacja Marcela Duchamp" = "Marcel Duchamp's Constellation." *Projekt* (Warsaw), 1, no. 1 (1971), 37-44.

Dadoun, Roger. "Rrose sschize: Sschize d'un portrait-théorie de Marcel Duchamp en Jésus sec célibataire." *L'Arc,* no. 59 (1974), 24-28.

Daley, Janet. "All the King's Horses . . ." *Art and Artists,* 8 (September 1973), 8-10. On the Readymades.

Dali, Salvador. "The King and Queen Traversed by Swift Nudes." *Art News,* 58 (April 1959), 22-25.

Dali, Salvador. "Why They Attack the 'Mona Lisa.'" *Art News,* 62, no. 1 (March 1963), 36, 63-64. On "LHOOQ."

Damisch, Hubert. "La Défense Duchamp." In: *Marcel Duchamp: Tradition de la rupture ou rupture de la tradition?* Paris: Union générale d'éditions, 1979. Pp. 65-115; English version in *October,* no. 10 (Fall 1979), 5-28.

Davidson, Abraham A. "Marcel Duchamp: His Final Gambit at the Philadelphia Museum of Art." *Arts Magazine,* 44 (September-October 1969), 44-45. On "Etant Donnés."

Davies, Ivor. "New Reflections on the 'Large Glass': The Most Logical Sources for Marcel Duchamp's Irrational Work." *Art History,* 2, no. 1 (March 1979), 89-94.

Dee, John. "Ce Façonnement symétrique." In: *Marcel Duchamp: Tradition de la rupture ou rupture de la tradition?* Paris: Union générale d'éditions, 1979. Pp. 351-402.

Delloye, Charles. "Marcel Duchamp, le 'Grand Verre' et le jeu de l'apparaître." *Art International,* 20 (December 1976), 54-60, 72.

Denizot, René. "Ainsi font, font, font. . . ." *Art Press,* no. 84 (September 1984), 8-10.

Desnos, Robert. "Préface pour une exposition Marcel Duchamp." In his *Ecrits sur les peintres.* Paris: Flammarion, 1984. Pp. 48-63.

Dhainaut, Pierre. "Raymond Roussel oseur d'influence." *Bizarre* (Paris), n.s. no. 34-35 (1964), 73-74.

d'Harnoncourt, Anne. "Before the Glass: Reflections on Marcel Duchamp before 1915." In: *Duchamp.* Barcelona: Fundación Caja de Pensiones, 1984. Pp. 30-36.

———— and Walter Hopps. "'Etant Donnés: 1° La Chute d'eau, 2° le gaz d'éclairage': Reflections on a New Work by Marcel Duchamp." *Bulletin of the Philadelphia Museum of Art,* 64, no. 299/300 (April-September 1969), 6-58; rpt. 1973 and 1987 as a monograph, with new afterword.

Dörstel, Wolfgang. "Perspectiva rhetorica." *Daidalos,* no. 11 (15 March 1984), 65-70.

Domingo, Willis. "Meaning in the Art of Duchamp." *Artforum,* 10 (December 1971), 72-77; (January 1972), 63-68.

Dorflex, Oillo. "Il Ready-Made di Duchamp e il suo rapporto con l'arte d'oggi." *Art International,* 8, no. 10 (December 1964), 40-42.

Drechsler, Wolfgang. "Marcel Duchamp et le temps." In: *L'Art et le temps: Regards sur la quatrième dimension.* Brussels: Société des expositions du Palais des beaux-arts, 1984.

————. "Das Objekt im Kubismus, bei Duchamp und Schwitters." In: *Faszination des Objekts.* Ed. Wolfgang Drechsler. Vienna: Gesellschaft der Freunde des Museums moderner Kunst, 1980. Pp. 45-56. On the Readymades.

————. "Zu den 'Ready-mades' von Marcel Duchamp." *Wiener Jahrbuch für Kunstgeschichte,* no. 34 (1981), 147–60.

Drost, Wolfgang. "L'Instantanéité: Schönheit, Augenblick und Bewegung in der Malerei von David bis Duchamp und in der frühen Photographie." In: *Augenblick und Zeitpunkt: Studien zur Zeitstruktur und Zeitmetaphorik in Kunst und Wissenschaften.* Ed. Christian W. Thomsen and Hans Holländer. Darmstadt: Wissenschaftliche Buchgesellschaft, 1984. Pp. 349–60.

Duboy, Philippe. "J.-J. Lequeu (1757–?), Duchamp." *XX^e Siècle,* n.s. no. 47 (December 1976), 13–18.

————. "Le Corbusier (1887–1965) con sidéré, ment moderne copyright by Rrose Sélavy (1887–1968)." *Art Press,* hors série no. 2 (1983), 57–59.

Durozoi, Gerard. "Le Roman-momie de la mariée: Feuilleton." *Opus International,* no. 49 (March 1974), 91–94.

Duve, Thierry de. "Les Moustaches de 'La Joconde': Petit Exercice de méthode." In: *Marcel Duchamp: Tradition de la rupture ou rupture de la tradition?* Paris: Union générale d'éditions, 1979. Pp. 403–26. On "LHOOQ."

————. "The Readymade and the Tube of Paint." *Artforum,* 24, no. 9 (May 1986), 110–21.

————. "Le Temps du ready-made." In: *Marcel Duchamp: Abécédaire: Approches critiques.* Paris: Musée national d'art moderne, Centre national d'art et de culture Georges Pompidou, 1977. Pp. 166–84.

Dyck, Jacques. "Amateurie: Kowalski/Pommereulle et Duchamp/Wittgenstein." *XX^e Siècle,* n.s. no. 51 (December 1978), 13–19.

Edson, Laurie. "Confronting the Signs: Words, Images, and the Reader-Spectator." *Dada/ Surrealism,* 13 (1984), 83–93.

Fagiolo dell'Arco, Maurizio. "Perché la Porta di Duchamp vale tanto?" *Bolaffiarte,* 10, no. 85 (January–February 1979), 46–49. On "Porte, 11, rue Larrey."

Farakos, Mary. "Octavio Paz y Marcel Duchamp: Critica moderna para un artista moderno." *Cuadernos hispanoamericanos,* no. 110 (August 1984), 78–96.

Faust, Wolfgang Max. "Marcel Duchamp: Dinge und Worte: Rrose Sélavy: Zur Beziehung von bildender Kunst und Literatur in der Moderne." *Sprache im technischen Zeitalter,* no. 59 (July–September 1976), 215–38; rpt. in his *Bilder werden Worte: Zum Verhältnis von bildernder Kunst und Literatur im 20. Jahrhundert, oder, Vom Anfang der Kunst im Ende der Künste.* Munich: Hanser, 1977. Pp. 135–60.

"Faut-il Vraiment Venerer Duchamp?" *Connaissance des arts,* no. 299 (January 1977), 46–55. Questionnaire and responses.

Feinstein, Roni. "Jasper Johns' 'Untitled' (1972) and Marcel Duchamp's 'Bride.'" *Arts Magazine* 57, no. 1 (September 1982), 86–93. On the "Large Glass."

Finch, Christopher. " . . . And Picabia." *Art and Artists,* 1, no. 4 (July 1966), 52–53.

————. "The Role of the Spectator." *Design Quarterly,* no. 73 (1968).

Fischer, Hervé. "Marcel Duchamp, l'inceste et le meurtre." In his *L'Histoire de l'art est terminée.* Paris: Balland, 1981. Pp. 19–28.

Fong, Monique. "Marcel Duchamp." *Les Lettres nouvelles,* May–June 1967, Pp. 70–76.

Forge, Andrew. "In Duchamp's Footsteps: Richard Hamilton's Reconstruction of 'The Bride Stripped Bare by Her Bachelors, Even' (the Large Glass)." *Studio International,* 171 (June 1966), 248–51.

Formentelli, Eliane. "Cantique-Duchamp, ou, La Théorie du moteur invisible." In: *Marcel Duchamp: Tradition de la rupture ou rupture de la tradition?* Paris: Union générale d'editions, 1979. Pp. 263-96.

Fratini, Francesca R. "Marcel Duchamp: Dagli Inizia ai Ready-mades." *L'Arte,* 2, no. 5 (March 1969), 55-79.

"French Artists Spur on an American Art." *New York Tribune,* 24 October 1915, sec. 4, Pp. 2-3; rpt. in *New York Dada.* Ed. Rudolf E. Kuenzli. New York: Willis Locker & Owens, 1986. Pp. 128-35.

Frigerio, Simone. "Situazione Parigi: Celebrazione Dada e nuovi romantici." *D'Ars,* 17, no. 78-79 (April 1976), 60-65.

Fritz-Bailey, Suzan, and M. W. Buckalew. "Alfred Korzybski and Marcel Duchamp: A Study in Science and Art." *Et Cetera,* 33, no. 4 (December 1976), 380-84.

Gassiot-Talabot, Gerald. "Contre-dossier: Persistent et Signent." *Opus International,* no. 49 (March 1974), 96-101.

Gateau, Jean Charles. "Réraison." In his *Abécédaire critique: Flaubert, Baudelaire, Rimbaud, Dàdas et surréalistes, Saint-John Perse, Butor, &c.* Geneva: Droz, 1987. Pp. 39-48.

Genêt. "Letter from Paris." *New Yorker,* 44, no. 37 (2 November 1968), 170-79.

Gervais, André. "De l'Angrais Duchamp de l'infratexte." *La Nouvelle Barre du jour,* May 1981, Pp. 56-77.

————. "Du Raide y m'aide en sa lecture, d'écriture: Trois Exemples." *La Nouvelle Barre du jour,* no. 82 (October 1979), 38-60. On the Readymades.

————. "Signed Sign MD: Autographique Portrait of an Artist en rhymes." *Parachute,* Summer 1978, Pp. 18-23. Rpt. in: *Marcel Duchamp: Tradition de la rupture ou rupture de la tradition?* Paris: Union générale d'éditions, 1979. Pp. 297-350. On the Readymades.

Glickman, Jack. "Creativity in the Arts." In: *Culture and Art: An Anthology.* Ed. Lars Aagaard-Morgensen. Nyborg: F. Lokkes; Atlantic Highlands, N.J.: Humanities Press, 1976. Pp. 130-46. On the Readymades.

Golan, Romy. "Matta, Duchamp et le mythe: Un Nouveau Paradigme pour la dernière phase du surréalisme." In: *Matta.* Paris: Editions du Centre Pompidou, 1985. Pp. 37-51. Transl. from English by Jeanne Bouniort.

Gold, Barbara. "The Mysteries of Marcel." *American Scholar,* 44, no. 1 (Winter 1974-75), 142-51. Review of *Marcel Duchamp, The Bride Stripped Bare by Her Bachelors, Even,* by John Golding, *Marcel Duchamp in Perspective,* Ed. by Joseph Masheck, and *Marcel Duchamp,* by d'Harnoncourt and McShine.

Goldsmith, Steven. "The Readymades of Marcel Duchamp: The Ambiguities of an Aesthetic Revolution." *Journal of Aesthetics and Art Criticism,* 42, no. 2 (Winter 1983), 197-208.

Gottlieb, Carla. "Self-Portraiture in Postmodern Art." *Wallraf-Richartz Jahrbuch,* 42 (1981), 267-302. On "Belle Haleine."

————. "Something Else: Duchamp's Bride and Leonardo." *Konsthistorisk Tidskrift,* 45 (June 1976), 52-57. On the "Large Glass."

————. "'Something Else' in Self-Portraiture." *Colóquio: Artes,* no. 39 (December 1978), 28-35.

Grabska, Elżbieta. "Duchampa malarza pisarza hermeneutyka w związku z obrazem 'Etant données.'" In: *Co robić po kubizmie?: Studia o sztuce europejskiej polowy XX wieku.* Ed. Jerzego Malinowskiego. Kraków: Wydawn. Literackie, 1984.

248

————. "O warsztatowo-gatunkowych przeslankach xx-wiecznego obrazoburstwa – wstepne uwagi." *Rocznik Historii Sztuki*, no. 12 (1981), 253–64. Summary in French. On "L'Elévage de poussière."

Graevenitz, Antje von. "De Deuren van de geest: De Symbolische Betekenis van de deur." *Openbaar Kunstbezit*, 24, no. 6 (December 1980), 208–14.

Gray, Cleve. "The Great Spectator." *Art in America*, 57, no. 4 (July–August 1968), 20–27.

————. "Retrospective for Marcel Duchamp." *Art in America*, 53, no. 1 (1965), 102–05. Review of exhibition at Cordier & Ekstrom, New York.

Greenberg, Clement. "Counter-Avant-garde." *Art International*, 15, no. 5 (20 May 1971), 16–19; rpt. in *Marcel Duchamp in Perspective*. Ed. Joseph Masheck. Englewood Cliffs, N.J.: Prentice-Hall, 1975. Pp. 122–33.

————. "Seminar Six." *Arts Magazine*, 50 (June 1976), 92–93.

Gustafson, Ingmar. "Marcel Duchamp." *Salamander*, no. 1 (1955), 37.

Hamilton, George Heard. "Duchamp, Duchamp-Villon, Villon." *Bulletin of the Associates in Fine Arts at Yale University*, 13, no. 2 (March 1945), 1–7. Includes catalog of exhibition at Yale University Art Gallery.

————. "The Exhibition of the Collection of the Société Anonyme-Museum of Modern Art, 1920." *Bulletin of the Associates in Fine Arts at Yale University*, 10, no. 3 (December 1941), 1–5.

————. "In Advance of Whose Broken Arm?" *Art and Artists*, 1, no. 4 (July 1966), 29–31; rpt. in: *Marcel Duchamp in Perspective*. Ed. Joseph Masheck. Englewood Cliffs, N.J.: Prentice-Hall, 1975. Pp. 73–76.

Hamilton, Richard. "Duchamp." *Art International*, 7, no. 10 (January 1964), 22–28; rpt. as "The Pasadena Retrospective" in his *Collected Words, 1953–1982*. London: Thames and Hudson, [1982?]. Pp. 198–206.

————."The Green Book." In: Duchamp, Marcel. *the Bride Stripped Bare by Her Bachelors, Even*. New York: Wittenborn, 1960; rpt. in: Hamilton, Richard. *Collected Words, 1953–1982*. Pp. 218–33.

————. "The Large Glass." In: *Marcel Duchamp*. Ed. Anne d'Harnoncourt and Kynaston McShine. New York: Museum of Modern Art, 1973. Pp. 57–67; rpt. in his *Collected Words, 1953–1982*. Pp. 218–33.

————. "Letter of Alison Knowles." In his *Collected Words, 1953–1982*. Pp. 236–37. On the Readymades.

————. "Magical Myth for Our Time." *Sunday Times* (London), 22 February 1970, p. 51; rpt. as "The Complete Works" in his *Collected Words, 1953–1982*. Pp. 234–35.

————. "Towards a Typographical Rendering of the Green Box." *Uppercase*, no. 2 (May 1959); rpt. in his *Collected Words, 1953–1982*. Pp. 182–84.

Hanimann, Joseph. "Infra-mince, oder, Das Unendliche dazwischen: zu einem Begriff aus dem Nachlass Marcel Duchamps." *Pantheon*, 44 (1986), 134–40, 203.

Hausmann, Raoul. "A la mémoire de Marcel Duchamp." *Studies in the Twentieth Century*, no. 2 (Fall 1968), 5–6. Also published in German as "In Memoriam Marcel Duchamp." *Manuskripte*, no. 25 (1969), 46.

Heap, Jane. "Comment." *Little Review*, 10, no. 2 (Fall–Winter 1924–25), 17–22.

Heeckeren, Jan van. "La Porte de Duchamp." *Orbes*, ser. 2, no. 2 (Summer 1933), xiv–xv. On "Porte, 11, rue Larrey."

Held, René R. "Marcel Duchamp: L'Imposteur malgré lui, ou, Le Grand Canular et la surréalité." In his: *L'Oeil du psychanalyste: Surréalisme et surréalité.* Paris: Payot, 1973. Pp. 218-55.

Henderson, Linda Dalrymple. "Italian Futurism and 'the Fourth Dimension.'" *Art Journal,* 41, no. 4 (Winter 1981), 317-23.

Hespe, Rainer. "Rigorose Aesthetik: Marcel Duchamp und die Pop Art." *Frankfurter Hefte,* 21, no. 10 (21 January 1966), 717-20.

Hess, Thomas B. "J'Accuse Marcel Duchamp." *Art News,* 63, no. 10 (February 1965), 44-45, 52-54; rpt. in: *Marcel Duchamp in Perspective.* Ed. Joseph Masheck. Englewood Cliffs, N.J.: Prentice-Hall, 1975. Pp. 115-20. Review of exhibition at Cordier & Ekstrom.

Hill, Anthony. "The Spectacle of Duchamp." *Studio International,* 189 (January–February 1975), 20-22.

Hobhouse, Janet. "Private Joke between Myself and Myself: The Centre Beaubourg's Inaugural Exhibition." *Art News,* 76 (April 1977), 41-43.

Hofmann, Werner. "Marcel Duchamp und der emblematische Realismus." *Merkur,* 19, no. 10 (October 1965), 941-55; English trans. in: *Marcel Duchamp in Perspective.* Ed. Joseph Masheck. Englewood Cliffs, N.J.: Prentice-Hall, 1975. Pp. 53-66.

Hoover, Francis Herbert. "Frederic C. Torrey and the Infamous Nude." *Southwest Art,* April 1974, Pp. 57-59.

Hopps, Walter. "Chronological Notes." *Art in America,* 57 (July–August 1968), 28-30.

————. "Marcel Duchamp: A System of Paradox in Resonance." In: *Marcel Duchamp, Pasadena Art Museum: A Retrospective Exhibition.* Pasadena: Pasadenà Art Museum, 1963.

Humble, P. N. "Duchamp's Readymades: Art and Anti-Art." *British Journal of Aesthetics,* 22, no. 1 (Winter 1982), 52-64.

————. "On the Uniqueness of Art." *Journal of Aesthetics and Art Criticism,* 42, no. 1 (Fall 1983), 39-47. On the Readymades.

"The Iconoclastic Opinions of M. Marcel Duchamp Concerning Art and America." *Current Opinion,* 59 (November 1915), 346-47.

Imponente, Anna."Vecchiali invisibile." *Filmcritica,* no. 312 (February 1981), 79-81.

Inboden, Gudrun. "Zur Bedeutung der 'Siebe' im 'Grossen Glass' von Marcel Duchamp." In: *Studien zur Kunst: Gunther Thiem zum 60. Geburtstag.* Stuttgart: Cantz, 1977. Pp. 51-53.

Izzo, Arcangelo. "Marcel Duchamp: L'Intelligenza delle cose" = "Marcel Duchamp: The Intelligence of Things." In: *Su Marcel Duchamp.* Naples: Framart, 1975. Pp. 15-32.

Jagoda, Eleanor. "Marcel Duchamp: Fantasies and Symbolism." *American Imago,* 34, no. 3 (Fall 1977), 205-23.

James, Carol P. "Duchamp's Early Readymades: The Erasure of Boundaries Between Literature and the Other Arts." *Perspectives on Contemporary Literature,* 13 (1987), 24-32.

————. "Duchamp's Pharmacy." *Enclitic,* 2, no. 1 (Spring 1978), 65-80.

————. "Marcel Duchamp, Naturalized American." *French Review,* 49, no. 6 (May 1976), 1097-1105.

————. "'No, Says the Signified': The 'Logical Status' of Words in Painting." *Visible Language,* 19, no. 4 (autumn 1985), 439-61.

————. "Reading Art through Duchamp's 'Glass' and Derrida's *Glas.*" *Sub-Stance,* no. 31 (1981), 105–28.

Janis, Harriet and Sidney. "Marcel Duchamp, Anti-artist." *View,* Series 5, no. 1 (March 1945), 18–19, 21–24, 53–54; rpt. in: *The Dada Painters and Poets.* Ed. Robert Motherwell. 2nd ed. Boston: G. K. Hall, 1981. Pp. 306–15.

Johns, Jasper. "The Green Box." *Scrap,* 23 December 1960, p. 4; rpt. in: *Marcel Duchamp in Perspective.* Ed. Joseph Masheck. Englewood Cliffs, N.J.: Prentice-Hall, 1975. Pp. 110–11. Review of Richard Hamilton's edition.

————. "Marcel Duchamp (1887–1968)." *Artforum,* 7, no. 3 (November 1968), 6; rpt. in: *Marcel Duchamp in Perspective.* Ed. Joseph Masheck. Englewood Cliffs, N.J.: Prentice-Hall, 1975. P. 147.

————. "Thoughts on Duchamp." *Art in America,* 57 (July–August 1969), 31.

Johnson, Ronald W. "Poetic Pathways to Dada: Marcel Duchamp and Jules Laforgue." *Arts Magazine,* 50, no. 9 (May 1976), 82–89.

Josephson, Matthew. "Anti-artist or Prophet?" *The Nation,* 190 (6 February 1960), 123–25. Review of Lebel, *Marcel Duchamp.*

Jouffroy, Alain. "La 'Distance infinie' de Duchamp." In his *Les Pré-voyants.* Brussels: La Connaissance, 1974. Pp. 24–27.

————. "Duchamp." In his *Une révolution du regard: A Propos de quelques peintres et sculpteurs contemporains.* Paris: Gallimard, 1964. Pp. 225–26.

————. "Entendre John Cage, entendre Duchamp: Dialogue avec Alain Jouffroy." *Opus International,* no. 49 (March 1974), 58–67.

————. "L'Influence des ready-mades de Marcel Duchamp." *XXe Siècle,* n.s. no. 41 (December 1973), 63–69.

————. "Etant donné Marcel Duchamp: 1) individualiste révolutionnaire; 2) respirateur." *Opus International,* no. 49 (March 1974), 18–23.

————. "Les Objecteurs: La 'Distance infinie' de Duchamp." *Quadrum,* no. 19 (1965), 6–9.

————. "36 Questions à Daniel Pommereulle autour de Duchamp." *Opus International,* no. 49 (March 1974), 78–80; rpt. in his *Les Pré-voyants.* Brussels: La Connaissance, 1974. Pp. 256–60.

Judd, Donald. "Marcel Duchamp and/or Rrose Sélavy." *Arts Magazine,* 39 (March 1965), 53–54; rpt. in: *Marcel Duchamp in Perspective.* Ed. Joseph Masheck. Englewood Cliffs, N.J.: Prentice-Hall, 1975. P. 121. Review of exhibition at Cordier & Ekstrom.

Judovitz, Dalia. "Anemic Vision in Duchamp: Cinema as Readymade." *Dada/Surrealism,* no. 15 (1986), 46–57; rpt. in *Dada and Surrealist Film.* Ed. Rudolf E. Kuenzli. New York: Willis Locker & Owens, 1987. Pp. 46–57.

Junod, Philippe. "Von Konrad Fiedler bis Marcel Duchamp." *Werk, Bauen und Wohnen,* 67/34 (December 1980), 14–18.

Kaprow, Allan. "L'Utilité d'un passé déterminé." *Opus International,* no. 49 (March 1974), 68–72.

Kare, Antero. "Marcel Duchamp: Paradoksi ja pioneeri." *Taide* (Helsinki), 13, no. 4 (1972), 28–33.

Karlstrom, Paul J. "Eilshemius and Modernism." In his *Louis M. Eilshemius: Selections from the Hirshhorn Museum and Sculpture Garden.* Washington: Smithsonian Institution Press, 1978. Pp. 10–25.

Kelly, Katherine E. "Tom Stoppard's *Artist Ascending a Staircase:* Outdoing the 'Dada' Duchamp." *Comparative Drama,* 20, no. 3 (Fall 1986), 191–200.

Keneas, Alexander. "The Grand Dada." *New York Times,* 3 October 1968, Pp. 1, 51.

Kenedy, R. C. "Günter Haese." *Art International,* 18 (April 1974), 30–31, 42, 59–60.

―――. "Wortgebilde durch Spiel und Kombinatorik, or, Why Duchamp Loved Words." *Visible Language,* 11, no. 2 (Spring 1977), 102–25.

Kiesler, Frederick J. "Design-Correlation." *Architectural Record,* 81, no. 5 (May 1937), 53–59. On the "Large Glass."

―――. "Les Larves d'imagie d'Henri Robert Marcel Duchamp." *View,* series 5, no. 1 (March 1945), 24–30.

Kirby, Michael. "Hommage à Marcel Duchamp: 'A Balcony Piece.' " *Opus International,* no. 49 (March 1974), 73–75.

Klein, Michael. "John Covert's 'Time': Cubism, Duchamp, Einstein: A Quasi-Scientific Fantasy." *Art Journal,* 33, no. 4 (summer 1974), 314–20.

Knowles, Alison. "To See Clearly & Afresh Each Moment." In: *Alphabets Sublime: Contemporary Artists on Collage & Visual Literature.* Ed. George Myers, Jr. Washington, D.C.: Paycock Press, 1986.

Kochnitzky, Leon. "Marcel Duchamp and the Futurists." *View,* series 5, no. 1 (March 1945), 41, 45; rpt. in *Marcel Duchamp in Perspective.* Ed. Joseph Masheck. Englewood Cliffs, N.J.: Prentice-Hall, 1975. Pp. 27–29.

Kourim, Zdenek. "Marcel Duchamp, visto por Octavio Paz." *Cuadernos hispano-americanos,* 88, no. 263–64 (1972), 520–29.

Kozloff, Max. "Duchamp." *The Nation,* 200, no. 5 (1 February 1965), 123–24; rpt. in his *Renderings: Critical Essays on a Century of Modern Art.* New York: Simon and Shuster, 1968. Pp. 119–27. Review of exhibition at Cordier & Ekstrom.

―――. "Johns and Duchamp." *Art International,* 8, no. 2 (March 1964), 42–45; rpt. in *Marcel Duchamp in Perspective.* Ed. Joseph Masheck. Englewood Cliffs, N.J.: Prentice-Hall, 1975. Pp. 138–46.

Kramer, Hilton. "The First of Our Publicity Masterpieces." *New York Times,* 30 December 1973, sec. 2, p. 19. On "Nude Descending a Staircase No. 2."

Krasne, Belle. "A Marcel Duchamp Profile." *Art Digest,* 26, no. 8 (15 January 1952), 11, 24.

Krauss, Rosalind. "The Naked Bride." *Partisan Review,* 46 (1979), 615–19. Review of Paz, *Marcel Duchamp.*

―――. "Notes on the Index: Seventies Art in America." *October,* no. 3 (Spring 1977), 68–81.

Kuh, Katherine. "Four Versions of 'Nude Descending a Staircase.' " *Magazine of Art,* 42 (1949), 264–65.

―――. "Marcel Duchamp." In: *20th Century Art from the Louise and Walter Arensberg Collection.* Chicago: Art Institute of Chicago, 1949. Pp. 11–18.

―――. "Walter Arensberg and Marcel Duchamp." *Saturday Review,* 53 (5 September 1970), 36–37; rpt. in her *The Open Eye: In Pursuit of Art.* New York: Harper & Row, 1971. Pp. 56–64.

Kuhns, Richard Francis, Jr. "Art and Machine." *Journal of Aesthetics and Art Criticism,* 25 (Spring 1967), 259–63.

Lambert, Jean-Clarence. "Au Désordinateur." *Opus International,* no. 49 (March 1974), 81–87.

Lascault, Gilbert. "Eloge de peu." In: *Marcel Duchamp: Tradition de la rupture ou rupture de la tradition?"* Paris: Union générale d'éditions, 1977. Pp. 37–64.

———. "Les Petites Energies et la puissance-timide." *L'Arc,* no. 59 (1974), 3–7.

Lebel, Robert. "L'Humeur absurde de Marcel Duchamp." *XXe Siècle,* n.s. no. 8 (January 1957), 9–12.

———. "Marcel Duchamp: Du Rébus et de l'infra-mince au courant d'air (ou d'art) du Japon." *Cahiers du Musée national d'art moderne,* no. 11 (1983), 124–29.

———. "Marcel Duchamp: Une Gifle à Paris." *XXe Siècle,* n.s. no. 13 (Christmas 1959).

———. "Marcel Duchamp and André Breton." In: *Marcel Duchamp.* Ed. Anne d'Harnoncourt and Kynaston McShine. New York: Museum of Modern Art, 1973. Pp. 135–41.

———. "Marcel Duchamp and Electricity at Large: The Dadaist Version of Electricity." In *Electra: L'Electricité et l'"électronique dans l'art au XXe siècle.* Paris: Les Amis du Musée d'art moderne de la ville de Paris, 1983. Pp. 164–73.

———. "Marcel Duchamp, hier et demain." *L'Oeil,* no. 112 (1964), 12–19.

———. "Notes sur le dernier Duchamp." *Coupure,* no. 2 (January 1970). On "Etant Donnés."

———. "Paris-New York et retour avec Marcel Duchamp, Dada et le surréalisme." In: *Paris-New York.* Paris: Centre national d'art et de culture Georges Pompidou, 1977. Pp. 64–77.

———. "Surréalisme: Années américaines." *Opus International,* no. 19–20 (October 1970), 44–52.

Le Bot, Marc. "Margelles du sens, ou, Les Musées de Marcel Duchamp." *L'Arc,* no. 59 (1974), 8–15.

Leiner, Jacqueline. "Marcel Duchamp devant la critique française de 1913 à sa mort." *Oeuvres & critiques,* 2, no. 1 (Spring 1977), 145–55.

Le Lionnais, François. "Echecs et maths." In: *Marcel Duchamp: Abécédaire: Approches critiques.* Paris: Musée national d'art moderne, Centre national d'art et de culture Georges Pompidou, 1977. Pp. 42–51.

Lenain, Thierry. "Le Dernier Tableau de Marcel Duchamp: Du Trompe-l'oeil au regard désabusé." *Annales d'histoire de l'art et d'archéologie de l'Université libre de Bruxelles,* no. 6 (1984), 87–104. On "Tu m'."

Levanto, Yrjänä. "Aina undelleen arvioitava Duchamp." *Taide* (Helsinki), 18, no. 3 (1977), 22–28. Review of Paris exhibition.

Lévêque, J. J. "Le Regne de Duchamp s'acheve." *Galerie-Jardin des arts,* no. 165 (January 1977), 27–30.

Lévesque, Jacques-Henry. "Marcel Duchamp." *Orbes,* ser. 2, no. 4 (summer 1935), 1–2.

Levin, Kim. "Duchamp á New York: Le Grand Oeuvre." *Opus International,* no. 49 (March 1974), 50–54.

Levy, Julien. "Duchampiana." *View,* series 5, no. 1 (March 1945), 33–34.

Lindamood, Peter. "I Cover the Cover." *View,* ser. 5, no. 1 (March 1945), 3. On the *View* cover illustration.

Linde, Ulf. "The Bicycle Wheel." In: *Marcel Duchamp—A European Investigation.* Calgary: Alberta College of Art, 1979. Pp. 54–60.

———. "La Copie de Stockholm." In: *Marcel Duchamp: Abécédaire: Approches critiques.* Paris: Musée national d'art moderne, Centre national d'art et de culture Georges Pompidou, 1977. Pp. 31–32. On the "Large Glass" reconstruction.

———. "Duchamp et Matisse." In: *Marcel Duchamp: Abécédaire: Approches critiques.* Paris: Musée national d'art moderne, Centre national d'art et de culture Georges Pompidou, 1977. Pp. 116–17.

———. "L'Esotérique." In: *Marcel Duchamp: Abécédaire.* Pp. 60–85.

———. MARiée CELibataire." In: Hopps, Walter, Ulf Linde, and Arturo Schwarz. *Marcel Duchamp: Ready-Mades, etc.* Paris: Le Terrain vague, 1964. Pp. 41–66.

———. "La Perspective dans les 'Neuf Moules maliques.'" In: *Marcel Duchamp: Abécédaire.* Pp. 160–65.

———. "La Roue de bicyclette." In: *Marcel Duchamp: Abécédaire.* Pp. 35–41.

———. "Tout n'est que célibat." In: *Marcel Duchamp: Abécédaire.* Pp. 111–13.

Lippard, Lucy R. "New York Letter." *Art International,* 9, no. 3 (April 1965), 48–64. Review of exhibition at Cordier and Ekstrom.

———, compiler. "The Romantic Adventures of an Adversative Rotarian, or, All-readymadesomuchof." In: *Marcel Duchamp.* Ed. Anne d'Harnoncourt and Kynaston McShine. New York: Museum of Modern Art, 1973. Pp. 117–24.

Lonc, Christopher. "Duchamp's 'Large Glass.'" *Glass Art Magazine,* August 1973, Pp. 32–33.

Loring, John. "A Book by Its Cover." *Arts Magazine,* 49, no. 3 (November 1974), 72–73.

Loy, Mina. "O Marcel, or, I Too Have Been to Louise's." *The Blind Man,* no. 2 (May 1917); rpt. with explanatory note in *View,* series 5, no. 1 (March 1945), 35, 51. Poem.

Lyotard, Jean-François. "Inventaire du dernier nu." In: *Marcel Duchamp: Abécédaire: Approches critiques.* Paris: Musée national d'art moderne, Centre national d'art et de culture Georges Pompidou, 1977. Pp. 87–109. On "Etant Donnés."

———. "Marcel Duchamp, ou, Le Grand Sophiste." *Chroniques de l'art vivant,* no. 56 (March–May 1975), 34–35.

McEvilley, Thomas. "I Think Therefore I Art." *Artforum,* 23, no. 10 (Summer 1985), 74–84.

McShine, Kynaston. "La Vie en Rrose." In: *Marcel Duchamp.* Ed. Anne d'Harnoncourt and Kynaston McShine. New York: Museum of Modern Art, 1973. Pp. 125–34.

"Marcel Duchamp." *Little. Review,* 10, no. 2 (Autumn/Winter 1924/25), 18–19. On the Monte Carlo Bonds.

Marck, Jan van der. "Pictures to be Read, Poetry to be Seen." *Journal of Typographic Research,* 2, no. 3 (July 1968), 259–70. On the "Large Glass."

Marling, William. "A Tense, Inquisitive Clash: William Carlos Williams and Marcel Duchamp." *Southwest Review,* 66, no. 4 (Autumn 1981), 361–75.

Martin, Katrina. "Marcel Duchamp's 'Anemic cinéma.'" *Studio International,* 189, no. 973 (January–February 1975), 53–60.

Masheck, Joseph. "Chance Is zee Fool's Name for Fate." In: *Marcel Duchamp in Perspective.* Ed. Joseph Masheck. Englewood Cliffs, N.J.: Prentice-Hall, 1975. Pp. 1–24.

———. "Two Blasts-from-the-Past in Picasso (and Yes, Marcel, You Too): Notes on Retroactive Influence." *Arts Magazine,* 59, no. 7 (March 1985), 131–34.

Massot, Pierre de. *"La Mariée mise à nu par ses célibataires, même."* Orbes, ser. 2, no. 4 (Summer 1935), xvii–xxii. Review of the *Green Box.*

Matisse, Paul. "Marcel Duchamp." *Cahiers du Musée national d'art moderne*, no. 3 (January–March 1980), 14–25.

———. "Some More Nonsense about Duchamp." *Art in America*, 68, no. 4 (April 1980), 76–83.

Matthews, J. H. "Marcel Duchamp." In his *André Breton: Sketch for an Early Portrait.* Amsterdam: Benjamins, 1986. Pp. 69–85.

Maur, Karen v. "Marcel Duchamp 'Fenêtrier': Überlegungen zu einer Neuerwerbung der Staatsgalerie Stuttgart." *Jahrbuch der Staatlichen Kunstsammlungen in Baden-Württemberg*, 18 (1981), 99–104. On "La Bagarre d'Austerlitz."

Menna, Filiberto. "Il Ready-made, ciò che viene dopo il ready-made" = "The Ready-Made and What Comes After It." In: *Su Marcel Duchamp.* Naples: Framart, 1975.

Micha, Olivier. "Duchamp et la couture." In: *Marcel Duchamp: Abécédaire: Approches critiques.* Paris: Musée national d'art moderne, Centre national d'art et de culture Georges Pompidou, 1977. Pp. 33–34.

Micha, René. "Etant donné 'Etant Donnés.'" In: *Marcel Duchamp: Tradition de la rupture ou rupture de la tradition?* Paris: Union générale d'éditions, 1979. Pp. 157–92.

———. "La Licorne de Philadelphie." *L'Arc*, no. 59 (1974), 61–66. On "Etant Donnés."

———. "Paris." *Art International*, 21, no. 2 (March–April 1977), 48–55. Review of Paris exhibition.

Michelson, Annette. "'Anemic Cinema': Reflections on an Emblematic Work." *Artforum*, 12, no. 2 (October 1973), 64–69.

Millet, Catherine, and Marcelin Pleynet. "Le Fétiche Duchamp: Entretien Catherine Millet, Marcelin Pleynet." *Art Press*, no. 1 (December 1972–January 1973), 4–7; rpt. in *Duchamp Readymades.* Ed. JoAnne Birnie Danzker. Vancouver: Vancouver Art Gallery, 1978. On the Readymades.

Molderings, Herbert. "Film, Photographie und ihr Einfluss auf die Malerei in Paris um 1910: Marcel Duchamp–Jacques Villon–Franz Kupka." *Wallraf-Richartz Jahrbuch*, 37 (1975), 247–86.

———. "Marcel Duchamp, die Schriften." *Kritische Berichte*, 11, no. 3 (1983), 67–71. Review of v. 1 of Serge Stauffers translation.

Moure, Gloria. "Marcel Duchamp visitado de nuevo" = "Marcel Duchamp Revisited." In: *Duchamp.* Barcelona: Fundación Caja de Pensiones, 1984. Pp. 16–21.

Müller, Grégoire. "Reflections on a Broken Mirror." *Arts Magazine*, 46 (April 1972), 33–35.

Mulas, Ugo. "Incontro con Duchamp." *Notiziario Arte Contemporanea*, no. 2 (February 1973), 29–30.

Muray, Philippe. "La Religion sexuelle de Marcel Duchamp." *Art Press*, no. 84 (September 1984), 4–7.

Mussman, Toby. "Anémic Cinéma." *Art and Artists*, 1, no. 4 (July 1966), 48–51.

———. "Marcel Duchamp's *Anémic Cinema."* In: *The New American Cinema: A Critical Anthology.* Ed. Gregory Battcock. New York: Dutton, 1967. Pp. 147–55.

Nabakowski, Gislind. "Rrose Sélevy, Eros c'est la vie, oder, Schon wieder ein Fall von technischer Geschichtsfalschung." *Heute Kunst*, no. 2 (July–August 1973), 14. On "Wanted $20000 Reward."

Nakahara, Yusuke. "Marcel Duchamp." *Mizue,* 846 (September 1975), 8–23.

Nesbit, Molly. "Ready-made Originals: The Duchamp Model." *October,* 37 (1986), 53–64.

Nicholson, Anne. "Invisibilities in the 'Large Glass.'" *Month,* no. 1310 (November 1976), 383–87.

Norton, Louise. "Buddha of the Bathroom." *The Blind Man,* no. 2 (May 1917); rpt. in: *Marcel Duchamp in Perspective.* Ed. Joseph Mascheck. Englewood Cliffs, N.J.: Prentice-Hall, 1975. Pp. 70–72. On "Fountain."

O'Doherty, Brian. "Inside the White Cube. Part III, Context and Content." *Artforum,* 15 (November 1976), 38–44.

Oehler, Dolf. "Hinsehen, Hinlangen: Für eine Dynamisierung der Theorie der Avant-garde: Dargestellt an Marcel Duchamp's 'Fountain.'" In: *Theorie der Avantgarde: Antworten auf Peter Bürgers Bestimmung von Kunst und bürgerlicher Gesellschaft.* Ed. W. Martin Lüdke. Frankfurt am Main: Suhrkamp, 1976.

Oliveira, Emídio Rosa de. "De Marey a Duchamp: Fotomorfoses, ou, A forma espec-tral do movimento." *Colóquio-Artes,* n.s. no. 69 (June 1986), 22–29.

———. "Máquinas, maquinarias e maquinações." *Colóquio: Artes,* ser. 2, vol. 54 (September 1982), 26–35. On the "Large Glass."

Oppitz, Mark. "Adler Pfeiffe Urinoir." *Interfunktion,* no. 9 (1973), 177–80. On "Foun-tain."

O'Rorke, Robert. "Into the Twilight Zone." *Art and Artists,* 8 (June 1973), 8–10. On the Readymades.

Oudiette, Olivier. "Duchamp Dada." *L'Evênement* (Paris), November 1968, Pp. 70–77.

Pape, Gerard J. "Marcel Duchamp." *American Imago,* 42, no. 3 (Summer 1985), 255–67.

Papineau, Jean. "Jean-François Lyotard: De la Fonction critique à la transformation: Entrevue." *Parachute,* summer 1978, Pp. 4–9.

Parisier Plottel, Jeanine. "Machines de langage: *Impressions d'Afrique* et 'La Mariée mise à nu par ses célibataires, même.'" In: *Théorie, tableau, texte, de Jarry à Artaud.* Ed. Mary Ann Caws. Paris: Lettres modernes, 1978. Pp. 13–23.

Parker, Robert A. "America Discovers Marcel." *View,* series 5, no. 1 (March 1945), 32–33, 51.

Paz, Octavio. "La Dulcinea de Marcel Duchamp"="The Dulcinea of Marcel Du-champ." In: *Duchamp.* Barcelona: Fundación Caja de Pensiones, 1984. P. 58. On "Portrait ou Dulcinée."

Peterson, Elmer. "Tirez-pas sur le Conferencier!: Tristan Tzara and Marcel Du-champ." *Dada/Surrealism,* no. 4 (1974), 62–65.

Pieyre de Mandiargues, André. "Isis de Colisee." *La Nouvelle Revue française,* no. 56 (August 1957), 361–65.

Pincus-Witten, Robert. "Entries: L'Ecole de Nice, a Missing Book." *Arts Magazine,* 60, no. 5 (January 1986), 86–89.

———. "Theater of the Conceptual: Autobiography and Myth." *Artforum,* 12 (October 1973), 41–46; rpt. in: *Marcel Duchamp in Perspective.* Ed. Joseph Mascheck. Englewood Cliffs, N.J.: Prentice-Hall, 1975. Pp. 162–72.

Pingaud, Bernard. "L'Objet littéraire comme 'ready-made.'" *L'Arc,* no. 59 (1974), 16–23. On the Readymades.

Prinz, Jessica. "The Fine Art of Inexpression: Beckett and Duchamp." In: *Beckett Translating/Translating Beckett.* Ed. Alan Warren Friedman, Charles Rossman, and Dina Sherzer. University Park: Pennsylvania State University Press, 1987. Pp. 95–106.

Raillard, Georges. "Rien Peut-être." *L'Arc,* no. 59 (1974), 52–60.

———. "Roussel: Les Fils de la Vierge." In: *Marcel Duchamp: Abécédaire: Approches critiques.* Paris: Musée national d'art moderne, Centre national d'art et de culture Georges Pompidou, 1977. Pp. 185–200. On the "Large Glass."

Ray, Man. "Bilingual Biography." *View,* series 5, no. 1 (March 1945), 32, 51; rpt. in *Opus International,* no. 49 (March 1974), 31–33.

———. [Tribute to Duchamp]. *Art in America.* 57, no. 4 (1969), 43.

Reed, David. "The Developing Language of the Readymades." *Art History,* 8, no. 2 (June 1985), 209–27.

Reff, Theodore. "Duchamp & Leonardo: L.H.O.O.Q.-Alikes." *Art in America,* 65 (January 1977), Pp. 83–93. Responses by Jack J. Spector, Hellmut Wohl, and John Dee, with Reff's replies, in May–June 1977, p. 5, and July–August 1977, p. 5.

Restany, Pierre. "L'Autre Face de l'art, 1." *Domus,* no. 578 (January 1978), 49–53.

———. "L'Autre Face de la critique reflète l'autre face de l'art." *Opus International,* no. 70–71 (winter 1979), 42–44.

———. "Des Machines célibataires aux machines inutiles." *XXe Siècle,* June 1974, Pp. 132–40.

Reuterswärd, Carl Fréderic. "Manet." In: *Marcel Duchamp: Abécédaire: Approches critiques.* Paris: Musée national d'art moderne, Centre national d'art et de culture Georges Pompidou, 1977. Pp. 114–15.

"The Richard Mutt Case." *The Blind Man,* no. 2 (May 1917), 5–6. On "Fountain."

Richter, Hans. "In Memoriam of a Friend." *Studies in the Twentieth Century,* no. 2 (Fall 1968), 1–4; rpt. under the title "In Memory of Marcel Duchamp" in *Form,* no. 9 (April 1969), 4–5; also rpt. under the latter title in: *Marcel Duchamp in Perspective.* Ed. Joseph Masheck. Englewood Cliffs, N.J.: Prentice-Hall, 1975. Pp. 148–50.

———. "In Memory of a Friend." *Art in America,* 57 (July–August 1969), 40–41.

———. "Marcel Duchamp: Le Magicien." In his *Dada Profile.* Zurich: Arche, 1961. Pp. 31–34.

Roché, Henri-Pierre. "Souvenirs sur Marcel Duchamp." *Nouvelle Revue française,* 1, no. 6 (June 1953), 1133–36; rpt. in: Lebel, Robert. *Sur Marcel Duchamp.* Paris: Trianon, 1959. Pp. 79–87; English transl. under the title "Souvenirs of Marcel Duchamp" in: Lebel, Robert. *Marcel Duchamp.* New York: Paragraphic Books, 1959. Pp. 79–87.

———. "Vie de Marcel Duchamp." *La Parisienne,* January 1955, Pp. 62–69.

Rosenberg, Harold. "The Art World: Not Making It." *New Yorker,* 47 (16 October 1971), 147–53.

———. "Duchamp: Public and Private." *New Yorker,* 18 February 1974, Pp. 86–91. Review of MOMA exhibition.

———. "The Mona Lisa without a Mustache: Art in the Media Age." *Art News,* 75 (May 1976), 47–50. On "LHOOQ."

Rosenthal, Nancy. "The Six-Day Bicycle Wheel Race." *Art in America,* 53 (October–November 1965), 100–05.

Roters, Eberhard. "Die Opferung und Verklärung der Braut." In: *Androgyn: Sehnsucht nach Vollkommenheit*. Berlin: D. Reimer, 1986. Pp. 127-43.

Roth, Moira. "Aesthetic of Indifference." *Artforum*, 16 (November 1977), 46-53.

————. "Ivan Karp on Marcel Duchamp." *Studio International*, 187, no. 963 (February 1974), 53.

————. "Marcel Duchamp in America: A Self Ready-Made." *Arts Magazine*, 51, no. 9 (May 1977), 92-96.

————. "Robert Smithson on Duchamp: An Interview." *Artforum*, 12 (October 1973), 47; rpt. in: *Marcel Duchamp in Perspective*. Pp. 134-37.

Roth, Moira and William. "John Cage on Marcel Duchamp: An Interview." *Art in America*, 61 (November-December 1973), 72-79; rpt. in: *Marcel Duchamp in Perspective*. Ed. Joseph Masheck. Englewood Cliffs, N.J.: Prentice-Hall, 1975. Pp. 151-61.

Rougemont, Denis de. "Marcel Duchamp mine de rien." *Preuves*, 18, no. 204 (February 1968), 43-47; rpt. without title in his *Journal d'une époque: (1926-1946)*. Paris: Gallimard, 1968. Pp. 562-68.

Roussel, Alain. "Le Ready-made, ou, La Fausse Réconciliation de l'art et de la vie." *Opus International*, no. 49 (March 1974), 88-89.

Rowell, Margit. "Kupka, Duchamp and Marey." *Studio International*, 189 (January-February 1975), 48-51.

Rubin, William S. "Reflexions on Marcel Duchamp." *Art International*, 4, no. 9 (1960), 49-53; rpt. in: *Marcel Duchamp in Perspective*. Ed. Joseph Masheck. Englewood Cliffs, N.J.: Prentice-Hall, 1975. Pp. 41-51.

Rudinow, Joel. "Duchamp's Mischief." *Critical Inquiry*, 7, no. 4 (summer 1981), 747-60.

Ruff, Theo. "Der Salzhändler und seine Schriften: Über das Unterfangen, die Zettelwirtschaft Marcel Duchamps ins Deutsche umzusetzen." *Du*, no. 8 (1981), 4-17. Review of Serge Stauffer's edition.

Rumney, Ralph. "Marcel Duchamp as a Chess Player and One or Two Related Matters: François Le Lionnais Interviewed by Ralph Rumney." *Studio International*, 189, no. 973, (January-February 1975), 23-25.

Russo, Adelaide. "Marcel Duchamp and Robert Desnos: A Necessary and Arbitrary Analogy." *Dada/Surrealism*, no. 9 (1979), 115-23.

Salzmann, Siegfried. "Mona-Lisa-Verfremdungen und -Metamorphosen in der Kunst des 20. Jahrhunderts." In: *Mona Lisa im 20. Jahrhundert*. Ed. Julian Heynen and Patricia Krutisch. Duisburg: Wilhelm-Lehmbruck-Museum der Stadt Duisburg, 1978. Pp. 79-111. On "LHOOQ."

Sandler, Irving. "The Duchamp-Cage Aesthetic." In his *The New York School: The Painters and Sculptors of the Fifties*. New York: Harper & Row, 1978. Pp. 163-73.

Sanouillet, Michel. "In Memoriam: Marcel Duchamp 'Quand les Muets se taisent.'" *Cahiers de l'Association internationale pour l'étude de Dada et du surréalisme*, no. 3 (1969), 6-7.

————. "Marcel Duchamp and the French Intellectual Tradition." In: *Marcel Duchamp*. Ed. Anne d'Harnoncourt and Kynaston McShine. New York: Museum of Modern Art, 1973. Pp. 47-55.

Sayag, Alain. "Marcel Duchamp." In: *Film als Film: 1910 bis heute: Vom Animationsfilm der zwanziger zum Filmenvironment der siebziger Jahre.* Ed. Birgit Hein and Wulf Herzogenrath. Cologne: Kölnischer Kunstverein, 1977, Pp. 120–21. On "Anémic Cinéma."

Sayre, Henry M. "Ready-Mades and Other Measures: The Poetics of Marcel Duchamp and William Carlos Williams." *Journal of Modern Literature,* 8, no. 1 (1980), 3–22.

Schmalenbach, Werner. "Die 'Schokoladenmühle' von Marcel Duchamp: Zu einer Neuerwerbung der Kunstsammlung Nordrhein-Westfalen in Düsseldorf." *Pantheon,* 32, no. 1 (1974), 64–71.

Schwarz, Arturo. "The Alchemist Stripped Bare in the Bachelor, Even." In *Marcel Duchamp.* Ed. Anne d'Harnoncourt and Kynaston McShine. New York: Museum of Modern Art, 1973. Pp. 81–98.

———. "Contributi a una poetica del ready-made" = "Contributions to a poetic of the ready-made." In: Hopps, Walter, Ulf Linde, and Arturo Schwarz. *Marcel Duchamp: Ready-Mades, etc.* Paris: Le Terrain vague, 1964. Pp. 16–36.

———. "Duchamp et l'alchimie." In: *Marcel Duchamp: Abécédaire: Approches critiques.* Paris: Musée national d'art moderne, Centre national d'art et de culture Georges Pompidou, 1977. Pp. 10–21.

———. "Fonti iconografiche degli 'Amanti' di Duchamp" = "Iconographical Sources of Duchamp's 'Lovers.'" In: *Su Marcel Duchamp.* Naples: Framart, 1975. Pp. 59–65.

———. "La Macchina celibe alchimistica." *Le Arti,* 25, no. 10–12 (1975), 23–32.

———. "Marcel Duchamp alias Rrose Sélavy alias Marchand du Sel alias Belle Haleine." *Data* (Milan), 3 (Autumn 1973), 30–38, 86–91.

———. "The Mechanics of the 'Large Glass.'" *Art International,* 10, no. 6 (Summer 1966), 102–04; also in *Cahiers de L'Association internationale pour l'étude de Dada et du surréalisme,* no. 1 (1966), 192–95.

———. "Rrose Sélavy alias Marchand du Sel alias Belle Haleine." *L'Arc* (1974), 29–35.

Sekuler, Robert, and Eugen Levinson. "The Perception of Moving Targets." *Scientific American,* 236, no. 1 (January 1977), 60–73. Includes illustration with brief discussion of "Spirale blanche," from Duchamp's Rotoreliefs.

Serra, Eulàlia, and Ignasi de Solá-Morales. "Espacios impenetrables: Nota sobre el montaje de la exposición de Marcel Duchamp" = "Impenetrable Spaces: Notes on the Mounting of the Marcel Duchamp Exhibition." In: *Duchamp.* Barcelona: Fundación Caja de Pensiones, 1984. Pp. 22–25.

Soby, James Thrall. "Marcel Duchamp in the Arensberg Collection." *View,* series 5, no. 1 (March 1945), 10–12.

Soupault, Philippe. "Marcel Duchamp." In his *Ecrits sur la peinture.* Paris: Lachenal & Ritter, 1980. Pp. 262–64.

Spiegel, Randy. "Marcel Duchamp, Anartist." *American Art Review,* 2, (July–August 1975), Pp. 121–28.

Spies, Werner. "The Grand Renunciation: On the Death of Marcel Duchamp." In his *Focus on Art.* New York: Rizzoli, 1982. Pp. 122–25.

———. "The Objective Image: From Duchamp's Readymades to Minimal Art." In his *Focus on Art.* Pp. 213–17.

Staber, Margit, "Marcel Duchamp." *Das Kunstwerk,* 14, no. 7 (January 1961), 3–10.

Stauffer, Serge. "Das 'Grosse Glass' und die 'Grüne Schachtel' von Marcel Duchamp." In: *Dokumentation über Marcel Duchamp*. Zurich: Kunstgewerbemuseum, 1960. Pp. 13–16.

———. "'L'Homme le plus sérieux de monde': Marcel Duchamp als Schachspieler." *Du*, no. 1 (1982), 62–67.

———. Imaginäres Gespräch mit Marcel Duchamp." In: Duchamp, Marcel. *Die Schriften*. Transl. and ed. Serge Stauffer. Zurich: Regenbogen-Verlag, 1981. Vol. 1, Pp. 306–08.

———. "rEaDy-MaDe, oder, Etant donné." In: Zaunschirm, Thomas. *Bereites Mädchen Ready-made*. Klagenfurt: Ritter, 1983. Pp. 7–10.

Steefel, Lawrence D., Jr. "The Art of Marcel Duchamp: Dimension and Development in 'Le Passage de la vièrge à la mariée.'" *Art Journal*, 22, no. 2 (Winter 1962/63), 72–80; rpt. in: *Marcel Duchamp in Perspective*. Ed. Joseph Masheck. Englewood Cliffs, N.J.: Prentice-Hall, 1975. Pp. 90–106.

———. "Marcel Duchamp and the Machine." In: *Marcel Duchamp*. Ed. Anne d'Harnoncourt and Kynaston McShine. New York: Museum of Modern Art, 1973. Pp. 69–80.

———. "Marcel Duchamp's 'Encore à Cet Astre': A New Look." *Art Journal*, 36, no. 1 (Fall 1976), 23–30.

———. "Some Thoughts on the Ready-Mades." In: *Marcel Duchamp—A European Investigation*. Calgary: Alberta College of Art, 1979. Pp. 51–53.

Stuckey, Charles. "Duchamp's Acephalic Symbolism." *Art in America*, 65 (January 1977), 94–99. On "Lazy Hardware."

Suquet, Jean. "Section d'or." In: *Marcel Duchamp: Tradition de la rupture ou rupture de la tradition?* Paris: Union générale d'éditions, 1977. Pp. 235–61.

———. "Le Signe de la concordance." *L'Arc*, no. 59 (1974), 36–43. On the "Large Glass."

———. "Le Signe du cancer." *Le Nef*, no. 63–64 (March 1950) (Special number, "Almanach surréaliste du demi-siècle"), 99–105; entire number rpt. Paris: Plasma, 1978. On the "Large Glass."

Szeeman, Harald. "De Duchamp au Musée des obsessions." *L'Arc*, no. 59 (1974), 80–85.

Tancock, John. "The Influence of Marcel Duchamp." In: *Marcel Duchamp*. Ed. Anne d'Harnoncourt and Kynaston McShine. New York: Museum of Modern Art, 1973. Pp. 159–78.

Tashjian, Dickran. "Henry Adams and Marcel Duchamp: Liminal Views of the Dynamo and the Virgin." *Arts Magazine*, 51, no. 9 (May 1977), 102–07.

———. "Marcel Duchamp and Man Ray." In his *Skyscraper Primitives: Dada and the American Avant-garde, 1910–1925*. Middletown, Conn.: Wesleyan University Press, 1975. Pp. 49–70.

———. "Seeing through Williams: The Opacity of Duchamp's Readymades." *Library Chronicle of the University of Texas at Austin*, n.s. no. 29 (1984), 35–47.

Taylor, Brandon. "Duchamp's Art Legacy." *Art and Artists*, 15, no. 2 (June 1980), 18–21.

Taylor, Simon Watson. "Apropos of Readymades." *Art and Artists*, 1, no. 4 (July 1966), 46.

Teyssèdre, Bernard. "'La Mariée mise à nu par ses célibataires, même': Pluchage d'un retard en verre inachevé par Rrose Duchamp." *Les Cahiers du chemin,* no. 6 (15 April 1969), 12–42.

———. "La Notion de ready-made généralisé aux origines du groupe 'Art & Language.'" *L'Arc,* no. 59 (1974), 67–71.

Thenot, Jean-Paul. "Marcel Duchamp and Duchamp Marcel." In: *Marcel Duchamp: A European Investigation.* Calgary: Alberta College of Art, 1979. Pp. 130–35.

Tisdall, Caroline. "'Etant Données': Duchamp's Last Work Ten Years After It Was Given." In: *Duchamp Readymades.* Ed. Jo-Anne Birnie Danzker. Vancouver: Vancouver Art Gallery, 1978.

Tomkins, Calvin. "The Antic Muse." *New Yorker,* 57 (17 August 1981), 80–83.

———. "Marcel Duchamp." In his *The Bride and the Bachelors: Five Masters of the Avant-garde.* New York: Viking, 1968. Pp. 9–68.

———. "Not Seen and/or Less Seen." *New Yorker,* 40 (6 February 1965), 37–93.

———. "What the Hand Knows." *New Yorker,* 59 (2 May 1983), 113–18.

Tono, Yoshiaki. "Duchamp e 'inframince'" = "Duchamp and 'Inframince.'" In: *Duchamp.* Barcelona: Fundación Caja de Pensiones, 1984. Pp. 53–56.

———, Arata Isozaki, and Yukinobo Kagiya. "Maruseru Dyushan." *Mizue,* 6, no. 867 (June 1977), 5–56.

Traeger, Jörg. "Duchamp, Malewitch und die Tradition des Bildes." *Zeitschrift für Ästhetik und allgemeine Kunstwissenschaft,* 17, no. 1 (1972), 131–38. On the Readymades.

Trini, Tommaso. "Duchamp dall'oltreporta: Intervista con Arturo Schwarz" = "Duchamp from Behind the Door." *Domus,* no. 478 (September 1969), 45–46. On "Etant Donnés."

———. "La Mariée Sélavy nella strategia del 'Grande Vetro'" = "The Mariée Sélavy in the Strategy of the 'Large Glass.'" In: *Su Marcel Duchamp.* Naples: Framart, 1975. Pp. 67–86.

Troche, Michel. "M.D. ne broie plus son chocolat lui-même." *Opus International,* no. 49 (March 1974), 103–05.

Vaccari, Franco. "Duchamp and the Concealment of Work." In: *Marcel Duchamp—A European Investigation.* Calgary: Alberta College of Art, 1979. Pp. 67–71.

Varley, William. "Beyond Irony." *Stand,* 8, no. 2 (1966), 35–43.

Vautier, Ben. "Notes sur Duchamp." *L'Arc,* no. 59 (1974), 86.

———. "Painting is Easy." In: *Marcel Duchamp—A European Investigation.* Calgary: Alberta College of Art, 1979. Pp. 136–38.

———. "Trois fenêtres de Ben." *Opus International,* no. 49 (March 1974), 90.

Volboudt, Pierre. "Marcel Duchamp, l'homme de l'écart." *XXe Siècle,* n.s. no. 42 (June 1974), 81–83.

Waldberg, Patrick. "Marcel Duchamp: L'Unique et ses propriétés." *Critique,* no. 149 (October 1959), 850–65; rpt. in his *Les Demeures d'Hypnos.* Paris: La Différance, 1976. Pp. 99–117. Review of *Sur Marcel Duchamp* and 2 other works by Robert Lebel.

Walters, Gary. "Marcel Duchamp and Negative Capability: Given in Response to Jack Burnham, 'Duchamp and the Kabbalah—Levels of the Mystical Imagination.'" *Presentations on Art Education Research,* no. 5 (1979), 93–103.

Weiss, Evelyn. "'La Boîte en valise,' ou, Das tragbare Museum." *Museen in Köln*, 10, no. 8 (1971), 974–76.

Wescher, Paul. "Marcel Duchamp: The Pasadena Retrospective Examines the Life Work of One of the Germinal Figures of the Modern Movement." *Artforum*, 2 (December 1963), 19–22.

Wheelan, Guy. "Un Lettre inédit de Marcel Duchamp." *AICARC Bulletin*, no. 1 (1974), 1–2.

White, Grahame. "Another Look at the 'Large Glass.'" *Art International*, 20 (December 1976), 68.

Wieand, Jeffrey. "Duchamp and the Artworld." *Critical Inquiry*, 8, no. 1 (Autumn 1981), 151–57.

Williams, William Carlos. "Glorious Weather." *Contact*, no. 5 (June 1923).

Wohl, Hellmut. "Beyond the 'Large Glass': Notes on a Landscape Drawing by Marcel Duchamp." *Burlington Magazine*, 119 (November 1977), 763–72. On "Du Tignet."

————. "In Detail: Marcel Duchamp and the 'Large Glass.'" *Portfolio*, 4, no. 4 (July-August 1982), 70–75.

Wood, Beatrice. "Marcel's Mischief, and Other Matters." *Architectural Digest*, 41, no. 5 (May 1984), 38–46. Interview by Barbara Kraft.

Exhibition Catalogs

Galerie La Boëtie (Paris). *Salon de "La Section d'or."* Paris: n.n., 1912. 10–30 October 1912.

Arts Club of Chicago. *Exhibition of Paintings by Marcel Duchamp.* Chicago: Arts Club, 1937.

Yale University Art Gallery (New Haven, Conn.). "Duchamp, Duchamp-Villon, Villon." Essay by George Heard Hamilton. *Bulletin of the Associates in Fine Arts at Yale University*, 13, no. 2 (March 1945), 1–7.

Art Institute of Chicago. *20th Century Art, from the Louise and Walter Arensberg Collection.* Chicago: Art Institute of Chicago, 1949. 20 October–18 December 1949.

Yale University Art Gallery (New Haven, Conn.). *In Memory of Katherine S. Dreier, 1877–1952: Her Own Collection of Modern Art.* New Haven: Associates in Fine Arts at Yale University, 1952. 15 December 1952–1 February 1953.

Rose Fried Gallery (New York). *Duchamp frères & soeur: Oeuvres d'art.* New York: Rose Fried Gallery, 1952. 25 February–March 1952.

Guggenheim Museum (New York). *Jacques Villon, Raymond Duchamp-Villon, Marcel Duchamp, 1957.* New York: Guggenheim Museum, 1957. 8 January–17 February 1957; also held at Museum of Fine Arts of Houston, 8 March–8 April 1957.

Kunstgewerbemuseum (Zurich). *Dokumentation über Marcel Duchamp.* Zurich: Kunstgewerbemuseum, 1960. 30 June–28 August 1960.

Pasadena Art Museum. *Marcel Duchamp, Pasadena Art Museum: A Retrospective Exhibition.* Pasadena: Pasadena Art Museum, 1963. 8 October–3 November 1963.

Kunsthalle Bern. *Marcel Duchamp, Wassily Kandinsky, Kasmir, Malewitsch, Josef Albers, Tom Doyle.* Bern: Kunsthalle, 1964. 23 October–29 November 1964.

Museum Haus Lange Krefeld. *Marcel Duchamp*. Krefeld: Museum Haus Lange Krefeld, [1964?].

Gimpel Fils (London). *Marcel Duchamp*. London: Gimpel Fils, 1964. December 1964–January 1965.

Galleria Schwarz (Milan). *Marcel Duchamp: Ready-Mades, etc.* Texts by Walter Hopps, Ulf Linde, and Arturo Schwarz. Paris: Le Terrain Vague, 1964.

[Gavina (Bologna)?]. *Marcel Duchamp ready-made*. Bologna: Gavina, 1965. June 1965?

Haags Gemeentemuseum (The Hague). *Marcel Duchamp: Schilderijen, tekeningen, ready-mades, documenten*. N.p.: n.n., 1965. 3 February–15 March 1965; also held at Stedelijk van Abbemuseum (Eindhoven), 20 March–3 May 1965.

Kestner-Gesellschaft (Hanover). *Marcel Duchamp, même*. Ed. Wieland Schmied. Hanover: Kestner-Gesellschaft, 1965. 7–28 September 1965.

Cordier & Ekstrom (New York). *Not Seen and/or Less Seen of/by Marcel Duchamp/Rrose Sélavy, 1904–64*. Text by Richard Hamilton. New York: Cordier & Ekstrom, 1965. 14 January–13 February 1965; also held at various other locations.

Tate Gallery (London). *The Almost Complete Works of Marcel Duchamp*. Catalog by Richard Hamilton. London: Arts Council of Great Britain, 1966. 18 June–31 July 1966.

Galleria Schwarz (Milan). *Marcel Duchamp*. Milan: Galleria Schwarz, 1966. 4 December 1965–3 February 1966.

Australian State Galleries. *Marcel Duchamp: The Mary Sisler Collection: 78 Works 1904–1963*. N.p.: n.n., 1967. Traveling exhibition.

Musée National d'Art Moderne (Paris). *Raymond Duchamp-Villon, Marcel Duchamp*. Texts by Jean Cassou and Bernard Dorival. Paris: Musée National d'Art Moderne, 1967. 7 June–2 July.

Musée des Beaux-Arts (Rouen). *Les Duchamps: Jacques Villon, Raymond Duchamp-Villon, Marcel Duchamp*. Rouen: Musée des Beaux-Arts, 1967. 15 April–1 June 1967.

Duchamp, Marcel. *The Lovers: Nine Original Etchings for* The "Large Glass" *and Related Works, Vol. II by Arturo Schwarz*. Text by Schwarz. Milan: Galleria Schwarz, 1969. Exhibition held 8–30 April 1969.

Galerie Spala (Prague). *Marcel Duchamp*. Text by Jindřich Chalupecký. Prague: Svaz cs. výtvarných umelcu, 1969. April 1969.

Galerie René Block (Berlin). *Marcel Duchamp: Ready-Mades, Radierungen*. Berlin: René Block, 1971. 3 April–1 May 1971.

Galleria Civica d'Arte Moderna (Ferrara). *Marcel Duchamp: Grafica e ready-made*. Text by Arturo Schwarz. Cento: Siaca arti grafiche, 1971. 19 March–9 May 1971.

Il Segnapassi (Pesaro, Italy). *Marcel Duchamp: Disegni e grafica*. Pesaro: Il Segnapassi, 1971. 31 August–20 September 1971.

Israel Museum (Jerusalem). *Marcel Duchamp: Drawings, Etchings for the "Large Glass," Ready-mades, Lent by Galleria Schwarz, Milano*. Jerusalem: Israel Museum, 1972. March–May 1972.

Galleria Schwarz (Milan). *Marcel Duchamp: 66 Creative Years: From the First Painting to the Last Drawing*. Catalog by Arturo Schwarz. Milan: Galleria Schwarz, 1972. 12 December 1972–28 February 1973.

Il Fauno, Galleria d'arte (Turin). *Marcel Duchamp*. Text by Janus. Turin: Il Fauno, 1972. 20 March–20 April 1972.

Städtische Galerie im Lenbachhaus (Munich). *New York Dada: Duchamp, Man Ray, Picabia.* Text by Arturo Schwarz; ed. Armin Zweite, Michael Petzet, and Götz Adriani. Munich: Prestel, 1973. 15 December 1973-27 January 1974; also held at Kunsthalle Tübingen, 9 March-28 April 1974.

Palazzo Reale (Naples). *La Delicata Scacciera: Marcel Duchamp: 1902-1968.* Ed. Achille Bonito Oliva. Florence; Centro Di, 1973. June-July 1973.

Philadelphia Museum of Art. *Marcel Duchamp; A Retrospective Exhibition.* Ed. Anne d'Harnoncourt and Kynaston McShine. Philadelphia: Philadelphia Museum of Art, 1973. 22 September-11 November 1973; also held at Museum of Modern Art (New York, 3 December 1973-10 February 1974) and Art Institute of Chicago, 9 March-21 April 1974.

Galerie Charles Kriwin (Brussels). *Marcel Duchamp.* Text by Pierre Sterckx and Vincent Baudoux. Brussels: Galerie Charles Kriwin, 1974. October 1974.

Detroit Institute of Arts. *Cobra and Contrasts: The Lydia and Harry Winston Collection.* Detroit: Detroit Institute of Arts, 1974. 25 September-17 November 1974. One section of the exhibition was entitled "Duchamp, Dada and Surrealism."

Kunsthalle Bern. *Le Macchine celibi = The Bachelor Machines.* Ed. Jean Clair and Harald Szeeman. Venice: Alfieri, 1975. Exhibition held in Bern and 7 other cities. German-French edition of the catalog published simultaneously under the title *Junggesellenmaschinen = Les Machines célibataires.*

Mercanto del Sale (Milan). *Marcel Duchamp, "un nuovo mondo."* Text by Ugo Carrega. Milan: Mercanto del Sale, 1975.

Chateau de Saint-Cirq-Lapopie (Lot). *New-York Dada: Peintures, sculptures, objets, documents.* N.p.: n.n., 1975. 12 July-1 October 1975.

Galleria Marin (Turin). *Il Grande Vetro in Marcel Duchamp, anche.* Text by Janus. Turin: Galleria Marin, 1975. January 1975.

Galerie La Hune (Paris). *Duchamp du trait.* Paris: Galerie La Hune, 1977. February 1977.

Musée National d'Art Moderne (Centre Pompidou) (Paris). *Marcel Duchamp.* Paris: Centre National d'Art et de Culture Georges Pompidou, Musée National d'Art moderne, 1977. 4 volumes issued for the exhibition "L'Oeuvre de Marcel Duchamp," 31 January-2 May 1977. Vol. 1: *Plan pour écrire une vie de Marcel Duchamp,* by Jennifer Gough-Cooper and Jacques Caumont; v. 2: *Marcel Duchamp: Catalogue raisonné,* ed. Jean Clair; v. 3: *Marcel Duchamp: Abécédaire,* ed. Jean Clair; v. 4: *Victor,* by Henri-Pierre Roché. For details, see Monographs section.

Vancouver Art Gallery. *Duchamp Readymades.* Vancouver: Vancouver Art Gallery, 1978. 29 April-4 June 1978.

Museum of Modern Art, Seibu Takawara (Tokyo). *Marcel Duchamp.* Tokyo: Seibu Takawara, 1981. Exhibition held 1 August-6 September 1981.

Duchamp, Marcel. *Marcel Duchamp's Travelling Box.* N.p.: Arts Council of Great Britain, 1982. Catalog of a traveling exhibition.

Arman, Yves. *Marcel Duchamp: Plays and Wins.* Paris: Marvel; New York: Galerie Yves Arman, 1984. Exhibition at Galerie Yves Armand, New York, and Galerie Beaubourg, Paris, 1984, and Galerie Bonnier, Geneva, 1985.

Ringling Museum of Art (Sarasota). *Marcel Duchamp; Works from the John and Mable Ringling Museum of Art Collection.* Sarasota: Ringling Museum of Art, 1983. 9 September 1983-8 January 1984.

Fundación Caja de pensiones (Barcelona). *Duchamp.* Barcelona: Fundación Caja de pensiones, 1984. Exhibition held in Barcelona and Madrid. Catalog issued in a Spanish/English and Catalan/English editions.

Museum Ludwig (Cologne). *Duchamp.* Cologne: Museen der Stadt Köln, 1984. 27 June–19 August 1984. Translation of the catalog of the exhibition in Barcelona and Madrid.

Galleria Vivita 1 (Florence). *Marcel Duchamp.* Florence: Galleria Vivita 1, 1987. Exhibition held 14 March–9 May 1987.

University Fine Arts Gallery, Florida State University. *Marcel Duchamp's Notes.* Text by Craig Adcock. Tallahassee: Florida State University, 1985. Exhibition 8 February–3 March 1985.

Arnold Herstand (New York). *The Brothers Duchamp: Jacques Villon, Raymond Duchamp-Villon, Marcel Duchamp.* New York: Arnold Herstand, 1986. Exhibition, 23 January–8 March 1986.

Galerie Tokoro (Tokyo). *Les 3 Duchamps: Jacques Villon, 1875–1963, Raymond Duchamp-Villon, 1876–1918, Marcel Duchamp, 1887–1968: 2 novembre–15 décembre 1984.* Tokyo: Galerie Tokoro, 1984.

Stadtmuseum Ratingen. *Marcel Duchamp als Zeitmaschine.* Ratingen: Stadtmuseum, 1987.

Menil Foundation (Houston). *Marcel Duchamp's " Fountain."* Essay by William Camfield. Houston: Menil Foundation, 1988.

NOTES ON CONTRIBUTORS

CRAIG ADCOCK teaches Art History at the University of Notre Dame. He is the author of *Marcel Duchamp's Notes from the "Large Glass": An N-Dimensional Analysis* (1983), and essays on Dada and its influence.

GEORGE H. BAUER teaches French and Comparative Literature at the University of Southern California. He is the author of *Sartre and the Artist*, (1969) and is currently completing two books: *Duchamp/La Mise en plis des lettres/ Vois Elle Con Sonne*, and *Duras and the Artist*.

WILLIAM A. CAMFIELD teaches Art History at Rice University. His publications include *Francis Picabia, His Art, Life and Time* (1979), *Tabu-Dada: Jean Crotti and Suzanne Duchamp* (1983), with Jean-Hubert Martin, and *Marcel Duchamp's "Fountain"* (1988).

THIERRY DE DUVE teaches Art History and theory at the University of Ottawa. He is the author of *Nominalisme pictural: Marcel Duchamp, la peinture et la modernité* (1984), and *Essais datés 1974–1986* (1987).

CAROL P. JAMES teaches French at the University of Wisconsin-Madison. She wrote her dissertation on Duchamp, and she has published essays on cinema and twentieth-century art and literature.

DALIA JUDOVITZ teaches French literature at UC-Berkeley. She has published essays on philosophy and literature, psychoanalysis, and aesthetics, and she is the author of *Subjectivity and Representation: The Origins of Modern Thought in Descartes* (1987).

RUDOLF E. KUENZLI teaches English and Comparative Literature, and directs the International Dada Archive at The University of Iowa. He is the coauthor of *Dada Artifacts* (1978), coeditor of *Dada Spectrum: The Dialectics of Revolt* (1979), editor of *New York Dada* (1986) and *Dada and Surrealist Film* (1987).

JEAN-HUBERT MARTIN is the director of the Centre Georges Pompidou in Paris. His publications include exhibition catalogs on *Francis Picabia* (1976), *Malevich* (1978) and, together with William Camfield, *Tabu Dada: Jean Crotti and Suzanne Duchamp* (1983).

FRANCIS M. NAUMANN teaches Art History at Parsons School of Design. He is the author of *The Mary and William Sisler Collection* (1984), and of numerous essays on New York Dada. His book on Man Ray will soon be published, and he is currently preparing an edition of Duchamp's letters.

PETER READ teaches French literature at the University of St. Andrews in Scotland. He is the author of several essays on twentieth-century art and literature.

ARTURO SCHWARZ is the organizer of a series of important exhibitions of Duchamp's works, and the author of *The Complete Works of Marcel Duchamp* (1969), and of numerous books on Duchamp, Dada, and alchemy.

TIMOTHY SHIPE, librarian, is the archivist of the International Dada Archive at The University of Iowa.

HELLMUT WOHL teaches Art History at Boston University. He is the author of *The Paintings of Domenico Veneziano* (1980) and of several other studies.

BEATRICE WOOD is one of America's pioneering ceramic artists. In 1985 she published her autobiography, *I Shock Myself*.